CHARLES SHEELER:

PAINTINGS and DRAWINGS

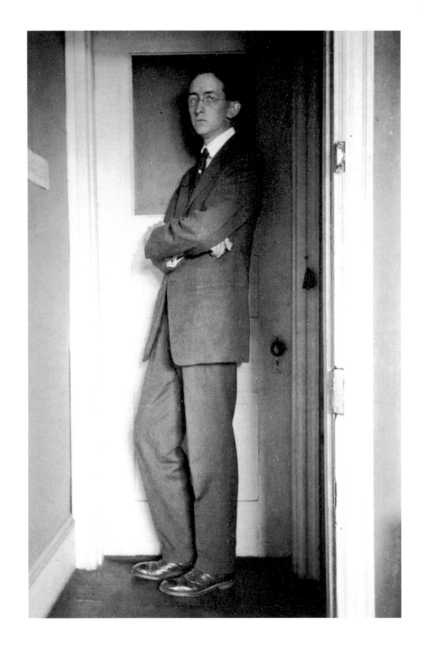

CHARLES SHEELER:

PAINTINGS and DRAWINGS

by Carol Troyen and Erica E. Hirshler

A New York Graphic Society Book

Little, Brown and Company, Boston

Charles Sheeler: Paintings, Drawings, Photographs
was organized by the Museum of Fine Arts, Boston
and is supported by a grant from the National En-
dowment for the Arts. The Luce Fund for Scholar-
ship in American Art, a project of the Henry Luce
Foundation, made possible the research for the ex-
hibition and catalogue and helped support the pub-
lication. The H. John Heinz III Charitable Trust also
generously supported the catalogue.

Copyright © 1987 by Museum of Fine Arts
Boston, Massachusetts

Library of Congress catalogue card no. 87-42966
ISBN 0-87846-284-8 (cloth)
ISBN 0-87846-288-0 (paper)

Typeset and printed by Acme Printing Co.,
Wilmington, Massachusetts

Bound by Acme Bookbinding Co.,
Charlestown, Massachusetts

Manuscript edited by Janet G. Silver

Designed by Carl Zahn

Cover (and jacket)
Composition Around White, 1959 (cat. no. 87)
Private collection

Chrysanthemums, 1923 (cat. no. 24)
Columbus Museum of Art. Gift of
Ferdinand Howald, 1931.

Frontispiece:
Charles Sheeler, c. 1913-18
Gelatin-silver print
The Lane Collection

New York Graphic Society books are published by Little,
Brown and Company, Inc.
Published simultaneously in Canada by Little, Brown and
Company (Canada) Limited.

Printed in the United States of America
First edition

Exhibition Itinerary

Museum of Fine Arts, Boston
October 13, 1987 - January 3, 1988

Whitney Museum of American Art, New York
January 28 - April 17, 1988

Dallas Museum of Art
May 15 - July 10, 1988

Changes in Exhibition:

Boston only:
cat. nos. 9, 40, 41, 48, 74, 76

Boston and New York only:
cat. nos. 28, 54, 73, 81

Boston and Dallas only:
cat. nos. 55, 37

Photo credits:

Richard W. Caspole, cat. no. 48, 52; Geoffrey Clements,
cat. nos. 23, 26, 46; Robert Mates, cat. no. 80; Joseph
Szaszfai, cat. no. 71; Malcolm Varon, cat. no. 65. *Life* Maga-
zine © 1938, Time Inc., fig. 24, cat. no. 56, fig. a, The Condé
Nast Publications, Copyright © 1929 (renewed 1957),
cat. no. 42, fig. b

This book is dedicated to BILL and SAUNDRA LANE,

friends of Charles Sheeler and champions of his work

Contents

Preface

The Museum of Fine Arts is proud to present "Charles Sheeler: Paintings, Drawings, Photographs," the most comprehensive show of this artist's work ever mounted and the first major survey since the exhibition held at the National Collection of Fine Arts in Washington, D.C., in 1968.

Sheeler was an American modernist of great significance. From the time of the Armory Show in 1913 until the mid-1950s, his contribution was singular in that it embraced painting, drawing, and photography in equal measure. Sheeler was always fascinated by how these media interrelated and by the expressive possibilities inherent in each. As early as 1922, Georgia O'Keeffe wrote of Sheeler in this way:

> No one considering his work questions his paintings and drawings as among the most interesting of their type in America today. To me his photographs are of equal importance. He is always an artist. He has done things with photography that he could not do with painting and vice versa.

Sheeler is the quintessential American artist. His subjects — the modest buildings of the Pennsylvania countryside, farmhouse interiors, the simple, unadorned forms of Shaker design, as well as industrial landscapes and New York skyscrapers — always show Sheeler to be passionately interested in basic structure and the powerful evocation of individual form. In constructing his geometrically precise compositions and paying close attention to the essential shapes of machines and buildings, Sheeler was the first artist to idealize American technology.

This book on Sheeler's paintings and drawings, one of two volumes that catalogue the exhibition, has been written by Carol Troyen, Associate Curator of American Paintings, and Erica E. Hirshler, Research Assistant. The companion volume on Sheeler's photographs is by Theodore E. Stebbins, Jr., and Norman Keyes, Jr. We trust that these two volumes, charting the total extent of Sheeler's work, will make a major contribution to the literature on the artist and will remain as an indispensable reference long after the exhibition has been dismantled.

Forty-seven public collections and private lenders have shared their paintings and drawings with us, as well as with the other participating museums: the Whitney Museum of American Art, New York, and the Dallas Museum of Art. We are deeply indebted to our museum colleagues and to the private collectors who have shared their objects with us, ensuring a thoroughgoing presentation of Sheeler's artistic accomplishment.

The project has benefited enormously over the past several years from the support and guidance of my distinguished predecessor, Dr. Jan Fontein. This occasion provides me with the opportunity to thank him for his role in the realization of this important show.

Finally, the exhibition was conceived by Charles Sheeler's great friend and champion William H. Lane, who came to understand and admire Sheeler's work long before most others recognized his genius. As plans for this exhibition proceeded, Bill and Saundra Lane worked closely with Jan Fontein and with the curators of the Museum of Fine Arts. The Lanes have been generous, supportive, hospitable, and understanding in every way, and they have truly made this exhibition and book possible.

The exhibition is subsidized by a grant from the National Endowment for the Arts, a federal agency. The Luce Fund for Scholarship in American Art, a project of the Henry Luce Foundation, made possible the research for the exhibition and catalogue and provided partial support for the publication.

Alan Shestack, *Director*

Lenders to the Exhibition

Addison Gallery of American Art, Phillips Academy, Andover, Massachusetts

Warren Adelson

The Art Institute of Chicago

The Baltimore Museum of Art

The Brooklyn Museum of Art, New York

The Butler Institute of American Art, Youngstown, Ohio

Collection of Constance B. and Carroll L. Cartwright

The Cleveland Museum of Art

Columbus Museum of Art, Ohio

The Corcoran Gallery of Art, Washington, D.C.

The Currier Gallery of Art, Manchester, New Hampshire

Dallas Museum of Art

DeCordova and Dana Museum and Park, Lincoln, Massachusetts

The Detroit Institute of Arts

Collection of Mr. and Mrs. Barney A. Ebsworth

Collection of Mr. and Mrs. Barney A. Ebsworth Foundation

Mr. and Mrs. James A. Fisher, Pittsburgh, Pennsylvania

Collection of Mr. and Mrs. George Greenspan

Harvard University Art Museums, Cambridge, Massachusetts

Mr. and Mrs. Richard C. Hedreen

Hirshhorn Museum and Sculpture Garden, Smithsonian Institution, Washington, D.C.

Mr. and Mrs. William C. Janss

The Lane Collection

Mr. and Mrs. Carl D. Lobell

James Maroney, New York

Steve Martin

Memorial Art Gallery of the University of Rochester, Rochester, New York

The Metropolitan Museum of Art, New York

Museum of Art, Rhode Island School of Design, Providence

Museum of Fine Arts, Boston

Museum of Fine Arts, Springfield, Massachusetts

The Museum of Modern Art, New York

Philadelphia Museum of Art

The Phillips Collection, Washington, D.C.

Mr. and Mrs. Meyer P. Potamkin

The Regis Collection, Minneapolis

The St. Louis Art Museum

Smith College Museum of Art, Northampton, Massachusetts

Daniel J. Terra Collection, Terra Museum of American Art, Chicago

Mrs. James L. Whitcomb

Whitney Museum of American Art, New York

Collection of Mathew Wolf

Yale University Art Gallery, New Haven, Connecticut

Anonymous Private Collections

Acknowledgments

This project had its beginnings in the exhibition "The Lane Collection: 20th-Century Paintings in the American Tradition," organized by the Museum of Fine Arts in 1983 and featuring fifteen paintings and drawings by Charles Sheeler. Since that time, the idea of presenting a comprehensive exhibition of Sheeler's works has been energetically promoted by Jan Fontein, former director of the Museum of Fine Arts, and we have profited at all stages from his interest, his enthusiasm, and his wise counsel. Equally helpful has been Theodore E. Stebbins, Jr., John Moors Cabot Curator of American Paintings, who initiated the plans for this exhibition and co-authored the volume on Sheeler's photographs that accompanies this one; his discerning eye and fine scholarship established the standards we have endeavored to meet here. This exhibition marks the inaugural paintings show mounted at the Museum of Fine Arts under the directorship of Alan Shestack, and we are grateful for his enthusiastic endorsement of the project and for his long-standing and often expressed admiration for Sheeler's work. The project has been funded since its inception by a generous grant from the Henry Luce Foundation, Inc.; additional funds were provided by the National Endowment for the Arts, and we thank both institutions for their support.

Many members of the staff of the Museum of Fine Arts have made contributions to this project. The museum's own Sheelers, as well as those in the Lane Collection and several belonging to other private collectors, were carefully examined and, where necessary, treated by our conservators; we are indebted to Alain Goldrach, Jean Woodward, Brigitte Smith, Irene Konefal, Roy Perkinson, and Elizabeth Lunning for their efforts. The assistance of Michael Morano and Gail English in framing and matting was equally valuable. In the Registrar's Office, the many details concerning packing and transporting the works in the exhibition were efficiently coordinated by Linda Thomas and her able staff, particularly Pamela J. Delaney, who also spent many hours typing the manuscript with unfailing dedication and good cheer. The staff of the MFA library, led by Nancy Allen, has been consistently supportive; special thanks are due to Bonnie Porter for tracking down many research materials difficult to obtain. Patricia Marr, Beverly Lombard, and the rest of the Data Processing staff provided much technical expertise. Many of the photographs in this volume were made by Janice Sorkow's talented staff in the photo studio, namely Thomas Lang, John Lutsch, and Gary Ruuska, and we appreciate her organization of this task and the devotion and skill with which it was performed. Judith Downes and Tom Wong of the Design Department prepared an installation for the exhibition that is as elegant as it is understated, and is a handsome tribute to Sheeler's genius as a designer. Our colleagues in the Paintings Department, especially Trevor J. Fairbrother (who read the manuscript and offered many helpful suggestions), Patricia Loiko (who managed the budget for this project), and Harriet Rome Pemstein, good-naturedly assumed many of our responsibilities while we were preparing the exhibition, and we thank them for their patience and support. Thanks are also due to Norman Keyes, Jr., co-author of the photography volume, who did a great deal of research in the initial phases of this project. Several other Paintings Department members – Cynthia D. Fleming, Francine Hogan, Lillian Joyce, Chantal Mahy-Park, and especially Michelle O'Malley – helped with research, and Marci Rockoff generously lent a hand with the typing.

We have profited from the advice of many scholars, collectors, and dealers who have shared their special knowledge of Sheeler. At the MFA, discussions with Clifford Ackley, Mary Comstock, Edward S. Cooke, Jr., John J. Herrmann, Jr., Sue Reed, and Barbara Shapiro helped us clear up points large and small. Among collectors, we are indebted to the great courtesy of the many lenders to this exhibition, as well as to Edith and Milton Lowenthal, Harvey and Françoise Rambach, and especially to the late Nathaly Baum, whose warm memories of Sheeler were so helpful in shaping our understanding of his personality. Terry Dintenfass and especially James Maroney shared much useful information and stimulating observations about Sheeler's work. In addition, we would like to thank Mr. and Mrs. Oliver Kallos and Mrs. Helen Regelman for their hospitality.

We are also indebted to scholars from

other institutions who generously contributed their special knowledge: at the Whitney Museum of American Art, Barbara Haskell and Patterson Sims; at the Dallas Museum, Anna McFarland, Steven A. Nash, and Rick Stewart (now at the Amon Carter Museum). The advice of several Sheeler scholars was enormously beneficial, and we thank Susan Fillin-Yeh, Martin Friedman, Charles Millard, and the late Frederick Wight for their time and interest in this project. Special thanks are also due to William Agee, Terry Ariano, Diane Baldwin, Linda Bantel, Edgar Peters Bowron, Robert Brown, John Caldwell, Harold D. Clark, Jr., E. Jane Connell, Helen Cooper, William Cuffe, Jay Fisher, Nina Gray, Bernard Heineman, Jr., Mary Jane Jacob, Ellen Jacobowitz, John T. Kirk (for his many helpful observations about the objects in Sheeler's pictures), John Kroll, Cheryl Leibold, Suzanne McCullagh, Edward J. Nygren, James F. O'Gorman, Ann Percy, Cervin Robinson, Steven W. Rosen, Mark Rosenthal, Louise F. Rossmassler, Bertha Saunders, Diana Strazdes, Susan Strickler, Nicki Thiras, Joyce Tyler, Diana Wasserman, Peter Wisbey, Robert Workman, and Judith Zilczer.

The contribution of six colleagues deserves special mention here: Carl Zahn, Director of Publications at the Museum of Fine Arts, has produced a catalogue whose handsome design exceeds even his high standards. His admiration for Sheeler has encouraged us throughout the project, and his many thoughtful observations about the artist's work have been extremely illuminating. Janet Silver, who edited the manuscript, lent sense and style to often muddy prose; her dedication and skill were invaluable in bringing this project to completion. And four scholars — Avis Berman, Olive Bragazzi, John P. Driscoll, and Karen Lucic — spent many hours sharing their special knowledge of Sheeler with us. The frequency with which their names appear in the notes is but a small measure of their contribution.

Finally, we are indebted to the lenders who have selflessly parted with their paintings and drawings for the duration of this exhibition. Principal among these are William and Saundra Lane, who have given enormously to this project in time, enthusiasm, and special insight. They have opened our eyes to both the poignancy and the wit in Sheeler's work, and have taught us to honor equally his remarkable achievements in painting and photography. Without the Lanes, this exhibition could not have taken place. Their involvement enables us to pay to Charles Sheeler the tribute he so richly deserves.

 C.T. and E.E.H.

"From the eyes inward":
Paintings and Drawings
by Charles Sheeler

Carol Troyen

*"Photography is nature seen from the eyes out-
ward, painting from the eyes inward. Photogra-
phy records inalterably the single image while
painting records a plurality of images willfully
directed by the artist."*

Charles Sheeler, 1937

I
The Philadelphia Years, 1900 - 1919

Shortly after his graduation from the Pennsylvania Academy of the Fine Arts in 1906, Charles Sheeler rented a studio on Philadelphia's Chestnut Street, which he shared with Morton Schamberg, his closest friend from the academy. Within the next few years, both painters also were to become accomplished photographers. But while their careers developed in tandem, they had very different personalities. A pair of photographic self-portraits from about 1913-14 (figs. 1 and 2) brilliantly evoke their contrasting characters. Schamberg, his thick hair elegantly marcelled, his gaze intense over his glittering pince-nez, the sleeve of his luxurious suit pushed back to reveal poetically long fingers and a slender wrist, was clearly the more dashing and sensuous of the two. The flamboyance and romance his portrait betrays were to be characteristics of his painting as well: he would become a dazzling colorist, and his compositions, whether abstract or based on nature, would express an air of fantasy and high-keyed emotion. In contrast to Schamberg's image, Sheeler's conveys a sense of his aloofness. He stands in the tiny vestibule of his studio, the narrow door frame and the upward angle of the camera exaggerating his lean, erect figure (a rigid variation on classical *contrapposto*), his shadowy profile cast on the door behind him. The restraint evident here would mark his painting style for the duration of his more than fifty-year career. Characterized by a concern for line and, above all, architectonic structure, and by a reticent, highly controlled technique, his pictures would be called cold and severe by many critics. In fact, many of them hide profound emotion beneath their austerity and, like this portrait, reveal their secrets only on close examination.

Born July 16, 1883, in Philadelphia, Charles Sheeler was the only child of Charles Rettew and Mary Cunningham Sheeler. His family was solidly middle class, his father supporting the family with modest wages earned at the Clyde Line of Norfolk, a large steamship company. After high school, Sheeler (with his parents' encouragement) attempted to enroll at the Pennsylvania Academy but was dissuaded by its director.[1] Instead, he began his artistic studies at the School of Industrial Art, affiliated with the Pennsylvania (now Philadelphia) Museum, and three years later sought additional training

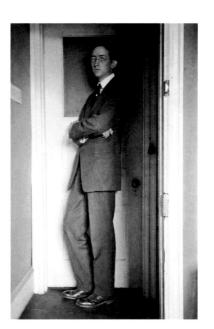

Fig. 1. *Charles Sheeler*, c. 1913-18, gelatin-silver print, The Lane Collection

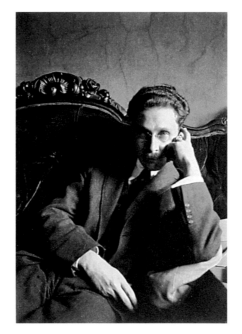

Fig. 2. *Morton Schamberg*, 1913-18, gelatin-silver print, The Lane Collection

at the Pennsylvania Academy. There he met Schamberg, who had enrolled the same year after obtaining a bachelor of architecture degree from the University of Pennsylvania.[2]

Despite their different backgrounds — Schamberg was from an upper-middle-class German-Jewish family — they became good friends in their three years at the Pennsylvania Academy. There both came under the influence of William Merritt Chase, the brilliant impressionist painter and bon vivant who taught the life and paintings classes. Sheeler and Schamberg spent a summer together at Gloucester, Massachusetts, painting little *plein air* studies in the Chasean manner, and made two trips to Europe — in 1904 to London and Holland, in 1905 to Spain — with Chase. After graduation they shared a Center-City studio located only a few blocks from the academy, as well as a country house on the outskirts of Doylestown, in Bucks County. They traveled to New York together to see exhibitions of contemporary art and participated in several avant-garde shows, where their work occasionally was confused.[3] In these early years, Schamberg was the more self-assured and successful of the two. His work was the first to be recognized by collectors,[4] and more than Sheeler, he was vitally involved in the Philadelphia art scene, reviewing exhibitions for the local paper and organizing, with H. Lyman Saÿen, the revolutionary "Exhibition of Advanced Modern Art" show at Philadelphia's McClees Gallery in 1916. For his part, Sheeler was the first to win the notice, and later the approbation, of Alfred Stieglitz, and promoted his studio-mate's cause for over a year before the impresario would acknowledge Schamberg's talent.[5]

There seems to have been no sense of jealousy or rivalry between the two artists. They progressed at about the same rate — Sheeler had his first solo show, at McClees, in 1908; Schamberg's followed in 1910 — and when it became apparent that they could not support themselves by their painting, they both turned to commercial photography to make a living. Beginning about 1912, Sheeler documented new buildings for local architects, while Schamberg established himself as a portrait photographer. They continued to paint in their spare time, setting up pictorial exercises that they

tackled jointly, frequently with astonishingly similar results (in one case a work by Schamberg was attributed to Sheeler for many years).[6]

When Schamberg died of pneumonia in October 1918, Sheeler's grief was deep and protracted. He wrote to Stieglitz, "This is the first moment that I have had the strength of spirit or body to tell you – that Schamberg died Sunday night of pneumonia following a cold. Knowing both of us as well as you did makes it unnecessary for me to tell you what it means for the one who remains."[7] It was at least in part the loss of Schamberg that finally persuaded Sheeler to leave Philadelphia for New York several months later, and ultimately to give up the Doylestown house. Never again would he have as profound and enduring a friendship with a painter.

Although Sheeler would later denigrate his artistic education, he in fact received excellent formal training. The School of Industrial Art, founded in 1876, was the first art school attached to an American museum to embrace English critic John Ruskin's philosophy of art education: the application of the spirit and training of the artist to the work of the artisan, in order to improve the artistic aspect of manufacturing and industry and to elevate the aesthetic sensitivity of the worker.[8] The school was run by the noted art educator Leslie Miller, and in addition to courses in textile design, illustration, applied design, and interior decoration, it offered classes in drawing and watercolor, conducted by the Munich-trained Herman Diegendesch (whom Sheeler later credited with providing his first meaningful training in the fine arts) and sculpture classes headed by Alexander Sterling Calder.

The school was large – more than one thousand were enrolled in 1900-1901 – but Sheeler managed to make his mark, earning certificates of commendation in industrial drawing and in decorative painting and applied art. Although he bridled at the school's Arts-and-Crafts orientation, and at its emphasis on using applied ornament derived from Egyptian, classical, and medieval sources to beautify industrial designs and manufactures, he none-

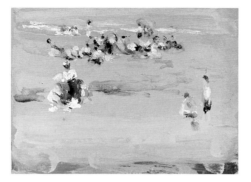

Fig. 3. Charles Sheeler, *Beach Scene*, c. 1906, oil on panel, The Lane Collection

theless was strongly influenced by his experiences there. His training in drawing disciplined his inherent talent as a draftsman; the exercises in copying ancient ornamental motifs may have awakened his fascination with pattern, which would give not only his paintings of interiors, with their proliferation of textiles, but also his industrial scenes their vitality. And the school's underlying premise – the belief in revealing the beauty residing in the useful – was one with which he would remain in sympathy for his entire career. Finally, enrollment in the school gave him ready access to the magnificent collections of the Pennsylvania Museum, including four galleries of early American ceramics, newly installed and opened the year he began classes.[9] That collection may have provided him with his first exposure to the kind of humble yet elegant artifact he would soon begin to acquire and to immortalize in his paintings.

Sheeler also gained much from his experience at the Pennsylvania Academy, which was a lively place when he enrolled there in 1903.[10] It had a prestigious faculty and attracted students from all over the country. Among the instructors were the well-respected local painters Thomas Anshutz and Cecilia Beaux, the portraitist Hugh Breckenridge, the illustrator Henry McCarter, and, leading the classes in painting, life study, and still life, the debonair William Merritt Chase. Sheeler was clearly dazzled by Chase, whose luxurious lifestyle, dashing physical appearance, and effortless

manner of painting must have represented, to an aspiring painter schooled in the mundane drudgery of applied design, the ideal image of the artist. Chase's practices as an instructor were equally exhilarating and romantic. In order to expose his students to the great art of the past and to the work of contemporary masters, he swept them off to Europe every summer, where he lectured to them about the bravura effects in the works of Hals, Velázquez, and El Greco and introduced them to the artists he considered the most important of his day – Leighton, Alma-Tadema, Sargent – even though they, like him, had their greatest achievements behind them.

At home, Chase schooled his acolytes in his own flamboyant manner of painting. He believed in the recording of spontaneous impressions as an essential principle of artistic creation, so he taught his students to sketch rapidly and directly on bits of board they carried with them on painting excursions to the countryside. Sheeler's earliest surviving painting, the tiny *Beach Scene* (fig. 3), is one such exercise in the Chasean manner. Possibly painted in Gloucester, it is fresh and sparkling, with lush, abbreviated brush strokes successfully evoking groups of bathers and the waves breaking on shore. Sheeler's few other works known from this period are less accomplished: the color tends to be muddy and somewhat ponderously applied, and the scenes lack light and a sense of spontaneity. Although Sheeler would soon reject Chase's immediate approach to subject matter and abandon his mentor's feathery impressionism for a style influenced by the more structural manner of Cézanne, for the next ten years he would remain faithful to the formula Chase prescribed: he painted on small panels, rarely larger than 14 by 10 inches, and confined himself to simple, modest subjects based, at least initially, on the direct observation of nature.

To Sheeler, Chase represented the exotic and mysterious side of art; Thomas Eakins, another painter to whom he was exposed while in school, only reminded him of the workaday side of picture-making. In fact, Sheeler shared much with Eakins: a concern for craft, a belief in meticulous preparation for works of art, the absence of any pretension in manner or style of dress, and, later, an interest in photography.

But Sheeler was unable to reconcile Eakins's deliberate manner with his own romantic notion of the artist as the inspired creator. Upon observing Eakins transfer a perspective drawing of his signature to his portrait of Leslie Miller (1901; Philadelphia Museum of Art), Sheeler commented, "This careful procedure led us to the conclusion that the man . . . couldn't be a great artist, for we had learned somewhere that great artists painted only by inspiration, a process akin to magic."[11]

Sheeler's affiliation with the Pennsylvania Academy enabled him to show his works at the annual exhibitions, and following his graduation in 1906 he was included regularly. He had two paintings (and five watercolors, in the Watercolor Annual) in the 1907 show, six in 1908, one in 1909, and five in 1910. Although he was less successful in placing works in the exhibitions of the National Academy of Design (NAD), and showed only one painting (out of fourteen submitted over a five-year period) at the Carnegie International in Pittsburgh, Sheeler's art was gaining exposure. Unfortunately, none of these works has been located, and their titles, for the most part, are not especially informative (*The River*; *Portrait Arrangement*), although occasionally a title will evoke an image done in the Ashcan school style (*The Flower Shop*; *Winter, New York*), a manner with which Sheeler acknowledged he was experimenting in those years.[12] Installation photographs from the Pennsylvania Academy annuals reveal only tiny, overframed pictures whose subjects are indecipherable, and in fact Sheeler's modest submissions attracted no critical notice and no buyers (the only recorded reaction seems to have come from the Fogg Art Museum's director, Paul Sachs, who wrote "very small" in the margin of his catalogue by Sheeler's entry to the 1908 NAD show). Nor was there much reaction to Sheeler's first solo exhibition, at the adventurous McClees Gallery, in 1908. The same year, and again in 1909, William Macbeth, the New York dealer who had been the first to show "The Eight," exhibited Sheeler's pictures at his gallery, with prices set at between $75 and $150. Although nothing sold, Sheeler was encouraged by the dealer's attentions.[13]

In December of 1908, Sheeler went to Europe with his parents and met up with Scham-

Fig. 4. Charles Sheeler, *Peaches in a White Bowl*, 1910, oil on canvas mounted on board, Dr. Barry King, El Paso, Tex.

berg. They first toured Italy, where Chase's lessons in the bravura manner of the Baroque masters were supplanted by an appreciation for the architectonic design and restrained handling of such early Renaissance painters as Masaccio and Piero della Francesca Sheeler then went on to Paris, where he was exposed to a new group of modern masters who replaced the role models Chase had proposed five years before. Although he arrived in Paris a few weeks too late to view all of Braque's l'Estaque landscapes (about which the term "cubism" was coined), which had been displayed by the dealer Henry Kahnweiler, many remained on the gallery's walls over the next several months. Bernheim-Jeune had a show of Seurat's conté crayon drawings; a group show at the Druet Gallery included works by Bonnard, Cézanne, Gauguin, and Van Gogh, and the Notre-Dame-des-Champs Gallery exhibited works by Braque, Picasso, and Derain.[14] Even more profound was the impact of Sheeler's visit to Michael Stein's apartment, where he saw more Braques, Picassos, and Cézannes – works that left him bewildered, but impressed.[15] Sheeler's third trip to Europe caused him to thoroughly reexamine his taste in art, and his ambitions. Neither impressionism nor pure painting generally nor anecdotal art would thereafter have any appeal for him. Chase's fluid, popular style and the transitory subject matter flourishing at the turn of the century quickly came to seem superficial. In his

own work, Sheeler turned away from the kind of picturesque themes implied by the titles of his now lost paintings (*The Harbor*; *Entrance to the Park*) in favor of a determined investigation of a more classical, structured manner of painting, inspired, for the most part, by Cézanne.

In September 1910, about a year and a half after his return from Europe, Sheeler sent work for a third time to William Macbeth. This time the dealer responded negatively: "I do not like the direction of your new work the least little bit. It is such a departure from old time sound methods, that I would not care to exhibit it. I hope it is only an experiment." Although Sheeler defended his new style in terms of the emphasis on structure and search for enduring values he had been impressed with in Europe – "There must always be the elimination of the unessentials and the striving after greater qualities," he said – Macbeth did not relent.[16] There is no record of Sheeler showing again in public until the Armory Show.

Although Macbeth disapproved of it, he was astute to recognize the new direction Sheeler's work had taken in 1910. Sheeler is known to have produced only two works that year, both simple still lifes: *Plums on a Plate* (cat. no. 1) and *Peaches in a White Bowl* (fig. 4), a daring study in color contrasts, painted with thick, creamy brush strokes. The hot reds and yellows of the peaches (which cast onto the ceramic bowl equally vibrant shadows of yellow and green) are set off against the cool tones of the tablecloth (no doubt white, but rendered in pale blue and green) and the startling black background. The color scheme is borrowed from Cézanne, as is the underlying premise that objects have no specific color of their own but rather reflect one another and are further affected by the intervening atmosphere. The asymmetrical composition is disquieting, an effect heightened by the plate being located so high in the picture space, and the table's surface tilting forward so the fruits seem in danger of spilling out of the picture plane. Except that the painting so clearly emulates Cézanne's seemingly unbalanced compositions and is in Sheeler's standard 10-by-14-inch format, it would appear to be a fragment.

Although there were few works by Cézanne in American collections when Shee-

ler returned from Europe, opportunities to study the French painter's work increased over the next decade. In 1911, twenty of Cézanne's watercolors were shown at Stieglitz's pioneering "291" gallery; in 1913, Sheeler visited the Philadelphia collector Dr. Albert Barnes for the first time, and although his only recorded reaction to Barnes's collection is one of general amazement and he mentions no specific works,[17] Barnes owned fourteen Cézannes by 1915; by 1923, when he established his foundation, there were about fifty.[18] Moreover, fourteen Cézannes were included in the Armory Show of 1913, including at least five that remained in American collections after the exhibition. By this time, the importance of these paintings was recognized by America's most adventurous critics, collectors, and artists. Schamberg could have been speaking for Sheeler when he put these works in historical perspective, pointing out their classical antecedents: "The art of Cézanne, Matisse, of Picasso, etc. is based upon the same ideas as that of Italy, Greece, Egypt, India, China, Africa or Mexico, in fact, of the art of all the centuries since its first manifestations."[19] Cézannes would be shown at the Montross Gallery in New York in 1916, at the Pennsylvania Academy in 1920, and at the Metropolitan Museum in 1921. Although these exhibitions occasionally elicited hostile reactions, prescient collectors — among them Walter and Louise Arensberg, Earl Horter, Marius de Zayas, and Agnes and Eugene Meyer, all supporters of Sheeler — had already assembled handsome collections of the work of Cézanne and other European moderns, which they made available to their artist friends.

Sheeler, ever laconic, said little about Cézanne. During the height of his study of the artist, his friends the Arensbergs lent him a small painting, *Still Life with Apples* (see cat. no. 31, fig. a) which Sheeler did not analyze but merely commented on, awestruck: "That picture was painted by one of the Angels. Incredible."[20] His description of the evolution of his artistic values during this period clearly shows a transfer of allegiance from Chasean to Cézannesque principles:

We realized that a picture might be assembled arbitrarily, with a primary consideration of design, that would be outside of time, place

Fig. 5. Charles Sheeler, *Studio Interior*, c. 1913, gelatin-silver print, The Lane Collection

or momentary conditions. With these observations our interest in representing the casual appearance of nature ceased. We were from then on to be interested in causes rather than effects.[21]

But the most persuasive evidence of Sheeler's admiration for Cézanne is a photograph of his own studio, made about 1913 (fig. 5). Hung on the walls and stacked along the floor are Sheeler's pictures from 1910-13. The only painting that is not his is a matted and framed reproduction of Cézanne's *Smoker* (1895-1900; The Hermitage, Leningrad), which he gave a place of honor, in the center of the wall, next to one of his Armory Show landscapes.

Beginning in 1910, Sheeler steeped himself in the lessons of Cézanne. His goal was the plastic rendition of simple forms, and he pursued it methodically, tackling the same subjects again and again, as though deliberately following a rigorous program of self-education. He allowed himself very few imaginary subjects

during those years, instead confining himself to modest still lifes — a few blossoms in a vase or fruits in a bowl, placed on a plain tabletop or, occasionally, against a crumpled Cézannesque drapery (fig. 6) — and prosaic landscapes, generally featuring a little boxlike house set well back in the picture, with an empty foreground and a few trees. Sheeler made these modest subjects more lively with striking color contrasts (often using the blue-green-lavender palette, laid down in blocky strokes, that Cézanne employed in the background of many of his still lifes) and a sense of three-dimensionality not apparent in his earliest works. He was not always successful. Although his compositional design was sure, in certain pictures (e.g., *Chrysanthemums*, 1912; Whitney Museum of American Art, New York) his colors become muddy, his brushwork clumsy. At this stage he was better able to manipulate volume and space than to manage pigment.

Sheeler's pictures from this period are char-

Fig. 6. Charles Sheeler, *Still Life – Spanish Shawl*, 1912, oil on canvas, The Lane Collection

acterized by a gravity consistent with his new, classical aspirations. He treated his subjects unemphatically, as though he were deliberately distancing himself from the personal and specific in his quest for the universal and immutable. His surfaces are heavily worked; no brush stroke seems spontaneous, no line whimsical or capricious. These pictures reveal Sheeler's physical and mental toil as he struggled to shake the methods of Chase and to make of his humble bouquets and undistinguished crockery what Cézanne described as "something solid and durable like the art of museums."[22]

Despite the labored manner in which Sheeler worked in those years, his output was probably somewhat greater than the twenty or so pictures that survive from the period 1910-13.[23] He was sufficiently confident of the quality of these paintings to submit six of them (Schamberg sent five) to the landmark "International Exhibition of Modern Art," the Armory Show, of 1913. He was no longer interested in making his mark in such orthodox settings as the National Academy of Design or the Pennsylvania Academy annuals, but sought to ally himself with a more adventurous group of artists. Four still lifes and two landscapes, priced between $150 and $250, are listed in the Armory Show catalogue, and although none sold, Sheeler's entries won him the further approbation of Arthur B. Davies, one of the exhibition's organizers, who had invited

him to participate.[24] Through Davies, the pioneering collector John Quinn learned about Sheeler's work and bought a group of his drawings (now Fogg Art Museum, Cambridge, Mass.) from an exhibition of contemporary art Davies organized at the Montross Gallery in 1915.

Sheeler was deeply affected by the Armory Show. It enabled him to see great paintings by Cézanne and to renew his acquaintance with Picasso, Braque, and Matisse, whose arbitrary color and inventive design he found liberating.[25] The show was, furthermore, his first exposure to Marcel Duchamp, who would be a lifelong influence. Sheeler claimed that the Armory Show's effect on his art was immediate and dramatic:

Following the Armory Show and largely influenced by it, my work dealt with abstract forms. Sometimes with a clue to natural forms being evident, but quite as often without that evidence. Always, however, derived directly from something seen in nature. Color was entirely arbitrary with the intention of contributing to the organization of forms comprising the design. These pictures represented an attempt to apply the principles found in the Early Italians and contemporaries of Paris.[26]

In fact, his involvement with abstraction was brief. In March 1914, Sheeler and Schamberg went to New York to see the synchromist exhibition at the Carroll Galleries, which inspired them to experiment with color abstraction. The resulting works – Schamberg's *Geometric Patterns* (1914; Regis Collection, Minneapolis) and Sheeler's *Abstraction: Tree Forms* (1914; Coll. Harvey and Françoise Rambach, New York) – are composed of thickly painted facets of primary color, Schamberg's evoking a standing figure and Sheeler's, characteristically, a simple landscape. Sheeler's *Abstraction*, and the more organic *Landscape #1* and *Landscape #6* (1914; private collection, and cat. no. 5), whose verdant color and springy outlines are reminiscent of 1907-8 Picassos, were his major forays into pure abstraction.

By 1915 the recognizable object had returned in Sheeler's work and the artist was pursuing architectonic structure as methodically as before. For three years (1913-16), he painted nothing but landscapes. His avowed

goal – the perception and expression of the order underlying the universe – was laid out in his first published manifesto, a statement in the catalogue of the Forum Exhibition in 1916.[27] That show, held at the Anderson Galleries in New York, featured two hundred works by seventeen artists ("the very best examples of the more modern American art"), selected principally by Stieglitz, Robert Henri, and Willard Huntington Wright. Sheeler was invited to participate by Stieglitz (who would also solicit works from Dove, Hartley, Marin, Maurer, and four others),[28] and he sent thirteen paintings and drawings executed between 1914 and 1916. These paintings still took Cézanne as their point of departure, but they are much more daring than those Sheeler painted at the time of the Armory Show and parallel the experiments of Braque and Picasso of six or seven years earlier.

Among the works Sheeler exhibited at the Forum Exhibition (which probably included cat. nos. 5, 6, 7, 8, and fig. 7) were several in which his manner approached an orthodox cubist style. In these paintings, uniform in style and subject, Sheeler used many of the pictorial devices developed by Braque and Picasso to analyze an object and to reconcile the conflict between the flat picture plane and the illusion of depth to which traditional painting aspired. Like the French painters, Sheeler splintered planes, so that the front and side of a house would be visible simultaneously. His objects share contours, so that roof line and tree branch become synonymous and thus seem to exist on the same plane. Outlines become detached from the shapes they describe and surfaces invade one another, as when the brushwork describing the foundation of a house blends into that defining the path before it. In many of these works, Sheeler set aside his habitual blue-green-lavender palette for the earth tones favored by Picasso and Braque, and for his random, patchy brushwork, substituted their finer hatching strokes as well. Sheeler continued working in an orthodox cubist manner for only a few years. However, the style's fundamental premises – objectivity, truth-telling, and freedom from the restraint of a single point of view – would be a lifelong quest, and he often used cubist techniques to achieve his goal. By 1917 he had adapted these

Fig. 7. Charles Sheeler, *Landscape No. 8*, 1915, current location unknown

devices to his own subject – barns. By the mid-twenties, the same traits surface again, but this time in ostensibly realistic compositions, where they are subsumed by Sheeler's innate love of pattern and genius for good design (see cat. no. 32). In the mid-teens, however, his paintings closely reflected their European models.

Although public exposure to Sheeler's work increased during this period, few of his works sold. In 1910 and 1911, needing to support himself, Sheeler sought jobs as a drawing instructor at several colleges, but without success.[29] In about 1912, he and Schamberg determined to take up commercial photography as a means of generating income, Schamberg to specialize in portraiture and Sheeler in architectural photography. Although Sheeler is believed to have been given a camera as a teenager, it is not clear how he came to master the medium. There were several exhibitions of serious photography in Philadelphia in the early years of the twentieth century, among them the annual salons of the Pennsylvania Academy and the Photographic Society, and the exhibitions sponsored by the John Wanamaker department store between 1906 and 1918. In 1906 Stieglitz sent an international exhibition, organized out of his own gallery, to the Pennsylvania Academy.[30] Yet Sheeler and Schamberg themselves may not have regarded photography as a serious artistic me-

dium at this point, for Sheeler later explained that he chose photography as a profession because it would not compromise his painting: "It was difficult to decide what you could do that wouldn't be detrimental to what you were aiming for . . . and we both decided that photography was clean work and it could be . . . a separate channel and needn't cross the path of painting."[31]

In about 1914, Sheeler began to work less for local architects and to specialize in photographing works of art. Soon he won assignments from New York galleries such as Knoedler, Brummer, and other dealers in older art. He quickly became quite skilled at photographing ancient sculpture – classical statuary, Chinese bronzes, and so on – and in 1915 ventured to send Alfred Stieglitz samples of this work and specimens of the photographic papers with which he had been experimenting. The master photographer was favorably impressed with Sheeler's work, and the two began an active correspondence that would continue until Sheeler moved to New York.

It was through Stieglitz that Sheeler met Marius de Zayas, who worked for a time at "291" and then in October 1915 opened his own gallery (with the backing of collector Agnes Meyer), the Modern Gallery, at 500 Fifth Avenue. In 1916 de Zayas showed a few of Sheeler's paintings from the Forum show and gave the artist several assignments photographing works of art from the gallery's stock and from his own collection. By the next year, Sheeler was the gallery's staff photographer and would later act as its manager in de Zayas's absence. This arrangement continued until late in 1921, when the de Zayas Gallery (successor to the Modern Gallery) closed.

Sheeler's association with the dealer was extremely stimulating, for, like Stieglitz, de Zayas brought new international art to New York. He mounted a Picabia show in 1916, a Derain exhibition in 1917, an exhibition of African art in 1919, and a show of Cézanne and Matisse in 1920. In addition, de Zayas promoted Sheeler's photographs as works of art, and in December 1917 gave him his first solo show in that medium. With de Zayas's encour-

agement, Sheeler began to recognize the artistic qualities in the prints he produced for commercial assignments, and early in 1918 they issued (in an edition of twenty-two) a deluxe album of Sheeler's photographs of de Zayas's collection of "negro sculpture."

Recognition of Sheeler's talent as a photographer soon equalled the approbation he was receiving for his paintings. Although he maintained he would prefer to paint than photograph, he was deeply pleased that two of the photographs he submitted to the Thirteenth Annual John Wanamaker Exhibition of Photographs were awarded prizes.[32] Once again he had Stieglitz to thank: just as Stieglitz had arranged for Sheeler's paintings to be included in the exclusive Forum exhibition in 1916, so he dominated the jury of the Wanamaker exhibition and selected the young photographers he most admired – Sheeler, Strand, and Schamberg – for the major prizes.[33]

The subject of the photographs Sheeler showed at the Wanamaker exhibition was the little house on the outskirts of Doylestown, Pennsylvania, that he and Schamberg had rented as a weekend retreat since 1910. Built in 1768 of Pennsylvania fieldstone, the house was two and a half stories tall, with one room on each floor, and when Sheeler discovered it, it retained many of its original features, from its enormous hearth to its iron hardware. He arranged to rent it through Henry Chapman Mercer, a local landowner, founder of a pottery that manufactured ornamental tiles, and talented amateur archaeologist.[34] In Mercer, Sheeler found a kindred spirit to share his enthusiasm for early American household objects. "Dr. Mercer . . . wasn't interested in painting at all but he was interested in Americana and he was a pioneer in collecting it in a big way, objects of domestic utility . . . early farm implements and things like that."[35] Although Mercer was motivated by a preservationist's instinct, while Sheeler was inspired by the elegance he perceived in American vernacular furnishings, their mutual reverence for the useful and the traditional bound them together.

Sheeler's photographs of his modest weekend house, made about 1917, illustrate that

reverence. Unlike Sheeler's paintings of the period, these photographs seem to modern eyes completely mature. They are graceful and innovative, both in their humble subject matter and in their distance from the pictorialist aesthetic, which had dominated international photography for more than twenty years. Though seemingly direct and spontaneous, these photographs were not completely unmanipulated: Sheeler was fond of placing a strong light behind objects to silhouette them, and in printing he favored warm-toned papers, which made the prints soft and velvety. As works of art, they are a pinnacle of achievement and would stimulate Sheeler's production in other media for the next thirty years. And the architectural features he photographed — hearth, window, doorway, and stairwell, with their implications of transition and passage — would become prominent motifs in many of his most personal and successful paintings (see cat. nos. 25, 29, and 43), revealing the romanticism underlying his determined search for classical structure.

E ven after his success at the Wanamaker exhibition, Sheeler continued to divide his time between commercial assignments in New York and, when he could, his creative work in Philadelphia. During this period, his systematic program of self-education continued: in 1918 he worked on a group of tabletop floral still lifes in gouache that are brilliantly colored but even more Spartan — sometimes only one blossom (see cat. no. 10) — than his 1912 tulips series. He produced an unusually loose conté crayon drawing of a house with exterior stairs (Coll. Harvey and Françoise Rambach, New York) reminiscent of the blocky yet fragmented structure of his 1915 landscapes and anticipating the theme and cubist energy of Charles Demuth's *Stairs, Provincetown* (1920; Museum of Modern Art, New York). And he sketched a large group of old barns in all sizes and media: small conté crayon drawings, pencil studies for larger works, and brightly colored paintings in tempera. Over a dozen of these are known, many based directly on photographs Sheeler made of eighteenth- and nineteenth-century barns he discovered in the Doylestown area, others

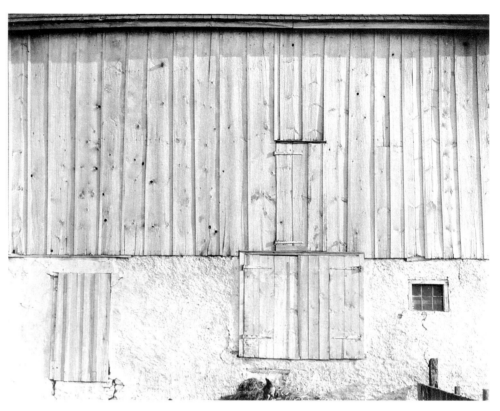

Fig. 8. Charles Sheeler, *Side of White Barn*, 1917, gelatin-silver print, The Lane Collection

so abstract as to be unconnectable with any surviving photograph. The most innovative works in this group are the photograph *Side of White Barn* (fig. 8) and the drawing *Barn Abstraction* (cat. no. 9). In the photograph, Sheeler employed devices that would recur repeatedly in his photographs and paintings for the next forty years. His subject is framed tightly and shown in a frontal view, with peripheral and foreground space virtually eliminated. This is perhaps the first photograph in which the subject is absolutely identified with the picture plane, and as such it is as modern, and as emphatic in its proclamation of itself as a work of art, as any still life by Picasso. *Barn Abstraction* is no less radical, and no less prophetic of Sheeler's later interests. In this large, iconic image, the buildings are reduced to an intricate but supremely balanced series of rectangles isolated on a sea of white paper. The drawing hovers between finish and mysterious dissolution: shadows are as concrete as the

forms that cast them, walls are transparent, and darkened windows at once define deep space and create an animated surface pattern. Sheeler's subject is highly schematized, yet it is far more persuasive than would be any naturalistic description of the classic lines and harmonious proportions he perceived in all of these vernacular structures. His vision was shared by the collectors Walter and Louise Arensberg, who bought *Barn Abstraction* soon after Sheeler finished it, and hung it in their New York apartment next to paintings by Cézanne, Duchamp, and Picasso.

II

The Twenties: Sheeler and the Avant-Garde

Sheeler was not a natural radical, nor was he unique in his enthusiastic espousal of Cézanne's style. In the early years of the twentieth century, American artists whose mature styles were as diverse as those of Alfred Maurer, Patrick Henry Bruce, Arthur G. Dove, and Stanton Macdonald-Wright were striving to emulate the French master. Like Sheeler, they deliberately restricted their attention to a few Cézannesque subjects:

Despite the acknowledged unimportance of subject matter, there seemed to be a surprisingly limited number of objects which, if painted, could be counted on to produce art — apples and oranges, a few varieties of green pears, and bananas; furniture, simple wooden chairs and tables, preferably unvarnished; houses, not too broken up with fenestration . . . landscapes — low mountains and hills rather than flat plains, not too solidly wooded.[1]

Among Sheeler's friends in Philadelphia, Arthur Carles, H. Lyman Saÿen, and Morton Schamberg were also attempting to throw off the academic manner in which they had been schooled and embrace the new art they had seen in Paris. Sheeler was hardly isolated: in the 1910s Philadelphia had an active and mutually supportive community of young, adventurous artists. The city boasted several broad-minded collectors, Albert Barnes and John G. Johnson among them, and opportunities to see new art, European and American, increased through such exhibitions as "Advanced Modern Art," featuring the works of Picasso, Braque, Brancusi, and Duchamp, held at the McClees Gallery in 1916; "Representative Modern Masters," a show of 256 impressionist, post-impressionist, and cubist works, held at the Pennsylvania Academy in 1920; and in 1921, also at the academy, "Later Tendencies in Art," a comprehensive collection of modern American works.[2] Sheeler nonetheless was dissatisfied with Philadelphia. In his autobiographical notes he wrote:

During the years following the Armory Show life in Philadelphia seemed much like being shipwrecked on a deserted island. Whatever was happening that was stimulating and conducive to work was taking place in New York. With Philadelphia Modern Art, as it was then called, was of the same status as an illegiti-mate child born into one of the first families, something to live down rather than welcome for the advantageous possibility of introducing new blood into the strain.[3]

His decision to leave the city undoubtedly was made over a long period of time; however, the deaths of Schamberg and Saÿen in 1918, his ripening friendships with New York based artists and collectors, and the increased number of photographic assignments from New York galleries made a move inevitable. By November 1919 Sheeler had given up his Chestnut Street studio and was settled at 160 East 25th Street in New York.

Although Sheeler is generally associated with the most avant-garde group of artists in New York — the painters, writers, and sculptors gathered around the collectors Walter and Louise Arensberg — he consistently maintained connections with various elements of the modern art community. Stieglitz's "291" gallery had closed in 1917, but its role as the principal showcase for international artistic developments was assumed by the Montross and Carroll galleries, by Marius de Zayas, whose De Zayas Gallery opened in the fall of 1919 with a show of African art, and by the Stefan Bourgeois Gallery, whose "Fourth Annual Exhibition of Modern Art: Art European — Art American" (1919) featured an essay by the French painter Albert Gleizes (who cryptically described the new American art as a "leap head first into the impersonal") and several works by Sheeler. The more romantic strain of young American painter — Dickinson, Maurer, Kent, and, after "291" closed, Hartley, Marin, and Demuth — was represented by Charles Daniel. In 1919 that dealer also exhibited four of Sheeler's works, two of which (*Zinnias* and *Flower in a Bowl*; see cat. no. 10) he sold to the Columbus, Ohio, collector Ferdinand Howald. Thereafter, Daniel would be the conduit for Sheeler's works to Howald, who eventually would own eight of the artist's most important early pictures. Daniel also gave Sheeler a solo show in 1922, which included sixteen paintings and drawings and seven photographs. Hailed for their "modernism," these works were described as being "of a quality to make pictures painted in the beginning of the movement seem dull and amateurish."[4] And Sheeler's connection with the New York Dada artists was underscored when his *Barn Abstraction* (cat. no. 9) was reproduced in the March 1919 issue of the little magazine *TNT*, which documented the group's activities and included contributions by Man Ray, Marcel Duchamp, and Walter Arensberg.

For the rest of the decade Sheeler maintained cordial relations, through painting, photography, or both, with the various art factions in the city, from moderate to avant-garde, and avoided the feuds that split the progressive artistic community in those years. He declined to participate in such provocative debates as "Can a Photograph Have the Significance of Art?," conducted in the magazine *MSS.* in 1922,[5] and apparently remained silent throughout the principal quarrel of the early 1920s, that between the Stieglitz camp (whose spokesman, Paul Rosenfeld, defended romantic and naturalistic art) and the Dadaists (defended by Matthew Josephson, who argued for the primacy of technology, urban life, and popular culture).[6] Content to remain on the sidelines, Sheeler drew from both groups in his painting and his friendships.

Sheeler maintained the same openness to all viewpoints in his photography. In February 1920 he showed thirty-nine works in a solo exhibition at Marius de Zayas's gallery, including a large number of his photographs of Bucks County barns and the interior of his Doylestown house. At the same time, using his recently acquired Debrie motion picture camera, he and Paul Strand made the six-and-a-half-minute film *Manhatta*, a revolutionary celebration of New York's towering skyscrapers and dramatic vistas. The film's content was as unprecedented as its technique: avoiding narrative and featured characters, it took its cues from painting and photography rather than from the theater. To emphasize the dizzying grandeur of the skyscrapers, many scenes were filmed from high angles, and people were viewed from great distances — a departure from standard film practice of the time. Camera movement was rapid, and shots of different scenes in lower Manhattan followed one another so quickly that they seemed to overlap, expressing the excitement and vitality of urban experience.[7] Furthermore, the film stimulated several of Sheeler's most important paintings of the period (cat. nos. 16 and 18)

and inaugurated a rich and productive interchange between the two media.

Despite the diversity of his associations, Sheeler's most enduring friendships remained those initiated at the salons hosted by Louise and Walter Arensberg. Their apartment on West 67th Street was the setting for impromptu Dada performances and furious debates about artistic theory, and provided opportunities to study the newest examples of radical American and European art, which the Arensbergs continually were acquiring. Sheeler probably met the collectors shortly after the Armory Show and thereafter attended their salons whenever he was in New York. Through them, he met Duchamp, Matthew Josephson (and possibly through Josephson, the poet William Carlos Williams),[8] Francis Picabia, Jean Crotti, and Man Ray. Sheeler always maintained enormous admiration and affection for the Arensbergs, whom he described as "the top people, because they . . . had that great ability, radar eye."[9] And even after they moved to Hollywood, having tired of the circus their apartment had become, they maintained a lively correspondence with Sheeler, bolstered by occasional visits and halted only by their deaths in 1953.

The admiration was mutual. In the 1910s, the Arensbergs acquired several of Sheeler's paintings and drawings, including two handsome renditions of Bucks County barns (cat. no. 9 and fig. 9) and a version of the idiosyncratic *Lhasa* (1916; current location unknown), inspired by the "forbidden city," the capital and religious center of Tibet. Their patronage continued throughout his career, despite financial reversals. In 1931 they acquired *Cactus* (cat. no. 41), which Sheeler later described as "one of my pets," and he occasionally sent them samples of his photography.[10] The Arensbergs also commissioned him to photograph their apartment, and the resulting five photographs reveal not only the honor they paid him by juxtaposing his works with their masterpieces by Cézanne, Matisse, Duchamp, and Braque but also another shared interest: Americana (fig. 10). Their decor – mixing modern painting and sculpture, African and pre-Columbian art, and vernacular early American furnishings – made a critical impression on Sheeler, whose later residences would echo this stimulating

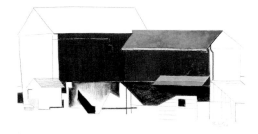

Fig. 9. Charles Sheeler, *Barn Abstraction*, 1918, black conté crayon and casein on paper, Philadelphia Museum of Art, The Louise and Walter Arensberg Collection

eclecticism. He also went antiquing with them and acted as their agent both for the dispersal of certain contemporary objects in periods of financial difficulty and for the acquisition of American antiques.[11]

The degree to which Sheeler participated in the Dada hijinks planned at the Arensbergs' is not known. Matthew Josephson's description of him during this period suggests that he maintained an amused distance from the more outrageous goings-on: "an older fellow . . . a tall, thin, gray man with very keen blue eyes, dryly humorous of speech, and as pithy in his talk about art as were the lines of his drawings."[12] He was not among those in attendance at one of the most scandalous Dada evenings, when the boxer and poet Arthur Cravan delivered a drunken lecture on the display at the Grand Central Art Galleries in 1917, which ended with the performer's striptease and near-arrest,[13] nor do the accounts of the freewheeling discussions of chess and Freudian analysis count him among the more vocal participants. Nonetheless, Sheeler served as photographer-in-residence for various projects sponsored by Arensberg circle members. For the *Little Review*'s winter 1922 issue, he photographed Baroness Elsa von Freytag-Loringhoven's *Portrait of Marcel Duchamp*. Her behavior (she sometimes appeared at the Arensbergs' with all her hair shaved off, or wearing a coal bucket on her head) was no less eccentric than that portrait, which was made from chicken feathers, springs, gears, and bits of wire. Sheeler's photographs of works by

Brancusi, Matisse, Picabia, and others were used to illustrate Duchamp's 1922 work *Some French Moderns Says McBride,* a notebook in which one of the *New York Sun* critic's essays on French painting is set in type that increases in size with each page until, on the last page, the mammoth lettering gives way to a conclusion in minuscule print. The witty, unpretentious construction was seen as a fitting tribute to McBride's unselfimportant yet insightful style; Sheeler's copy of the book (Museum of Modern Art, New York) is inscribed (though their collaboration is uncredited elsewhere) "Rrose cher Sheeler."[14] Sheeler's artistic achievements were acknowledged in other avant-garde publications as well: two of his Bucks County barn drawings were reproduced in the November 1922 issue of *Broom*, to which Williams and Strand were frequent contributors, and in the October 1923 issue, his famous *Self-Portrait* (cat. no. 25) and several of his photographs were shown. A reproduction of his painting *Skyscrapers* (cat. no. 18) appeared in the sole issue (April 1923) of *Futurist Aristocracy*. And he contributed the cover drawing – a variant on the lower half of *Skyscrapers* – for a pamphlet later described as "the last Dada fling in America,"[15] the satiric *Aesthete 1925*, put together over one frenzied night by Williams, Edmund Wilson, Hart Crane, and others in response to the scathing portrait of their literary generation that H. L. Mencken had published in his *American Mercury* the year before.

Of all the artists and literati with whom Sheeler associated at the Arensbergs', Marcel Duchamp won his greatest and most lasting esteem. In the 1930s, when Sheeler was involved in representing American technology in his art, he described Duchamp as "built with the precision and sensitiveness of an instrument for making scientific machinery." Later in life, his characterization, though less poetic, was no less admiring: "Marcel, of course, was in a class by himself. . . . He was vastly superior in every way . . . he had a very fine mind and I think his pictures are very outstanding in French art or in any art."[16] In the works by Duchamp that Sheeler most admired, he found reinforcement for the aesthetic principles he was trying to realize in his own images: the subordination of the hand (the gestural and

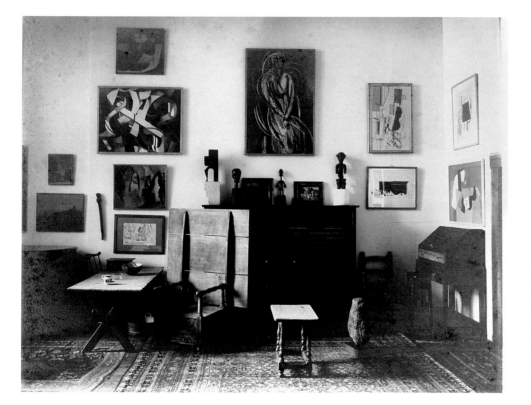

Fig. 10. Charles Sheeler, *Living Room of New York Apartment of Louise and Walter Arensberg (Southeast Corner)*, c. 1918, print, Collection of the Whitney Museum of American Art, New York, Gift of James Maroney and Suzanne Fredericks

perhaps inspired by the fractured planes of such works as *Nude Descending a Staircase*, Sheeler's theme is the analysis of motion: sails and masts are multiplied in extravagant excess of their function, and what at first appears as a flotilla of ships becomes, on further inspection, a very few vessels, their graceful maneuvers dissected and shown in sequence as they glide through a stage-set sea.

In these pictures, as well as in *Skyscrapers* and *Church Street El,* Sheeler temporarily abandoned the cream, blue, green, and lavender palette in which he had been working for nearly a decade in favor of the ochres, rusts, browns, and oranges used by the French painters in their works produced around 1912. Like them, Sheeler does not submit his forms to natural light (and thus imbue them with an illusionistic three-dimensionality and a comprehensible location in space) but often shows them appearing to be lit from within, so they seem to glow and to pulse forward, in defiance of natural laws. There is little appropriation of Duchamp's sly wit or his emphasis on chance, except perhaps in the coy transmutation of human parts into flower forms. *Self-Portrait* is often interpreted as Sheeler's most Dada-like work[19] — and indeed, with the headless form of the artist reflected in the window, the peculiar prominence given to the telephone, and the absurd tangle of wires leading nowhere, it can be read as a diagram of Duchamp's mission to free art from the restrictions of perceived reality in favor of underlying meaning, however enigmatic. But *Self-Portrait*'s confessional aspect, and its shy, lonely mood, which stems from its implicit invitation to raise the shade and regain contact with the artist, reveals a strain of romanticism that has no parallel in the work of Duchamp.

By the time Sheeler met Duchamp at the Arensbergs', the French artist's impact on the American avant-garde had more to do with his iconoclasm than his paintings.[20] Yet many of his principles must have struck a chord with Sheeler and provided reassurance for the direction in which his art would turn in the early 1920s. In 1915 Duchamp wrote, "I wanted to get away from the physical aspect of painting. I was much more interested in recreating ideas in painting. . . . I wanted to put painting once again at the service of the mind."[21] In his auto-

self-assertive aspect of art) to the eye (its intellectual component); and the presentation of an analytic understanding, rather than a passive impression, of the visual world. He praised Duchamp's *Nude Descending a Staircase* (1912; Philadelphia Museum of Art) ("the most controversial picture" in the Armory Show) for being "the very antithesis of what we had been taught. For in it the statement was all important and the means by which it was presented skillfully concealed." Of *The Bride Stripped Bare by Her Bachelors, Even (The Large Glass)* (1915-23; Philadelphia Museum of Art), he noted that "the craftsmanship gave evidence of the remarkable ability of the hand to carry out the orders of the eye."[17]

Duchamp's actual influence on Sheeler is more difficult to gauge. Sheeler later claimed not to fully understand the various projects directed by the French painter during his early years at the Arensbergs', and acknowledged that the "mysterious overtones" he perceived in his own images were more closely related to surrealism than to Duchamp.[18] Nonetheless, in several of the works Sheeler produced around the time of his arrival in New York there are connections with certain stylistic traits in the art of Duchamp and Picabia. *Flower Forms* (cat. no. 13), with its pulsing, bulbous shapes and sublimated sexual imagery, expresses in gentler language the mechano-erotic forms of paintings such as *The Bride* (1912; Philadelphia Museum of Art) or Picabia's *I See Again in Memory My Dear Udnie* (1913; Museum of Modern Art, New York). In *Pertaining to Yachts and Yachting* (cat. no. 22),

biographical notes, Sheeler addressed a parallel theme, writing of his work of the early twenties: "It was also my aim to eliminate the evidence of painting as such, and to present a design giving the least evidence of the means of accomplishment."[22] For Duchamp, getting away from the physical aspect of painting meant ceasing to paint altogether after about 1918. For Sheeler, it meant enforcing an even more rigorous discipline in his art. He eliminated thick paint, textural passages, areas of bare canvas — the technical devices that gave his landscapes of the 1910s so much vitality — and in fact he virtually stopped painting in oil between 1922 and 1926. His surfaces became smooth and self-effacing; his line remained securely tied to form. There were no longer any independent linear gestures or flourishes of pigment to call attention to the creative process or to the manual talent of the creator. Color was often arbitrary, or at least put primarily at the service of design and only secondarily required to serve a descriptive function. Sheeler no longer had any use for the decorative or the picturesque. As is especially clear in his still lifes of the early 1920s (see cat. nos. 19, 20, 21), he tried to make his art as direct and reductive as possible. His compositions were increasingly spare; objects were displayed without setting or context. This unemphatic style not only reflected Duchamp's deadpan presentation of peculiar objects as works of art but also paralleled the efforts of the American writers of their circle (Williams, Josephson et al.) to root out the adjectival, the rhetorical, and the charming in their work.[23]

Sheeler never commented on Duchamp's Readymades, except to imply, at the end of his life, that he found them puzzling, since for him art remained at base a visual matter.[24] But in Duchamp's reliance on the element of chance and the reduction of the creative process to the act of selection, there is a link with Sheeler's penchant for making art out of unlikely, untraditional subjects (such as telephones, empty stairwells, smokestacks) and for happening on his subject matter rather than deliberately pursuing it. Thus the skyscraper pictures evolved out of *Manhatta*, and at the end of the decade, Sheeler took "a chance on opening the other eye" and discovered that "maybe some pictures could be pulled out"

from his photographs of the Ford plant near Detroit, yielding several masterpieces of painting.[25]

Yet the differences between Sheeler's and Duchamp's aesthetic programs were as critical as their similarities. Although Duchamp's work clearly inspired Sheeler, its flamboyance, its shock quotient, and particularly the Readymades' assertion of the primacy of the creator who declared them art were antithetical to the passivity and reticence in Sheeler's style of picture-making and his manner of choosing his subject matter.[26] His reluctance to use flashy paint, or overtly personal imagery or to dramatize momentary impressions were part of his abasing the magic of art and abnegating the notion of the artist as divinely inspired genius. And whereas the Readymades challenged the basic principles of art — reducing creation to selection and upsetting the traditional relationship between image and object represented by making them identical — Sheeler reaffirmed those principles by making the mundane elegant.

In 1921 the Arensbergs gave up their New York apartment and resettled permanently in California. In February 1923 Duchamp sailed for Paris, where he would remain, except for his brief visits to the United States in 1926 and 1933, until 1942. De Zayas's second gallery, at 549 Fifth Avenue, was forced to close late in 1921 and, his financial situation still bleak, he was required to sell his impressive collection of African and pre-Columbian art, old master drawings, and works by modern French painters (including two Cézannes, two Rousseaus, an abstraction by Picasso, and two conté crayon drawings by Seurat) at auction at the Anderson Galleries in 1923. Thereafter, much of de Zayas's artistic activity would center around exhibitions he organized for the newly formed Whitney Studio Club (1918), a large and nondoctrinaire association of artists bankrolled by Gertrude Vanderbilt Whitney and masterminded by her astute secretary, Juliana Force.

In April 1921, Sheeler married Katharine Baird Shaffer, a stout, vivacious woman two years his senior.[27] She, too, lived for a time in Philadelphia (and may have met Sheeler

there); their relationship developed in New York, where Katharine moved in the late teens to keep house for her brother. In the first years of their marriage, the Sheelers changed addresses three times (including a summer spent at the Arensbergs' 67th Street apartment). Between 1921 and 1923, Sheeler showed his work in at least six different galleries, including the Daniel and Montross galleries and the Gallery of Modern Decorative Art at the Wanamaker department store. In another attempt to gain exposure and make sales, he sent two pictures to the "experimental" auction of "works by living American Artists of the Modern Schools . . . The Property of the Artists to be sold by their order," organized and promoted by Alfred Stieglitz. Sheeler's work occasionally attracted the attention of such progressive critics as Henry McBride. Among his early patrons, Howald and Quinn continued to buy, and new collectors, such as Duncan Phillips (who acquired *Skyscrapers* in 1926) were beginning to take an interest. Still, like de Zayas, Sheeler was somewhat rootless until his helpful colleague introduced him to Juliana Force and encouraged his involvement in Whitney Studio Club activities.

Force and Sheeler had several interests in common in addition to modern art. In about 1914 she bought a country house (Barley Sheaf) in Doylestown, her birthplace, not far from the weekend house Sheeler maintained through the 1920s. She filled the house with early American furnishings, and although her taste in such objects was far more eclectic than Sheeler's, she had a discerning eye and assembled a collection of Shaker furniture and other objects that equaled Sheeler's in quality.[28] And at the end of the decade, following Sheeler's lead (as well as that of Alexander Brook and Peggy Bacon), she bought a house in South Salem, New York, which she used as a showcase for her Shaker collection.

The painters and sculptors affiliated with the Whitney Studio and the Whitney Studio Club formed another supportive community, although one even less unified than the Arensberg circle — not because, like the Dadaists, their basic premise was anarchic, but because the purpose of these associations was to provide a meeting place and exhibition space for all artists of promise who were without other

representation in New York. Unlike Stieglitz, who molded his followers into a cohesive generation, Force did not choose only painters who worked in a particular style but constantly endeavored to expand the Whitney's interests and serve ever-younger artists. Thus the group included, at various times, Ashcan school painters such as Ernest Lawson and John Sloan; romantics such as Charles Demuth and Oscar Bluemner (who were the only representatives of the Stieglitz group to show at the Whitney); thoroughgoing modernists, including Stuart Davis and Joseph Stella, whose work echoed contemporary European styles; such artists as Walt Kuhn and Eugene Speicher, who were influenced by an older tradition of French painting; a new generation of realists, including Edward Hopper and Glenn O. Coleman; and many artists, such as Joseph Pollet, Nan Watson, and Allen Tucker, working in a miscellany of styles, who are barely remembered today. Most of the artists who showed repeatedly at the Whitney were moderates: there was no Dada or pure abstraction, on the one hand, and on the other, no impressionism of the sort still dominating the conservative exhibitions of the National Academy of Design; but all manner of painting and sculpture in between was welcomed. There were monographic shows, big annual exhibitions, and smaller group shows, and certain artists were encouraged to organize exhibitions around subjects that interested them. De Zayas arranged a show of Picasso and African art in 1923; Henry Schnackenberg installed American folk art in 1924, and that same year Yasuo Kuniyoshi chose "Portraits and Religious Works" for exhibition.

Sheeler's involvement with the Whitney is traceable to the spring of 1921, when his photograph of a Gothic Madonna was reproduced as the frontispiece of the April issue of *The Arts* (fig. 11), a magazine closely affiliated with the organization.[29] By 1923 Sheeler had many connections with the Whitney. He became the gallery's (and the periodical's) photographer, its sometime arts reviewer, one of its exhibitions managers, and, as indicated by his regular participation in Whitney exhibitions and frequent mention in *The Arts* reviews, one of the organization's favored painters.

The photographic projects Sheeler under-

Fig. 11. Charles Sheeler, *Gothic Madonna*, c. 1921, gelatin-silver print, The Lane Collection

Fig. 12. Charles Sheeler, *"Whittier's Home,"* 1924, gelatin-silver print, The Lane Collection

took for the Whitney and *The Arts* were for the most part documentary. He photographed the works reproduced in the eight-page pamphlet commemorating the "Exhibition of Early American Art" Henry Schnackenberg organized for the Whitney Studio Club in February 1924 (see fig. 12). He also provided photographs for several of the 1923 issues of *The Arts*. These included illustrations for articles on Albert Barnes's collection of modern art (January and February 1923); on Negro art (March); on William Glackens (April); on Gaston Lachaise (June, later issued as a deluxe volume with elegant collotype reproductions); and on Brancusi (July). In acknowledgment of his talent as a photographer of works of art, beginning with the magazine's January 1923 issue, the Arts Publishing Corporation advertised "Photographs of Modern Painting and Sculpture and of the Masterpieces of African Art by Charles Sheeler," available to *The Arts* subscribers at a 20 percent reduction. Finally, in the August 1923 issue, Charles Downing Lay published a lengthy article on the "New Architecture in New York," with nine photographs credited to Sheeler. These included not only more or less conventional portraits of some of the city's new landmarks — such as the Singer Building, the Ambassador Hotel, the Public Library, and the Shelton — but also several of the enigmatic views of backs and corners of buildings recorded from a high vantage point that reflect Sheeler's innovations in *Manhatta*.

Except for the publication of these images, however, *The Arts* and the Whitney provided no avenue for the presentation of Sheeler's photographs as works of art. From the beginning, the Whitney restricted itself to the traditional fine arts categories — painting, sculpture, prints and drawings — and the notion of including photography in this group, to be studied, displayed, and collected, until very recently fell outside of the organization's purview. Other American museums in the twenties and thirties, however, were beginning to recognize the aesthetic and historical importance of photography. New York's Metropolitan Museum acquired its first photographs in 1922 and the Museum of Fine Arts, Boston, in 1924 (both as the result of gifts from Stieglitz). The Museum of Modern Art first exhibited photographs (including Sheeler's) in its murals show of 1932; it

mounted a major survey of photography five years later.

In the meantime, Sheeler continued to exhibit his paintings and photographs side by side, in tacit acknowledgment of their equal status as works of art. In his solo exhibition at Charles Daniel's gallery in 1922, he showed his highly praised still life series known as "Suspended Forms" (see cat. nos. 20 and 21), as well as several photographs, which were less well received by reviewers.[30] The 1923 exhibition of the Salons of America included his *Pertaining to Yachts and Yachting* (cat. no. 22) "and a group of wholly remarkable photographs by the same artist."[31] Although Sheeler himself declined to defend his works in either medium, others spoke for him. In the issue of *MSS.* dedicated to the question "Can a Photograph Have the Significance of Art?," Georgia O'Keeffe rose to the defense of Sheeler's photography: "No one considering his work questions his paintings and drawings as ranking amongst the most interesting of their type in America today. To me his photographs are of equal importance. He is always an artist."[32]

In addition to providing photographs to illustrate articles in *The Arts*, Sheeler also contributed several essays. The first, in May 1923, was a review of a show of Stieglitz photographs at the Anderson Galleries. The article was to cause a permanent break with the master photographer. Although the essay was full of praise for many of Stieglitz's images in the show, he expressed reservations about Stieglitz's dedication to platinum prints, which he found unnecessarily precious and self-conscious, and advocated instead "prints growing out of a less aristocratic element, such as silver."[33] Stieglitz had little contact with Sheeler after that. The review also caused the termination of Sheeler's friendship with Paul Strand, who angrily defended Stieglitz against Sheeler's imagined slights.[34] Sheeler and Strand would not meet again until the 1950s.

In August 1923, Juliana Force arranged for Sheeler to move from his remote lodgings on 147th Street into the apartment above the Whitney Studio Club's new galleries at 10 West 8th Street. He would stay at that address for two years — welcome security after four peripatetic years in New York. He surely found his new location in the heart of the

Greenwich Village art community stimulating, for despite his photographic assignments and his responsibilities in the Whitney Galleries, he was extremely prolific during this period. Most of his compositions were still lifes, but one drawing of an interior, made in 1924, presents an intriguing vision of his new home. *Stairway to Studio* (cat. no. 28), which depicts the main stairwell of the 8th Street building, is an odd representation of life at the Whitney Studio Club, which normally was full of people and pictures and the site of lively discussions and parties. Sheeler shows the hallway empty, his violent one-point-perspective construction propelling the viewer up the stairs until halted by the gate stretched across the top. The stairway image is one Sheeler would use frequently to suggest emotional transition as well as physical passage; here he alludes to both his desire for community and his need for privacy, for sanctuary, for separation from an atmosphere as raucous (if less outrageous) as that which he'd known at the Arensbergs'. It was inevitable that, after leaving the Whitney apartment in the late spring of 1925 and a brief stay at another Village address, he would then leave the city entirely. He settled in South Salem, New York, some forty miles away.

Among the obligations of his tenancy in the Whitney apartment were duties as gallery manager for some of the Studio Club's activities. Thus, in 1923 he assisted Schnackenberg with his folk art show and de Zayas with an exhibition of Picasso and African sculpture, and in March of 1924 he organized his own exhibition of the works of Picasso, Duchamp, de Zayas, and Braque. His essay "Notes on an Exhibition of Greek Art," which appeared in the March 1925 issue of *The Arts* accompanied by his own photographs, testifies to his involvement in that exhibition, which de Zayas organized for the Whitney Studio Galleries.

Greek art served Sheeler as a justification and model for his own artistic ambitions. He himself had spoken repeatedly about the universal truths and enduring values that, in his view, art was supposed to represent. Like many of his contemporaries, he had first tried to express these values abstractly. Increasingly, he felt they were best presented through realism: "Gradually . . . I came to believe that a picture could be built having incorporated in it

Fig. 13. Charles Demuth, *Eggplant and Pears*, 1925, Watercolor over graphite on paper, Museum of Fine Arts, Boston, Bequest of John T. Spaulding, 48.765

Fig. 14. Charles Sheeler, *Still Life with Pitcher and Peaches*, 1923, crayon and pencil on paper, Collection of the Santa Barbara Museum of Art, Gift of Wright Ludington

the underlying principles of structural design implied in abstraction, the sharply focused attention of isolated forms, and be presented in a more realistic manner."[35] Yet Sheeler's pursuit of realism was not without its difficulties, for there were few examples in the previous generation of American artists to whom he could turn. Artists such as Chase had used a realistic manner to describe momentary impressions, a large group of still life painters had applied a direct and unassuming style to the portrayal of mundane, particular objects — portrayals that were utterly lacking in transcendence — and even the greatest painters of the era, among them Homer and Ryder, used a descriptive style to present a romantic and

theatrical vision of the world.[36] But in Greek sculpture Sheeler found a noble precedent for expressing enduring values in representational art: "As . . . is beautifully demonstrated in the Aphrodite [in this exhibition], . . . as great purity of plastic expression may be achieved through the medium of objective forms as has been thought to be only obtainable . . . by means of a purely abstract presentation of forms." He believed that in these sculptures realism was only a façade (albeit a highly satisfying one), behind which was a structure "skillfully concealed," capable of elevating the particular to the ideal.[37] In his own work, this skillful concealment of the means of expressing that ideal would become as important as the ideal itself.

Although it included a few of his relatively abstract New York pictures, Sheeler's solo exhibition at the Whitney Studio Galleries in March 1924 indicates the depth of his commitment to realism by this time. Of the twenty-two works shown, eight were landscapes or landscape vignettes, one was a drawing of a nude, and the rest — thirteen pictures in a variety of media, but all on paper — were still lifes produced between 1922 and 1924 (see cat. nos. 19, 20, 21, 24, and 27). These were descriptive yet austere, featuring simple objects (often the same form, like the dark green wine glass or the Etruscan vase) silhouetted against a sea of white space. They were rendered with an extraordinary economy of means: many of them, despite Sheeler's arresting use of color, are basically line drawings; others seem like cutouts of elegant shapes pasted against a blank page. In few of these works does Sheeler describe any kind of a setting for his objects, even to the point, in the case of the tabletop still lifes, of barely representing the tabletop. When they appeared, these still lifes were greatly admired for their meticulousness, and for reducing art to its essentials. One reviewer noted: "The definite refinement of Mr. Sheeler's art is a complete denial of the validity of the free and careless gesture of romanticism."[38]

Sheeler's realism was interpreted as a direct outgrowth of his American artistic heritage, what Forbes Watson called "the native flavor in his art." Watson, the first critic to publish an extended profile of Sheeler's work (in The

Arts, May 1923, featuring many of the objects that would subsequently appear in the Whitney show), instituted the notion of Sheeler's realism as essentially American. This theme was developed by such later scholars of his work as Constance Rourke, who subtitled her 1938 biography of Sheeler "Artist in the American Tradition," and Wolfgang Born, who noted in his comments on the artist that "the demand for literal description is a basic factor in American art."[39] For Watson, parallels with Sheeler's art were to be found in early American furniture, with its "clear-cut fineness, the cool austerity, the complete distrust of superfluities." He found the American character of Sheeler's work in its "ultimate literalness," its "extremely simplified realism."[40]

Realism traditionally has been understood as a styleless style, as a direct and unmediated transcription of nature. In the hands of American artists, it had been seen as a style most appropriate for the rendering of native subject matter, and one based on observation rather than on the application of academic principles and traditions. Embellishment, fantasy, or ornament had little place here. In Sheeler's still lifes of 1922-24, the artist's careful drawing and reticent, self-effacing technique, as well as the seemingly blunt compositional program (it is as though he simply put a vase in the middle of the table and painted it), make them appear to be a direct and unreflective recording of particulars. His painstaking approach — so unlike Chase's glibness, or O'Keeffe's sensuous use of pigment, or Demuth's swiftness and sophistication — carries conviction. His straightforward descriptions seem honest, and true.

Sheeler himself fed the notion that his was a styleless style. Toward the end of his career, even after he had returned to abstraction, he would insist, "My things don't go beyond the boundaries of the actual."[41] His definition of the artist's role — "We are as parts of the electrical system — designed to carry the current on" — is but a modern metaphor for Emerson's notion of the artist as a "transparent eyeball."[42] The image is a diffident one, and reflects a century of American ambivalence toward the fine arts. Beneath the modernity of Sheeler's still lifes and city views is a puritanical strain, evident in the very way he applies his paint. By the 1920s, his style had become deliberately

antisensuous, as though he distrusted shimmering glazes and thick pigment applied with abandon. Sheeler's humble subjects, the modest scale of his pictures, and even their unadorned frames deflect the associations with luxury and privilege that had troubled commentators on the fine arts since the founding of the republic.[43] Sheeler resisted art's subjective dimension, insisting instead upon its duty to reveal the structures underlying nature as a means of arriving at enduring values. In this moralistic posture he is again heir to Emerson, who advocated that art at its best was history, and its greatest role, to educate.[44]

Yet Sheeler's realism in the twenties was far from artless or naive: the didactic aspect of his pictures from this period is subordinate to their extraordinary visual grace. His comments on Greek sculpture, the seriousness with which he took folk art, and the increasing sophistication with which he absorbed the lessons of Cézanne and domesticated the revolutions of Duchamp indicate his sympathetic accommodation to other styles. He was above all a professional, well trained and thoughtful, and readily acknowledged his sources.[45]

Sheeler's critics have persisted in viewing his work in formal terms only. Beginning in the 1920s, his pictures were seen as "cool, cerebral art, all steely perfection, crystalline impersonality and purity of style. . . . In nearly all of them the subject is more or less an excuse, the point of departure for a scheme of abstractions. . . . The forms, beautiful in themselves, are without associations, without literary content."[46] Sheeler again did little to discourage this one-dimensional view of his art. His distaste for obvious self-expression caused him to suppress and undercut his own romanticism, to avoid the overtly nostalgic or picturesque, and to inhibit the emotional lyricism in pictures such as Tulips – Suspended Forms (cat. no. 21) or Gloxinias (Coll. Harvey and Françoise Rambach, New York) by deliberately making the drawing or composition awkward or by leaving a great deal of the paper blank. (In Demuth's hands, the same device serves the opposite function: his elegant fruits and vegetables seem to dissolve into some unspecified, spiritual atmosphere, creating of mundane forms an exotic and personal poetry; see fig. 13). Yet to see Sheeler's work of this pe-

riod as "eminently sane in its . . . regard for surfaces, curves and their juxtapositions"[47] is to overlook the differences, in his "Suspended Forms" series, for example, between the lush *Tulips – Suspended Forms*, which he gave to his friend William Carlos Williams, and the more restrained and measured *Suspended Forms (Still Life)* (cat. no. 20), which he kept for himself. Behind the forcefulness of his bluntly colored and chastely drawn pictures was a sensibility that relished the old and well-used object, rich in associations.

In 1923 Sheeler told a sympathetic critic that he aspired to reveal "the absolute beauty we are accustomed to associate with objects suspended in a vacuum."[48] And indeed, his still lifes of the early 1920s do have a peculiarly airless quality. Their classical antecedents, as Sheeler defined them, are evident, but in these pictures are also traces of less august traditions. In many cases, they contain so few objects spread out over so broad a space that they seem empty (fig. 14). They often contain slight distortions of scale and form (for example, an overlarge apple, or the crumpled handle of a pitcher, which creates the distracting suggestion of an ear), off-putting in renderings otherwise so pristine, and they frequently contain a puzzling accumulation of miscellaneous, unrelated objects (why associate a Greek pot, an apple, a vase, and some round candies in a glass dish?). These still lifes are exquisite and yet vaguely troubling. Their slightly bizarre quality may be a mild reflection of the Dada constructions Sheeler photographed in the late 1910s, but they aspire to provoke the double take rather than to shock. Also disquieting are the compositional naivetes in these seemingly perfect works: space is nearly flat; objects are often spread laterally across the paper in an additive arrangement, and they are shown frontally and scrutinized individually. These devices recall the folk art Sheeler admired so much, although he never went so far as to emulate entirely the absence of perspective typical of primitive painting. The "extremely simplified realism" of these still lifes is in fact evocative and profound. In pursuing the classical, eternal structures contained in these familiar objects, Sheeler was also discovering their mystical core. Increasingly, Sheeler's art concerned the point at which the accurate shades off into the mysterious.

Nineteen twenty-seven was the last year in which Sheeler would maintain a significant connection with the Whitney. He participated in the Whitney Studio Club's twelfth annual exhibition of painting and sculpture, their "Multinational" exhibition, organized by de Zayas, and their "traveling exhibition," which was seen in Minneapolis, San Francisco, Denver, New Orleans, and Cambridge before returning to New York in May of 1928. Also in 1927, Sheeler's ties to the avant-garde were temporarily renewed when he served on the Artists' Committee of the Machine-Age Exposition in New York (but apparently displayed none of his own work). That show, sponsored by the *Little Review*, was an eclectic gathering of paintings, drawings, photographs, and architects' drawings, but was largely an industrial arts exhibition, including objects from six European countries and the United States.

By the beginning of 1927, although quite possibly earlier, Sheeler and his wife, "fed up with the city," had moved to their South Salem house, "a bungalow-like building out in the hills by an old church and graveyard surrounded by a stone wall, with a convenient bootlegger down the road."[49] Although he would maintain a studio in Manhattan (first on 40th Street, then on 49th, and finally on 44th Street, between First and Second Avenues), he was increasingly distant from Whitney-sponsored events. He and Katharine did go to Charlestown, New Hampshire, that summer, where Juliana Force rented a large house, called Maxstoke, which she intended to be a country retreat for the Whitney Studio Club's artists, paralleling the artists' colonies at Woodstock (primarily for those affiliated with the Art Students' League), Ogunquit, and Yaddo (which began welcoming writers and composers in 1926). Maxstoke lasted only one season, but it may have been the first occasion on which Sheeler met Edward Hopper, who was also in residence.

Sheeler's growing away from the Whitney was not the result of any disagreement with Watson, Force, or other members of the association but rather a product of his preoccupation with a new phase of his career. In about 1926, Edward Steichen recruited him to be a staff photographer for Condé Nast publications (in which his photographs occasionally had appeared since 1917); he soon would be contributing as many as twenty photographs a year, primarily fashion and celebrity portraits, to *Vogue* and *Vanity Fair*. That Sheeler should succumb to the lure of commercial photography is not surprising. It was extremely lucrative, and although it did reduce the time he could spend on painting and drawing, he could not hope to support himself on the occasional sales of those works. Furthermore, it brought him into contact with a talented group of photographers. The photography scene in New York was dominated by two major groups: the "artistic" photographers, gathered around Stieglitz, and the photojournalists and commercial photographers, of whom Steichen was the most talented. Having been expelled from the first group, Sheeler gravitated toward the second. In addition to work for Condé Nast, he was also producing advertising photographs for such products as Firestone tires, L. C. Smith typewriters, and Champion spark plugs. In October 1927, he embarked on what would be his most important commission: the advertising agency N. W. Ayer arranged for him to go to Detroit to take documentary photographs of the new Ford Motor Company plant at River Rouge.

III

The Thirties: The Rouge and the Interiors

Shortly before Sheeler left for Detroit in October 1927 to photograph the Ford Motor Company's new River Rouge plant, J. A. Spender, an English journalist making the grand tour of the United States, posed the question, "Where does the 'real America' begin." He concluded that the new frontier began with Detroit:

> Detroit is the first true example of the modern booming mass-producing industrial America that you meet as you go west. First in time and still supreme, for here the pope of the movement, Henry Ford, pitched his tabernacle, promulgated the doctrine and invented the laws, rules, and methods which are practised by his now innumerable disciples throughout the continent. Detroit . . . [should] be considered the mother-city of the new industrial America.[1]

Although the automobile industry, which had brought Detroit to prominence, was flourishing, its linchpin, the Ford Motor Company, was in fact foundering by the time Spender arrived. Whereas in the early twenties the Model T, Ford's big seller and for many years the only car the company produced, had captured 50 per cent of the market, by 1927 its market share had dropped to less than 15 per cent, and Ford reluctantly agreed the car was outmoded. In May 1927 he announced the end of the Model T. In the third week of October, the first Model A rolled off the assembly line, an up-to-date, well-designed, well-made car.[2]

To accommodate the new model, the famed Ford assembly line had to be adapted, and Henry Ford ordered that the necessary changes be incorporated into the recently constructed River Rouge factory, designed by architect Albert Kahn on two thousand acres of land in Dearborn. Kahn's vast plant was a radically innovative complex, a model of its kind. Convinced that multistoried factories were inefficient, he constructed low steel-frame structures with entire walls of glass. These were clean, bright, and airy and, unlike most "machine age" buildings, were unornamented, claiming their architectural merit in their proportions, utility, and design.[3] For his part, Ford was determined to be independent of suppliers and mandated that the Rouge be capable of all phases of production, thus turning it into a self-contained, self-sufficient industrial city.[4] As Spender observed, "Beginning with coal and iron, which comes from Ford mines, everything is here, and all is self-sufficing. The Ford ore enters at one end and comes at [sic] the other as motors or parts of motors, which are taken away on the Ford railway or in Ford ships."[5]

The reopening of the Rouge plant and the emergence of the new car was a major news event for Detroit, and Sheeler arrived in the city late in October 1927,[6] just as the first Model A was completed. Although he may have produced some straightforward photographs of the automobile that appeared in the New York Times, he was not sent there as a photojournalist.[7] Rather, Vaughn Flannery, the art director for Ford's advertising agency, N.W. Ayer and Son, persuaded his client to commission a series of documentary photographs that would appear in various publications and would serve as a creative interpretation of American industry.[8] Flannery, who had worked with Sheeler on other advertising projects, recommended him for the job, and after some hesitation (dispelled after seeing some of Sheeler's photographs) Edsel Ford, nominal president of the Ford Motor Company and in charge of the firm's advertising, agreed.

Sheeler was in Detroit for about six weeks, and although he undoubtedly made many photographs while he was there, he submitted to Ford only thirty-two finished prints in fulfillment of his commission. He was given a great deal of independence on this project, and was not required (nor did he choose) to present a comprehensive portrait of the plant's activities or a narrative documentation, from coal to car, of how an automobile is made. His photographs do not celebrate the plant's workers, its management, its famous assembly line, or its more famous founder.[9] And nowhere in the series is a car, or even a readily recognizable part, visible, so that Ford's product can be identified. The most that is seen is a fender.

Instead of the cars, Sheeler focused on the machines at the River Rouge plant. He seemed drawn especially to steel production, which was the heart of the industry and its most dramatic phase, rather than to later stages, such as the casting and assembly of parts, in which spaces were more congested and the work more intricate, making them less indicative of the magnificent design of the Rouge.[10] The machines themselves seem animate and marvelous, more dreamlike than real. For Sheeler, their magic lay in their awesome bulk and force, which he transformed in his photographs into poetic shapes and incantatory rhythms. He treated the Rouge's architecture in a similar fashion, so that the real appears mystical and heroic. The cavernous spaces of factory sheds become cathedral-like, as Sheeler's camera captures the light pouring in through clerestory windows; between the Rouge's buildings, cranes, conveyors, and bridges soar overhead like Gothic tracery. In short, following his mandate from Ford and Ayer, Sheeler took as his subject not the River Rouge plant itself (in fact, the name Ford is visible in only one or two of the photographs) but the new American industry as a whole. His thirty-two photographs, seen together, are not a gritty documentary of the internal workings of that industry but rather celebrate "the industry of our dreams."[11] Sheeler clearly was awed by the Rouge, not because of its product (although he would always admire fine cars), but because of the Utopian grandeur of its conception.

The new Ford plant was seen as a visionary city; its observers sang its praises using spiritual metaphors and with religious zeal. Sheeler himself justified his choice of industrial subject matter by referring to the medieval sanctuary, asserting that the factory was a contemporary substitute for religious experience.[12] Ford News captioned Sheeler's photograph Ladle Hooks "the cathedral of industry." Matthew Josephson also saw the Ford factory as a church, noting that "Ford filled the windows of his powerhouse with stained glass," an image that echoes both Henry Adams and the more prosaic, boosterish Calvin Coolidge: "The man who builds a factory builds a temple, [and] the man who works there worships there." But the factory did not only offer economic salvation; it was seen by Spender and others as the means to achieving Utopia:

> As the medieval Gothic builder dreamt of his Cathedrals and Abbeys, so the devout American industrialist sees the dream city of his im-

agination rising from these beginnings. . . . De-
troit will in a few years be one of the most
enormous industrial Exhibitions in the
world. . . . It should have no slums; its streets
should be airy and clean; and its parks and
open spaces ample and beautiful.[13]

Sheeler's Rouge photographs were immediately successful. They were treated both as advertising images and as works of art, being reproduced on the covers of *Ford News* and in the adventurous little magazines *Transition* and *Hound and Horn*. They caught the attention of the pioneer photography dealer Julien Levy, who included them in the inaugural exhibition "American Photography" mounted in November 1931 in his New York gallery. There they were defended as the equal of painting[14] and the next year, when Levy and Lincoln Kirstein organized an exhibition of mural designs for the Museum of Modern Art (this was the first time that institution exhibited photographs as works of art, and one of the first occasions in which a museum presented painting and photography on an equal footing), Sheeler was invited to participate. His contribution, entitled *Industry* (1932; Art Institute of Chicago), was a collage combining three photographs from the Rouge series.

Despite the recognition afforded Sheeler's photographs, the Rouge experience dealt a traumatic blow to his painting. On his return to South Salem he began to suffer from painter's paralysis. He later described the experience in terms of revelation ("I was out there on a mission of photography. Period. And when I got there, I took a chance on opening the other eye and so then I thought maybe some pictures could be pulled out."),[15] but it resulted in a long period of rumination. His production decreased drastically in 1928-29, as he noted with disgust in a letter to Walter Arensberg: "As for painting – I am tempted now and then to buy some interesting colors or canvas. I hope they don't deteriorate before they are used."[16] But by the end of this period, he had emerged with a new technique, new imagery, and a new working method.

In finding the River Rouge plant and other industrial sites to be suitable subjects for his painting, Sheeler was no pioneer. Such artists as George Ault, Joseph Stella, and Charles Demuth had been painting factories and machin-

Fig. 15. Charles Demuth, *Incense of a New Church*, 1921, oil on canvas, Columbus Museum of Art, Gift of Ferdinand Howald

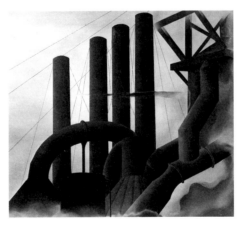

Fig. 16. Elsie Driggs, *Pittsburgh*, 1927, oil on canvas, Collection of the Whitney Museum of American Art, New York, Gift of Gertrude Vanderbilt Whitney

ery since the beginning of the decade.[17] Not all of their images are laudatory – Demuth's ominous *Incense of a New Church* (fig. 15), for example, sardonically inverts the metaphor of factory as modern cathedral to suggest the dark underside of the industrial Utopia – but most were far more fanciful than Sheeler's Rouge photographs and the paintings that followed. Many artists' paintings of industrial subjects were exhibited in a 1928 show at the Daniel Gallery, including Elsie Driggs's primeval *Pittsburgh* (fig. 16) and possibly her 1927-28 *River Rouge* (current location unknown) – she also visited the plant in 1927. That exhibition undoubtedly reassured Sheeler that industrial themes were appropriate pictorial subject matter.

What was novel was Sheeler's new working method, in which he used photographs and photographic techniques to generate compositions for paintings. Although as early as 1918 he had used his own photographs as the basis for a series of conté crayon studies of Bucks County barns, his first mature integration of painting and photography was *Upper Deck* (cat. no. 35). For the first time, his subject matter came out of a commercial assignment. In about 1927 Sheeler was commissioned to photograph the flagship of the White Star Line, the *Majestic*, a luxurious modern vessel so enormous and complete in its facilities that, just as the Rouge was a self-contained industrial city, so the *Majestic* was "a floating town, with homes for 5200 persons."[18] Neither the three surviving photographs of the ship nor *Upper Deck* reveal the vessel's great size, its capacity for speed, or the fashionable trappings alluded to in the painting's title (an ocean liner's upper deck generally housed the first-class promenade and recreational facilities). Rather, Sheeler shows part of the power mechanism of the ship, its motors, ventilator stacks, and exhaust manifolds. Yet like many of the machines he photographed at the Rouge, his close-up, cropped, sharply angled vision disguises the apparatus' functions and creates an intriguing mechanical fantasy.

Comparison with the two works in oil Sheeler had recently completed – *Spring Interior* and *Gladioli* (cat. nos. 33 and 34) – demonstrates the new technique he inaugurated with his new painting. *Upper Deck* has a smooth

surface, replacing the relatively lively brush strokes and varied textures of the earlier works, and his palette is subtler, as pearly hues are substituted for strong primaries. There is a fresh emphasis on structure and a further effacement of the artist's personality: Sheeler's enamel-like paint application encourages the eye to penetrate directly to the abstract core of the painting, undistracted by any pattern of brush strokes or by incidental details. Even more radically, Sheeler formulated the painting's composition through the lens of the camera, rather than on a sketch pad or spontaneously on the canvas itself. His use of a photograph as a compositional device, or, as Sheeler termed it, his "blueprint," began with *Upper Deck*.[19] It allowed him to avoid the accidental and, through the process of selecting detail and laying out the picture as a whole, to emphasize the "underlying abstract structure" of "pictures realistically conceived."[20]

Like his new technique, Sheeler's use of photographic "blueprints" was a way of making the hand inconspicuous, of downplaying the creative gesture, of minimizing the artist's role as intermediary between the object rendered and the perceiver. Sheeler's lucidity, his straightforward realism, was seen as essentially truth-bearing. The same had been said of his Rouge photographs: "[His] point-of-view may best be called truthfulness, for he believes in presenting the picture in naked reality, with no retouching and no sentimental overtones."[21] Sheeler later would echo this theme in his own description of *Upper Deck*, which deflects attention from himself and the creative process onto his subject: he claimed that the painting "involved no arbitrary rearrangement because of an esthetic impulse. These forms existed on their own terms. . . . Because they function there is a sense of truth about them."[22]

Sheeler asserted repeatedly that *Upper Deck* was a watershed in his development, his first mature work.[23] At the time he produced this work, he was forty-six years old — a late bloomer in an era of precocious development. The times fostered artists who created their first masterworks while in their early twenties: F. Scott Fitzgerald was twenty-four when he published *This Side of Paradise*, Picasso twenty-five when he painted *Les Demoiselles d'Avignon*, and so on. Sheeler stood somewhat apart

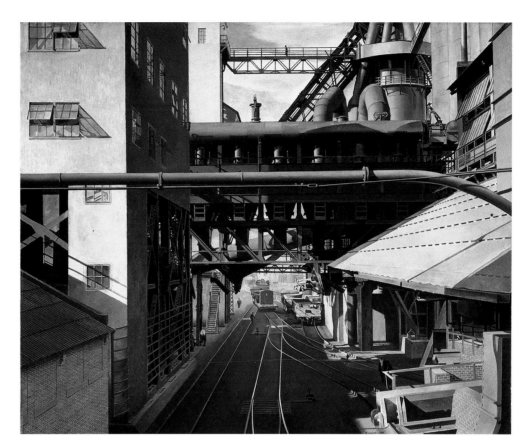

Fig. 17. Charles Sheeler, *City Interior*, 1935, aqueous adhesive and oil on composition board, Worcester Art Museum, Bequest of Elizabeth M. Sawyer, in memory of Jonathan and Elizabeth M. Sawyer

from his time and, following his own muse, did not blossom as a painter until he reached middle age.

Like his photographs of the *Majestic*, Sheeler's photographs of the Ford plant suggested subjects for his paintings. His first attempts were two small watercolors, *River Rouge Industrial Plant* (cat. no. 36, fig. b) and *Classic Landscape* (cat. no. 37, fig. b), which anticipate his major treatments in oil, *American Landscape* (cat. no. 36) and *Classic Landscape* (cat. no. 37). Between 1930 and 1936, he produced two additional oils (cat. no. 46 and fig. 17), a tempera (cat. no. 57, fig. a), and three conté crayon drawings (cat. nos. 38 and 39, and *Smokestacks* [cat. no. 38, fig. a]) based on what he saw and photographed at the Rouge.

These paintings and drawings, like the photographs of the plant, were not meant to tell the factory's whole story. No cars appear in these works; instead they focus on the buildings where peripheral activities took place — the cement plant, the slag screen house, the glass plant, and so on. Like the photographs, too, the paintings show a denatured world — there is no greenery, no animal life — and they are even more severe in their elimination of the figure. In the photographs, the figures play an active if minor role: we see them walking along the tracks, tending the giant stamping press, forging die blocks. In the paintings, the figure is virtually absent. A tiny figure runs along the railroad tracks in the far distance in *American Landscape*, a half-dozen faceless

workers lounge along the buildings in *City Interior*, and the head of a figure faces out of the picture in the lower left corner of *Industrial Architecture* — and that is all. Furthermore, in the photographs the machines are generally shown at work, although their function is not always specified. At the same time, without glamorizing them, Sheeler shows them as timeless, stalwart, architectonic forms. This impulse reaches its apex in the oil *Classic Landscape*, where mundane silos are transformed into a Greek temple. The generic titles Sheeler gave his paintings and drawings — *American Landscape*, *City Interior*, *Industrial Architecture* — suggest that he did not intend to immortalize the particulars of Ford's creation, but rather wanted to pay homage to the far-reaching effects of Ford's vision. Unlike the more intimate photographs, which bring the viewer inside the factory buildings and close to the machines, the paintings emphasize the magnificent expanse and bewildering complexity of the industrial city growing out of the flat and barren Dearborn plain. In these paintings, Sheeler introduces the factory-scape as the new American wilderness.

Sheeler's Rouge paintings combine a contemporary, innovative technique inspired by the artist's achievements in photography with an echo of his American artistic heritage. Many of the details, and in certain cases whole compositions, derive from the photographs. More important, as he had in most of the photographs, in these pictures Sheeler avoided conventional landscape construction of near, middle, and far distance and allowed his photographer's sensibility to shape the space. *American Landscape*, for example, presents a panoramic scene of extraordinary breadth. The emphatic verticals of the crane, the smokestack, and their reflections rhythmically mark off spatial intervals, and the implied motion of the smoke rising and the crane lifting and dropping all suggest a grand epic: the story of the Rouge as the story of American Industry. Yet the picture is without narrative climax or heroic focus. Rather, the additive composition, the compressed bands of space, the complex massing of details, are a product of the deliberately unselective camera eye. The flattened space of this picture and the expansion of the subject beyond our field of vision is an

abstracting photographic device Sheeler had used inventively since *Side of White Barn*.

Similarly, in the conté crayon drawings, Sheeler's careful cropping of the image and his close-up views, which isolate the subject and disguise both its scale and its role in the production sequence, all suggest infinite expansion. At the same time, the viewer is plunged into the heart of a mysterious, circumscribed space, an external architecture defined by the girders, pipes, and conveyors that converge overhead. Virtually devoid of figures and other indications of labor, these drawings nonetheless are extremely energetic. Their rich tonal contrasts, their contrapuntal visual patterns metaphorically suggesting the machines' activity, and above all their immediacy had origins in Sheeler's discerning photographic eye.

The compositions of these paintings also derive from Sheeler's knowledge of photography. The plunging three-dimensional space and the precision and focus that remains constant as the eye moves into depth in *River Rouge Plant* and *City Interior* are reminiscent of stereoscopic images. In *Classic Landscape*, the imposition of a photographic vision on a painterly one is most dramatic: although no photograph survives that records the precise details of this picture, the exaggerated scale of the ties in the foreground and the incredible rush of motion created by the railroad tracks converging just beyond the picture's edge can be attributed to the expressive distortions achievable with a wide-angle lens.

Although these pictures are shaped by different photographic devices, there is a consistent effect: the spaces seem to burst beyond the confines of these pictures, as though the canvas or sheet were unable to contain the grandeur of the new industrial landscape.[24] Unlike such nineteenth-century painters as Frederic Church and Albert Bierstadt, who resorted to bigger and bigger canvases when they found normal-sized supports insufficient to capture the magnificent expanse of the American wilderness, Sheeler was able to accommodate his new, spectacular vision on modest-sized canvases. Yet he perpetuated the tradition of the heroic American landscape in these pictures, and for the first time in his career succumbed to a romantic, theatrical impulse (even, in *River Rouge Plant* and *City Inte-*

rior, using stage-set spaces to evoke the plant's self-containment). In *American Landscape* we witness an epic procession; in *Classic Landscape* we sweep through a huge, empty foreground space to a great iconic form — here, cement silos, mute and mysterious, have replaced Cotopaxi and Mount Corcoran.

The sensibility of a visionary is apparent not only in Sheeler's dramatic, soaring spaces but also in the minutiae of his pictures. His predecessors believed that the sublime resided equally in the smallest leaf and the grandest mountaintop, and so rendered flora and fauna with a miniaturist's concern for accuracy. Sheeler's use of dense detail and pattern — formed by windows and smokestacks, and by the repeating rhythms generated by struts and girders, pipes and bricks — and, above all, his extraordinary technical control combine to present a pristine industrial landscape. He uses clear colors, crisp contrasts of black and white, and a smooth, nearly inconspicuous application of paint to define a world that, like Church's Arctic or Bierstadt's Yosemite, seems to run of its own accord, without human intervention.[25]

Especially in *Classic Landscape*, however, Sheeler tempers his idealization of industry with a suggestion of its dehumanizing side. That painting presents a modern-day Parthenon in the form of a cement plant. The silos dominate a productive, if austere, landscape, standing massive and immutable against the changing Midwestern sky. They are stable, silent anchors against the violent, roaring perspective of the railroad tracks. There are no figures, no trees, no moving vehicles in this sun-bleached vista; it is governed by its own self-contained rhythm and order. If *American Landscape* is a panoramic masterpiece, then *Classic Landscape* is iconic, totemic — an emblem of an ideal and mechanical world. While adapting their pictorial language, Sheeler transformed the ideology of nineteenth-century American landscape painters who found the sublime in undisturbed nature. At the same time, the language of the machine age — the ultrarationality of this geometrically pure architecture, the denatured landscape, and the total effacement of the human figure — creates a rather chilling effect. For Sheeler, the industrial sublime was both heroic and disquieting. More

than his photographs, his paintings showed the River Rouge plant as a brave new world.

Also during the early 1930s, in a burst of painterly productivity, Sheeler embarked on a series of paintings that show, with detailed accuracy, the interiors of his homes in South Salem, New York, and Ridgefield, Connecticut. Like the Rouge pictures, these paintings have titles that are generic and occasionally sentimental: *Interior, Home, Sweet Home, Newhaven, American Interior*, and *Americana* (cat. nos. 32, 43, 44, and 52, and fig. 18). The juxtaposition of two similarly titled pictures, *American Landscape* and *American Interior*, is a sufficient reminder that the machine age, which celebrated the factory and the airplane, coincided with the colonial revival. Like many Americans, Sheeler considered the home a sanctuary (hence "Newhaven"), a bastion of comforting tradition against the corporate and industrial values of the 9-to-5 world. Thus Frederick Allen, in his pioneering study of the 1920s, *Only Yesterday*, noted that by 1929 there were more than twenty-three million cars in America, but that the era also had produced a new breed of intellectual, "the men and women who had heard of James Joyce, Proust, Cézanne, Jung, Bertrand Russell, John Dewey, Petronious, Eugene O'Neill, and Eddington; who looked down on the movies but revered Charlie Chaplin as a great artist, could talk about relativity even if they could not understand it, [and] collected early American furniture."[26]

Sheeler began collecting American antiques in the mid-1910s. By the 1920s, his rather specialized interest had become a widespread phenomenon, as extremely wealthy collectors such as Henry Francis du Pont and Francis P. Garvan began gathering choice examples of American furnishings. This taste for Americana has been variously attributed to postwar isolationism and patriotism (and the concomitant pride in American, as opposed to European, art); to a romanticization of the preindustrial past (as disturbing realities of the industrial present such as labor unrest and the poverty of urban slums became increasingly apparent); and to an identification with "nobler" Anglo-Saxon stock as waves of Mediterranean and

Fig. 18. Charles Sheeler, *Americana*, 1931, oil on canvas, Edith and Milton Lowenthal, New York

Eastern European immigrants flooded America.[27] Such collectors as du Pont, Garvan, and Henry Ford were very visible by the 1920s. They paid unprecedented prices for American objects (du Pont is believed to have spent $44,000 for a Philadelphia high chest at a 1929 auction); they sponsored exhibitions, such as the Duncan Phyfe show of 1922 and the "Girl Scout Loan Exhibition" of 1929, which featured such objects; they donated money and furnishings for high-style colonial and federal era "period rooms," such as those dominating the American wing at the Metropolitan Museum, which opened in 1924; and finally they established museums of their own — Ford's Greenfield Village opened in 1929, du Pont's Winterthur in 1930. Their activity inspired middle-class collectors, for whom forays into the countryside in search of antiques became yet another enjoyable pastime made possible by their new Fords.

These wealthy collectors gravitated toward elaborate, aristocratic objects that would have been owned by their forebears; Sheeler's

taste, on the other hand, was for the vernacular. The objects he collected and featured in his paintings — the candlestand, the slatback armchair, the ceramics, the pewter plate — were, for the most part, production-line items designed for a middle-class buyer. They have little ornament; rather, their appeal is in their lines and their proportions. Most were nineteenth-century pieces and were classic forms, surviving in provincial areas long after new forms had replaced them in centers of high-style production and taste. Their modesty and simplicity won Sheeler's admiration; he sought these same traits in modern art.

The colonial revival era also inspired a vogue for folk art as part of a larger interest in various kinds of primitive, indigenous, naive, and non-high-style art that had begun in the 1910s. This enthusiasm was maintained largely by artists in search of new sources of energy and ideas, and by adventurous collectors reacting against overornamented, elitist, academically fostered pieces. Sheeler repeatedly was exposed to African and Oceanic art in his early years — at the Steins' and elsewhere in Paris, at the 1914 exhibition at the "291" gallery, at de Zayas's 1919 show, at the Arensbergs' — and made handsome photographs of these objects. Marsden Hartley, Max Weber, and other artists with whom he was acquainted had incorporated motifs from native American art into their works by the 1910s; by the twenties this interest had expanded to include American primitive painting and sculpture, which was avidly collected by a number of artists (many of whom were members of the Whitney Studio Club): Robert Laurent, Hartley, Elie Nadelman, Yasuo Kuniyoshi, and others.[28] In addition to the 1924 folk art exhibition at the Whitney Studio Club, which Sheeler lent pictures to, installed, and photographed, there were shows of provincial American paintings and carvings at the Valentine Dudensing Gallery, the Downtown Gallery, and the Harvard Society of Contemporary Art in Cambridge.[29] The final legitimization of folk art came with shows at the Newark Museum in New Jersey, which in 1930 mounted "American Primitives: An Exhibit of the Paintings of 19th century Folk Artists," including works lent by Laurent, William Zorach, and Nadelman, and at the Museum of Modern

Art, which in 1932 presented "American Folk Art, the Art of the Common Man," featuring 174 objects from Abby Aldrich Rockefeller's collection.

Although Sheeler acquired a number of folk paintings in the 1920s, he did not adopt the primitive aesthetic so directly as Hartley, Nadelman and others did.[30] They were drawn to its colorful, decorative side and to its abstract linear rhythms; Sheeler's appropriation was more subtle. American primitives, generally flat and schematic, provided reinforcement for his own rejection of such academic pictorial conventions as consistent perspective and scale in order to get at an object's essence.

Also during this period, renewed archaeological interest in American sites turned public attention to indigenous architecture. In 1930 the architect Eleanor Raymond published *Early Domestic Architecture of Pennsylvania*, containing photographs and drawings of the Ephrata Cloisters and the humble barns, churches, houses, and mills in Bucks, Lancaster, and Montgomery counties that Sheeler had explored in the teens. Her work carried on the mission of Henry Mercer, who established a museum to preserve the tools, farm implements, and domestic goods used by early inhabitants of the area. Henry Ford's Greenfield Village, based on the populist premise that history was far more than the leavings of the political and social elite, also preserved souvenirs of everyday life, and he constructed his own kind of period room on the grounds: replicas of Independence Hall, Thomas Edison's laboratories, and his own birthplace. Sheeler and for a period Charles Demuth (see his *In the Province (Lancaster)*, 1920; Philadelphia Museum of Art, originally owned by the Arensbergs) had a similar interest in America's vernacular monuments. In fact, these artists' initial investigations of the barns of Bucks County and the mills and meetinghouses of Lancaster anticipated by several years the more widespread archaeological revival. Nostalgia played some part in their attention to these humble structures, but Demuth's renderings are generally tinged with irony, and Sheeler's pictures – the photographs and temperas of barns in the 1910s and the oils of interiors of the 1920s and 1930s – are characterized by a straightforward approach relatively free of pictur-

esque sentiment. Sheeler's works also emphasize traditional forms integrated naturally into contemporary life: his eighteenth-century barns stand on working farms, his furnishings are shown in daily use. Sheeler claimed that it was the underlying modernity and functional excellence of these objects that made them relevant and that had attracted him to them in the first place: "I don't like these things because they are old but in spite of it. I'd like them still better if they were made yesterday because then they would afford proof that the same kind of creative power is continuing."[31]

Finally, during the same period that Sheeler was working on his series of domestic interiors, interest in Shaker furnishings was burgeoning among collectors of Americana. The leading experts of the day, Faith and Edward Deming Andrews, published their first articles on Shaker material in *Antiques* in 1928 and 1929; in the years that followed, they organized numerous exhibitions of Shaker art, drawn largely from their own collection, culminating in the 1935 exhibition "Shaker Handicrafts" held at the Whitney Museum. Sheeler's mentor Juliana Force bought Shaker furniture enthusiastically in the 1920s and 1930s, and even dubbed the South Salem home where she housed her collection "Shaker Hollow." Sheeler was acquiring Shaker pieces during the same period. The first time Shaker furniture appears in his painting is in the 1926 *Interior*, which shows a dining table, but presumably he owned Shaker pieces before then.

Sheeler's taste in American antiques was quite complex. In keeping with his insistence that the objects he admired were essentially modern in their utility and economy of design was his preference for vernacular over high-style objects. His collection was eclectic, mixing Shaker, Pennsylvania German, and colonial pieces, with an occasional English object (such as the rush seat ladderback chair that appears in *Americana*, *Newhaven*, and *American Interior*),[32] which presumably he bought thinking it was American. Sheeler seems not to have had much historical curiosity about the furnishings he acquired, yet his eye, particularly for Shaker objects, was discerning. In fact, over a dozen of his pieces were borrowed by the equally discerning collector-curator Henry McIlhenny for a 1962 exhibition of Shaker objects at the Phil-

adelphia Museum, and shortly afterward Hancock Shaker Village bought fifteen of Sheeler's pieces, which it has deemed worthy of permanent display.

Sheeler's preference for these objects was no doubt an outgrowth of his rejection of nineteenth-century taste, especially as espoused by the School of Industrial Art. There the notion of beauty was bound up with complexity of line, lush materials, and especially with ornament. Vernacular pieces and works such as those the Shakers produced, which were undecorated and thus believed to show few signs of hand-craftsmanship, were found homely and uninteresting. But Sheeler recognized the elegance of these plain, humble forms as well as the high quality of their materials and craftsmanship. He found the Shaker aesthetic to be in sympathy with modern design: "In some [Shaker] cabinet work [is] the anticipation, by a hundred years or more, of the tendencies of some of our contemporary designers toward economy and what we call functional in design."[33] In fact, Sheeler's interest in Shaker crafts may have inspired him to try his hand at designing domestic objects, and for the 1934 Downtown Gallery exhibition "Practical Manifestations in Art" (organized in the wake of the Museum of Modern Art's highly successful "Machine Art" exhibition, and dedicated to the premise that painting and decorative arts are governed by the same aesthetic) he made, among other objects, salt and pepper shakers and textiles that echo the elegant simplicity of Shaker designs.[34]

The practical and egalitarian values residing in Shaker arts – as well as such aesthetic principles as emphasis on line and on regular geometric shape and avoidance of ornament – were also a part of the credo espoused by the Bauhaus. Sheeler was well aware of Bauhaus art by the late twenties, when many of the workshop's leading designers began to emigrate to the United States. One of the few pieces of contemporary furniture Sheeler is know to have owned was the "Wassily" chair by Marcel Breuer, who had been associated with the Bauhaus when he designed it. Yet despite the parallels between the Shaker and the Bauhaus aesthetic, there is little in Sheeler's work that can be attributed to the influence of

the Bauhaus style. Determinedly apolitical, Sheeler put no sociological premium on functional design as the European artists did.[35] Nor did he gravitate toward the rest of their design philosophy: their employment of industrial materials, their deliberately streamlined forms and self-evident construction. Rather, he admired the warmth and richness of Shaker design – so unlike that of the Bauhaus – the rich woods, the soft and graceful contours, the velvety surfaces, and above all the modesty of the creator.

It was in Shaker design and not in modern craftsmanship, then, that Sheeler found reassurance for his own artistic program. Just as the plain Shaker surfaces did not distract the eye from perceiving the perfect proportions of the objects, so Sheeler's smooth technique did not interfere with the appreciation of his flawless design. He rejected ornament as that which disguises truth, and from the simple silver frames that surrounded his pictures to the nongestural style with which he painted, he consistently avoided the decorative in his work. The uniformity of Shaker objects, which submerges its maker's stylistic "signature," makes them seem universal without diminishing their beauty – a value to which Sheeler aspired.

Sheeler's taste in Americana is well documented. His folk paintings were inventoried by the Downtown Gallery at his death; the bulk of his Shaker collection was sold to Hancock Shaker Village in 1964, and the rest of his household furnishings passed to private collectors after the death of his second wife.[36] The most revealing sources for information about Sheeler as a collector, however, are the paintings and photographs he made of his South Salem and Ridgefield houses, which not only inventory the pieces he owned but preserve the way he lived with them.

Sheeler produced seven paintings of these houses between 1926 and 1934, and at least seven photographs (plus a group of negatives and contact prints) after 1929. The photographs (figs. 19 and 20; see also cat. no. 52, fig. a) reveal extremely pleasant interiors. The architecture of the South Salem house was more comfortable than distinguished, but the Ridgefield house, with its exposed beams, huge casement windows, and soaring cathedral

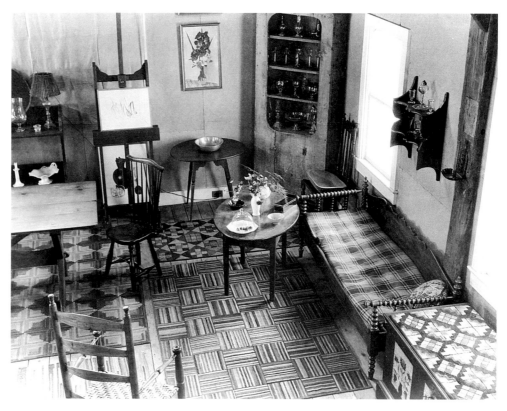

Fig. 19. Charles Sheeler, *South Salem Interior*, 1929, gelatin-silver print, The Lane Collection

ceilings, was most unusual. The photographs emphasize the light that poured in through the windows, making Sheeler's glass collection sparkle and the polished tabletops shine. Sheeler's interiors show an astonishing proliferation of patterns. He lived with an eclectic mix of objects: a pale, smooth Shaker box balanced against a thick, multicolored Whieldon-ware mug with raised decoration, or a lean, rectilinear dining table accompanied by an English chair with fat legs, bulbous turnings on its stretcher bar and thick, wavy slats forming its back – a chair, in short, that stems from the vernacular tradition but is nonetheless antithetical to Shaker design in its complexity and Baroque movement.

The photographs of Sheeler's homes reveal that the love of pattern that is an essential feature of his compositional design was also characteristic of his daily surroundings. Not just the

varied textiles but also the geometric shapes of chairs, tables, ceramics, and their shadows were deliberately arranged. Doorways frame important pieces and provide views into more private spaces, just as they do in seventeenth-century Dutch interiors. Most of the photographs were taken from above, so that the viewer's perspective on Sheeler's interiors is omniscient, all-seeing. These spaces are clearly lived in, as is indicated by the pile of *New Yorker* magazines at the foot of the bed and other casual details, but Sheeler's photographs are hardly candid snapshots. Rather, they record carefully calculated still lifes, with objects placed very much to their owner's satisfaction. They preserve Sheeler's private, idealized vision of these spaces. In them, Sheeler sought the kind of comfort that the Shaker communities provided.

Shaker communities may have been Uto-

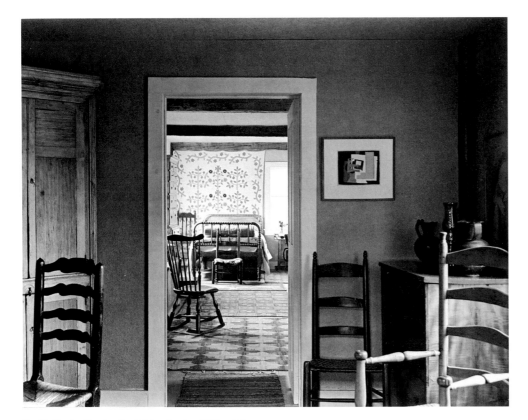

Fig. 20. Charles Sheeler, *South Salem Interior*, 1929, gelatin-silver print, The Lane Collection

Many of the same objects recorded in the photographs appear once again in the paintings, often in the same relation to one another. Unlike the earlier paintings featuring these pieces, here the age and wear of the furnishings are not disguised. Sheeler's palette is clear and warm; the patterning, made more vibrant by the introduction of color, is compounded: not only is there a proliferation of multi-colored textiles, but the regular shapes of the pieces of furniture themselves become part of the surface pattern. Although the photographs record a lively mix of traditional and modern, there are no modern objects, and none of Sheeler's own pictures, in the paintings. The only exception is found in *Home, Sweet Home*, where a keystone shape formed by shadows unites the modern heater and the old-fashioned hearth in a witty conflation of present and past.

Oddly, the paintings are often more tightly framed and more eccentrically cropped than the photographs; the cropping frequently eliminates windows and doors, precluding any sense of contact with the outside world. The interiors become hermetically sealed spaces, permitting no entry and no exit. This sense of claustrophobia is aggravated by Sheeler's unusual vantage points. The tilted-up ground plane in *Americana*, the aerial view there and in *American Interior*, and the vertiginous view down the stairs in *Newhaven* create spaces that are vaguely uncomfortable. They are not spaces that one moves through easily. Instead of the soft natural light coming in through the windows in the photographs, the illumination in these pictures is the artificial light of the photographer's lamp. In this light, the sense of comforting familiarity diminishes as edges sharpen and shadows deepen. Such shadows become as much a part of the surface pattern as the forms that cast them, and – like the shadow of the slatback chair in *Home, Sweet Home* or the spidery shadow cast by the Windsor chair in *Newhaven* – they also become somewhat eerie.

Above all, the disquieting contrast between inviting forms and unwelcoming spaces in the paintings is magnified by the absence of living things. If the photographs show interiors perfectly arranged – rooms tidied, forms positioned in the service of artificial idealization –

pian, self-sufficient, and self-contained, but they were also extremely comfortable; in the nineteenth century many nonbelievers sought sanctuary there. Sheeler, intrigued by such societies (he had been attracted to the Ephrata Cloisters in the 1910s), photographed and painted the settlements at Hancock, Massachusetts, and New Lebanon, New York, repeatedly in the 1930s,[37] even though by then the communities were practically defunct. He was in sympathy with the Shakers' achievement, and understood, and perhaps romanticized, the spirituality he perceived in their existence: "There were no dark corners in their lives, and their religion thrived on light rather than the envelopment of a dark mystery."[38] He invested in his own residences the same sense of refuge the Shaker communities had once afforded – hence the name "Newhaven" for his Ridgefield house, and his poignant comments to Louise Arensberg, written from there

shortly after the death of his first wife: "This place has come to hold something of the qualities of a cloister. These four walls are near to being the boundaries of my world. It is at least something to have one thing remaining that you have built with loving care against the things which happen outside our plans."[39]

Sheeler's sentimental feelings about his house were handsomely expressed in the photographs, which he never intended to display in public. He immortalized the same spaces in his paintings of interiors, at least two of which, *Newhaven* and *American Interior*, closely reflect surviving photographs. The others incorporate photographic devices: the camera's raking perspective, cropping to provide a sense of intimacy, and so on. But unlike the photographs, which are an affectionate record of a carefully constructed environment, a bell-jar world, the paintings convey a message that is both elliptical and ambiguous.

the paintings are disturbingly empty. No people, no animals (despite Sheeler's numerous house pets), no greenery is present. The chair pulled up to the oil burner in *Home, Sweet Home* is conspicuously vacant; in *Americana*, the backgammon board registers one of the most exciting moments of play but there is no one to witness it. In *Home, Sweet Home* and *Newhaven*, despite the warm tones and multiplicity of patterns, the space seems spare, aseptic, depopulated.

The emptiness of the interiors seen in the paintings introduces an ironic undertone to the patriotic, sentimental titles Sheeler gave them. These cozy spaces with their friendly, familiar forms, which at first glance appear to provide a kind of refuge from the urban, industrial present, begin to seem less welcoming, less hospitable, less real. It is hard to say whether Sheeler was speaking only personally or for his whole generation in intimating a kind of hollowness in the embracing of America's past. But what is clear is that, despite their warmth, in all of these interiors there is a lingering sense of absence.

Sheeler's pictures of his own house immortalize what he considered to be the best of American craftsmanship, embodying, as did his own art, straightforward truthfulness – modest, functional, and unadorned. These interiors, with their concentration of vernacular objects and their echoes of Shaker style, create a mythology of the American past parallel to that created by du Pont at Winterthur but having more in common with Sheeler's vision of Ford's River Rouge plant: self-contained and without pretense, functioning harmoniously without human interference, but governed by some higher order. In both groups of pictures Sheeler used modern vernacular – in part, the language of photography – to bring the ideals of the past into the present. In the River Rouge pictures, both the heroic and the horrific sublimity of the American wilderness are transplanted into the new industrial landscape. In the domestic pictures, which are exactly contemporary, the myth of the American past is grafted onto the modern interior, its promise of sanctuary undermined by loneliness.

Neither the personal aspect of these paintings nor their reverence for the American past was remarked upon by contemporary critics,

Fig. 21. Charles Sheeler, *The Open Door*, 1932, conté crayon on paper, Edith and Milton Lowenthal, New York

who explained them almost entirely in formal terms, as they had the River Rouge pictures and the still lifes from the 1920s. With their traditional, familiar objects, Sheeler's interiors were seen as a clever way of persuading the reluctant viewer to accept modern styles:

Still another picture is called "Americana" and shows how a cute Yankee painter can get away with cubism in a country that says cubism is against the law. Old-fashioned hook rugs are on the floor . . . and they have the kinds of patterns you see in early cubist pictures, accented by the lights and shadows that filter through a ladder-backed chair that stands against the light.[40]

For Sheeler, the paintings were both a continuation of his practice of using the camera in picture-making and an exploration of his own past. A group of conté crayon drawings he executed during this prolific period was part of the same quest.

Sheeler produced at least sixteen drawings in conté crayon between 1930 and 1937, when he abandoned the taxing medium for over a decade. Apart from the Rouge draw-

ings, most of these represent domestic themes, their compositions and even their velvety surfaces suggested by Sheeler's photographs from the teens of the barns of Bucks County and especially of the interior of his Doylestown house (fig. 21). Once again, his photographs became the blueprints for these pictures: Sheeler would later claim that the conté drawings were the works "which most closely approach photographs" and which "were made to see how much exactitude I could attain."[41] The photographs, and the drawings that followed them fifteen years later, although seemingly candid and natural, were not unmanipulated. In particular, the use of strong back lighting allowed Sheeler to achieve nocturnal effects and eloquent silhouettes that underscore the haunting emptiness of these images. But unlike his paintings of interiors, the drawings have relatively straightforward compositions, generally with a large focal motif. The cropping is far less radical, and there are fewer eccentric angles of vision or shifting perspectives. The drawings are about light, and about mysterious shadows.

Sheeler's achievement in the medium was unsurpassed by that of any modern painter except, perhaps, Seurat.[42] He was able to maintain extraordinary control in his drawings (he probably used conté in pencil form, its sharp point allowing him to work even more precisely) and asserted that, more than any other drawing medium, conté enabled him to attain the richest blacks while retaining sharp contours. With conté, individual marks could readily be buried, so that it was easy to achieve a seamless, strokeless texture akin to the smooth, nongestural surfaces for which he was striving in his oils. The exactitude, the rich, sensuous textures, and the evocative tonal contrasts conté allowed enabled Sheeler to fulfill the high ambitions he maintained for his drawings: he wanted them to be as fully realized as his paintings in form and design;[43] often, they were also their equal in intricacy, emotion, and scale.

Other than the Rouge pictures and the conté drawing *Totems in Steel* (cat. no. 53), whose subject comes from *Manhatta*, there is little machine age imagery in Sheeler's work of the 1930s. Even the picture he painted for the Public Works of Art Project (which originally requested a portrait) showed some old-fashioned farm buildings (*Connecticut Barns in Landscape*, 1934; National Museum of American Art, Smithsonian Institution, Washington, D.C.) rather than a newly constructed bridge or dam. The only other modern elements occur in an affecting portrait of his wife Katharine (cat. no. 48), drawn the year before her death, in which she is seated in the Breuer chair, and a group consisting of a large drawing and two paintings (cat. nos. 40, 41, and 42) made of his Manhattan studio, where he did commercial photographic work. Located in a new art deco-style building, his studio itself was fairly austere, and contained little more than his photographic equipment, an art deco pedestal, and an early model of Danish designer Kaare Klint's "safari chair," one of the most advanced furniture designs of its day. These pictures – *Tulips*, *Cactus*, and *View of New York* – all were executed in 1931 and have, at first glance, the same blunt, monumental, literal quality as the Rouge pictures. And in their modern imagery, their rigorous, gridlike structures, and their cool tonalities, they appear completely unlike the colorful interiors Sheeler painted at the same time. Yet these pictures are equally personal and allude, in Sheeler's typically veiled, restrained way, to a major turning point in his career.

During the 1920s, although Sheeler's reputation grew and he was represented in many exhibitions, no dealer gave him an exclusive contract or promoted his work. Unlike Marsden Hartley and Arthur B. Dove, he was not neglected by curators and collectors during this period but was included in most group shows surveying the contemporary scene – he was even spotted, and given a great deal of exposure, by the trio of brilliant students (Lincoln Kirstein, John Walker, and Alfred Barr, Jr.) who ran the Harvard Society of Contemporary Art – but he had had no solo show since the Whitney Studio's exhibition of 1924. However, in 1930 a few of his paintings, including *Upper Deck*, were shown at the Downtown

Gallery, which by then had become the most adventurous showcase for contemporary American art in New York. The next year, its energetic director, Edith Gregor Halpert, offered to become Sheeler's exclusive representative and to give him a solo show; at the same time, she strongly recommended that he curtail his photographic work, which she felt was detrimental both to his productivity and to the reception of his paintings.

The choice was a difficult one for Sheeler. His commercial practice was flourishing, enabling him to finance luxurious cars and European travel, as well as a move from a compact bungalow in South Salem to a brand-new, roomy house in more fashionable Ridgefield, and he also was attaining increased recognition as an art photographer. He had recently returned from a five-month trip to France and Germany,[44] where his work was included in the American section of the landmark "Film und Foto" exhibition in Stuttgart, and he had made an extraordinary series of photographs of Chartres Cathedral. His inclusion in highly selective group shows – at the Albright Art Gallery in Buffalo and the Harvard Society of Contemporary Art in 1930, and at the Julien Levy Gallery in 1931[45] – is testimony to the respect accorded his photography.

Yet Edith Halpert's advice that Sheeler terminate his public career as a photographer, though it now seems severe, may have been wise for the times. Photography was considered an inferior art form (the *New York Times* review of the Julien Levy Gallery exhibition begins, "Photography, long a parvenu among the fine arts . . ."),[46] and the fact that Sheeler worked in both painting and photography was confusing to the public. Critics were beginning to comment on the photographic aspects of his painting, neutrally in some cases, but increasingly with the intimation that the paintings' dependence on photography deprived them of all creative spark: "Canvases such as the 'American Landscape,' 1930, the 'Classic Landscape,' 1931, and 'River Rouge Plant' of 1932 carry this effect of tinted photography over into the sphere of the poster."[47] Despite Sheeler's accomplishment as a photographer, his primary artistic goal had always been to achieve greatness as a painter, and following his successful solo paintings exhibition at the

Downtown Gallery in November 1931, he withdrew from the staff at Condé Nast, accepted very few other commercial assignments, and virtually ceased exhibiting his photographic work.[48]

Sheeler's decision to follow Halpert's recommendation was quite courageous. Although he often bridled at the time his commercial work demanded, it had long provided him with financial security. Independently conceived projects, like the photographs he made at Chartres, were the source of a great deal of satisfaction. Other photographic compositions were highly stimulating to his work as a painter and draftsman. Sheeler's conté drawings of the thirties, most of which were based on photographs and which he himself maintained came closest to the look and feeling of his photographs, was symptomatic of the difficulties of his decision. Even more revealing are the three images of his Manhattan studio that show his camera covered, his lamps unplugged, and his client or model gone, indicating that the studio is not in use. In *Tulips* and *Cactus* (cat. nos. 40 and 41), the model or product that normally would have been positioned before the camera has been replaced by the kind of still life subject Sheeler painted repeatedly in the 1920s and to which he may have seen himself returning. *View of New York* (cat. no. 42) is even more poignant in its allusions to Sheeler's ambivalence about setting aside his financial mainstay and preparing to devote himself almost entirely to his career as a painter. Here the studio, with its shrouded camera and vacant chair, represents the artist's farewell to photography; the open window, looking out not onto New York's majestic skyline but onto a cloud-filled sky, draws upon the traditional romantic emblem of transition from a cozy (if sometimes stultifying) interior to the exciting (but potentially dangerous) outside world, between the familiar present and the temptations of an uncertain future.

IV
The Forties: Art and Industry

Sheeler's exclusive arrangement with Edith Halpert to show his paintings at the Downtown Gallery proved to be beneficial to both. He soon became one of her "blue chip" artists, and through the two and a half decades she represented him, she was able to sell his work consistently and for good prices.[1] And unlike Stuart Davis and other artists in her stable, with whom her relationship was often stormy, Sheeler was always loyal.

From the beginning of the association, Halpert was much more successful than Marius de Zayas, Charles Daniel, and other dealers had been in publicizing Sheeler's work. She regularly featured it in shows in her own gallery and elsewhere, and was able to place his pictures in important public and private collections. Even before she became his agent, she included his work in Downtown Gallery group exhibitions; through the following decades he was featured in shows enticingly titled "Paintings by 12 Younger Americans" (1937), "In the 1920s" (1937), "What Is Wrong with This Picture?" (1943), and "For Museums and Aggressive Collectors" (1944), and his work was generally praised by reviewers. The response to the Downtown Gallery's 1934 watercolor exhibition was typical:

For sheer technical accomplishment along naturalistic lines the group by Charles Sheeler commands attention. The clearness of eye and sureness of hand that can tame ordinarily harsh crayon to such subtleties are little short of marvelous. Take that "Doorway" [The Open Door, fig. 21] with its large placid planes and subtle play of whites, or the "Interior with Stove" [1932; Coll. Joanna T. Steichen, New York] with its triumphantly solved problem of black against black. In a way it meets the camera on its own ground – with the difference that this seems like photography stripped of the accidental and irrelevant, which seems to give it almost an abstract quality.[2]

In November 1931, Halpert gave Sheeler a solo exhibition at the Downtown Gallery, his first in seven years. It included many of the works that are now considered among Sheeler's best pictures – *Upper Deck, Classic Landscape, Cactus* (cat. nos. 35, 37, 41), and so on – and was particularly well received by New York critics. Sheeler's absence from the New York painting scene was noted, as was the fact that in that interval his work had gained in "strength and pictorial impressiveness." The issue of the relationship of Sheeler's paintings to his photographs (none of which were shown) was handled as favorably as Halpert could wish: "While Mr. Sheeler's painting invariably suggests the accurate accounting of the camera, so nearly does he come to recording natural exactitude of line and form, there is at the same time a super-sensuous quality in his still-life arrangements and landscapes that separates his efforts from those of the machine and that gives them their special vitality and charm."[3]

Also through Halpert's efforts, Sheeler began to be included in museum exhibitions devoted to American modernism. Although he was not chosen to participate in the Museum of Modern Art's first such show, "19 Americans," held in 1929, as a result of Halpert's influence he was represented by five works (most other artists showed no more than three) in the Modern's 1930-31 show "Painting and Sculpture by Living Americans," including *Upper Deck*, lent by the Downtown Gallery. Thereafter, he would be included in "Trois Siècles d'Art aux Etats-Unis" (1938), organized by the Museum of Modern Art for the Musée du Jeu de Paume, Paris, and in "Art in Our Time" (1939) and "American Realists and Magic Realists" (1943), both at the Museum of Modern Art, with works lent by the Downtown Gallery or its clients. In 1934 Sheeler's *View of New York* (cat. no. 42) and two other works were submitted by the gallery to the mammoth "First Municipal Art Exhibition" held at Rockefeller Center; in 1942, Halpert lent *Steam Turbine* (cat. no. 61) to the Metropolitan Museum's "Artists for Victory" show, and over the next two decades his works were included in group exhibitions in Houston, Detroit, Cincinnati, Chicago, Philadelphia, and other major urban centers, all at Halpert's instigation. He was represented consistently in museum annuals such as the Carnegie International and the Pennsylvania Academy Annual, as well as the Whitney Biennial and that institution's landmark exhibitions "Abstract Painting in America" (1935), which included two early Sheelers, and "Pioneers of Modern Art in America" (1946), which presented an eight-work survey of Sheeler's development from 1910 to 1922. Sheeler's increased visibility in the 1930s and early 1940s was due in part to the growing interest in American modernism generally during that period; nonetheless, Halpert played a substantial role in the promotion of his work, particularly outside New York, often (as was the case with "Paintings and Drawings by Charles Sheeler" held in 1932 at the Arts Club of Chicago) organizing whole exhibitions from Downtown Gallery holdings.

Halpert was equally adept at persuading museums across the country to buy Sheeler's work. Other than *New York* at the Art Institute of Chicago and the related painting, *Skyscrapers*, at the Phillips Collection in Washington (cat. nos. 17 and 18), Sheeler was unrepresented in museum collections prior to his affiliation with Halpert. (Ferdinand Howald would make his magnificent gift to the Columbus Museum of Art, including eight Sheelers, in 1931, the same year the artist became associated with the Downtown Gallery.) But during the thirties, Halpert would sell *Upper Deck* and *Feline Felicity* (cat. no. 50) to Harvard's Fogg Art Museum, *City Interior* (fig. 17) to Worcester, *Ephrata* (cat. no. 51) to the Springfield (Mass.) Museum of Art, *View of New York* to the Museum of Fine Arts, Boston, and *Rolling Power* (cat. no. 59) to the Smith College Art Museum. Even her failures were impressive: shortly after Harvard turned down *American Interior* (cat. no. 52), she sold it to one of Yale's supporters, who subsequently donated it to the Yale University Art Gallery. And in 1934, she nearly persuaded the Tate Gallery in London to buy *View of New York*.[4]

Equally important, Halpert introduced Sheeler and his work to a new group of patrons, principal among them Abby Aldrich Rockefeller. Rockefeller, working with Halpert, built a collection that would become the nucleus – indeed, almost the whole – of the American modernist collection of the Museum of Modern Art. The eight Sheelers, including *Self-Portrait, American Landscape*, and *Of Domestic Utility*, (cat. nos. 25, 36, and 49) she acquired from the Downtown Gallery between 1929 and 1933 and gave to the museum in 1934 and 1935 make that institution (along with the Whitney, where the influence of Juli-

ana Force's discerning eye would long be felt) the richest repository of Sheeler's work in the country.

With Halpert's encouragement, Mrs. Rockefeller engaged Sheeler for special projects, such as a conté crayon drawing of Central Park (cat. no. 47), which preserved her favorite view of the park before it underwent relandscaping in the early 1930s.[5] The most significant of these assignments involved the pictures Sheeler made at her request of the newly restored buildings at Colonial Williamsburg. Sheeler later recalled that the commission came through the Downtown Gallery; ironically, Mrs. Rockefeller initially recommended that he photograph the buildings for her.[6] She subsequently engaged Sheeler to make two paintings of historic houses at Colonial Williamsburg, the Governor's Palace and Bassett Hall, with whose restoration the Rockefeller family had been deeply involved for almost a decade.[7] Sheeler apparently visited Williamsburg briefly in November of 1935.[8] He returned before Christmas, and for the several months he required to complete the commission he sublet the curator's house ("sort of built into the wall of the Governor's Palace") and employed his maid, Mary Eliza, who may have been the subject for his well-known photograph "Aunt Mary."[9]

The first painting, The Governor's Palace (1936; Colonial Williamsburg, Va.) was delivered to Mrs. Rockefeller by the Downtown Gallery in early April 1936. Sheeler eventually would complete four works, three paintings and a drawing, of which The Governor's Palace and Bassett Hall (1936; Colonial Williamsburg, Va.) fulfilled the original commission, and which were sold to Mrs. Rockefeller for $1500 each. Those two paintings were subsequently installed at Colonial Williamsburg; they hang in the Williamsburg Inn today. Sheeler made the other two works independent of the commission. The oil, Kitchen, Williamsburg, was acquired by Mrs. Rockefeller and remained in the family; the drawing became part of Halpert's private collection.

As was generally the case with Sheeler's work, the pictures he made not on commission but from his own motivation are the most evocative. The contents of the Williamsburg kitchen appealed to his taste for humble, utili-

Fig. 22. Charles Sheeler, The Nation's Capitol, 1943, oil on canvas, National Museum of American Art, Smithsonian Institution, Transfer from the U.S. Department of State

tarian objects. Even the most complex piece in the room, the New England banister-back chair, was a vernacular form, like the furniture in his own home. The commissioned paintings, Bassett Hall and The Governor's Palace, and similar projects such as The Nation's Capitol (fig. 22) and Old Slater Mill (1945; Regis Collection, Minneapolis), undertaken in later years, suffer from an obligation to historically accurate detail and are less engaging. Contemporary critics treated these pictures with tact and discretion. Of The Governor's Palace, Constance Rourke wrote, "Nothing is stressed: the building simply exists, with finality, with splendor and pride," and John Baur commented, "Yet there are pictures like Bassett Hall . . . where one feels there has been a relaxing of the tension, where a more unqualified, untransformed realism has had its way."[10] But to the modern viewer, Sheeler's new style of unaccented, meticulously detailed realism borders on the illustrational.

Sheeler himself was dissatisfied with such works, for they were, like his earliest architectural photographs, just jobs to him. Unlike the

Bucks County barns, the Shaker buildings, or Albert Kahn's factory at River Rouge, the buildings at Williamsburg were not structures he especially appreciated, nor, in his mind, were they part of a visionary place created by dynamic personalities. Furthermore, he had private reasons for being discontent with the Williamsburg pictures. They were painted during several years of extraordinary loneliness following his wife's death. During this period, loyalty to his dealer, who had become his major source of financial and emotional support, turned to a deeper affection, which she did not return; the Williamsburg assignment felt like exile to him.[11]

It is likely that Sheeler did little or no painting at Williamsburg with his subjects actually in front of him, but as had become his practice by then, he drew upon his extensive series of photographs, which served him as aide-mémoire for the paintings. As Rockefeller had guaranteed, these photographs were far superior to the technically adept but not particularly innovative pictures produced by Williamsburg's staff photographer, F. S. Lincoln.[12] Nonetheless, Sheeler claimed that they, too, were not up to his standards. He declined to loan, sell, or give them to the Williamsburg archives as he was asked to do, and also refused the opportunity to have a "small display" of them there, stating (perhaps in deference to his agreement with Halpert) that they were "of the nature of notes for possible future reference, rather than photographs of pictorial interest."[13] The only exceptions were the photographs of Aunt Mary, which he was invited to display at the Zeiss Company showrooms in New York in 1936 and which were featured in Life magazine two years later and of the kitchen (which Sheeler clearly valued, for he printed it in several sizes and subsequently exhibited it at the New York Camera Club).

The rest of the decade was a period of retrenchment for Sheeler. He returned to his favorite themes – barns, tabletop still lifes – and produced a small number of works in tempera, conté crayon, and oil, which vary in quality and many of which (e.g., Totems in Steel [cat. no. 53], The Upstairs [fig. 23], and Blue Interior with Window [1935; Fitchburg (Mass.) Art Museum]) drew upon his repository of photographic images from the 1910s and 1920s. The

Fig. 23. Charles Sheeler, *The Upstairs*, 1938, oil on canvas, Cincinnati Art Museum, The Fanny Bryce Lehmer Fund

few new subjects he did essay during these years were generally the result of commissions, such as the painting *Clapboards* (1936; Pennsylvania Academy of the Fine Arts, Philadelphia), painted for *House and Garden* to illustrate an article on roofs by R. [Richardson] Wright that appeared in the May 1937 issue.

Sheeler's most important commissions from this period came from the offices of Henry Luce, whose new magazines *Fortune* and *Life* were consistent employers of many of the artists of the period, among them Walker Evans, Margaret Bourke-White, and Fernand Léger. *Fortune* was founded to be the organ of commerce – to appeal to the gentlemanly businessman rather than to the "money grubber" – and to give business new dignity and a rightful place in American society. From the beginning it was planned as a deluxe periodical ("as beautiful a magazine as exists in the United

States"), with an elegant format and handsome typeface, printed on antique stock and with a heavy cover, employing such well-respected writers as Archibald MacLeish, James Thurber, and Dwight MacDonald, and recruiting famous painters and photographers to produce its illustrations. The formula was immediately successful. By the end of 1930, the year it was introduced, its circulation was ten thousand and grew to more than a hundred thousand in less than five years.[14]

Sheeler was one of many artists hired to paint for *Fortune*. His *Silo* (cat. no. 56) appeared on the April 1939 cover, following issues with cover illustrations by A. M. Cassandre and Miguel Covarrubias and preceding examples by Herbert Bayer, Léger, and Ralston Crawford.[15] Despite the disparate political views held by contributing artists, the subjects of these covers were generally corporate in character, featuring mammoth machines, industrial architecture, agribusiness equipment, views of factories, and so on – although Ben Shahn did contribute a series of illustrations for an issue devoted to "The Labor Situation" (November 1946) and Diego Rivera offered a group of pictures documenting "Mexico in Revolution" (October 1938). The magazine also maintained a special interest in the arts. It published a generously illustrated issue on New York City in July 1939, which featured a special section on the painter's city with high-quality reproductions of paintings by Sloan, Bellows, O'Keeffe, Hopper, and others. The following December, it devoted a laudatory issue to the Museum of Modern Art.

Sheeler's work did not appear in either of these special New York issues. Instead, he was the subject of a four-page feature article ("Charles Sheeler Finds Beauty in the Commonplace") in *Fortune*'s sister magazine, *Life* – one of the first American painters to be so honored. The article, which appeared August 8, 1938, reproduced five of Sheeler's paintings, three of his photographs, and showed several pictures of the artist at work at his Ridgefield home. Part of the purpose of the article was to publicize the cover Sheeler produced for *Fortune*, for one of the illustrations shows him at his easel, working on *Silo* (cat. no. 56, fig. a). Its other goal, which Sheeler undoubtedly did nothing to discourage, was to demystify the life

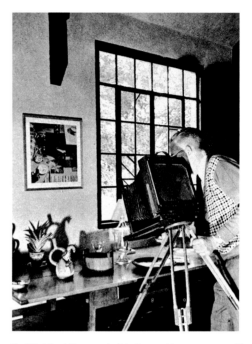

Fig. 24. Alfred Eisenstaedt, "He focuses his camera on a still life," *Life*, August 8, 1938, p. 42

of the artist and the art-making process, and to portray them instead as a typically American. The caption of a photograph of Sheeler accompanying the article identified him as looking more like a college professor than an artist. Another picture (fig. 24) showed him in his house, photographing a still life arrangement on his Shaker table; the article explained that he worked a 9-to-5 schedule "like any day laborer." The attitude reflected in the article's title, as well as the homely snapshots of the artist at work, is consistent with traditional American views on the arts. As Toqueville observed in 1830, Americans "cultivate those arts which help to make life comfortable rather than those which adorn it. They habitually put use before beauty, and they want beauty itself to be useful."[16]

Sheeler subsequently was recruited by Luce's organization to produce a series of pictures featuring industrial subject matter, to be published in a special portfolio entitled "Power." Originally, the commission was extremely ambitious, specifying eleven paintings to be produced over a two-year period. Al-

Fig. 25. Charles Sheeler, *Coal*, 1945, oil on canvas, Commerce Bancshares, Inc., Kansas City, Mo.

though the specific terms of the commission are unclear, most likely the magazine's editors offered the same generous arrangement that had governed Sheeler's production of *Silo*, namely, that they would buy the publication rights and oversee reproduction of the works, while the paintings would remain Sheeler's property.[17] As with the Rouge photographs, Sheeler had not sought out the opportunity to render machine age subjects but rather was solicited for the job; and once again the general guidelines for the subject matter were dictated by his patron, but Sheeler was given license to choose the individual themes.[18] During 1939 he traveled throughout the country in pursuit of appropriate subject matter. His camera once again served as sketchbook and as aide-mémoire; his photographs, especially those of Boulder Dam, are also distinguished works of art. His travels finally yielded six works, five oil paintings and one tempera, and at least one image that he decided not to use for the "Power" series but produced some years later as an independent composition (fig. 25).[19] Completed early in 1940, the paintings were published in *Fortune*'s December 1940 issue, which coincided with a special exhibition of the originals at the Downtown Gallery. Although there was some criticism of what was felt to be the paintings' overly photographic quality,[20] they were generally well received, and half the group sold almost immediately.

Fortune's purpose in commissioning these paintings was unabashedly boosterish. The machines Sheeler represented were generally the largest, most advanced, and most productive of their day; as examples of new technology they were allied with social and economic progress. As the Depression ended and as Hitler's invasion of France made the specter of war even more threatening, the great machines, with their extraordinary energy-producing capacity, were an assertion of national power and defensive readiness.[21] The commentary accompanying the pictures contained statistics about the scale and power of the machinery – each was the world's largest, or the fastest, and so on – and described how they could function "with few stops, no fuel, and very little supervision." The language of military preparedness was coupled with Utopian imagery, as machinery was portrayed as the avenue to a more comfortable, more secure future. Turbines, generators, and steam engines were described as symbols "of a colossal sharing," providing "comfort to many"; a power plant's energy cycle was seen as "a model for the cosmos." Most revealing, the editors' description of the *Yankee Clipper*, a magnificent new airplane, portrayed technology as freedom over the limits imposed by nature and man's own frailty:

> ...it allows a man to go as he pleases. Hills are no longer hills up which he must labor, his muscles tiring. He presses his foot on the accelerator and wheels over them. Forests and lakes are no longer barriers. He pulls back on the stick and floats over them. He loses old realities and gains new ones. The internal combustion engine has suddenly expanded his adventure in space.[22]

The "Power" series was intended to sell technology to a nation that was still largely small-town and agrarian; most of the behemoths Sheeler depicted had not been built in urban centers but were imposed on the countryside. If *Fortune*'s editors believed technology would work miraculous changes and thus would guarantee that America's great potential – her manifest destiny – would be realized, they saw no conflict between their adulation of the machine and America's traditional reverence for nature. Rather, they promised that the man-

made devices Sheeler depicted "seek to use co-operatively the limitless power of nature."[23] Technology was a source of benefit and excitement, not a disruption of the natural order.

In promoting industrialism as integral to American life, *Fortune*'s commentary resolutely disregarded the widespread flight from technology in the late 1920s and 1930s. In a period that embraced the machine, there was simultaneously a nostalgic retreat into simple, homogeneous, preindustrial small-town American culture. This nostalgia was evident in phenomena as disparate as the popularity of Ford's Greenfield Village, the revival of colonial styles in domestic architecture, the enthusiasm for such literary works as *Our Town* and *Abe Lincoln in Illinois* (both published in 1938) and for films such as John Ford's *Stage Coach* and especially *Gone with the Wind* (both released in 1939). And Sheeler, anointed painter of the machine age,[24] completed his tours of Boulder Dam and the Tennessee Valley Authority to return home to a sanctuary filled with nineteenth-century artifacts.

Sheeler's attitude toward the monumental implements he was charged with depicting, while not deviating drastically from *Fortune*'s determinedly optimistic, upbeat notions, was nonetheless more ambivalent and more deeply rooted in nineteenth-century concepts of the machine, and of nature. That he did not admire his subjects uniformly is first apparent in the surprising variations in medium and scale of the works in the series. He employed no consistent format, palette, or point of view. Rather, his choices were carefully adjusted to complement his interpretations of his subject matter: the most intimate scale and delicate medium were reserved for the most old-fashioned image (*Primitive Power*, cat. no. 57); the largest canvas for the most massive and ominous machine (*Suspended Power*, cat. no. 60); the most brilliant and unrealistic color for the most otherworldly image (*Conversation – Sky and Earth*, cat. no. 62), and so on. More consistent was the technique that Sheeler employed for these six images, which was a continuation of the seamless realism he had been developing during the decade. His surfaces were even smoother; details (though selectively rendered) were increasingly finely wrought. There is no indication of the creative struggle

behind these pictures. Traditional, centrally focused compositions are rare in the series; rather, Sheeler used formulas developed through photography (dramatic angles of vision, innovative cropping) with great sophistication. These works are highly polished and highly accomplished. The tendency toward the illustrational (which would plague his work through the 1940s) is here curbed by expressive color and creative design.

While *Fortune*'s commentary emphasizes the impressive scale and productivity of these machines, Sheeler's pictures demonstrate his precept of finding beauty in the useful. To *Fortune*, these machines were the key to America's prosperity; to Sheeler, they were the stuff of art. His view is a continuation of the Emersonian notion that "in nature all is useful, all is beautiful," and that the distinction between the fine and useful arts, between the poetic and the technological, may someday be abandoned.[25] The connection between use and beauty in the American tradition goes back to Benjamin Franklin as well: "Nothing is good or beautiful but in the measure that it is useful."[26] Sheeler's unassertive style and his meticulous transcription of detail suggest that the implements he paints rather than the paintings themselves are the source of beauty. This is especially apparent in *Rolling Power* and *Yankee Clipper* (cat. no. 58), where his technique of cropping, excerpting the evocative detail from the whole, focuses the viewer's attention not on the subject's ability to move at unheard-of speeds but on its elegant silhouette or, in the case of *Rolling Power* (in which the drive wheels are rendered as though they were a bronze relief), on its sculptural intricacies.

Sheeler's strategy – portraying the train and the airplane not as dynamos but as art – was understood by at least one reviewer, who described the *Yankee Clipper* in terms of its formal design and its sensuous surfaces: "Its sleek, glistening hulk is relieved by the rapier blades of the propeller."[27] More often, however, Sheeler was criticized for overlooking "the soul of the machine," for being interested only in "the static shell in its beauty and economy of form without its throbbing internal life."[28]

Sheeler's characterization of machinery as art differed from the attitudes of other painters associated with the machine age. Gerald

Murphy in *Watch* (1924-25; Dallas Museum of Art), for example, shows mechanical forms to be a stimulating subject for abstract design. Thomas Hart Benton, in *Instruments of Power* (1930; The Equitable Life Assurance Society of the United States, New York) interpreted such devices as sociological symbols to be featured in narrative representation. Sheeler's attitude is, in a sense, a continuation of a nineteenth-century American tradition. Artists such as Charles Willson Peale, Robert Fulton, Horatio Greenough, and others honored the artistry in the machine. Perhaps the closest parallel with Sheeler is Thomas Eakins. In Eakins's early, precise drawing of a lathe, the intricate interrelationship of parts is portrayed as an elegant sculpture; in his portrait of Henry A. Rowland (1891; Addison Gallery of American Art, Phillips Academy, Andover, Mass.) the magical, glittering spectroscope testifies to the poetry the artist found inherent in mechanical devices.

Furthermore, Sheeler's relative indifference to function (none of the machines he paints is obviously in operation, nor is the product of their gargantuan spinnings and turnings ever dramatized) parallels the romantic awe with which late-nineteenth-century Americans observed that era's counterpart to the hydroelectric turbine, the Corliss engine.[29] A guidebook to the Philadelphia Centennial, where the engine was first displayed, used the image of a divine colossus to describe it: "The first thing to do is to see the tremendous iron heart, whose energies are pulsating around us. . . . Poets see sublimity in the ocean, the mountains, the everlasting heavens; in the tragic elements of passion, madness, fate; *we* see sublimity in that great flywheel, those great walking beams and cylinders, that crank shaft . . . – in the magnificent totality of the great Corliss engine."[30]

I n works like *Conversation – Sky and Earth*, Sheeler's unusual vantage point and disorienting truncation of the electrical apparatus express the awesome incomprehensibility the machine inspired. One reviewer commented on the miraculous effect of the structure Sheeler depicts, which "makes the imagination leap" as Sheeler silhouettes it "against a turquoise

sky in this strange, unearthly country, where until the Dam came no spear of grass grew."[31] A similar sense of magic comes through in Sheeler's photographs of Boulder Dam, where a thin skin of concrete, topped by fairyland pavilions, holds back a giant pool of black water. The contrasts Sheeler uses here – of textures, of dark and light, of natural and manmade forms – lend themselves to the imaginative invention of parables of good and evil.

Fortune's editors were as given to hyperbole as were the nineteenth-century commentators. They used religious imagery to suggest that Sheeler's paintings were illustrations of the technological sublime, noting the "heavenly serenity" of his style and his "devout intensity," and comparing the quiet of the room housing the turbine in *Suspended Power* to "a corridor of the Vatican."[32] These rapturous metaphors contained none of the ambivalence expressed by Sheeler, for whom the technological sublime was both wonderful and threatening and, as demonstrated by *Primitive Power*, not unequivocally rooted in modernity.

Sheeler's ambivalence too has links to nineteenth-century attitudes. Like the Corliss engine, the machines he depicted inspired both awe and dread, and without veering too far from objective description, Sheeler's work suggests that they are capable of breaking out of human control and unleashing terrible, destructive power. In particular, both *Steam Turbine* and *Suspended Power* subtly convey the potential threat posed by machinery, evoking the delicious, creeping horror of a gothic melodrama. *Steam Turbine*, with its dense, claustrophobic composition, its deliberately murky colors, and its rather portentous steely form, is in Sheeler's view more ominous than euphoric. *Fortune* describes it as a device that can "harness the whirlwind"; Sheeler's vision, with its incomprehensible array of pipes, pumps, and mute steel, is nightmarish and inhuman. Similarly, the mammoth device in *Suspended Power* that *Fortune* reverentially describes as "floating majestically down into its pit" is for Sheeler equally visionary, equally unsettling.[33] It contains the promise of power coupled with an unmistakable threat: the great phallic structure exudes aggressive sexuality; the slicing blades silently lower ever closer to the worker, like the pendulum in Poe's pit.

As much as Sheeler's attitude toward modern technological wonders parallels nineteenth-century views of new machinery, it also reflects traditional ambivalence toward the power of nature. This is especially evident when his reaction is one of awe, as in *Conversation – Sky and Earth*, the one unabashedly romantic composition in the series.[34] The viewer, imagining himself at Sheeler's side, looks up in amazement at a magnificent, delicate latticework of insulators and wires flattened against primeval rocks and a dazzling azure sky, just as Bierstadt looked up at the Domes of the Yosemite. This nostalgic link with earlier art was perceived by Jeanette Lowe, one of the most insightful commentators on the "Power" pictures: "The romantic painter of another era would find himself inspired by a natural waterfall. Sheeler is no less inspired by an idea of a waterfall compounded by the mind of man."[35]

The late thirties, when Sheeler was at work on the "Power" series, was a period of considerable recognition for him. Both the promotional *Life* magazine article and Constance Rourke's sensitive and sympathetic monograph, based on Sheeler's autobiographical notes, appeared in 1938. The "Power" portfolio, appearing in the elaborate Christmas 1940 issue of *Fortune*, gave Sheeler considerable exposure, enhanced by the solo show of the six pictures at the Downtown Gallery that coincided with the issue's publication.

Sheeler's arrangement with *Fortune* prohibited him from exhibiting these works before they appeared in the magazine. In recognition of the series' importance to his career, however, the editors did permit one painting, *Yankee Clipper*, and one of the related photographs to appear in Sheeler's solo show at the Museum of Modern Art, which opened October 4, 1939. Organized by associate curator Dorothy Miller, it was the first monographic show to be installed in the new Philip Goodwin/Edwin Durrell Stone building on West 53rd Street, and only the fifth such exhibition to be offered to a living American artist in the museum's ten-year history.

The exhibition at the Museum of Modern Art was Sheeler's first solo show in eight years, his first in a major museum, and the first to survey, with a large quantity of works, his entire career. There were 105 paintings, drawings, and watercolors, from the 1910 *Plums on a Plate* (cat. no. 1) to *Yankee Clipper*; 4 prints (excluding, of those made to date, only *Barn Abstraction*, with which Sheeler was always relatively dissatisfied), and 73 photographs, examining his remarkable production in that medium from the Doylestown interiors to views of Boulder Dam, and including some of his Condé Nast and advertising photographs as well. His involvement with industrial design was acknowledged with the inclusion of the salt and pepper shakers, flatware, and textiles he had produced a few years earlier.

The catalogue was lavishly illustrated – twenty-nine works were reproduced – and Sheeler and his close friend William Carlos Williams each submitted a statement. Sheeler's was a straightforward recapitulation of his favorite themes: "Pictures realistically conceived might have an underlying abstract structure" and "Today it seems to me desirable to remove the method of painting as far as possible from being an obstacle in the way of consideration of the content of the picture." Williams, writing more obliquely, asserts that Sheeler's art resides in his vision: "It is his eye for the thing that most distinguishes Charles Sheeler," and praises his ability, like Cézanne's, to contain the "local" in "the universal."[36]

These larger principles were not the grounds on which Sheeler's art was introduced to the public. Rather, the Museum of Modern Art's publicity billed Sheeler as an artist with universal appeal – "This is art that the expert appreciates and the layman enjoys" – and as a realist pure and simple, the champion of a styleless style, with no formal subtleties intervening: "No layman is ever puzzled by any of Sheeler's work. A tree, a barn, a cat, a brick wall looks like a tree, a barn, a cat, a brick wall and can be mistaken for nothing else."[37]

Unfortunately, what the layman was expected to admire was the cause of discomfort to many critics, who failed to see the expressive power and evocative content behind Sheeler's descriptive style. Although a few praised his "universal clarity of vision, sensitivity to structure, and meticulous technique," an equal number saw him as an unimaginative technician, whose subjects, though scrupulously executed, "have still not been fully brought to life. Perhaps the fault lies in the immaculate conception."[38]

As Halpert had feared, the juxtaposition of paintings and photographs caused certain observers to question the legitimacy of Sheeler's most recent work, with its smooth, extremely detailed realism, and to ask whether Sheeler's paintings of the late thirties were more than "tinted photographs." In this context, the qualified response of the reviewer for *Art News* must have been gratifying:

I admit, too, that what difference there is between the oil entitled Clapboards *and a tinted photograph is not much. But none the less an oil like that casts a haunting spell: perhaps it is the angle of vision from the chimney-pot, perhaps it is the fine disposition of gables, perhaps it is the contrast of greys and sky-blues, certainly it is the underlying abstraction behind it all.*[39]

Despite the mixed response, the Museum of Modern Art's show greatly enhanced Sheeler's reputation. Over the next six or seven years, he would be included in numerous museum exhibitions in New York and elsewhere (including solo shows held in 1944 at the Dayton Art Institute and in 1946 at the Addison Gallery of American Art in Andover, Mass.). In these exhibitions, such as "Pioneers of Modern Art in America" (1946), an ambitious survey of American art from 1908 to 1922 organized by the Whitney, he was often cast in the role of one of the senior figures of American modernism – an honorable designation, but one which carried with it the implication that Sheeler and the others were already history.

Perhaps the most interesting of these exhibitions was the Museum of Modern Art's "American Realists and Magic Realists" (1943), dedicated to the display of the native version of surrealism. A group of nineteenth-century painters, including trompe l'oeil specialists Richard La Barre Goodwin and William Harnett, were included in the "Retrospective" section; Sheeler, along with Hopper, made up the section called "20th-Century Pioneers"; the bulk of the show, the "Contemporary" portion, was given over to the bizarre and disturbing imagery of such artists as Ivan Albright, Paul Cadmus, Louis Gugliemi, and Peter Blume.

Sheeler and Blume had maintained a friendly rivalry since the early 1930s, when Sheeler expressed his admiration for the younger artist.[40] The sense of competition between them was exacerbated in the early forties when Blume was eagerly pursued by major museums: the Museum of Modern Art bought his *Eternal City* (1937) in 1942 and the Metropolitan Museum awarded Blume's *South of Scranton* second prize in its 1942 "Artists for Victory" exhibition and subsequently purchased the painting, while Sheeler's entry, *Steam Turbine*, went unrecognized by the jury and didn't sell for another eight years. In the Museum of Modern Art's "Realists and Magic Realists" show, Blume was represented by eight works, Sheeler by only four, and, as though to reinforce the idea that he was a pioneer but perhaps not a contemporary force, none of these was later than the mid-thirties. However, the inclusion of *City Interior* demonstrated that, where most of the more recent work in the show was conspicuously shocking, Sheeler's sharp focus and precise representation gave his painting a subtly disconcerting quality.

To the modern eye, Sheeler's paintings do not seem especially surreal. However, two works of the period, one recent and one in progress at the time of the exhibition, do seem to exemplify Alfred Barr's definition of magic realism: "a term sometimes applied to the work of painters who by means of an exact realistic technique try to make plausible and convincing their improbable, dreamlike, or fantastic visions."[41] They testify to the convergence of Sheeler's style, for a brief moment, with this most peculiar movement.

The better known of the two is *The Artist Looks at Nature* (cat. no. 66). Despite the novelty of the design, Sheeler's painting has roots in a traditional subject, the artist at his easel, but with a twist: Sheeler is painting not what he sees before him – in this case, a rather barren landscape – but rather a subject he held in his mind's eye. As such, it can be read as a parable of artistic creation, and a gloss on the conventional self-portrait. At the same time, it contains reference to a very private series of images that served as landmarks in Sheeler's life: a photograph, circa 1917, of the interior of his house in Doylestown; a conté crayon

Fig. 26. Charles Sheeler, *Nativity*, 1941, oil on canvas, Private collection, New York

drawing, made after that photograph, which he gave to his friend and mentor Edward Steichen; and another photographic self-portrait, probably made about 1931 in his 44th Street studio, which became the lower corner of *The Artist Looks at Nature*. The landscape in which Sheeler situates himself (which some scholars have found reminiscent of Boulder Dam, and which, with its high, sheer walls, fences, battlements, and flat, bleached-out terrain, conveys, at the height of World War II, a military aura) is spare, acid colored, unwelcoming. With his face turned away from the viewer, Sheeler suggests, elliptically as always, that the contents of his memory and imagination are far richer than the reality he sees around him, that the past for him is more satisfying than the present, and that if he is indeed a realist, a purveyor of a styleless style, then it is only in his technique.

Sheeler's other painting of the period that can be said to be in a "magic realist" vein is far less familiar. It was a favorite of the artist's and remained in his collection until his death. Like *The Artist Looks at Nature*, *Nativity* (fig. 26), is personal and enigmatic, and, in its satiric reference to voyeurism, also quite humorous. The

landscape in the far distance of *Nativity* is more benign than that in *The Artist Looks at Nature*, but it has the same kind of indecipherable space and is the same acid color. The quizzical cow, perhaps a surrogate for the artist, looks as if it strayed in from a painting by Peter Blume. The stone archway is in part what explains the title, for it is reminiscent of similar structures in such Northern Renaissance masterpieces as Roger van der Weyden's *Nativity* from the Bladelin Altarpiece (Staatliche Museen, Berlin, Gemäldegalerie Dahlem), belonging to a school of painting Sheeler always admired.[42] In the immediate foreground is a puzzling miscellany of objects: a striped chair, with high-heeled pumps, a straw hat, and a pair of hose draped over the back; and at right, plump, naked legs stretched out seductively on an enormous flat tree stump, their owner sunbathing, perhaps. In addition to being a witty and irreverent satire on traditional nativities, the painting is slyly autobiographical. It was conceived at the height of Sheeler's romance with Musya Sokolova, a Russian emigrée some twenty-five years his junior. Musya, a former ballet dancer, was lively, fun-loving, and flirtatious, and Sheeler clearly found her attractive and rejuvenating. They were married in April 1939 and subsequently moved to Bird's Nest, a small stone cottage in Irvington-on-Hudson, New York.

During the war, Sheeler took on a number of commercial assignments, many of them arranged or encouraged by Edith Halpert, despite her earlier edict, to help him combat the slow market and economic deprivations of those years. The number of photographic assignments he received outnumbered his commissions for paintings. For *Fortune*, he photographed a collage composed of souvenirs of three great nineteenth-century writers, Melville, Thoreau, and Whitman, for the magazine's series "Americans Whose Careers Are Relevant Today," which appeared in 1944. At about the same time, he made a series of photographs of a synthetic rubber plant in West Virginia, which also resulted in at least four paintings: *It's a Small World* (1946; Newark [N.J.] Museum), *Incantation* (cat. no. 67), *Catwalk* (1947; Coll. Mr. and Mrs. Barney A. Ebsworth, St. Louis), and *Mechanization* (1949; Whitney Museum of American Art, New

York). His most important photographic assignment, which lasted from July 1942 until July 1945, was to photograph the collections of the Metropolitan Museum for publication. Working with museum curators, Sheeler selected his subjects, choosing the most elegant works from all the major collections. Like the photographs of works of art he produced in the 1920s, these images are as classical and eloquent as his subjects.

Less satisfying and successful were the paintings commissioned from him during those years. *Old Slater Mill* (1945; Regis Collection, Minneapolis), painted for the owner of that property (now a historic site) in Pawtucket, Rhode Island, is like the Williamsburg pictures, rather lifeless and literal; *Riding Through Gatun* (1946; Citibank, New York), a view of the Panama Canal produced as an advertisement for National City Bank, New York, was equally illustrational. Sheeler was one of several artists employed to produce advertising images for National City Bank during the war years; Rockwell Kent and John Steuart Curry also provided pictures of military and industrial subjects. That corporation's use of famous artists to establish a dignified yet culturally progressive image for itself (Sheeler's painting was reproduced with the caption "Locks That Unlock World Trade") was part of a larger trend in advertising. The pioneer was Container Corporation of America, which employed Jacob Lawrence, Fernand Léger, Ben Shahn, Herbert Bayer, and many others. Lucky Strike, DeBeers Diamonds, and Dole Pineapple (which sent Georgia O'Keeffe to Hawaii in 1940) also sought out artists of stature to establish a tone of quality for their products.[43]

The war years and those immediately following saw the increased involvement of industry in the arts. Corporate collections were begun; businesses such as the Pepsi-Cola Company and Hallmark Cards began sponsoring exhibitions and competitions at the end of the war. Sheeler was a sporadic participant in these. In 1957 he won second prize of $1,000 in Hallmark's International Art Award competition (from among fifty artists invited to submit work) for *Two Against the White* (1957; Fine Art Collection, Hallmark Cards, Inc., Kansas City, Mo.); Edward Hopper, another of Sheeler's nemeses, won the $2,000 first

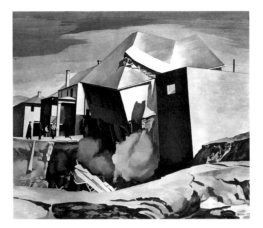

Fig. 27. Charles Sheeler, *Catastrophe*, 1944, tempera on panel, Wichita Art Museum, Roland P. Murdock Collection

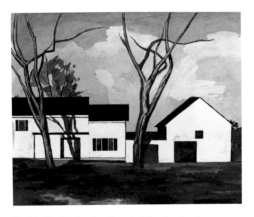

Fig. 28. Charles Sheeler, *Farm Buildings in a Landscape*, 1947, tempera on paper, from the Warner Collection of Gulf States Paper Corporation, Tuscaloosa, Ala.

prize.[44] By this time, Sheeler was an enthusiastic advocate of such activities, but in the 1940s he was a rather reluctant participant, and the paintings he produced under these circumstances were never particularly inspired.

Sheeler's own independently conceived creative work also declined during this period. Other than his two intriguing "magic realist" pictures and a series of tiny, exquisite temperas produced between 1940 and 1942 that survey his favorite subjects (*Fugue* [cat. no. 63], a power plant in New Bedford, Mass.; *White Sentinels* [cat. no. 65], a barn complex in New Milford, Conn.; *Interior* [Coll. Mr. Herbert Goldstone, New York], a still life featuring Sheeler's Shaker table and Etruscan pitcher; and *Red Against the Light* [Dayton Art Institute], barns again), much of his work was relatively weak and repetitive. Some of his paintings (e.g., *Birds Nest*, 1944; Coll. Carl Stocker, Coral Gables, Fla.), while charming, seem sentimental; others, such as *The City* (1947; Herbert F. Johnson Museum of Art, Cornell University, Ithaca, N.Y.) are reprises of themes rendered more profoundly earlier in his career; still others (e.g., *Catastrophe*, fig. 27) show him casting about for new inspirations for subject matter (in this case, he based his painting on a photograph cut out of a newspaper).

During the same period, Sheeler was experimenting with several different styles, and here too he seems uncertain, indecisive. Most of the paintings, whether oil or tempera, were rendered in the precise, straightforward realistic style he perfected in the late 1930s. The weakest of these lapse into illustration, while the strongest display elegant compositional design and expressive use of color. He also worked with a cartoonlike style resulting from an oversimplification of forms. These pictures (see fig. 28) were generally executed in tempera; they are composed of loose washes and shaggy outlines, usually feature natural forms, and often are a near-caricature of themes Sheeler had addressed in the past. He also returned to abstract imagery during this period, the most successful paintings (see cat. no. 67) inspired by his industrial photographic projects. As he would later explain, these brightly colored, graphically dynamic pictures represented a return to an old solution for his favor-

V
The Late Work:
Painting and Photography

ite artistic problem: "Every picture should have a steel structure, and, by frankly revealing it instead of covering it with embellishments, I believe that my new work shows a pronounced change."[45]

When the war ended, Sheeler was sixty-two and no longer in the artistic mainstream. Although the more conservative critics and museums could insist that realism was returning to prominence,[46] such expressionist painters as Gorky, Gottlieb, Hofmann, and Pollock were beginning to command attention in the galleries and the art press. Whereas by now Sheeler was nationally recognized – his work was automatically accepted in museum annuals, he was invited to serve on juries, and so on – it was very much as a senior figure, an *eminence grise*. The postwar years were a period of stagnation for him, and he was badly in need of fresh inspiration.

Once again, support came from Edith Halpert. She encouraged sales of his recent paintings with vigorous marketing techniques, placed his work in group shows across the country, and featured him in solo shows at her gallery – in 1946, 1949, and 1951 – far more frequently than in earlier years. She also encouraged, and perhaps arranged, his participation in a new venture, terms as artist-in-residence, first at the Addison Gallery in Andover, Massachusetts (1946), and subsequently at the Currier Gallery of Art in Manchester, New Hampshire (1948). Although his visits were brief, they seemed to provide what he needed: new subject matter and an innovative working method, which would sustain him for the rest of his career.

In September 1946, Bartlett Hayes, director of the Addison Gallery of American Art at the Phillips Academy, Andover, invited Sheeler to serve as artist-in-residence for a few weeks. His visit was planned to coincide with an exhibition in his honor at the Addison, scheduled for late October of that year. It was also conceived by Hayes to inaugurate a new program for the Addison to purchase contemporary works of art, whereby the artist was to spend a period of time on campus, after which the gallery would purchase the "creative results of this term of residence." Sheeler was to have no obligations to the student body and was not required to focus on any particular subject; rather, the program was to provide him with "intellectual security" in a system of support inspired by patterns of patronage in Renaissance Florence.[1]

A year and a half later, Sheeler received a similar invitation from the Currier Gallery of Art in Manchester, New Hampshire, inspired by a successful exhibition of his works there in January 1948. As set out by Currier director Gordon Smith, the terms of the invitation were exceedingly favorable to the artist: he was required to stay in New Hampshire only briefly, there were to be no demands on his time, and he was guaranteed a fee of $1000 for two sketches produced as a result of his visit there (no restrictions were placed on his choice of subject matter), from which the trustees would then select one to be worked up in oil for an additional $1500.

Sheeler's residencies proved to be both lucrative and inspiring; several important friendships, especially with Hayes, resulted, and, most important, the two experiences seemed to rejuvenate the artist and restore his creative powers.

During these two visits – he was at Andover for about six weeks, and at Manchester for two – Sheeler spent more time observing his surroundings than producing works of art. He did no painting on the spot but rather followed his usual practice of taking photographs, which he referred to as his "notes . . . in shorthand," to gather information and record impressions.[2] At Andover he took a few straightforward photographs of the Academy Building (which resemble those he made of the Governor's Palace at Williamsburg), and he later

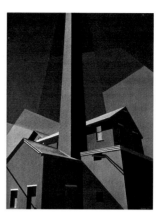

Fig. 29. Charles Sheeler, *Ballardvale*, 1946, oil on canvas, Addison Gallery of American Art, Phillips Academy, Andover, Mass.

made a few paintings and wash drawings of the townscape, but what really attracted his interest was a decrepit mill building at Ballardvale, on the outskirts of Andover.

Sheeler's photographs of the mill depict it as a romantic ruin, poignantly isolated and neglected, in a state of picturesque decay. In his painting of the same subject (fig. 29) the artist idealized the building, painting it in brilliant primaries and showing the smokestack, miraculously restored, silhouetted against the sky as though it were a church spire. His response to the abandoned Amoskeag textile mills in Manchester was identical. In his photographs he interprets the buildings poetically, as once-stalwart structures reclaimed by nature. His paintings of the same site present the factory buildings as regularized, pristine forms, models of the vernacular architecture and socioeconomic organization they once were.

Bartlett Hayes viewed these terms as artist-in-residence as something of a turning point for Sheeler, and in fact not since his visit to the River Rouge plant had a subject inspired the artist with its stimulating combination of the heroic and the real.[3] The decayed buildings at Ballardvale and Manchester offered new themes and provided Sheeler with much-needed relief from the listless subjects and tedious commercial assignments he had recently been working on. Between 1946 and 1953, Sheeler produced over twenty images in oil, tempera, ink wash, and conté inspired by either Ballardvale or the Amoskeag Mills, culmi-

nating in *New England Irrelevancies* (cat. no. 75), which combines forms from both sites. Even more important, working with his "shorthand notes," the photographs he took at the site, Sheeler evolved a new method of generating designs both descriptive and abstract, designs that expressed his perception of his subjects as both mundane and immortal. Superimposing two negatives, he would print a composite photograph that both evoked the actual site and suggested an entirely original compositional design. In his early use of the technique (see *Manchester*, cat. no. 69), he combined photographs only of the same site; in later works, such as *Lunenburg* (cat. no. 78) or *New England Irrelevancies*, he took far greater liberties, conflating two distinct settings. By his own estimation, *New England Irrelevancies* was "the farthest I've gone" in bringing together two associated images: "it is . . . the overtone of the previous image and the more present one, that combines in this picture."[4]

Sheeler's new method suggested not only the compositional outlines but also the tonal contrasts of the final image. The uppermost negative of the "sandwich" yielded the more shadowy forms, and these in turn evoked the memory of the place. The interconnection of the shadow and the substance, the remembered and the observed, was a long-term preoccupation for Sheeler; his composite photographs provided a new way to express these very personal resonances.

Sheeler's use of composite photographs was not without precedent in his work. At about the time of his move from Philadelphia, he had deliberately used the overprinting technique to generate an extraordinary photographic abstraction of the female nude, and in 1932 he had combined (and in one case reversed) several of his Rouge photographs to make his triptych *Industry*, which was displayed in the Museum of Modern Art's exhibition "Murals by American Painters and Photographers" of that year. But for the first time in these works of the late forties, his use of photographic composites was less an end in itself than an inventive means of generating a composition in another medium. As such, it was part of Sheeler's lifelong project to find creative ways to have his photography serve his painting.

Sheeler had been forging connections between the two media for more than thirty years. The first instance probably came in about 1917, when he made a series of pictures of barns he found in the Bucks County countryside, conferring importance on these humble structures by the very fact of finding them worthy of photographing. The photographs, romantic in their own right, were used as sources for a series of small, charming conté crayon drawings and several works in tempera made about the same time. In the drawings and paintings, the barns are schematized and simplified; this generalization, as well as the structures' modest scale and isolation in a field of white paper, emphasizes both their picturesque and their architectonic qualities. These barn pictures probably mark the first occurrence of Sheeler's turning to his photographs for information, both factually accurate and expressively distilled and intensified, about subjects that he found of enduring interest but to which he could not easily return.[5] He would continue to use his photographs as sketches and aide-mémoire for most of his career. Far from being exceptional, the practice was employed by numerous artists of his own day, among them Ben Shahn and Diego Rivera, as well as several nineteenth-century American painters, including Homer and Eakins, who depended on photographs for the same kind of preliminary information.[6]

At least one of his Bucks County photographs, *Side of White Barn* (fig. 8), was critically important for Sheeler's compositional style in a much more significant and innovative way. Sheeler photographed the barn straight on, framing it tightly so that it filled the visual field without any peripheral distractions, yet he did not crop it to distort, to abstract, or (as with his c. 1919 photographs of nudes) to evoke another subject. So interpreted, the barn is concrete and immutable. Its façade is wedded to the picture plane, the foreground is virtually eliminated, and, with it, so is the sense that the barn belongs to another, fictional reality. And although the barn is old and weathered, its structural elegance is intact. Sheeler eschewed the picturesqueness of disorder and refrained from emphasizing a significant fragment for dramatic impact or indulging (as he had with the nudes) in the provocation of the withheld

detail. This extraordinary, highly disciplined strategy, one as much of characterization as composition, would be used in some of Sheeler's most evocative paintings and drawings (see cat. nos. 31 and 64).

The tentative interchange between Sheeler's barn photographs and his small drawings in the late teens led to a more courageous innovation. In about 1920, Sheeler began to explore a subject — the newly built skyscrapers in New York — simultaneously in four media: painting, drawing, still photography, and motion-picture photography. His deftness and versatility greatly impressed his fellow artists. Edward Weston, on a trip east late in 1922, was sent by Stieglitz to see Sheeler's work; he concluded that Sheeler's photographs presented an extraordinary image of New York and were the finest architectural photographs he had seen. On his way home, he stopped in Chicago, where he visited the Art Institute. Later recalling that visit, he placed Sheeler in rather exalted company: "My thoughts went back to a haystack by Monet, sailboats by Manet, a landscape by Cézanne, and a drawing by Charles Sheeler of New York skyscrapers."[7]

More recent critics have seen the relationship between Sheeler's New York paintings and his photographs almost exclusively in formal terms. The photographs are viewed as lending the paintings crisply recorded details, a sense of order, tautness of surface, and so on. In both media, Sheeler is praised for using light and shadow abstractly, not descriptively, "to create an over-all non-objective pattern." Most tellingly, critics give credit to visual angles suggested by the camera for relieving the geometric severity of the paintings: "The tilting over and closing in of the sides of tall structures, an effect produced when a lens is pointed upward, give vitality to his work."[8]

This analysis, while not inaccurate, disregards the emotional content shared by the New York paintings and photographs. In these subjects, Sheeler proves himself to be the master of the lucid understatement. Not for him were the awe-inspired dramatic vistas and claustrophobic skyscraper canyons for which Berenice Abbott was celebrated, or the starry-eyed romance (and sometimes terror) of Georgia O'Keeffe's New York views. Nev-

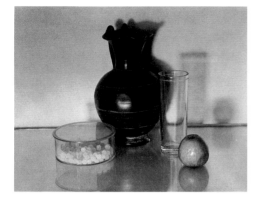

Fig. 30. Charles Sheeler, *Still Life*, c. 1922, gelatin-silver print, The Lane Collection

ertheless, in a painting like *Church Street El* (cat. no. 16), whose vertiginous perspective and unearthly luminosity were both suggested, but not dictated, by the camera, Sheeler's deeply felt response to the stimulating and overwhelming aspects of the new New York are obvious.

Aside from this group of images, few of Sheeler's paintings and drawings executed in the 1920s seem to have had photographic prototypes. He was principally involved with still life in those years, and although later he occasionally would photograph his still lifes before painting them,[9] here they would only have imposed an unnecessary intermediate step. However, in the case of the one painted work for which a close photographic counterpart is known – *Suspended Forms (Still Life)* (cat. no. 20) – the drawing and photograph are extraordinarily different expressions. Ironically, the photograph (fig. 30) is the more evocative. Its classical, pyramidal grouping of forms, horizontal format, silvery tones, and soft shadows create a still life that seems almost old-fashioned. In the drawing, Sheeler tightened the arrangement, eliminated shadows, used a taut, upright grouping, and interjected the electric red of the apple to arrive at a composition that is stunningly modern.

Sheeler's still lifes of the period tend to show forms in isolation, not grouped narratively, symbolically, or in an informative setting, and this sense of detachment, of separation, could be in part the legacy of his photographic vision. In its search for objectivity, his photog-

raphy of the 1920s was inherently distancing, a quality that Sheeler utilized not only in his camera images but also in his painterly project of depicting "forms suspended in a vacuum."[10] Many photographers of this era were dedicated to the cropped image and the photographic close-up, and to abstracting a subject so strongly that its contextual associations virtually disappear. Paul Strand was perhaps the major practitioner of these devices, but Sheeler used them too, in some of his architectural views, in his masterful photographs of Chartres Cathedral, made in 1929, and especially in his nudes. This sense of dissociation likewise informs his painted still lifes of the period, which despite Sheeler's realistic rendering of detail are nonetheless characterized by an eerie disjunction of forms, forms robbed of their substance by the elimination of shadows, and of their context by the extraction of peripheral objects and surrounding space.

The 1920s also saw Sheeler's only significant examination of figurative subjects, with either the camera or the pencil. There are his series of classically restrained nude drawings (see cat. nos. 14 and 15), his semi-satiric *Lady of the Sixties* (1925; Coll. Carl Rieser, New York), three self-portraits (one headless and elliptical, the others straightforward and competent, if slightly dull), and the poignant portrait of his wife Katharine (cat. no. 48), and that is all. Sheeler never sought a career as a portraitist in any medium (although *Katharine* makes clear he was not lacking in ability in this genre), perhaps because of the kind of temperament the genre requires. Portraiture demands that the artist seek access to another person's view of reality, that he be a flatterer or a voyeur, fascinated by the foibles of unusual types and individual characters, or (like Eakins) that he project his own personality onto the subject, so that every portrait becomes an autobiography. For Sheeler, inherently diffident, such emotional identification would have seemed intrusive and distasteful. On the other hand, most of Sheeler's commercial photographic work, undertaken for *Vanity Fair* and *Vogue*, was figurative, either celebrity portraits or fashion photography. Sheeler's achievements here are far less persuasive than in any other genre he attempted. The reasons again may lie with the genre, which demands the idealiza-

tion of the subject and requires making the model as beautiful as possible. Such treatment was antithetical to Sheeler's instinct to make a virtue of plainness, to show the achievement, the value, in the everyday.[11]

Throughout the 1920s Sheeler's private, painted work dealt largely with still life subjects, while his public, photographic work was primarily figurative. At the end of the decade he found a way to bring the two media together. He himself called *Upper Deck* (cat. no. 35) a landmark in his development; it and the River Rouge images are perhaps his best-known and most riveting works. From their first New York showing, Sheeler's reputation rested on these pictures.

Sheeler's view of industrial subjects earned him the title the "Raphael of the Fords;"[12] but despite this machine age epithet, his innovation was not in his choice of subject matter. To whatever factory or area he was summoned, another artist had preceded him there: Weston and Margaret Bourke-White had made their first industrial photographs before him (Weston's *Armco Steel* was made in 1922, and Bourke-White's views of Otis Steel, near Cleveland, in 1927); Elsie Driggs had visited the Rouge plant early in 1927 and recorded her observations in an impressionistic painting (current location unknown) and drawing (Whitney Museum of American Art, New York). Bourke-White also photographed the Rouge, in 1930, and the Amoskeag Mills in Manchester, in 1932. For the most part these artists were more caught up in the mystery and drama, in the persuasive power of the subject matter, than he. As Bourke-White said, "There is a power and vitality in industry that makes it a magnificent subject for photography. . . . It reflects the age in which we live. . . . The steel mills are at the very heart of industry with the most drama, the most beauty."[13] Compared with an artist like Bourke-White, whose melodramatic photographs of industry are as much about the exciting struggle to make the pictures – clambering onto a high catwalk surrounded by shooting sparks – as they are about formal issues, Sheeler's work seems cool, static, and understated. His artistic struggle is nowhere apparent, and the power of the machines he immortalized is only implicit.

Sheeler's paintings of the Ford plant, especially *Classic Landscape* (cat. no. 37), are more overtly dramatic than his photographs and mark a new development in his project to integrate the two media. For the first time, Sheeler composed a painting as though he were looking through a camera lens. His application of photographic strategies to a painted composition is all the more astonishing in these epic pictures because they simultaneously recall traditional, romantic landscape subjects. In them, Sheeler reinterpreted the American wilderness, the nineteenth-century symbol of manifest destiny, as the new industrial landscape, monumental, unpeopled, and full of promise. As he had in *Side of White Barn*, in which innovative photographic techniques gave a modern cast to a two-hundred-year-old subject, here again Sheeler brought together the historical and the contemporary, the memory and the reality, and made modern photography serve the traditions of the fine arts.

The climax of Sheeler's career as both a painter and a photographer came in the early 1930s, on the heels of the great success of the Rouge pictures and the positive reception afforded both his 1931 solo show at the Downtown Gallery and the contemporary exhibition, in which his photographs were featured, at Julien Levy's gallery. The years that followed have been characterized as a period of "radically diminished effort and output" in Sheeler's photography.[14] Yet this reduced production seems to have had little to do with any disaffection with the medium, although Sheeler probably was somewhat relieved to be freed from his commercial work, which he often found tedious. Rather, the cause may have lain with his willingness to acquiesce to Halpert's wish that he curtail his photography in order to devote more time to his painting. Furthermore, his wife's illness and death sapped his creative energies, and the photography commissions Halpert arranged for him proved to be no panacea. Sheeler's photographic output seems to have suffered both from the pressure of commissions, such as Williamsburg, that took him far from home,

and from his increased determination to have his photographs serve his painted work.

The decline in Sheeler's photographic production, his resignation from the staff at Condé Nast, and his withdrawal from active involvement in the world of creative photography occurred just at the time the debate between "fine art" and commercial photography had come to a head. In 1929 Carl Sandburg published his adulatory book on Edward Steichen, which contains a spirited defense of the photographer's career as a commercial artist. He quotes Steichen himself on the issue: " 'I welcome the chance to work in commercial art. If I can't express the best that's in me through such advertising photographs as "Hands Kneading Dough," then I'm no good.' " And, " 'There never has been a period in which the best thing we had was not commercial art.' "[15] To this justification Sandburg added that Michelangelo's great works done for the Medicis, as well as the commissions awarded to Raphael, Titian, and Leonardo, were in their own way commercial art.

Such assertions were felt as a slap in the face to the Stieglitz cult, which had labored tirelessly to establish the aesthetic primacy of photography. Most vocal of the respondents was Paul Rosenfeld, who turned his review of Sandburg's book into a defense of photography as a fine art, particularly as practiced by Stieglitz and Paul Strand (he also mentions in this connection the work of Steiner, Sheeler, and Man Ray). Equally vehement was Strand himself, who unequivocally condemned the idea of art serving the demands of advertising.[16] These responses to Sandburg made it clear that the battle to have photography accepted as a fine art was far from won, and that Steichen's work was considered a defection.

Artists of Sheeler's generation had long been defensive about photography. Many of the great photographers of Sheeler's generation had begun their careers in the "fine arts" — Abbott studied sculpture, Schamberg was trained as an architect, Steichen began as a painter, and so on — and later switched to photography or adopted it as means of financial support. Although few artists other than Sheeler and Ben Shahn maintained active careers in both photography and another medium, their roots in the fine arts allowed them

to identify themselves as "artists with a camera."[17]

Characteristically, Sheeler took no public stand in these debates, but undoubtedly he was sensitive to the issues raised. He resented time taken up by his commercial photography and would live to see his work trivialized by advertising.[18] He had long since been cut off from the Stieglitz group and adored Steichen, but nonetheless was vulnerable to the reservations about photography expressed by some of his closest advisers, from Marius de Zayas (". . . photography is not Art. It is not even an art. Art is the expression of the conception of an idea. Photography is the plastic verification of a fact.")[19] to Edith Halpert, who even after Sheeler's death feared that the "lesser art" of photography would undermine Sheeler's credibility as a painter: "[I am] upset about the possibility of reorienting Charles's reputation as a painter by focusing so much attention on the photographs, which relate so closely to the paintings which followed. It took me years and years to change the public attitude which was built up so many years ago, indicating that he merely transferred one medium to another."[20] Writing his autobiographical notes in 1937, Sheeler expressed pride in his photographic output but intimated that because photography is descriptive rather than interpretive, it is the lesser medium, and he identified himself as a painter foremost: "Photography is nature seen from the eyes outward, painting from the eyes inward. Photography records unalterably the single image while painting records a plurality of images wilfully [sic] directed by the artist."[21] From the early 1930s on, photography would be far less an independent medium for Sheeler than it had been before, and despite the superb quality of many of the prints he produced, and his obvious pleasure in the medium, it would be subordinate to his painting in the eyes of his public and to some degree to the artist himself.

In the 1930s, Sheeler produced a remarkable group of drawings in conté crayon, many with photographic origins. His progress was slow because the medium required painstaking control, and an exhibition Halpert planned never came to pass for lack of sufficient material.[22] Nevertheless, between 1930 and 1937

Sheeler produced fourteen drawings in conté crayon, representing subjects as diverse as construction sites (*Totems in Steel*, cat. no. 53), his photography studio (*Tulips*, cat. no. 40), and Chartres Cathedral (*Flying Buttresses*; National Gallery of Art, Washington, D.C.). The most compelling of these (*The Open Door* [fig. 21], *Interior with Stove*, *Of Domestic Utility* [cat. no. 49]) relate to photographs he made in Bucks County some fifteen years before, or to their contemporary counterparts, such as *Feline Felicity* (cat. no. 50). He favored conté because it was the one medium that allowed him to approximate with equal sensual appeal the fine detail, evocative silhouettes, and velvety textures of those photographs. The deep, rich blacks and soft contours that Sheeler was able to achieve in these drawings create a sense of nostalgia, giving an antique patina even to those pictures, such as *Ballet Mechanique* and *Industrial Architecture* (cat. nos. 38 and 39), that were based on recent photographs of modern subjects. Again, Sheeler's photographs were linked with his need to bring the past, which to the fifty-year-old artist had come to seem a more comforting time, into the present. In the early 1930s they also served him as a means to reprise, however elliptically, more private thoughts and more personal images than he generally presented in his paintings. The conté drawings of the thirties are among Sheeler's most virtuosic works and reflect his most successful translation of his photography into another medium.

At the end of the decade, Sheeler was recruited for a project that again allowed him to intertwine painting and photography inventively. The "Power" paintings, created for *Fortune* in 1939-40, were all preceded by photographs, although few of the photographs that survive served Sheeler as an exact source. Sheeler acknowledged only that the photographs provided information for his paintings. As he said of *Rolling Power*, "Since I could not camp beside [the locomotive] for the three months I required to paint it, I made a photograph."[23] Sheeler's coy refusal to elaborate on the interconnection between these two series of images is consistent with his general artistic reticence, also apparent in his reluctance to preserve sketches and preliminary schemes, and in his style itself. As he noted cryptically, "I

have come to favor the picture which arrives at its destination without the evidence of a trying journey, rather than one which shows the marks of a battle. An efficient army buries its dead."[24]

Sheeler's suppression of the preliminary, the spontaneous, and the gestural in his paintings, and the close correlation between them and the photographs of this period in particular, have often led critics to regard the photographs as templates for his paintings and to judge both as creatively deficient as a result. Yet the photographs themselves represented extraordinary artistic forethought and inventiveness, and Sheeler selected them from larger groups of images as the most pictorially convincing.

A comparison between *Suspended Power* and the related photograph *Installation* (cat. no. 60, fig. a), one of a handful of images out of almost a hundred negatives and contact prints Sheeler made during the "Power" project that he found worthy of rendering as fine prints, makes clear Sheeler's differing ambitions for the two media in this period. With his camera, Sheeler diligently recorded the details of the scene and captured the intriguing anecdotal moment in which the workers, reflecting the viewers' curiosity, peer into the mammoth pit at the huge apparatus settling into its housing. Several of the figures were transplanted from the photograph to the oil, although the painting's dramatic composition was suggested by another photograph Sheeler made at the site (only the negative survives; it is not known whether Sheeler ever printed it). In the painting, which for Sheeler was always the more idealizing medium, peripheral and foreground details have been subordinated to the centered composition, making the turbine hanging in midair a sinister icon. And whereas the value structure of the photograph, in which sharp contrasts are eschewed in favor of middle tones, has been carried over to the painting, the addition of color — flesh tones, maroons, and lavenders (and in other paintings in the series, colors equally imaginative) — signals the conversion of the relative truth-telling of the photograph into the interpretive fiction of the painting.

The "Power" images, both paintings and photographs, represent a stylistic departure

from the works Sheeler produced in the early part of the decade. The photographs are crisper, cooler, more factual; the paintings too appear more matter-of-fact, their artistry concealed beneath smooth surfaces and almost illustrationlike clarity of design. The latter quality in turn comes from the absence of spontaneity in execution, and in particular from the avoidance of any roughness or variety in the surfaces — the "marks of a battle" to which Sheeler was fond of alluding.

The unadulterated literalism of these pictures was the climax of a general trend away from abstraction and toward more precisely descriptive works characteristic of American art in the 1930s. Realists such as Thomas Hart Benton, Edward Hopper, and Charles Burchfield were widely exhibited and collected during this decade; even artists such as Stuart Davis and Georgia O'Keeffe, long committed to abstraction, reintroduced readily recognizable objects and a more descriptive manner into their styles. For the most part, this trend won the approbation of critics, from Thomas Craven, once a defender of modern art, but by this time a champion, on patriotic grounds, of American scene painting, to the more liberal and far-sighted Henry McBride. But for some critics, studying the seamless realism of the "Power" pictures and of contemporary works Sheeler exhibited at his solo show at the Museum of Modern Art, the close relationship between painting and photography provoked reservations about the originality of the painted work. Several observers began to question, as Halpert had feared they would, why Sheeler bothered to paint: "If in the fullness of their particular statement, these photographs express more powerfully, and more profoundly what the artist wants to say, then why attempt to approximate such statements with brush or pencil."[25]

The major change in Sheeler's painting style in the mid-1940s, the intensification of his palette (see cat. no. 67), is often attributed to his experiments with color film, primarily Kodachrome, during this period.[26] In fact, his sensitivity to graphic design, and in particular to the illustrations done by fellow artists for *Fortune* and other publica-

tions during the war, may have played an equally important role in his moving away from soft, opalescent hues to brighter colors, generally primaries, as well as in the reassertion of his preference for rather schematized, geometric images. During the 1940s, Fernand Léger, Herbert Bayer, Ralston Crawford, and many others produced vividly colored, diagrammatic designs, generally based on industrial themes, for the magazine's cover. This new graphic aesthetic, born partly of Bauhaus reductionism and partly of advertising, seems to have affected Sheeler, who soon followed suit with a series of similar images such as *Against the Sky a Web Was Spun* and *Incantation*, which would also appear in *Fortune*.[27]

Despite his work for *Fortune* and for the Metropolitan Museum of Art, Sheeler remained relatively isolated from the art world during this period. His contact with fellow artists seems to have been almost exclusively with photographers. He and Weston worked together photographing barns in northwestern Connecticut in 1941; Ansel Adams came to visit him about that time; and he continued to be in close touch with Steichen, who by then was dividing his time between the Museum of Modern Art, where he directed the photography department, and a country house in West Redding, Connecticut, not far from Irvington-on-Hudson, New York, where the Sheelers had moved in 1942.[28] Sheeler reportedly was one of a few mourners (with David McAlpin) to attend the scattering of Stieglitz's ashes at Lake George in 1946.[29] At about the same time, he received a book of photographs, affectionately inscribed, by Margaret Bourke-White.[30] Yet through this period he seems to have been rather passive, content to let his colleagues come to him. It was not until he returned from Manchester in 1948 that his passion for travel, so evident in the 1920s and 1930s, returned.

During the last decade of his career, Sheeler made two trips to California (1954 and 1956), visiting Weston in Carmel and photographing with Adams and with Pirkle Jones in Yosemite and San Francisco. He kept up contact with Steichen, exchanging "recipes" for papers and printing techniques as he had with Stieglitz many years before.[31] He met Eero Saarinen, the architect he most admired, in 1955; the

next year he went to Warren, Michigan, to see that master's famed General Motors Research Laboratory. He traveled to Maine for a holiday in 1955 at John Marin Jr.'s, and to Williamsburg for a vacation in 1958. Earlier, in 1952, he had brought to Irvington several old friends, including Steichen, to celebrate John Marin Sr.'s eighty-second birthday.

Marin was one of the few painters with whom Sheeler acknowledged close acquaintance. Of the artists with whom his work was most often compared in the early years, Demuth and O'Keeffe, he claimed to know Demuth only slightly, although both were at the Pennsylvania Academy in 1905 and 1906, and both later became close friends with William Carlos Williams. He met O'Keeffe through Stieglitz in about 1919 but maintained that she was difficult to get to know, and would acknowledge little connection in style or motivation between her work and his: "I think we are quite diametrically opposed. . . . There's a large element of symbolism in O'Keeffe's work, as you can readily see, and none whatever in mine." Among the younger artists described as "Precisionists" with whom Sheeler is often associated, he admitted knowing Spencer and Crawford only slightly through the Downtown Gallery. Of the artists represented by Halpert, he expressed his greatest admiration for Stuart Davis, who was not only a great colorist but, like Sheeler, a supreme designer.[32]

Sheeler's awareness of new art, particularly abstract expressionism, then coming into prominence in New York, is more difficult to gauge. He was in New York frequently in the early fifties, photographing Midtown buildings, yet he claimed to spend little time viewing contemporary exhibitions because they were "a little bit distracting to my own work"; his response to what, if anything, he saw in the New York galleries is not recorded. On the one hand, he valued his independence from contemporary trends and seemed relatively indifferent to recent developments (in a 1959 interview he expressed reservations about Pollock and deKooning for their intrusive use of paint and for not being, in his view, particularly American);[33] he is hard-pressed to name a group of artists he especially admires. On the other hand, he advocated open-mindedness, as one newspaper interview demonstrates:

"When queried about present day non-objective and expressionistic painting, Sheeler's comment is, 'Don't condemn it. There are many beautiful things about these. Furthermore, the painter approaches his painting in a different light which the average man will not always understand or appreciate at first glance.' "[34]

Much of Sheeler's exposure to the new art being made in the 1950s came through his friend William H. Lane, who at the time was avidly collecting both Sheeler's work and that of a younger generation. Lane would bring pictures from New York to his home in central Massachusetts, frequently stopping off at Irvington to share his recent finds with the Sheelers. A photograph of about 1953 (The Lane Collection) by Musya Sheeler records one of these spontaneous art exhibitions, in which paintings by Baziotes, Gottlieb, and Hofmann, among others, were spread out along Sheeler's fence. Lane recalls the artist's keen interest in these pictures, but also his acerbic reaction to one of the thickly impastoed Hofmanns, stylistically so different from his own work: "I'd hate to be the guy who has to clean that."[35]

Lane was one of several businessmen with whom Sheeler became friendly in the 1950s. He also established cordial relationships with industrialists who commissioned paintings to document their factories and mills. In 1955 Leigh Block, then vice-president of the Inland Steel Company, invited Sheeler to the Chicago area to depict that factory complex, which resulted in the painting *Western Industrial* (1955; Art Institute of Chicago). In the early 1950s, the head of public relations at U.S. Steel summoned Sheeler to Pittsburgh to work on a mural. The project was never realized, but the trip nevertheless resulted in several inventive compositions, among them *Ore into Iron* (cat. no. 77) and *Aerial Gyrations* (1953; San Francisco Museum of Modern Art). One of Sheeler's closest acquaintances in the business community was the Dayton industrialist Otto Spaeth, who, like Lane, was an avid collector of modern art and bought many works from the Downtown Gallery in this period.

Spaeth, who had diverse business interests, invited Sheeler to Milwaukee in 1952 to see the Pabst Brewery, in which he owned consid-

erable stock. Sheeler found it "a very exciting subject" and produced *Convolutions* (cat. no. 73), one of the liveliest of his late industrial pictures. And in honor of the Meta-Mold Aluminum Corporation, of which he was chairman, Spaeth commissioned the idiosyncratic painting *Meta-Mold* (1952; Amcast Industrial Corporation, Dayton, on loan to the Dayton Art Institute) and a large mobile by Alexander Calder to decorate the company's office building in Cedarburg, Wisconsin. In 1952 he opened that building with an exhibition of "an honor role of modern art," including works by Sheeler, Cézanne, Matisse, Picasso, Shahn, Hartley, and Dove, lent by such prominent industrialists as Rockefeller and Ford, and featuring as well many gems from Spaeth's own collection. Other exhibitions followed, designed to increase the sensitivity to art and fine design among company employees and the citizens of Cedarburg[36] — ambitions curiously echoing those of the School of Industrial Art, where Sheeler's training had begun fifty years before. Now the marriage of art and industry met with Sheeler's hearty approval.[37]

Sheeler's best-publicized and, with his fee set at $4500, one of his most lucrative commissions in the 1950s was the painting he produced for the board room of the General Motors Research Laboratory in Warren, Michigan. That commission was for a work 48 by 30 inches (one of the largest pictures Sheeler ever produced), in which the artist was to express "the spirit of research." Sheeler, who revered the laboratory's architect, Eero Saarinen, was both enthusiastic about the opportunity and coyly boastful about his design: "I have decided the canvas will be my masterpiece."[38]

The General Motors laboratory building presents a functional, efficient-looking exterior, an outgrowth of the Miesian Bauhaus style, while the inside is a fantasy, a dramatic stage set. Its famous stairway, made of stainless steel and other standard industrial materials, features slender steel cables replacing traditional balusters so that it seems to float, and allows for grand, aristocratic descents from the board room to the lobby below. In a sense, the building's stairway was the architectural equivalent of Sheeler's paintings: on the surface it is straightforward and utilitarian,

Fig. 31. Charles Sheeler, *General Motors Research*, 1956, oil on canvas, General Motors Research Laboratories, Warren, Mich.

clean and spare, but at the same time it possesses a highly imaginative and evocative subtext.

Sheeler visited the laboratory in August 1955 and later spoke of Saarinen's architecture as the inspiration for his painting, *General Motors Research* (fig. 31). The design miracle of the spiral stairway was the focus of the painting, accompanied by two other inventions in which the lab took great pride: the Helmholz Coil, a device designed to increase the accuracy of studies of magnetism, and the Dodrill-GMR mechanical heart, which greatly facilitated open heart surgery.[39] Sheeler disregarded the scale and color of these devices and rendered them abstractly, piling one on top of another in what he himself later would identify as "the most elaborate design I have ever had."[40]

In *General Motors Research* and the other commissioned works from the 1950s, as well

as the subjects he pursued independently, Sheeler consistently made use of photographic composites. The new method yielded powerful graphic designs, which were generally abstract yet remained recognizable, clear, and disciplined. This device also enabled Sheeler to achieve a sense of transparency, and so to evoke a world simultaneously real and fantastic. He used the same process for the pictures of barns and New York buildings he painted during this decade. Sheeler found a gratifying continuity in returning to his earliest subjects and once again drew upon his own past to make a modern statement: "When occasionally one of my works turns up [it] gives me an indication of being a seed for better things to come. . . . They take their place in the whole piece of cloth from which my work has been cut."[41] Thus, in 1952 he returned to lower Manhattan and made a series of photographs of the building he had immortalized thirty years before in *Skyscrapers* (cat. no. 18), and used his new technique to generate compositions for two paintings, *Convergence* (cat. no. 72) and *New York #2* (fig. 32). In those paintings, as in *Skyscrapers*, space is ambiguous and the relationship between forms arbitrary, and lights and darks are arranged to form a lively surface pattern. But for the shallow space in the earlier painting, in which the buildings lie like a flat screen across the picture plane, Sheeler substituted an iconic wedge thrusting powerfully into depth. The composite technique generated designs in which shadows have as much presence as concrete structures, and in which the prismatic multiplication of shapes yields a dizzying pattern of architectural profiles. Paralleling the recurrence of these early themes was Sheeler's return to familiar compositional strategies. In both the early and the late barns, Sheeler isolated and so immortalized relatively ordinary, unpicturesque structures. In his architectural subjects, whether he was depicting landmark buildings or relatively undistinguished ones, Sheeler created icons. The soaring thrust of these buildings recalls Sheeler's 1927 lithograph *Delmonico Building*. There, too, the viewer must crane his head uncomfortably to take in the whole of the building's clean, shapely shaft as it diminishes and nearly dissolves into the sky. There is little peripheral detail to distract; the buildings

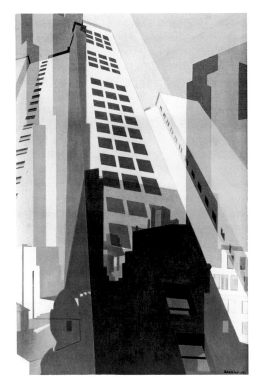

Fig. 32. Charles Sheeler, *New York #2*, 1951, oil on canvas, Munson-Williams-Proctor Institute, Utica, N.Y., Museum Purchase

are characterized as forceful and heroic. In this work Sheeler clearly relied on formal power rather than historic associations to suggest the building's iconic splendor, for he chose to depict it from the back, the most unprepossessing view.

Another innovation of Sheeler's late years, introduced about 1953, was the use of studies made on glass (and subsequently, on Plexiglas), to facilitate the transfer of the image from photograph to canvas and especially to plan color. By this time, Sheeler's process for making oil paintings was quite complex, requiring as many as seven different methodically pursued steps. He first would take a series of photographs of his chosen subjects, then select several negatives to sandwich together to print as composite photographs, generally trying several combinations before arriving at a satisfactory design. He then would frame the image, either with a penline drawn on the photo-

graph itself or with the mat window, to determine the outer dimensions of the image. He even experimented briefly with tracing forms from the photographs on pieces of acetate to enable him to transfer the outlines of his image. He would make a small pencil drawing of the chosen design, which he attached to a sheet of glass, and then apply color. When the color relationships were worked out to his satisfaction, he would then re-create the whole design on a large canvas and record it by coloring in tempera the pencil drawing behind the glass sheet. Sheeler always conceived of his work in terms of final images and was reluctant to expose any of the intermediate stages of this process. He discarded most of the composite photographs through which he generated his designs.[42] He also destroyed some of the glass studies before he was persuaded of their intrinsic visual interest.

Sheeler's elaborate process for making pictures was tedious and ultimately distancing: because it required numerous repetitions of the design, some spontaneity inevitably was lost. Although the procedure was time-consuming, it didn't seem to limit the artist's production. During the fifties, the last decade of his career, Sheeler created at least four major oils a year, plus the related studies on paper and on glass, as well as several remarkable series of photographs – of New York buildings, and of the beech trees on the grounds of his home in Irvington, among others. He continued to experiment, trying out the Land camera with Ansel Adams in Yosemite, for example, and, based on that visit, embarking on a series of paintings of pure landscapes, a genre he had rarely tackled during his long career. He maintained a vigorous exhibition schedule, showing both old and new works. His major show of the decade was a retrospective in 1954, organized by Frederick Wight for the Art Galleries at the University of California at Los Angeles; it traveled to five other cities. In 1956 a group of thirty paintings and drawings from the William H. Lane Foundation, ranging in date from 1904 to 1955, was shown at the Downtown Gallery; two years later, Halpert showed sixteen new paintings at the gallery.

By this time Sheeler was clearly enjoying the role of elder statesman – he was in his seventies – and accepted awards and agreed to

serve on juries although he'd turned down such opportunities before.[43] He was working energetically, although he often became caught up in the process of generating his pictures to the detriment of the final product. His works were increasingly conceptual, and less and less about the art of painting. A wry quip to an interviewer made at the very end of his career is revealing: "In regard to art instruction, I've decided two things can be taught – 1. Sharpen your charcoal and get the paint out of your brushes – 2. The rest is up to you."[44] This advice, though offered only half seriously, nonetheless reveals Sheeler's lifelong Spartan attitude toward painting, his commitment to line and its facility for disciplined, clear description, and his rejection of impasto as the conveyor of spontaneous emotion. Sheeler's is a restrained, patient, cerebral art, one in which the application of pigment, by his own admission, was more a necessity than a pleasure – necessary for communication of the idea, the image, which for him was what mattered most: "Since the value of the mental picture can only be determined by the degree of response it is able to arouse in another person, it must be restated in physical terms – hence the painting."[45] Ironically, his advice to budding artists echoes the theory behind old-fashioned academic art training (which his old mentor, Chase, had overthrown): drawing is to be emphasized, and painting not sanctioned until design and delineation are mastered.

Although even Sheeler's early critics saw in his works the pitfalls of his preoccupation with process,[46] it is the late work that suffers from his repeated working of the same designs in different media. In the 1950s, Sheeler's small-scale works are generally the most satisfying, especially the fresh, freely brushed images in tempera on glass and Plexiglas (see cat. nos. 74, 76, 80 and 84) and some of the small temperas that followed the oils, which are gems of graphic design. The late oils tend to be denser, flatter, more graphic, and blunter in value contrasts; the studies on glass that preceded them are more luminous, more delicate and atmospheric. Sheeler did not suppress gesture in the smaller images, and the viewer can delight in both their design and the vivacity of the brushwork.

In 1959, Sheeler suffered a stroke that en-

ded his painting career; he died six years later. Several of his last oils, including *Lunenburg* and the masterful *Composition Around White* (cat. no. 87), are works of both grandeur and vitality. His late paintings are considerably larger and his compositions more expansive and open than the bulk of his earlier work. The overlapping planes in these images evoke a kind of imaginary world while maintaining their own abstract energy. Color, too, signals the presence of an invented scene and the distance of the paintings from the photographs that spawned them. Sheeler did not feel bound by realistic, local color in these late works: hues were distributed with an eye not to description but to the creation of a handsome pattern of darks and lights on the picture surface. His favorite tones in those years were maroons and blues, rose and lavender, often arranged in subtle gradations, so that a factory wall or the side of a barn appears opalescent. Like his subject matter, Sheeler's palette was returning to first things: his favorite hues in his paintings of the teens recur in the work of the fifties. Furthermore, these paintings are a reminder that Sheeler's method of superimposing negatives to create compositional designs was instinctive as well as intellectual, for it was at base an accidental, spontaneous process. The results, as he shifted negatives around, were unpredictable, yielding combinations of forms he hadn't consciously planned. His method was a kind of instinctive cubism, in which photography was used to fragment and recombine forms, not for the purpose of arriving at a fuller, more objective re-creation of the object, but rather to bring together forms remembered with those recently observed.

By combining negatives, Sheeler was able to weld together disparate images and experiences linked in his mind. In *Composition Around White*, based on a New England barn complex, there are evocations of Shaker structures, of the surprisingly concrete shadows that fell across the façades of Bucks County barns, of the heroic ruins at Amoskeag and Ballardvale, and even of the tiny, charming houses Sheeler painted in the teens. Sheeler's own explanation of the key ingredient in those earlier works unravels the mystery here: "Shadows were considered to be concrete forms as essential to the structure of the pic-

ture as the solids appearing in it, rather than being projections from the solids denoting the absence of light."[47]

The best of Sheeler's work, early and late, is about the conflation of shadow and substance, of the remembered and the freshly seen, and how a new vision triggers treasured memories. Sheeler's paintings, with their photographic underpinnings to reflect "nature seen from the eyes outward," comprise nothing less than a fifty-year exploration of his understanding of reality. At the same time, they are a nostalgic attempt to bring the past forward into the present. That such an intellectually ambitious program could be visually satisfying in so many different media is a tribute to the romantic soul behind the disciplined hand that crafted them.

NOTES

I

The Philadelphia Years, 1900–1919

1. See Frederick S. Wight, *Charles Sheeler: A Retrospective Exhibition* (Art Galleries, University of California, Los Angeles, 1954), p. 11.

2. See Ben Wolf, *Morton Livingston Schamberg* (Philadelphia, 1963), pp. 17-20.

3. See the catalogue of the "Exhibition of Paintings and Drawings" at the Montross Gallery, New York (1914), in which the illustration of Schamberg's work accompanies the listing of Sheeler's paintings in the show, and vice versa.

4. One of Schamberg's paintings, a landscape, was sold from the Armory Show, and John Quinn bought his *Canephoros* (Coll. Mr. and Mrs. Malcolm Eisenberg, Philadelphia) that same year. No significant sale has been recorded for Sheeler before 1915.

5. See Sheeler to Stieglitz, December 5, n.d. (probably 1916), Stieglitz Archive, Beinecke Library, Yale University, New Haven, Conn.

6. *Landscape* (c. 1912; Corcoran Gallery of Art, Washington, D.C.), long attributed to Sheeler, more likely was done by Schamberg. It was one of four examples that Schamberg photographed for reproduction as postcards, which he sent to Walter Pach (illustrated in Wolf, *Schamberg*, p. 78). The somewhat acid, green-gold palette is closer to Schamberg's work of the period; Sheeler characteristically used blues, lavenders, and rose tones at this time. Moreover, the technique of letting the warm brown of the panel show through and the lush ribbons of paint are typical of Schamberg's deft handling of the medium; Sheeler's earliest efforts are somewhat more labored.

7. Sheeler to Stieglitz, n.d. [October 15, 1918], Stieglitz Archive.

8. See L. W. Miller, "The Philadelphia School of Industrial Art," *The Art Amateur* 16 (April 1887): 114-15.

9. See Twenty-fifth Annual Report, Pennsylvania Museum of Art (1901), pp. 18-19.

10. He nonetheless would later speak disparagingly of the school: he compared the building – by Frank Furness, one of Philadelphia's greatest architects – to the elephant house at the zoo and decried the school's poor record of achievement, noting that of the approximately 250 students attending when he was there, "there were only two people that came through that you ever heard of again – Demuth and Sheeler" (interview by Bartlett Cowdrey, December 9, 1958, pp. 3-5, Archives of American Art, Smithsonian Institution, Washington, D.C.).

11. The story of Sheeler's only encounter with Eakins, and his reaction, are recounted in Constance Rourke, *Charles Sheeler, Artist in the American Tradition* (New York, 1938), pp. 14-15. He never revised his opinion. In his 1958 interview with Cowdrey, he referred again to the story, then observed, "And I still don't like him any better than before I knew him" (p. 5).

12. See Rourke, *Sheeler*, p. 6.

13. See G. McC. [Garnett McCoy], "Charles Sheeler: Some Early Documents and a Reminiscence," *Journal of the Archives of American Art* 5 (April 1965): 1.

14. For an extensive list of the exhibitions in Paris while Sheeler was there, see John House and Mary Anne Stevens, *Post-Impressionism: Cross-Currents in European Painting* (Royal Academy of Arts, London, 1979), pp. 294-95, and the sections at the back of the *Burlington Magazine* for 1908 and 1909, "Exhibitions Open During December," etc.

15. "They were strange pictures which no amount of description, of which I had considerable in advance, could prepare me for the shock of coming upon them for the first time. . . . But this much was evident in spite of the bewilderment, that something profound was in the making" (Sheeler Papers, Archives of American Art, Smithsonian Institution, Washington, D.C., NShl:62-64).

16. Macbeth and Sheeler, in McCoy, "Some Early Documents," p. 2.

17. See Sheeler to Robert Henri [May 1913]: "I have just returned from a visit to Dr. Barnes's Collection and I am still reeling!! . . . I had no idea that such a treasure house was so near at hand" (Sheeler correspondence, Beinecke Library, Yale University, New Haven, Conn.).

18. See Joseph J. Rishel, "Cézanne and Collecting in Philadelphia," in *Cézanne in Philadelphia Collections* (Philadelphia Museum of Art, 1983), p. x.

19. Schamberg, *Philadelphia Inquirer*, January 19, 1913, in Wolf, *Schamberg*, p. 27.

20. Sheeler, in Bartlett Hayes, Jr., "Reminiscence," in Martin Friedman et al., *Charles Sheeler* (National Collection of Fine Arts, Smithsonian Institution, Washington, D.C., 1968), p. 68.

21. Sheeler Papers, NShl: 60-61. Chase had no use for Cézanne and thought he was a mediocre painter. He is reported to have warned a friend, "Sell the stuff now while you can get some money for it. You won't if you wait too long" (in Ronald Pisano, *The Students of William Merritt Chase* [Heckscher Museum, Huntington, N.Y., 1973], p. 26.

22. Cézanne, in House and Stevens, *Post-Impressionism*, p. 55.

23. In her catalogue raisonné of Sheeler's works (*The Stylistic Development of the Work of Charles Sheeler* [Ph.D. diss., State University of Iowa, 1963]), Lillian Dochterman lists thirteen paintings from this period. John Driscoll ("Charles Sheeler's Early Work: Five Rediscovered Paintings," *Art Bulletin* 62 [March 1980]: 124-33) has discovered additional works; still others, as yet unlocated, are recorded in Sheeler's photographs of the period, particularly his photographs of his Chestnut Street studio.

24. Sheeler originally submitted five paintings to the Armory Show's Domestic Committee, which was charged with choosing among works offered by artists who had not previously been asked to participate. Because Sheeler had been invited, however, he was not required to submit his works to the jury; a penciled note in the committee's record book indicates "taken care of by Kuhn." Six paintings by Sheeler are listed in the catalogue: *Red Tulips* (1912; Regis Collection, Minneapolis); *Landscape* (cat. no. 4); *The Water Fall* (1911; Raymond L. Balasny, New York); *The Mandarin* (Munson-Williams-Proctor Institute, Utica, N.Y.); *Dahlias and Asters* (cat. no. 2); and *Chrysanthemums* (1912; Whitney Museum of American Art, New York). See Milton Brown, *The Story of the Armory Show* (Greenwich, Conn., 1963), pp. 67, 290. There is evidence that Sheeler may have had at least one other painting on view at the Armory Show. Inscribed in Sheeler's hand on the stretcher of *Still Life–Spanish Shawl* (fig. 6) is: "this picture was in the Armory Show/1913/Charles Sheeler."

25. "We had never thought a picture [Matisse, *The Red Studio*, 1911; Museum of Modern Art, New York] could look like that – but there it was to prove it. Pictures like this offered further evidence that a picture could be as arbitrarily conceived as an artist wished" (Sheeler Papers, NShl:74).

26. Ibid., 74-75.

27. *The Forum Exhibition of Modern American Painters* (Anderson Galleries, New York, 1916), n.p.

28. See Judith Zilczer, "The World's New Art Center: Modern Art Exhibitions in New York City, 1913-1918," *Archives of American Art Journal* 14, no. 3 (1974): 5.

29. Sheeler applied for positions at the University of Michigan and the Rhode Island School of Design, among other schools, but was unsuccessful – although the Michigan interview resulted in his first recorded sale. See Sheeler to John Trask, managing director of the Pennsylvania Academy, December 29, 1911, Archives, Pennsylvania Academy of the Fine Arts, Philadelphia.

30. See Carolyn Diskant, "Modernism at the Pennsylvania Academy, 1910-1940," in *In This Academy* (Pennsylvania Academy of the Fine Arts, Philadelphia, 1976), p. 206.

31. Sheeler, interview by Martin Friedman, June 18, 1959, pt. 2, p. 31, Archives of American Art, Smithsonian Institution, Washington, D.C.

32. *Bucks County House* took first prize, *Bucks County Barn* took fourth.

33. Stieglitz's control over the Wanamaker proceedings was the cause of some resentment to several critics and photographers. See W. G. Fitz, "A Few Thoughts on the Wanamaker Exhibition," *The Camera* 22 (April 1918): 201-7.

34. For a discussion of Sheeler, Mercer, and the Doylestown house, see Karen Davies's excellent article, "Charles Sheeler in Doylestown and the Image of Rural Architecture," *Arts Magazine* 59 (March 1985): 135-39.

35. Sheeler, interview by Friedman, pt. 2, p. 4.

II

The Twenties: Sheeler and the Avant-Garde

1. Lee Simonson, *Part of a Lifetime: Drawings and Designs, 1919-1940* (New York, 1943), p. 21.

2. For a discussion of modern art in Philadelphia in the early twentieth century, see Darrel Sewell's introduction to *Philadelphia: Three Centuries of Art* (Philadelphia Museum of Art, 1976), pp. xx-xxii, and Joseph J. Rishel, "Cézanne and Collecting in Philadelphia," in *Cézanne in Philadelphia Collections* (Philadelphia Museum of Art, 1983), pp. x-xiv. The impact of the 1916 show in particular was felt all the way up to Boston. The arts reporter for the *Boston Evening Transcript* contrasted the dreary Pennsylvania

Academy annuals containing "a thousand paintings, each a little different, and each like some neighbor" with the more exhilarating show at the McClees Gallery, "thirty canvases, and two sculptures. All of them very different, some even indifferent, but most of them arresting, troubling, inspiriting, or nauseating" (Kenneth Macgowan, "Philadelphia's Exhibit of 'What is it?'" *Boston Evening Transcript*, May 27, 1916, pt. 3, p. 6).

3. Sheeler Papers, Archives of American Art, Smithsonian Institution, Washington, D.C., NSh1:83.

4. "Current Shows in New York Galleries," *American Art News* 20 (April 1, 1922): 6.

5. See Sheeler to Stieglitz, June 5, 1922, Stieglitz Archive, Beinecke Library, Yale University, New Haven, Conn.

6. The debate came to a climax with the publication, in 1924, of Edmund Wilson's acerbic article "An Imaginary Conversation: Mr. Paul Rosenfeld and Mr. Matthew Josephson," *The New Republic*, April 9, 1924, pp. 179-82.

7. See Robert Parker, "The Art of the Camera: An Experimental 'Movie,'" *Arts and Decoration* 15 (October 1921): 369, 414; and Scott Hammen, "Sheeler and Strand's *Manahatta*: A Neglected Masterpiece," *Afterimage* 41 (January 1979): 6-7.

8. Williams and Sheeler, who were to become lifelong friends, probably first met at the Arensbergs' but didn't become well acquainted until several years later. Matthew Josephson, in *Life Among the Surrealists* (New York, 1962, pp. 253-54) takes credit for bringing the poet and painter together, at "a Dutch-Treat dinner in a speak-easy" sometime between 1920 and 1922; however, Williams in his autobiography (New York, 1951, p. 322) recalls first meeting Sheeler when "he was making a living by photography and living in an apartment on 8th Street," which would be 1923 or later.

9. Sheeler, interview by Bartlett Cowdrey, December 9, 1958, p. 10, Archives of American Art, Smithsonian Institution, Washington, D.C.

10. Sheeler to Walter Arensberg, August 7, 1939, Arensberg Archives: Charles Sheeler Papers, Philadelphia Museum of Art, Twentieth Century Department.

11. See Sheeler to Walter Arensberg, August 28 [no year]; written from 2130 North Gratz Street, Philadelphia; and Sheeler to Arensberg, March 7, 1930, Arensberg Archives. See also Francis Naumann, "Walter Conrad Arensberg: Poet, Patron, and Participant in the New York Avant-Garde, 1915-1920," *Philadelphia Museum of Art Bulletin* 76 (Spring 1980): 28.

12. Josephson, *Life Among the Surrealists*, p. 251.

13. See Dickran Tashjian, *Skyscraper Primitives: Dada and the American Avant-Garde, 1910-1925* (Middletown, Conn., 1975), pp. 79-80.

14. See Alan Burroughs, "Review of 'Some French Moderns Say McBride,'" *The Arts* 3 (January 1923): 71-72.

15. Tashjian, *Skyscraper Primitives*, p. 142.

16. Sheeler Papers, NSh1: 78; interview by Martin Friedman, June 18, 1959, pt. 2, p. 14, Archives of American Art, Smithsonian Institution, Washington, D.C.

17. Sheeler Papers, NSh1:72-79. Duchamp's response to Sheeler's work was much more laconic, but tremendously gratifying to the American painter. (Though four years

older than Duchamp, Sheeler clearly regarded him as a mentor.) Upon seeing Sheeler's drawing *Self-Portrait* (cat. no. 25), Duchamp, according to Sheeler, commented only, "I like it" (interview by Friedman, pt. 2, p. 9). It was Duchamp who photographed Sheeler for a feature article in *Vanity Fair*, "Among the Best of American Painters" (March 1923, p. 52). Their relationship developed over the next two decades, despite Duchamp's infrequent visits to the United States after 1923. Sheeler wrote to Louise Arensberg in 1933 of his initial intimidation, and increasing friendship, with Duchamp: "I very much enjoyed seeing him again after seven years. Something of a more intimate nature seems to develop between us with the years and I am glad that it is so. It hasn't been one of those friendships that bursts into bloom over night. Perhaps I was too awestruck in the early years and too readily accepted the prevailing belief that any Franco-American alliance must be on different terms from any other alliance" (November 10, 1933, Arensberg Archives).

18. Sheeler, interview by Friedman, pt. 2, p. 9.

19. See Susan Fillin Yeh, "Charles Sheeler's 1923 'Self-Portrait,'" *Arts Magazine* 52 (January 1978): 106-9.

20. For Duchamp's influence on American artists, see John Tancock, "The Influence of Marcel Duchamp," in *Marcel Duchamp*, ed. Anne d'Harnoncourt and Kynaston McShine (Museum of Modern Art, New York, and Philadelphia Museum of Art, 1973), pp. 159-78.

21. Duchamp, "A Complete Reversal of Art Opinions by Marcel Duchamp, Iconoclast," *Art and Decoration* 5 (September 1915): 428.

22. Sheeler Papers, NSh1:85-86.

23. See Josephson, *Life Among the Surrealists*, p. 51.

24. See Sheeler, interview by Friedman, pt. 2, p. 9.

25. Sheeler, interview by Cowdrey, p. 46.

26. A further indication of Sheeler's artistic reticence in this period is the scale on which he worked. The largest picture he produced between 1919 and 1922 was *Pertaining to Yachts and Yachting* (cat. no. 22) at 20 by 24 inches, while Duchamp and Picabia routinely painted canvases twice that size.

27. See City of New York, Office of the City Clerk, Certificate of Marriage Registration. Their marriage frequently has been published – erroneously – as taking place in 1923. I thank Olive Bragazzi for this information. I am also indebted to Karen Lucic for information about Katharine Sheeler.

28. Financial circumstances required Force to sell off most of her Shaker furnishings at the end of the 1930s. Many of the best pieces went to Mrs. John D. Rockefeller, Jr., in a private transaction arranged by Edith Halpert; the rest were dispersed at an auction at Force's South Salem house, Shaker Hollow, in May 1937, in a sale conducted by the era's expert on Shaker artifacts, Edward Deming Andrews. Ironically, it was also Mrs. Rockefeller who provided some of the funds to enable Hancock Shaker Village to acquire Sheeler's collection in the 1960s.

29. *The Arts* was founded by Hamilton Easter Field, but after his death was taken over by Forbes Watson, whose long-term romantic relationship with Force, and the subsidies provided by Gertrude Vanderbilt Whitney, made it very nearly a house organ.

30. See "Charles Sheeler," *New York Times*, Sunday, April 9, 1922.

31. "The Exhibitions," *The Arts* 3 (June 1923): 428.

32. O'Keeffe, "Can a Photograph Have the Significance of Art?" *MSS.* 4 (December 1922): 17.

33. Sheeler, "Recent Photographs by Alfred Stieglitz," *The Arts* 3 (May 1923): 345.

34. See Strand, "Letter to the Editor," *New York Sun and Globe*, June 23, 1923, p. 20.

35. Sheeler Papers, NSh1:93.

36. See Sheeler's comments on Homer, Eakins, and Ryder in Constance Rourke, *Charles Sheeler, Artist in the American Tradition* (New York, 1938), pp. 184-86.

37. Sheeler, "Notes on an Exhibition of Greek Art," *The Arts* 7 (March 1925): 153.

38. Forbes Watson, "Paintings by Seven Americans Return from Paris Invasion," *New York World*, January 27, 1924. Avis Berman generously provided me with this clipping.

39. Wolfgang Born, *American Landscape Painting* (New Haven, Conn., 1948), p. 214.

40. Watson, "Charles Sheeler," *The Arts* 3 (May 1923): 338, 341.

41. Sheeler, in Frederick S. Wight, *Charles Sheeler: A Retrospective Exhibition* (Art Galleries, University of California, Los Angeles, 1954), p. 23.

42. Sheeler Papers, NSh1: 110; Ralph Waldo Emerson, *Nature*, part 1 (1836) *The Complete Works of Ralph Waldo Emerson*, ed. Edward Waldo Emerson (Boston, 1903-1904), 1:10: "Standing on the bare ground . . . all mean egotism vanishes. I become a transparent eyeball; I am nothing; I see all; the currents of the Universal Being circulate through me; I am part and parcel of God."

43. One of the earliest and most frequently quoted expressions of doubt about the value of art to American society is John Adams's question, "Are we not in too great a hurry in our zeal for the fine arts?" See Neil Harris, *The Artist in American Society: The Formative Years, 1790-1850* (New York, 1966), p. 33.

44. See Emerson, "Art" (1841), *Emerson's Essays*, ed. Irwin Edman (New York, 1951), p. 248.

45. In a manuscript of an essay on still life intended for a 1925 issue of *The Arts* but never published, Sheeler praised the formal properties of the works of Cézanne and Chardin (an exhibition of whose work he enthusiastically recommended to Walter Arensberg; see Sheeler to Arensberg, January 10, 1927, Arensberg Archives), while acknowledging as well their emotional core. See Forbes Watson Papers, Archives of American Art, Smithsonian Institution, Washington, D.C., D56:1092-94.

46. Dudley Poore, "Current Exhibitions," *The Arts* 7 (February 1925): 115.

47. *Minneapolis Daily Star*, n.d., Archives, Whitney Museum of American Art, New York. I thank Bernard Heineman, Jr., for sending me this clipping.

48. Sheeler, in Thomas Craven, "Charles Sheeler," *Shadowland* 8 (March 1923): 71.

49. Williams, *Autobiography*, p. 322.

III

The Thirties: The Rouge and the Interiors

1. J. A. Spender, *Through English Eyes* (New York, 1928), p. 19.

2. See David A. Hounshell, *From the American System to Mass Production, 1800-1932* (Baltimore, 1984), pp. 274-79.

3. See Richard Guy Wilson, Dianne H. Pilgrim, and Dickran Tashjian, *The Machine Age in America, 1918-1941* (Brooklyn Museum, 1986), p. 185.

4. See Allan Nevins and Frank Ernest Hill, *Ford: Expansion and Challenge, 1915-1933* (New York, 1957), pp. 201, 293. See also Mary Jane Jacob and Linda Downs, *The Rouge: The Image of Industry in the Art of Charles Sheeler and Diego Rivera* (Detroit Institute of Arts, 1978), p. 7.

5. Spender, *Through English Eyes*, p. 23.

6. Not mid-November, as occasionally cited. See Sheeler to Walter Arensberg, October 25, 1927, Arensberg Archives: Sheeler Papers, Philadelphia Museum of Art, Twentieth Century Department.

7. See Susan Fillin Yeh, *Charles Sheeler and the Machine Age* (Ph.D. diss., City University of New York, 1981), pp. 138, 153, and plate 51.

8. See Jacob and Downs, *The Rouge*, p. 11.

9. There is little documentation of Sheeler's admiration for Ford's personality, and even for industry as such; rather, he was captivated by the car-maker's grand vision: "One doesn't believe it possible that one man could be capable of realizing such a conception" (Sheeler to Walter Arensberg, October 25, 1927, Arensberg Archives).

10. See Jacob and Downs, *The Rouge*, pp. 11-12.

11. Winslow Ames, "A Portrait of American Industry," *Worcester Art Museum Annual* 2 (1936-37): 97.

12. "In a period such as ours, when only a few isolated individuals give evidence of a religious content, some form other than that of the Gothic Cathedral must be found for our authentic expression. Since industry predominantly concerns the greatest numbers, finding an expression for it concerns the artist" (Sheeler Papers, Archives of American Art, Smithsonian Institution, Washington, D.C., NSh1:107).

13. See *Ford News* 9, no. 4 (1929), cover; Matthew Josephson, "Henry Ford," *Broom* 5 (October 1923): p. 139; Calvin Coolidge, in *William E. Leuchtenberg, The Perils of Prosperity, 1914 to 1932* (Chicago, 1958), p. 188; Spender, *Through English Eyes*, p. 21.

14. "The language of art is always dominant in these Ford photographs. The fine drawing, the athletic tenseness of line, the plastic sequences, the exquisite textures, the intricate rhythms, are as sure, as conscious, as the best modern painting. . . . The elements of pictorial interest are the same as those in painting" (Samuel M. Kootz, "Ford Plant Photos of Charles Sheeler," *Creative Art* 8 [April 1931]: 265).

15. Sheeler, interview by Bartlett Cowdrey, December 9, 1958, p. 46, Archives of American Art, Smithsonian Institution, Washington, D. C.

16. Sheeler to Walter Arensberg, January 11, 1928,

Arensberg Archives. In a later letter (December 10, 1928), he said, "I continue in my dual role of photographing much, and painting now and then" (Arensberg Archives).

17. See Yeh, "Charles Sheeler: Industry, Fashion, and the Vanguard," *Arts Magazine* 54 (February 1980): 155.

18. "Largest Ship Nears Completion Abroad," *New York Times*, August 22, 1921, p. 6. See also Yeh, *Sheeler and the Machine Age*, pp. 180-81.

19. Sheeler, interview by Martin Friedman, June 18, 1959, pt. 1, p. 2, Archives of American Art, Smithsonian Institution, Washington, D. C.

20. Sheeler, "A Brief Note on the Exhibition," *Charles Sheeler – Paintings, Drawings, Photographs* (Museum of Modern Art, New York, 1939), p. 10.

21. Kootz, "Ford Plant Photos," p. 265

22. Sheeler, in Rourke, *Charles Sheeler, Artist in the American Tradition* (New York, 1938), p. 145.

23. See ibid., p. 143. See also Sheeler Papers, NSh1:107.

24. For a discussion of the different, and very much more conventional, compositional styles of Sheeler's contemporaries who painted industrial subjects, see Yeh, "Industry, Fashion, and the Vanguard."

25. The absence of figures in Sheeler's Rouge paintings and photographs reflects relatively accurately what he observed there, since most of his scenes were set outdoors, while most of the actual labor, including the famous assembly line, occurred inside the buildings. Nonetheless, Sheeler's ascetic vision was paralleled by other sanguine views of the role of the worker at the Rouge. J. A. Spender (*Through English Eyes*, pp. 26-28) noted: "Indeed, the team-work was so perfect. . . . [The assembly line] looks uncommonly like turning men into machines, yet these men looked uncommonly happy and alive. . . . There is a certain exhilaration in working together for an intelligent purpose which all can realize." Later observers have disagreed. Allan Nevins and Frank Ernest Hill (*Ford*, pp. 295-97), for example, argue that although the plant was safe, clean, and efficient, and although the machines relieved the worker of heavy manual labor, morale had deteriorated by the late 1920s. They cite, among other causes, the overwhelming size of the plant, the anxiety produced by the assembly line pace, and the workers' physical isolation. Sheeler's vision was, as always, selective.

26. Frederick Lewis Allen, *Only Yesterday: An Informal History of the Nineteen-Twenties* (New York, 1931), p. 228.

27. For a further analysis of the motivations for collecting American antiques in the 1920s, see Barbara Clark Smith's preface to *After the Revolution: The Smithsonian History of Everyday Life in the Eighteenth Century* (New York, 1985), esp. pp. x-xii. I thank John T. Kirk for directing me to this fascinating essay.

28. See Beatrix T. Rumford, "Uncommon Art of the Common People: A Review of Trends in the Collecting and Exhibiting of American Folk Art," *Perspectives on American Folk Art* (New York, 1980), pp. 14-15.

29. Harvard's show, which was organized in connection with the Massachusetts Bay Colony tercentenary celebration, maintained that these objects "created one hundred or two hundred years ago have the most valid and direct links with contemporary art." The exhibition brochure lists "Mourning Pictures," "Ship Pictures," "Models in Water

Colour for Tattoos," and so on. In contrast, the Museum of Fine Arts, Boston, presented at the same time "A Loan Exhibition of One Hundred Colonial Paintings," emphasizing the work of Copley, Blackburn, and Gilbert Stuart.

30. At his death, Sheeler owned eleven folk paintings, including three on glass, one on velvet, and a "Pennsylvania Tinsel Picture," which Edith Halpert appraised at a total of $1265. At least one of these pictures, the *Temple of Egina*, had been included in the Whitney Studio Club's 1924 show (Downtown Gallery Papers, Archives of American Art, Smithsonian Institution, Washington, D.C.).

31. Sheeler, in Rourke, *Sheeler*, p. 136.

32. Such chairs were relatively inexpensive but nonetheless were considered the fanciest American ladderback chairs and were highly collectible. In fact, this form was not made in America, but was imported in quantity from England through the early twentieth century. See John T. Kirk, *American Furniture and the British Tradition to 1830* (New York, 1982), fig. 764.

33. Sheeler Papers, NSh1:114.

34. See my "After Stieglitz: Edith Gregor Halpert and the Taste for Modern Art in America," in *The Lane Collection: 20th-Century Paintings in the American Tradition* (Museum of Fine Arts, Boston, 1983), p. 43. The connection between Shaker crafts and Sheeler's interest in designing objects for domestic use was suggested by Mary Jane Jacob in "The Impact of Shaker Design on the Work of Charles Sheeler" (Master's thesis, University of Michigan, 1976), p. 29. I am indebted to Jacob for sharing this excellent study with me. See also Susan Fillin-Yeh, *Charles Sheeler: American Interiors* (Yale University Art Gallery, New Haven, Conn., 1987).

35. An early expression of this point of view is found in Adolf Loos, *Ornament and Crime* (1908): "Cultural evolution is equivalent to the removal of ornament from articles in daily use. . . . If I pay as much for a smooth box as a decorated one, the difference in labor time belongs to the worker" (cited in Janet Malcolm, "The Modern Spirit in Shaker Design," *Shaker* [Renwick Gallery, National Collection of Fine Arts, Smithsonian Institution, Washington, D.C., 1973], p. 20).

36. Sheeler's collection of early American furnishings is now dispersed. His Pennsylvania German dower chest, made in 1781 by the Lebanon County artisan Christian Seltzer, is now in the Museum of Art, Pennsylvania State University (see cat. no. 3, fig. a). Other pieces of Sheeler's furniture are now owned by Mr. and Mrs. Andrew Dintenfass of Philadelphia and other private collectors (see Yeh, *Sheeler: American Interiors*). Some of his glass collection is at the Addison Gallery of American Art, Phillips Academy, Andover, Mass.

37. Apparently Sheeler did not visit Hancock Shaker Village and Mount Lebanon Shaker Village until about 1930, although he had begun acquiring Shaker pieces sometime before that, primarily "from a dealer in Ridgefield, Conn." (Sheeler to Mrs. Lawrence K. Miller, June 11, 1962, Archives, Hancock Shaker Village). Between 1932 and 1956, Sheeler painted more than a dozen views of various buildings in the two Shaker communities. The Laundry at Hancock is represented in *Shaker Laundry* (1934; Chrysler Museum, Norfolk, Va.) and related studies; its southwest corner is depicted in *Shaker Detail* (1941; Newark [N.J.]

Museum) and recurs, considerably abstracted, in *On a Shaker Theme* (1956; Museum of Fine Arts, Boston). The Great Stone Barn at Mount Lebanon (which collapsed in 1972 and is now being restored), seen from the south side, inspired *Shaker Barns* (1945; Coll. Mr. and Mrs. Daniel Fraad, Scarsdale) and a preliminary watercolor for the picture. Finally, the Barn and 1939 Two-Barn Complex at Hancock were Sheeler's source for the mistitled *Buildings at Lebanon* (1949; Walker Art Center, Minneapolis) and for *Conversation Piece* (1952; Reynolda House Museum of American Art, Winston-Salem, N.C.) and its tempera study (1952; The Lane Collection). These identifications, which correct earlier erroneous information, were made by Mary Jane Jacob in "The Impact of Shaker Design," pp. 30-38. In addition, Sheeler made many photographs of the buildings at Hancock and Mount Lebanon, among them the Round Barn at Hancock and the Great Stone Barn at New Lebanon, and, the most evocative of these, a small group of photographs of the stairwells and windows of the 1824 Meeting House at New Lebanon, now serving as the library of the Darrow School.

38. Sheeler Papers, NSh1:119-20.

39. Sheeler to Louise Arensberg, August 21, 1933, Arensberg Archives.

40. Henry McBride, *New York Sun*, November 21, 1931, Whitney Museum Papers, Archives of American Art, Smithsonian Institution, Washington, D. C., NWh1:184.

41. Sheeler, in *Art News* 45 (March 1946): 30.

42. Sheeler had long been aware of Seurat's conté crayon drawings – several were on view at the Galeries Bernheim, Paris, while he was there in 1908-9; his friend Marius de Zayas owned two (which he sold with the rest of his collection in October 1923); and individual examples occasionally were reproduced in *The Arts* (e.g., as the frontispiece of the August 1923 issue) – but it seems unlikely that the French master's soft and smoky images influenced Sheeler's more precise style.

43. See Sheeler Papers, NSh1:111.

44. Sheeler recounted his enthusiasm for his trip in a letter to Walter Arensberg: "This is to inform you that we are back again in these United States. The trip was interesting but far too short. It would have been fine to have made a year of it. Germany is the land of our adoption. It feels good to be there – ." His itinerary included Stuttgart, Munich, Nurnberg, Berlin, Hamburg, Bremen, Rothenburg and Innsbruck, as well as France, where his visit to Chartres was "the outstanding experience" and where he "climb[ed] all over the exterior of the Cathedral with a camera" (August 14, 1929, Arensberg Archives).

45. The exhibition in Buffalo ("Modern Photography at Home and Abroad") included works by Paul Outerbridge, Man Ray, Bernice Abbott, Margaret Bourke-White, and ten Sheelers, ranging from a few photographs of the Doylestown house to his most recent pictures from Chartres and Nurnberg. Levy's show, "A Retrospective Exhibition of American Photography," while including some nineteenth-century and pictorialist photography, emphasized a group of modern masters, including Stieglitz, Steichen, Strand, Weston, and Sheeler.

46. Katherine Grant Sterne, "The Camera: Five Exhibitions of Photography," *New York Times*, December 6, 1931, sec. 9, p. 18.

47. Edward Alden Jewell, "Sheeler in Retrospect," *New York Times*, October 8, 1939, sec. 9, p. 9.

48. Sheeler's withdrawal from his commercial photographic practice can be gauged by the work he produced for *Vanity Fair*, Condé Nast's most popular magazine. Between July 1926 and October 1931 (when his last photograph, a portrait of the actress Helen Menken, appeared) he published close to seventy fashion illustrations and celebrity portraits in the periodical. In 1926, thirty-four of these photographs were published; in 1927, sixteen, and in 1928, eleven. But from 1929 to 1931 he produced only three, and none at all for *Vogue*, to which he also had been a contributor. In the next decade, he exhibited on occasion at the New York Camera Club, participated in the Museum of Modern Art's 1937 exhibition "Photography 1837-1937," and included photographs ranging in date from 1914 to 1939 in his 1939 retrospective at the Museum of Modern Art, but he never again had a solo exhibition as a photographer, and never showed a photograph at the Downtown Gallery. Edith Halpert's determination that Sheeler's photography not dominate his painting career is indicated by her rejection, on his behalf, of a commission from Edsel Ford to make a photographic mural for the Ford Building at the Century of Progress Exhibition held in Chicago in 1934: "While Mr. Sheeler has – as you know – a large series of photographs made at your order showing various aspects of the Ford Plant, he is so completely engrossed in painting these days he does not wish to continue his photographic work" (Halpert to Ford, March 7, 1934, Downtown Gallery Papers).

IV

The Forties: Art and Industry

1. At Sheeler's first Downtown Gallery show, in 1931, Halpert priced the major oils (*Upper Deck, Classic Landscape, Home Sweet Home,* and *Americana*) between $2200 and $2500. In contrast, just five years earlier, Charles Daniel sold *Skyscrapers* to Duncan Phillips for a mere $400.

2. *New York Sun*, November 8, 1934, Downtown Gallery Papers, Archives of American Art, Smithsonian Institution, Washington, D.C., ND11: 168. Other reviews preserved at the archives suggest that Sheeler was the universal favorite of the show, eliciting praise from Carlyle Burrows of the *New York Herald Tribune* (November 11, 1934) and Margaret Breuning of the *New York Post* (November 10, 1934), among others.

3. "Exhibitions in New York: Charles Sheeler," *Art News* 30 (November 21, 1931): 8. See also Henry McBride, "Paintings by Charles Sheeler: Landscapes and Still Life That Are Unquestionably of the Machine Age," *New York Sun*, November 21, 1931: "It is seldom that an artist succeeds with two different media and employs each of them to fortify the other. Charles Sheeler is such an exception. He is one of the best of our modern photographers and one of the outstanding painters of America."

4. See Edith Halpert to Lord Duveen, March 7, 1934, Downtown Gallery Papers. I am grateful to Diane Tepfer for this information.

5. Rockefeller gave special commissions to many artists in those years, among them Stefan Hirsch, Yasuo Kuniyoshi, Duncan Ferguson, Marguerite Zorach (who created an enormous portrait in embroidery of the Rockefeller family), and Ben Shahn (who painted portraits of the Rockefeller horses). See Dorothy C. Miller, "Contemporary American Paintings in the Collection of Mrs. John D. Rockefeller, Jr.," *Art News: The 1938 Annual* 36 (March 26, 1938): 184.

6. See Sheeler, interview by Bartlett Cowdrey, December 9, 1958, p. 50, Archives of American Art, Smithsonian Institution, Washington, D.C. A letter from her secretary states, "Mrs. Rockefeller has asked me to give you the name of Mr. Charles Sheeler of Ridgefield, Connecticut, as a man who does very unusually good photography. She recalls that you have recently had a set of pictures taken of Williamsburg, but if you should contemplate further work and of a superior quality, Mr. Sheeler would be the man to do it" (Anna L. Kelly to Kenneth Chorley, June 11, 1935, Archives, Colonial Williamsburg, Va.).

7. The restoration of Colonial Williamsburg was first proposed to John D. Rockefeller, Jr., by the Reverend William Archer Rutherfoord Goodwin of Williamsburg in 1926. Work began in 1928 under the motto, "That the future may learn from the past." Refurbishing of the Governor's Palace, Raleigh Tavern, the Capitol building, and Bruton Church, the major centers of early life in the town, were completed and dedicated early in 1934. Colonial Williamsburg opened to the public in April of that year. By 1936, sixty-seven structures had been repaired and ninety-one colonial buildings reconstructed. By the time work was stopped by the United States's entry into World War II, $20 million had been spent on the renovation, and more than two hundred thousand tourists a year were visiting the town. See Parke Rouse, Jr., *The City That Turned Back Time* (Williamsburg, Va., 1952), n.p., and *A Guidebook for Williamsburg, Virginia* (Williamsburg, Va., 1936), pp. 22-23.

8. See Sheeler to Edith Halpert, November 11, 1935, Downtown Gallery Papers.

9. Sheeler, interview by Cowdrey, p. 51; Sheeler to Walter Arensberg, January 27, 1936, Arensberg Archives: Sheeler Papers, Philadelphia Museum of Art, Twentieth Century Department.

10. Constance Rourke, *Charles Sheeler, Artist in the American Tradition* (New York, 1938), p. 174; John I. H. Baur, "A 'Classical' Modern," *Brooklyn Museum Quarterly* 26 (January 1939): 24.

11. On January 22, 1935, Sheeler wrote to Halpert: "You are the center of my life and I live for the primary purpose of offering as a tribute to you all that I hope to do." A year later [April 30, n.d., but undoubtedly 1936], his tone is more despairing: "I don't believe your program of negation of me has permitted you to know how very deeply I feel about painting. If it were only making a living I have already proved I could do better in another field. Is it any wonder that feeling this way *Bassett Hall* looks like the end of the road for me?" (Downtown Gallery Papers). Halpert handled the situation with extraordinary sensitivity. Sheeler returned from Williamsburg dissuaded from his suit but with his pride intact and his loyalty to Halpert and the Downtown Gallery unshaken.

12. Some of Lincoln's photographs are reproduced in his article "Photographing Williamsburg," *U.S. Camera* (January 1939): 37-40.

13. B. W. Norton (Director of Public Relations, Colonial Williamsburg) to Sheeler, October 7, 1936, and August 8, 1938; and Sheeler to Norton, August 16, 1939, Archives, Colonial Williamsburg.

14. See Robert T. Elson, *The World of Time Inc.: The Intimate History of a Publishing Enterprise*, vol. 1 (1923-41) (New York, 1968), pp. 130-35, 150, 220.

15. Sheeler eventually would have ten of his works reproduced in *Fortune*. In addition to *Silo*, the six paintings illustrating the theme "Power" (see below) appeared in the December 1940 issue; his photograph of a blast furnace and dust catcher from the River Rouge series would appear in December 1941, accompanying an article entitled "Modern Art, Modern Living." *Incantation* (cat. no. 67) and *Against the Sky a Web Was Spun* (1948; current location unknown) were reproduced in the November 1946 and August 1948 issues, respectively.

16. Alexis de Tocqueville, *Democracy in America* (1830), ed. J. P. Mayer, trans. George Laurence (Garden City, N.Y., 1969), p. 465.

17. See Sheeler to William Carlos Williams, July 12, n.d., and December 8, n.d. (probably 1938), Sheeler Papers, Archives of American Art, Smithsonian Institution, Washington, D.C., NY59-5:725-26 and 737-38.

18. See Sheeler to Arensberg, August 7, 1939, Arensberg Archives.

19. "This *Fortune* job combined with work to be done for my show crowds me so much that I am virtually a prisoner. I have just returned from several days spent in the coal regions of Pennsylvania, Scranton, Wilkes Barre, Hazelton and Mauch Chunk, persuing [sic] a monster shovel which strips the earth off the coal. It gives one a good idea of what those tall prehistoric monsters were like which could feed on the leaves from the tops of trees. With the difference that this monster has a Diesel engine for a heart and prefers crude oil for its diet" (ibid).

20. See Milton Brown, "Sheeler and Power," *Parnassus* 13 (January 1941): 46.

21. The connection between the "Power" article and America's defensive posture at the outbreak of World War II was first made by Rick Stewart in a highly informative lecture, "So That They May See Again: Charles Sheeler, *Fortune*, and the Aesthetic of Power," delivered at the Henry Luce Foundation Symposium in New York City, April 4-5, 1986.

22. "Power: A Portfolio by Charles Sheeler," *Fortune* 22 (December 1940): 74, 80, 82.

23. Ibid., p. 73.

24. The Downtown Gallery's press release issued in advance of the debut of the "Power" pictures there in December 1940 claimed that Sheeler was awarded the *Fortune* commission "because he represented in our contemporary art world the spirit of 20th century America, the machine era with its throbbing perfection and controlled vitality, its clarity and simplified complexity" (Downtown Gallery Papers).

25. *The Complete Works of Ralph Waldo Emerson*, ed. Edward Waldo Emerson (Boston, 1903-4), 2:368, in John F. Kasson, *Civilizing the Machine: Technology and Republican Values in America 1776-1900* (New York, 1976), p. 139.

26. Franklin, in Rourke, *The Roots of American Culture and*

Other Essays, ed. Van Wyck Brooks (New York, 1942), p. 3.

27. "Sheeler Paints Power," *Art Digest* 15 (December 1, 1940): 8.

28. Brown, "Sheeler and Power," p. 46.

29. "It rises loftily . . . an athlete of steel and iron with not a superfluous ounce of metal on it; the mighty walking-beams plunge their pistons downward, the enormous fly-wheel revolves with a hoarded power that makes all tremble, the hundred life-like details do their office with unerring intelligence" (William Dean Howells, "A Sennight of the Centennial," *Atlantic Monthly* 38 [1876], rpt. in *Democratic Vistas, 1860-1880*, ed. Alan Trachtenberg [New York, 1970], p. 85).

30. Richard Henry Stoddard, ed., *A Century After: Picturesque Glimpses of Philadelphia and Pennsylvania* (Philadelphia, 1876), p. 348, in Kasson, *Civilizing the Machine*, p. 164.

31. J.L. [Jeanette Lowe], "Sheeler's Symbols of the Machine Age," *Art News* 39 (December 7, 1940): 11.

32. "Power," p. 74.

33. Ibid., pp. 80, 74.

34. He later wrote to Walter Arensberg of his admiration for Boulder Dam – the only site he visited in his "Power" researches that he singles out for special mention: "I am glad that you liked the photograph of Boulder Dam. That is the best I know how to do in photography and I am glad to have it represent my appreciation of that magnificent project" (June 4, 1940, Arensberg Archives).

35. J.L., "Sheeler's Symbols of the Machine Age," p. 11.

36. Sheeler, "A Brief Note on the Exhibition," and Williams, "Introduction," *Charles Sheeler: Paintings, Drawings, Photographs* (Museum of Modern Art, New York, 1939), pp. 10, 8.

37. Clipping of Museum of Modern Art press release, Sheeler Papers, 1811:12.

38. "Modern Museum Enshrines Charles Sheeler," *Art Digest* 14 (October 1939): 5-6.

39. James W. Lane, "Of Sheeler's Immaculatism: The Modern Museum's One-Man Show," *Art News* 38 (October 7, 1939): 10.

40. "Sheeler is doing better work, and we feel he has been helped by Blume. He thought Blume's 'Parade' the high spot of Modern Painting in America." Charles Daniel to Ferdinand Howald, July 18, 1931, Howald Archives, Columbus [Ohio] Museum of Art. However, some years later, looking at a work by Blume with his friend William H. Lane, Sheeler reportedly sniffed, "I could do that" (conversation with William H. Lane, July 1986).

41. Alfred H. Barr, Jr., *American Realists and Magic Realists*, ed. Barr and Dorothy C. Miller (Museum of Modern Art, New York, 1943), p. 5. Lincoln Kirstein, in his introduction to this catalogue, amplifies Barr's definition: "Magic realists try to convince us that extraordinary things are possible simply by painting them as if they existed." He then traces the antecedents of such a style to the bizarre, low country paintings of Massys, Bruegel, and Bosch, noting – as is particularly revealing for Sheeler – the repressed, puritan nature of such art: "There is something peculiarly northern or at least Protestant about this attitude. There is emotion,

but the feeling runs narrow and deep rather than violent or accidental. All looseness is wasteful. Impulsiveness cannot be afforded lest it seem the impatience of an amateur who enlarges his incapacities into a style of dilettante idiosyncracy. It is a puritanical artifice wherein a termite gusto for detail is substituted for exuberance, exquisite or, at the least, painstaking handling for the spontaneous miracles of bold brushwork and edible surfaces" (p. 7).

42. See Rourke, *Sheeler*, pp. 142, 181.

43. See James Sloan Allen, *The Romance of Commerce and Culture* (Chicago, 1983), pp. 24-25, and Russell Lynes, "Whose Business Is Art?" *Art in America* 44 (Spring 1956): 11-13.

44. In a 1983 interview, Sheeler's friend William H. Lane quoted the artist as saying, "That guy haunts me," meaning not that Sheeler found Hopper's images haunting, but rather that Hopper's career, and the interpretation of his images, dogged Sheeler's (interview by Theodore E. Stebbins, Jr., January 15, 1983, transcript, pt. 2, p. 10, Museum of Fine Arts, Boston).

45. Sheeler, in S.P. [Stuart Preston], "5 Stars for February," *Art News* 47 (February 1949): 15.

46. For example, in the years following the war, the Whitney remained faithful to its tradition of supporting figurative artists and gave solo shows to Kuniyoshi, Weber, and Hopper, as well as mounting a large series of monographic exhibitions dedicated to the work of eighteenth- and nineteenth-century masters – Ralph Earl, Robert Feke, William Rimmer, Ralph Blakelock, Albert Ryder, and Thomas Cole.

V

The Late Work: Painting and Photography

1. Bartlett H. Hayes, Jr., to Sheeler, September 11, 1946, The Lane Collection.

2. Sheeler, interview by Bartlett Cowdrey, December 9, 1958, p. 19, Archives of American Art, Smithsonian Institution, Washington, D.C.

3. See Hayes to Charles W. Millard, December 7, 1965, The Lane Collection.

4. Sheeler, in G. McC. [Garnett McCoy], "Charles Sheeler: Some Early Documents and a Reminiscence," *Journal of the Archives of American Art* 5 (April 1965): 4.

5. According to Sheeler, these photographs provided "a reduced image of my subject matter, more informative than any drawing." His purpose was "not to produce a replica of nature but to attain an intensified presentation of its essentials, through greater compactness of its formal design by precision of vision and hand" (Sheeler Papers, Archives of American Art, Smithsonian Institution, Washington, D.C., NShl:113).

6. For a comprehensive discussion of this issue, see Van Deren Coke, *The Painter and the Photograph* (Albuquerque, 1964). While on fishing trips in Quebec, Homer and his brother used a camera to take small photographs, which are close to certain of his watercolors (e.g., *Two Men in a Canoe* [1895; Portland (Maine) Museum of Art] parallels the photograph *Homer in a Canoe* [Bowdoin Col-

lege, Brunswick, Maine]). Eakins used photographs more consistently than Homer did in planning his pictures, and ironically was subjected to the same charge leveled at Sheeler, namely, that his images were imitative, labored, inartistic, and were discredited by the presence of "hard, photographic little figures" (Leslie W. Miller, *American Architect and Building News* [1882]:185).

7. Edward Weston, *The Daybooks of Edward Weston*, ed. Nancy Newhall, vol. 1: Mexico (New York, 1961), p. 7.

8. Coke, *The Painter and the Photographer*, p. 213. See also Charles W. Millard, "The Photography of Charles Sheeler," in Martin Friedman et al., *Charles Sheeler* (National Collection of Fine Arts, Smithsonian Institution, Washington, D.C., 1968), p. 85.

9. See fig. 24.

10. Sheeler, in Thomas Craven, "Charles Sheeler," *Shadowland* 8 (March 1923): 11.

11. In Sheeler's paintings and drawings of the thirties, figures play a minor but critical role. In the industrial pictures, they indicate the gargantuan scale of the machinery around them and are always deliberately peripheral to the subject being addressed, even to the point, in *Industrial Architecture* (cat. no. 39), of showing only a head, in the lower left corner, moving out of the picture's space. By the 1940s, with the exception of *The Artist Looks at Nature*, *Nativity*, and the anomalous *Improvisations* (1945; The Lane Collection), the figure virtually disappears (although not from the photographs); Sheeler's work comes to depict what William Carlos Williams called "depopulated landscape." Sheeler himself explained that the figure dropped out of his work in later years because it didn't fit in with his program of painting "the overtone of one image recently seen . . . combined with the one presently being viewed" (interview by Martin Friedman, June 18, 1959, Archives of American Art, Smithsonian Institution, Washington, D.C).

12. Charles Corwin, *New York Daily Worker*, February 4, 1949, in Friedman et al., *Sheeler*, p. 57.

13. Margaret Bourke-White, *Portrait of Myself* (New York, 1963), p. 49.

14. Charles W. Millard III, "Charles Sheeler: American Photographer," *Contemporary Photographer* 6 (1967): n.p. According to Millard, during this period Sheeler began using his photographs "consciously and extensively for preliminary studies for paintings. He turned out few first-rate creative photographs and none of the impressive series that had previously characterized his photography."

15. Steichen, in Carl Sandburg, *Steichen the Photographer* (New York, 1929), p. 51.

16. See Paul Rosenfeld, "Carl Sandburg and Photography," *The New Republic*, January 22, 1930, p. 252, and Paul Strand, "Steichen and Commercial Art," *The New Republic* February 19, 1930, p. 21.

17. I am grateful to Avis Berman for discussing these ideas with me.

18. "I become increasingly bored with the work I have to do and the fact that I seem to be incapable of making life more enjoyable than it is" (Sheeler to Walter Arensberg, February 6, 1929, Arensberg Archives: Sheeler Papers, Philadelphia Museum of Art, Twentieth Century Department). The February 1949 issue of *Harper's Bazaar* (p.

120) featured a two-page spread of spring sportswear in which the models were posed against large-scale, schematic drawings of barns, with the credit "Backgrounds inspired by Charles Sheeler" (Downtown Gallery Papers, Archives of American Art, Smithsonian Institution, Washington, D.C.).

19. Marius de Zayas, "Photography," *Camera Work* 41 (January 1913): 17. Despite these reservations, de Zayas would later become one of the major supporters of Sheeler's photographic work.

20. Edith Halpert to Musya Sheeler, April 11, 1967, Downtown Gallery Papers.

21. Sheeler Papers, NShl:94.

22. See Sheeler to Walter Arensberg, June 27, 1933, Arensberg Archives.

23. Sheeler, in Millard, "The Photography of Charles Sheeler," p. 86.

24. Sheeler Papers, NShl:89.

25. Edward A. Jewell, "Sheeler in Retrospect," in "Modern Museum Enshrines Charles Sheeler," *Art Digest* 14 (October 15, 1939): 6. Sheeler no doubt was stung by such criticisms, but he made no comment until five years later, when he sent an agitated letter to *Art News* defending the Museum of Modern Art's beleaguered exhibitions policy (which he praised as offering the viewer the opportunity to exercise "the privilege of selection," tellingly defended as the core of the creative act). His uncharacteristic participation in this art world debate allowed him to refute Emily Genauer, the *World-Telegram*'s art writer, who had been one of the harshest critics of his 1939 show: "[Sheeler is] just prophylactic, painting septic, bloodless pictures devoid of all signs of the intensity, the explosiveness, the dreams, the passions, the fears and the aspirations of life and the living" (ibid., p. 6).

26. See Coke, *The Painter and the Photographer*, p. 217, and Millard, "The Photography of Charles Sheeler," p. 86.

27. *Incantation* was reproduced in *Fortune*'s November 1946 issue (p. 127); *Against the Sky a Web Was Spun* (1948; current location unknown) appeared on the cover of the magazine's August 1, 1948, issue.

28. Adams, describing a visit with the Sheelers at Irvington, remembered: "Musya greeted us with warmth and Charles with his usual austere admission of pleasure to see us. He was a deceptively shy man, firm and quiet, and a great artist. I admire his photography but believe he was even more impressive as a painter" (*Ansel Adams: An Autobiography* [Boston, 1985], p. 205).

29. See Jan Garden Castro, *The Art and Life of Georgia O'Keeffe* (New York, 1985), p. 123.

30. See Vicki Goldberg, *Margaret Bourke-White: A Biography* (New York, 1986), p. 87.

31. See Sheeler to William H. Lane, April 12, 1958, The Lane Collection.

32. See Sheeler, interview by Friedman, pt. 1, pp. 7, 15; pt. 2, pp. 26-27.

33. Ibid., pt. 1, pp. 22-25. Sheeler's intimation that he was independent of and rather distant from fellow painters is typical of his self-absorption and, conversely, of his modesty. He apparently befriended several younger artists. One of them, Jacob Lawrence, remembers him fondly:

"When I was quite young, I was very fortunate. Coming out of the Service I met many older artists who befriended me; some were very famous. Charles Sheeler was one. He invited me to his studio. It's very interesting seeing people's studios and how they work. You can get a feeling for the artist's personality. Sheeler's studio was like a clinic – very, very neat, very precise, everything exactly where it should be, and this is the kind of person he was" (in Ellen Harkins Wheat, *Jacob Lawrence, American Painter* [Seattle Art Museum, 1986], p. 149).

34. Maurice LaReau, "Art and Artists," column in unidentified Fort Lauderdale, Florida, newspaper, about October 11, 1959, included in letter from Musya Sheeler to William H. Lane, October 11, 1959, The Lane Collection.

35. Conversation with Lane, winter 1986.

36. See Ben Barkin, "Art at Meta-Mold," *Art in America* 44 (Spring 1956): 36-38.

37. "Sheeler believes it is necessary to have a tie-up between the artist and industry. He finds that while there are generous private collectors today, and while young people are more and more coming to buy pictures, still private collecting on the part of art lovers is not enough to keep the sincere artists of the country going. Industry must step in" ("Two Wisconsin Sheeler Works Finished," *Milwaukee Journal* [December 28, 1952], sec. 7, Downtown Gallery Papers).

38. Sheeler to Edith Halpert, n.d. (in response to her letter of January 13, 1956), Downtown Gallery Papers.

39. See Mary Jane Jacob and Linda Downs, *The Rouge* (Detroit Institute of Arts, 1978), p. 17.

40. Sheeler to Dr. Helen Boigon, January 6, 1956, Sheeler Papers, NY59-5:209-10.

41. Sheeler to Edith Halpert, June 9, 1956, Downtown Gallery Papers.

42. See Sheeler to Mr. Chanin, December 1953, Downtown Gallery Papers.

43. In 1957, at the age of seventy-four, Sheeler was honored with the Philadelphia Museum School of Art's Alumni Award for Distinguished Achievement. That same year, he won second prize in the Fourth International Hallmark Art Awards for his painting *Two Against the White*. In 1962 the American Academy of Arts and Letters presented him with their Award of Merit medal; the following year, he was elected to membership in the National Institute of Arts and Letters (an organization to which he had been elected in 1955, but had declined membership).

44. Sheeler, in LaReau, "Art and Artists."

45. Sheeler Papers, NSh1:106.

46. See Craven, "Charles Sheeler," p. 71.

47. Sheeler Papers, NShl:67.

Catalogue of the Exhibition:

Paintings and Drawings

1

Plums on a Plate, c. 1910
Signed lower right: *Sheeler*
Oil on wood panel, 10½ x 14 in.
(26.7 x 35.5 cm.)
Mr. and Mrs. Meyer P. Potamkin

Plums on a Plate is one of Sheeler's earliest paintings to combine realistic spatial recession with abstract surface pattern. Broadly painted in oil on a small panel, this still life heralds a profound shift in Sheeler's work, from the relatively conventional landscapes and interiors he had painted under the influence of his instructor William Merritt Chase, to a new appreciation for structure and form stimulated by the art he saw in Europe in 1909. As Sheeler wrote, "When I came back, I couldn't resume where I had left off, I had to bail out."[1] He began this process by restricting his subject matter, and for the next few years he concentrated almost exclusively on modest tabletop still lifes (see cat. nos. 2 and 3). In 1910-11, he created three like-sized panels of fruit simply arranged in a low white dish: *Peaches in a White Bowl* (fig. 4) *Oranges* (private collection), and *Plums on a Plate*.

The solidity of form and harmony of color Sheeler achieves here reflect his admiration for the accomplishments of Cézanne, whose work he had seen in Paris the preceding year. Inspired by the French master, Sheeler applied his pigment in dense, blocky strokes, allowing the thickness of the paint to express the three-dimensionality of the subject. The plums crowd the small plate and, because of the tipped perspective, seem to cling to the surface plane rather than to obey the laws of gravity. Each fruit and leaf is modulated with a variety of violets and greens, creating a pattern of color across the surface of the composition. In the shaded area, the irregular aqua shadow below the dish has a mass of its own; it is as tangible as the objects that create it. Shadows would play an increasingly important role in Sheeler's paintings: for him they became "as essential to the structure of the picture as the solids appearing in it."[2]

Sheeler sent several paintings to New York dealer William Macbeth for proposed exhibition in September 1910; *Plums on a Plate* may have been part of this group. Macbeth was committed to American art and had shown Sheeler's work before, but he was unable to accept these new paintings, which he found too experimental. Sheeler expressed regret and wrote, "It is not possible to continue to repeat the things one has done – there must always be the elimination of the unessentials."[3]

The next time Sheeler exhibited his work in New York it would be at the Armory Show.

1. In Friedman et al., *Sheeler*, p. 17.
2. Sheeler Papers, NSh1:67.
3. In McCoy, "Charles Sheeler," p. 2. McCoy quotes their correspondence at length.

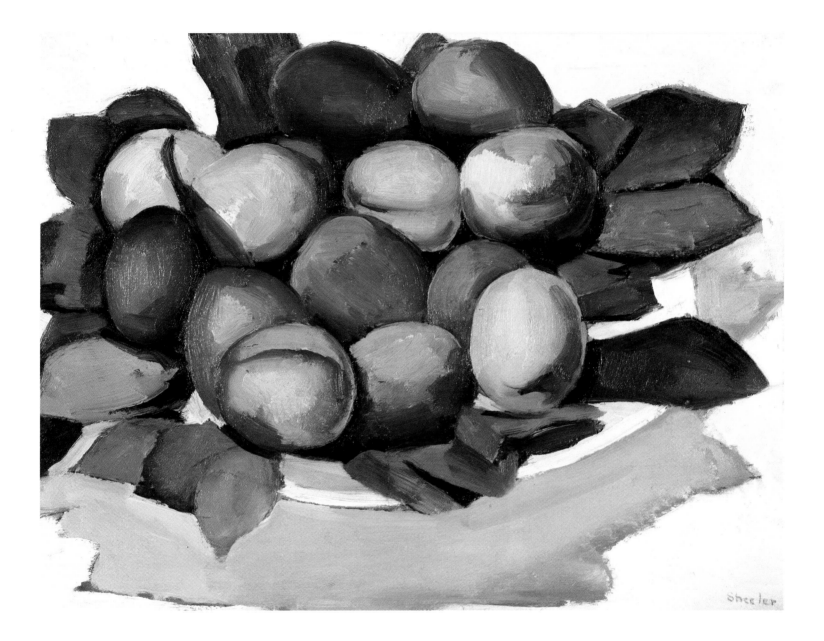

2

Dahlias and Asters

Inscribed on reverse:

C.R./'Dahlias/and/Asters'/C.R. Sheeler/1912

Oil on canvas, 20⅛ x 14⅛ in.

(51.1 x 35.6 cm.)

In the Collection of the Corcoran Gallery of Art, Washington, D.C. Gift of Joan B. Detweiler, 1962

Dahlias and Asters was probably painted toward the end of the summer of 1912, when these late-season flowers would have been readily available. Sheeler's development through this year can be traced through the simple floral still lifes he produced, from *Three White Tulips* (cat. no. 3), which was doubtless painted in the spring, to the autumn *Chrysanthemums* (1912; Whitney Museum of American Art, New York). As the seasonal blossoms shifted, so did Sheeler's palette, from the opalescent pinks, blues, and greens of *Three White Tulips* to the dark grays and burnt orange of *Dahlias and Asters*.

Sheeler kept the same compositional format in all of these works, isolating a modest bouquet of domestic flowers in one of several Chinese vases he owned. In *Dahlias and Asters*, the elegant jar is placed exactly at center, its attenuated shape balancing the horizontal registers of the background. The pigment is thickly applied, one wide daub of the brush defining each of the petals in the tightly packed arrangement. This technique shows Sheeler's departure from the academic training he had received from William Merritt Chase, himself an accomplished still life painter. Where his teacher used full, buttery strokes, Sheeler applied his paint in short, patchy blocks. Chase preferred color harmonies; Sheeler here allowed the warm reds and oranges of the flowers to stand out in brilliant contrast to the cool, dark blue-green background. Shadows are strongly cast and take on an emphatic presence as they form a double halo behind the vase and flowers at left.

Sheeler's blocky style, his emphasis during this period on still life and landscape subjects, and his tendency to work in series all reflect his admiration for a new mentor, Paul Cézanne. Cézanne had become a source of inspiration to many young American painters who went to Paris after the turn of the century. Sheeler had made the trip in 1908, when he visited Sarah and Michael Stein and heard Leo Stein enthusiastically advocate Cézanne's work. By 1913, when Sheeler exhibited six paintings, including *Dahlias and Asters*, in the Armory Show, he was fully committed to a modernist style.[1]

1. Of this group, four were still lifes. *Dahlias and Asters* was lent by the artist; it was priced at $200 but did not sell.

3

Three White Tulips
Signed and dated lower left: *Sheeler 1912*
Oil on panel, 13¾ x 10½ in. (35 x 26.7 cm.)
The Lane Collection

As though he were following a deliberate program of self-education, Sheeler in the early 1910s often worked in series, setting himself compositional problems with a limited number of variables and conscientiously exploring their permutations. *Three White Tulips* belongs to one such series, of which three additional examples have been located, each painted in 1912 in oil on panel and measuring approximately 14 by 10½ inches. One of these depicts white tulips (Coll. Glenn C. Janss, Sun Valley, Idaho), and two show red tulips (Coll. Paula and Alan Schwartz, Phoenix; Regis Collection, Minneapolis). Sheeler adhered to the same general formula in all four pictures, with only minor variations in the number of flowers, their arrangement, and the vessel that holds them. Although at least one of these pictures (*Red Tulips*; Regis Collection, Minneapolis) was sent to the Armory Show and thereafter to several other exhibitions, they remained essentially private and were never sold. Sheeler gave *White Tulips* to a nephew, this picture passed to A. W. Bahr (presumably a neighbor of Sheeler's in Ridgefield, Connecticut), and the other two were in his personal collection at his death.

Three White Tulips represents the series at its simplest and most successful.[1] The flowers are centered in the panel, their blossoms spread out in an elegant chevron that appears to fan out flat across the picture surface but also to twist slightly in space. The tabletop, outlined by a heavy black line that recedes diagonally into depth, is painted in the same opalescent hues and with the same patchy and slightly clumsy brush strokes as the background, vase, blossoms, and leaves – only the thick outline and the occasional use of white for highlights separate one form from another. The pictorial issues Sheeler evidently was exploring here were those preoccupying much of the international avant-garde during this period: the reconciliation of description and

Fig. a. Christian Seltzer, *Pennsylvania German Dower Chest*, 1781, Museum of Art, The Pennsylvania State University

decoration, of flat and illusionistic space, and of the relative utility of local and ambient color in unifying and organizing a composition. His guide in this quest may well have been Cézanne, with whose work he was by this time acquainted. Cézanne's special love for casual floral subjects, his use of animated, seemingly unstudied brush strokes going off in all directions (particularly in the backgrounds of his pictures), and his use of heavy outlines that threaten to detach themselves from the forms they define are here emulated, if not quite mastered.

It has been suggested that these pictures of tulips also point to Sheeler's appreciation of similar motifs appearing on chests, ceramics, and birth and marriage certificates produced by the Pennsylvania Germans in the late eighteenth and early nineteenth centuries. Sheeler knew their designs well, for as early as 1910 he spent numerous weekends exploring rural Bucks and Lancaster counties (the heart of "Pennsylvania Dutch" country), and from his student days had frequented the Barber Collection of Pennsylvania Dutch crafts housed at the Pennsylvania (now Philadelphia) Museum.[2]

A dower chest he once owned (fig. a) features ornamental panels of symmetrically arranged, schematically drawn tulips (a favorite motif of the Pennsylvania Germans) arrayed much as Sheeler does in *Three White Tulips*. Splayed across the picture surface, they create a simple, charming arrangement. This unusual marriage of influences – the integration of revolutionary stylistic concerns and decorative patterns with roots in folk or primitive art – linked Sheeler with the most progressive artistic minds of his day. And although his technique is not fully mature here (he would soon substitute a smoother stroke and subtler palette for the heavy impasto and intense color), *Three White Tulips* established a pattern for the rest of his work. Hereafter, his richest pictures would be those in which the traditional and the modern are harmoniously intertwined.

1. That Sheeler was pleased by this rudimentary compositional arrangement is suggested by the frequency with which he returned to it. See, e.g., his lithograph *Roses* (c. 1923) or the drawing *Timothy* (1924; Santa Barbara Museum of Art).
2. See Driscoll, "Sheeler's Early Work," p. 130.

4

Landscape

Inscribed on reverse: *C. R. Sheeler/1913*
Oil on panel, 10½ x 13⅞ in. (26 x 35 cm.)
Private collection, Boston

Both Sheeler and his friend Morton Schamberg were invited to participate in the Armory Show by Walt Kuhn and Arthur B. Davies, two organizers of the historic exhibition, which was held at the 69th Street Regiment Armory in New York from February 17 to March 15, 1913. An invitation exempted artists from submitting their paintings to the jury evaluating unsolicited works, but by some misunderstanding Sheeler sent five to the judging, including this painting and four still lifes.[1] He eventually was represented by at least six paintings, and Schamberg by five.[2] *Landscape* was priced at $150 but did not sell; nor did it — or any of Sheeler's other paintings in the show — attract any critical attention. Nonetheless, his participation in an exhibition that also included works by Cézanne, Picasso, Braque, Duchamp, and other innovative painters signaled his arrival into the progressive art community in New York. This simple landscape was furthermore the beginning of an intense investigation of the subject that would preoccupy him for the next several years.

The composition of *Landscape* is simple. A broad, empty foreground crisscrossed by diagonal paths and gentle rises is followed by a blocky little house — almost a cartoon shape — set well back into the middle distance; on either side are stands of bare trees. Low mountains, their jagged peaks echoing the geometric crests of the hillocks in the foreground, rise up behind the house, which seems cozily nestled in its natural surroundings. Sheeler compensated for the plainness of his design with brilliant, electric color, and with a technique that, compared to his more labored and densely painted canvases of the previous year (see cat. nos. 2 and 3), is remarkably free. The design was spontaneously brushed in on a wood panel measuring about 10 by 13 inches — the format Sheeler used repeatedly in those years. But rather than cover the entire surface, he allowed the warm brown of the panel to show through, evoking the bare ground of his spring landscape. The lean pigment (unlike the richer materials he had been using) and matte surface, as well as the deliberately blocky strokes and jagged lines used in the foreground and for the stands of trees, relieve the static, conventional look of the house and give abstract energy to those passages.

At precisely this time, Schamberg was producing similar-sized compositions of virtually identical subjects. Never had the two artists been so close. The uncanny similarity of this picture and Schamberg's *Landscape (with House)* (1913; private collection) may well have resulted from a joint sketching expedition. Sheeler seems to have taken a cue from his colleague in the use of playful, high-key color and schematized drawing, for the Cézannesque manner of his previous work is little in evidence here. For the next three years, Sheeler would paint such little houses amid trees again and again in a variety of experimental styles, each more abstract and energetically modern than the last (see cat. nos. 5, 6, 7, and 8.)

Landscape proved to be a prophetic work for Sheeler. Its subject, its palette of intense greens, lavenders, and blues, and the prismatic treatment of the sky would all recur in his landscape paintings over the next thirty years. Whether or not Sheeler realized the seminal importance of the painting, he was clearly very fond of it, for after the Armory Show, he hung it in a place of honor in his studio, next to a reproduction of a Cézanne.

1. See Brown, *The Story of the Armory Show*, pp. 66-67.
2. Ibid., pp. 288-90.

5

Landscape No. 6
Signed and dated lower left: *Sheeler*/1914
Oil on panel, 13¾ x 10½ in. (35 x 26.7 cm.)
Private collection

Rapidly painted in brilliant colors upon a small wood panel, *Landscape No. 6* is one of the most exuberant of the group of small landscapes Sheeler painted from 1913 to 1916 (see cat. nos. 4-8). It relates to a series of crayon drawings Sheeler made in 1914 (fig. a), in which the recognizable forms of houses and trees are systematically reduced to sinuous, graceful crescent shapes. In *Landscape No. 6*, these rhythmic forms are translated into bright, animated patterns of color.[1]

Sheeler began by quickly sketching the image in heavy pencil on an unprepared board. He then filled it in with color, bringing the pigment up almost to the pencil lines but leaving them clearly visible. The lines stand out against the warm blond wood of the panel, which is allowed to show through, lending the composition the spontaneity of a sketch. Colors and shapes suggest rather than describe the landscape. Sky, foliage, and architecture are represented by curvilinear triangles of indigo, ultramarine, deep green, yellow, and orange. These heightened colors reflect Sheeler's admiration for the high-keyed palette and arbitrary hues of the Fauves, especially Matisse, whose work had been well represented at the Armory Show. Sheeler wrote that Matisse's art proved that a painting could be as "arbitrarily conceived as the artist wished."[2]

The color rhythms of *Landscape No. 6* are reminiscent of the synchromist style, developed by Morgan Russell and Stanton Macdonald-Wright in 1913. Sheeler most likely saw their work when it was first exhibited in America at the Carroll Gallery in New York in March 1914, shortly before he painted *Landscape No. 6*. Or he may have discovered synchromism through his close friend Morton Schamberg, who in early 1914 was experimenting with a new bright palette and abstract form (see his *Figure C (Geometrical Patterns)*, 1914; Regis Collection, Minneapolis). By March 1916 several of Sheeler's pictures had been selected for the Forum exhibition, a show featuring synchromist works that was organized by Macdonald-Wright's brother, Willard H. Wright. Conceived as a nativist response to the Armory Show, the Forum exhibition sought to present the best of American modernism. *Landscape No. 6* was one of nine Sheelers included there.

Fig. a. Charles Sheeler, *Landscape*, 1914, black crayon on paper, Fogg Art Museum, Harvard University, Gift of Mr. and Mrs. Charles B. Hoyt

1. *Landscape* (1914; private collection) is closely related in composition and color to the present picture.
2. Sheeler Papers, NSh1:74.

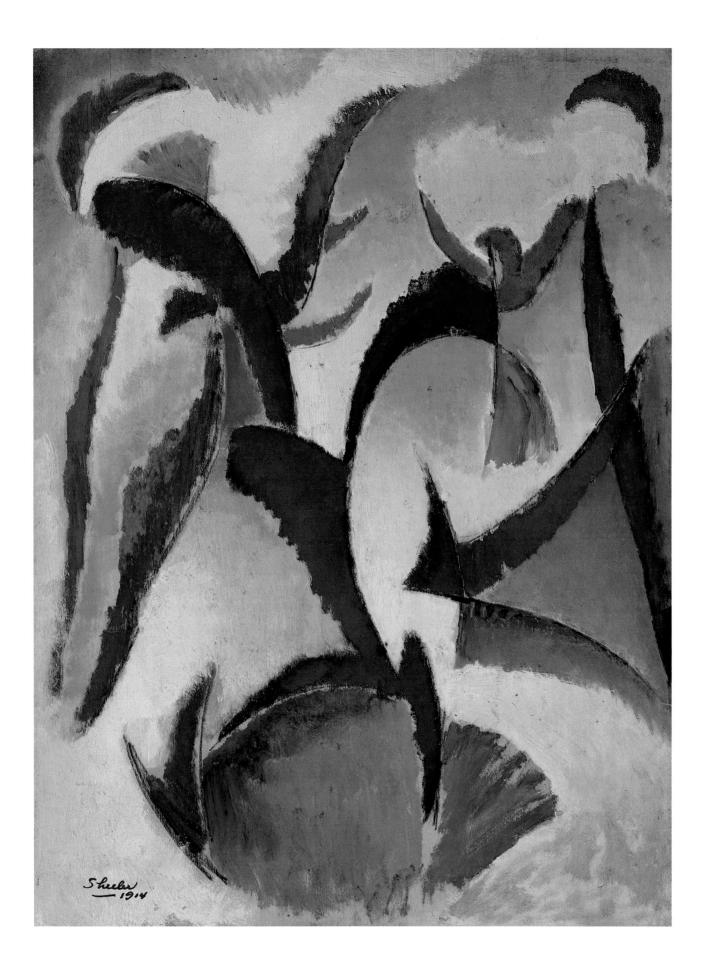

6

Landscape
Signed lower right: *C. Sheeler*/1915
Inscribed on reverse: *Landscape-1915*
Oil on panel, 10½ x 14 in. (26.7 x 35.5 cm.)
The Lane Collection

By 1915 Sheeler had thoroughly exorcised both the style and the method of his first mentor, William Merritt Chase, and, like several American artists of his generation, was looking to recent European masters for guidance as he forged a modern style. For him the stimulus was Cézanne, and secondarily Braque and Picasso as they learned from Cézanne, and his thoughtful adaptation of their lessons are evident here.

Sheeler's subject is once again a little house in a grove of trees. His composition is picturesque and conventional: the building is centered; the boughs of the trees in the foreground are arched gracefully overhead, framing the house in a protective bower. Sheeler revitalized this sentimental structure by employing the fractured planes of cubism. He collapsed the space and rearranged the surfaces of the house so that its doorway dissolves into the stucco façade, the foundation is nowhere clearly established, and (in a device frequently employed by Cézanne and by Braque and Picasso after him) the curve of the bough in the foreground at right so closely echoes the roof line of the house that they seem to be on the same plane.

Sheeler planned this landscape and its complex linear pattern in a charcoal drawing about two-thirds the size (fig. a). The drawing was sufficiently accomplished and yet daring to appeal to the discerning collector of modern art John Quinn, who bought it from the Montross Gallery in 1915 for $30. But while the drawing seems organic, spontaneous, directly observed, the painting marks Sheeler's liberation from the restrictions of naturalism. No light source is indicated, details are eliminated, and forms are manipulated for design rather than descriptive effect. The addition of color – Sheeler's characteristic palette of cream, rose, green, and cobalt blue – enhances the composition's abstract quality, for it has been applied independent of form, generating lively patterns of darks and lights. Over these is laid a skein of heavy black lines (perhaps influenced by Cézanne's use of Prussian blue outlines in his pictures) that are also detached from the objects they purport to describe. The shaggy hatching, inspired by Cézanne's "constructive strokes," creates a tantalizing physical surface. As a result of these devices, Sheeler's unex-

Fig. a. Charles Sheeler, *Landscape No. 1*, 1915, black crayon on paper, Fogg Art Museum, Harvard University, Gift of Mr. and Mrs. Charles B. Hoyt

ceptional subject becomes profound: it can be viewed as relief, as spatial conundrum, and as animated surface design.

The adventurousness of this painting has been recognized almost since its creation. It was included in the 1916 "Forum Exhibition of Modern American Painters." With *Plums on a Plate* and *Landscape* (cat. nos. 1 and 4), it was one of the earliest works included in Sheeler's solo exhibition at the Museum of Modern Art in 1939. And it represented Sheeler in the Whitney Museum's "Pioneers of American Abstraction" show, a landmark exhibition that traced the evolution of modern art in America.

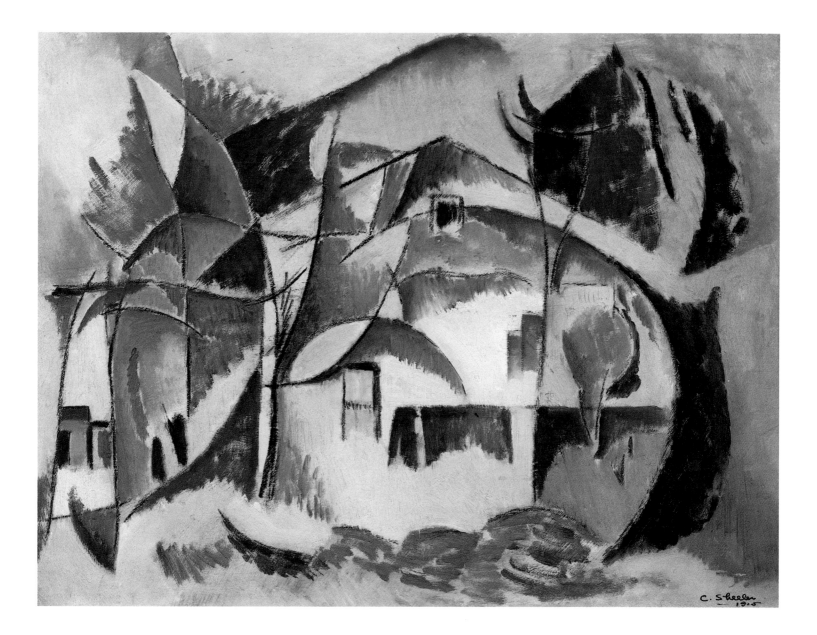

7

House with Trees
Signed and dated lower left: *Sheeler 1915*
Inscribed on reverse: *Landscape no. 7-1915*
Oil on panel, 10½ x 13⅞ in. (26.7 x 35.3 cm.)
Museum of Art, Rhode Island School of Design. Jesse Metcalf Fund

By 1915 Sheeler had returned to a more active interest in representational form, investing the decorative cubism of his earlier landscapes (see cat. nos. 5 and 6) with a new attention to the three-dimensional mass of buildings. In *House with Trees*, discrete areas continue to dissolve into delicate arabesques, but the heavy red tile roof and thickly painted ochre walls lend a new weight to the composition.

While the house depicted here was probably in the Doylestown area, it looks as though it could be in the southern France beloved by Cézanne and Braque. The squat rural buildings, reduced to simple cubes almost free of interrupting doors and windows, have the Mediterranean flavor of L'Estaque, a favorite area of both French painters (fig. a). Sheeler's vibrant color scheme encourages the comparison, with the warm orange tones of the architecture set against contrasting forest green and charcoal gray. This gray area, perhaps representing background trees, prevents the house from receding into the cobalt blue sky of the background and it stays on the picture surface. It is this tenacious surface quality that makes Sheeler's work so different from that of his French counterparts. While they strove to find new methods to portray three-dimensional form upon a two-dimensional canvas, Sheeler remained concerned with the surface plane itself, emphasizing pattern rather than structure and selecting elements from nature that pleased his innate sense of design. But his experiments with pure abstraction did not entirely satisfy him, and *House with Trees* marks Sheeler's first step in his reconciliation of realism with surface pattern in his paintings.

House with Trees is most probably one of the nine small landscapes Sheeler exhibited at the Forum exhibition in the spring of 1916.[1] In the foreword to the exhibition's catalogue, critic Christian Brinton wrote: "Art in its initial stages never was, and was never meant to be, merely imitative. It was an indication, rather than an imitation."[2] In *House with Trees*, Sheeler imitated neither the cubist style of his French contemporaries nor the actual appearance of his naturalistic subject. The picture indicates the direction that his art would take, as he sought a simultaneous depiction of the real world and a revelation of the "cosmic order" underlying it.[3]

Fig. a. Georges Braque, *Road Near L'Estaque*, 1908, oil on canvas, Collection of The Museum of Modern Art, New York, Given anonymously (by exchange)

1. The checklist survives in typewritten form; *House with Trees* is probably cat. no. 141 – *Landscape No. 7, 1914* – despite the discrepancy in date. It is inscribed "Landscape No. 7 – 1915" on the reverse. *Landscape No. 8* (fig. 7) is similar in style; it was illustrated in the Forum catalogue (no. 137).

2. Christian Brinton, foreword to pamphlet accompanying the "Forum Exhibition of Modern American Painters," Anderson Galleries, New York, March 13-25, 1916.

3. "... to communicate his sensations of some particular manifestation of cosmic order – this I believe to be the business of the artist" (Sheeler, ibid).

8

Landscape #1

Signed and dated lower left: *Sheeler/1916*

Oil on canvas, 24 x 18 in. (61 x 45.7 cm.)

Private collection

Landscape #1 is the last of Sheeler's most overtly abstract works. It marks the end of a period of experimentation with cubism which had been stimulated by the Armory Show. Larger than the rest of the modestly scaled panel pictures in the series (see cat. nos. 5-7), it may have been intended as a dramatic centerpiece for Sheeler's display at the Forum exhibition.[1] *Landscape #1* was acquired by John Quinn, the New York lawyer who championed modern art and who eventually would own nine Sheelers, including *Flower Forms* (cat. no. 13). Those pictures are among the artist's most avant-garde, and indicate the collector's marked preference for adventurous European paintings and for American works influenced by them.[2]

Sheeler displays a confident understanding of cubism in *Landscape #1*. Using a restricted palette, he reduced the rural architecture and countryside of the Doylestown area to a system of verticals and horizontals. The squat building of *House with Trees* (cat. no. 7) reappears here in a sharply abbreviated form: a small window anchors the center of the composition, while above and beside it hover acutely angled lines that recall the form of a steeply pitched gable roof. Colors that had been used to define the house and trees in the earlier work reappear in *Landscape #1*, but they are now isolated from their descriptive role. Here the deep blue of the clear sky and forest green of the foliage are seen as irregular shapes in the upper right corner, and the terra-cotta of the roof appears in three discrete triangles to the lower left. Sheeler modulated the surface texture of the picture by varying the thickness of his paint, sometimes building up a thick, opaque gray surface and in other areas using much thinner layers of pigment, the gray often partially covered by a thin layer of creamy yellow. This lends the composition a sketchlike quality that is enhanced by Sheeler's seemingly quickly drawn, thick black lines.

Sheeler's *Landscape #1* reflects not only his interest in the work of French painters such as Georges Braque (whose work Sheeler's friend Marius de Zayas had shown in his Modern Gallery the previous year) but also his kinship to fellow painter Morton Schamberg. Schamberg had created a series of cubist landscapes in

Fig. a. Morton Schamberg, *Landscape, Bridge*, 1915, oil on panel, Philadelphia Museum of Art, Given by Dr. and Mrs. Ira Leo Schamberg

1915 (fig. a), loosely brushed with a similar palette and organized around a grid of sketchy black lines.

1. Signed 1916, this picture must have been completed by March of that year when it was included in the Forum exhibition, cat. no. 139. It was the most recently painted and the most expensive of the artist's works shown there.

2. See Zilczer, *"The Noble Buyer."*

9

Barn Abstraction
Signed and dated lower right: *Sheeler-1917*
Fabricated black chalk on Japanese paper,
14⅛ x 19½ in. (36.3 x 49.5 cm.)
Philadelphia Museum of Art. The Louise and
Walter Arensberg Collection

Sheeler began to study the vernacular architecture of Bucks County, Pennsylvania in about 1917. He made a series of photographs, a few tempera studies, and a number of conté crayon sketches of old barns, developing a direct, unadorned style. *Barn Abstraction* is one of the earliest and most beautiful representations of this theme, which would occupy Sheeler throughout his career.

Severe and unembellished, sparely rendered in conté crayon upon inexpensive paper, *Barn Abstraction* combines the cubist concern for the objective analysis of form with a peculiarly American subject. Critic Henry McBride noted this coincidence, stating that "Mr. Sheeler's barns are genuine Bucks County barns . . . compositions that are as compact as Picasso's."[1] Sheeler reduced the wood, stone, and stucco of typical Pennsylvania barn buildings to a few simple lines and shapes. The composition is carefully balanced: large and small dark black squares representing an open door and windows are offset by blank areas where contour lines dissolve and the image melts into the paper. The thinly spaced short vertical strokes defining a roof at left are matched by the longer strokes of barn siding at the right. The tones are carefully modulated, ranging from deep black to a soft silvery gray, enlivening the deliberate balance between forms. Sheeler drew his lines freehand, and the slight variations, as well as the tension between recession and surface pattern, animate the composition. By surrounding the barn with a sea of white space, Sheeler isolated it from any context; it becomes an iconic image of the harmony and beauty he perceived in all these simple buildings.[2]

The year after *Barn Abstraction* was completed, it was acquired by Walter and Louise Arensberg. Sheeler had known these collectors since about 1916 and was a regular visitor

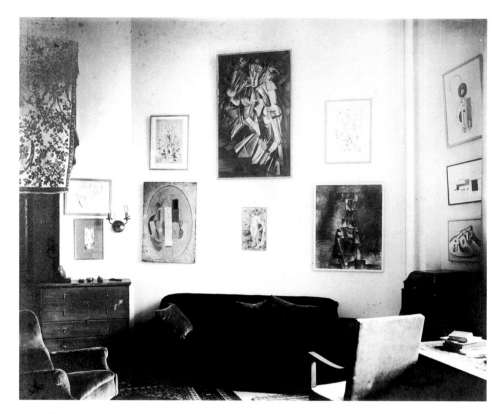

Fig. a. Charles Sheeler, *Living Room of New York Apartment of Louise and Walter Arensberg (Northwest Corner)*, c. 1918, gelatin-silver print, Collection of the Whitney Museum of American Art, Gift of James Maroney and Suzanne Fredericks

to their frequent evening gatherings, soirees that attracted both European and American members of the avant-garde. He shared with the Arensbergs not only an interest in modernist painting but also an enthusiasm for simple American antiques. This unlikely marriage of styles – the vernacular and the modern – is at the heart of *Barn Abstraction*, and accounts for its appeal to the Arensbergs. They hung the drawing in their living room, near their most celebrated acquisition, Duchamp's *Nude Descending a Staircase*, a fact recorded by Sheeler himself in a series of photographs he made of the Arensberg apartment in about 1918 (fig. a).[3]

1. McBride, "Sheeler Attracts Attention," p. 7.
2. Sheeler re-created this image in a lithograph, *Barn Abstraction*, of which only a few impressions were made. That many of these prints were produced in the 1950s confirms the continued inspiration Sheeler found in this drawing.
3. Walter Arensberg reproduced this drawing in the little magazine *TNT* in March 1919.

10

Flower in a Bowl
Signed and dated lower right: *Sheeler/1918*
Watercolor, gouache and pencil on paper,
15 x 12 in. (38.1 x 30.5 cm.)
Warren Adelson

In the summer of 1918, Sheeler began a group of flower studies of an elementary and traditional compositional type: the tabletop still life. For these he posed a few common blossoms upright in an ordinary vessel, either a low, pale porcelain bowl or an unadorned, slender-necked vase. At least three watercolors resulted from this exercise. In the next few years all three would be shown in New York and purchased by astute collectors of modern art who would become Sheeler's most important early supporters. *Zinnia* (Coll. Mr. and Mrs. Joseph Davenport, Jr., Lookout Mountain, Tenn.) was purchased by John Quinn; *Zinnias* (fig. a) and *Flower in a Bowl* were bought by Ferdinand Howald in 1919 from the dealer Charles Daniel for $150 and $100 respectively. These were the first of eight Sheelers Howald would acquire; they were also among the artist's first sales.

Flower in a Bowl is related to a photograph Sheeler made in Doylestown a year or two before; the two are often compared in terms of the artist's "rigorous ordering of organic specimens for design purposes,"[1] and indeed in both works the zinnia seems unusually erect and frontal, an effect Sheeler accentuated in the gouache by tilting up the bowl and the tabletop. By contriving to give the flower an upright posture and deliberately placing it slightly off-center, Sheeler imbues the zinnia with an animated, almost anthropomorphic quality: it seems to nod and gesture to the viewer. The compositional imbalance, particularly the precarious placement of the bowl near the edge of the table (while at the same time it rests on the bottom border of the sheet) creates a slight sense of instability, a feeling of disquiet that is unusual in a subject traditionally associated with serenity. More typical is the drawing's chromatic richness: three intense blues (in the bowl, the table, and the background) parallel a triad of greens (from a bright yellow green to a medium tone tinged with blue to a deep forest hue) and, in the concentrically arranged petals, contrast with cleverly layered rosy tones (from pale salmon to coral to magenta). The pigment is applied opaquely throughout, but in certain areas – the rim of the bowl in particular – the white of the paper is used to suggest highlights, and the heavy pencil lines add a distinct jauntiness to the form.

Fig. a. Charles Sheeler, *Zinnias*, 1918, watercolor on paper, Mr. and Mrs. Gerald P. Peters, Santa Fe, N.M.

1. Ella M. Foshay, *Reflections of Nature: Flowers in American Art* (New York, 1984), p. 151.

11
Bucks County Barn
Signed and dated lower right: *Sheeler/1918*
Gouache and conté crayon on paper,
16⅛ x 22⅛ in. (41 x 56.5 cm.)
Columbus Museum of Art.
Gift of Ferdinand Howald, 1931

By 1917 Sheeler had begun sketching unpretentious barns in Bucks County, Pennsylvania. Perhaps in response to their simplicity, he eliminated from his stylistic vocabulary the fanciful arabesques that had enlivened his compositions since the Armory Show (see cat. nos. 5 and 6), and favored instead chaste straight lines and solid blocks. The following year, Sheeler reexamined these drawings and began to work some of them up into more ambitious pieces. *Bucks County Barn* is based on one of these earlier conté drawings, *Barns* (fig. a).[1]

The preliminary work is a small sketch, quickly rendered with simple lines and shading hastily drawn in. Shadows have been all but abolished, allowing the design to become two-dimensional. The barn would float freely on the page but for the lean-to at right, which Sheeler has brought right to the edge of the paper to firmly anchor the image. The finished work, *Bucks County Barn*, also makes use of this sort of cropping, which causes the main structure and its assortment of sheds to read as a continuous horizontal band. By eliminating the bottom contour line of the barn complex, Sheeler dissolved the concrete boundary between the background and the buildings' façades. The device suggests soft grass growing along the walls of the barn, but its realism is undermined by the abstract effect that results. The tension between the flat paper and the illusion of space created by the cubelike accumulation of buildings is most acute in the very center of the composition, where a thick vertical band of conté crayon describes the receding side of the stone barn. At the same time, the vertical band remains insistently on the surface, reminding the viewer that this picture is much more than a simple representational image. It is instead a distillation of reality to its purest forms, an idealized presentation of volume and texture. As Sheeler said, "I sought to reduce natural forms to the borderline of abstraction, retaining only those forms which I believed to be indispensable to the design of the picture."[2]

Sheeler's technique in *Bucks County Barn* is a contrast of freedom and control. While the picture as a whole is tightly disciplined, it also features remarkable painterly passages. Sheeler used a rich, deep red for the central pavilion, rusty browns and oranges for the others.

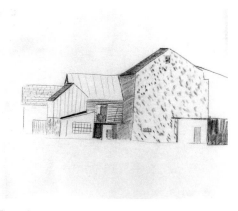

Fig. a. Charles Sheeler, *Barns*, c. 1918, conté crayon on paper, Columbus Museum of Art, Museum Purchase, Howald Fund, 1972

Rather than carefully delineating the randomly laid masonry of the large barn's fieldstone wall, as one might expect, Sheeler recorded its irregularities with quick dabs of ochre and gray-blue gouache, which occasionally overstep their conté crayon border. This pattern, reprised in a small area at the left, adds vitality to the otherwise contained image.

Bucks County Barn was first shown in Sheeler's solo exhibition at Marius de Zayas's gallery in February 1920. Critic Henry McBride remarked: "The artist may win some applause from totally uninstructed persons, who will see that Mr. Sheeler's barns are genuine Bucks county barns in spite of something in the work that the instructed will call 'cubism.' "[3] One of the "instructed," Ferdinand Howald, bought *Bucks County Barns* in September 1923, adding it to one of the most important early collections of modern art in America.

1. While the present picture is clearly based on *Barns*, two other sketches depict the same buildings: *Barns* (1917; Albright-Knox Art Gallery, Buffalo) and *Side of a Barn* (1917; Glenn Janss Collection, Sun Valley, Idaho).
2. Sheeler Papers, NSh1:85.
3. McBride, "Sheeler Attracts Attention," p. 7.

12

Hallway (Interior)
Former title: *The Stairway*
Signed and dated lower right:
Charles Sheeler-1919
Oil on canvas, 23¾ x 15⅞ in.
(60.3 x 40.3 cm.)
Mrs. James L. Whitcomb

In 1919 Sheeler turned from the landscapes and still lifes he had been producing to a new subject, the domestic interior. It would become one of his major themes. Sheeler had studied simple rooms and staircases in a series of photographs of his house in Doylestown, but this hallway, with its gracefully turned newel post, belongs to an unidentified building. This painting was one of the last works Sheeler completed before moving to New York; he considered it a companion piece to *Flower Forms* (cat. no. 13).

Of similar size, the two pictures are the antithesis of each other: *Flower Forms*, with its dark, luminous color scheme and undulating curves, is rich and sensuous; *Hallway*, with its flat planes, angular rhythms, and thinly applied paint, is almost ascetic. Only the dark blue of the stairs recalls the deep colors of the other work. Yet despite their visual dissimilarity, these two paintings share an aesthetic goal, one that became an integral part of Sheeler's work: to bring a realistic image to the point of abstraction by emphasizing its innate design and by using arbitrary color.

All the features of *Hallway* are schematized. As Constance Rourke noted: "the blue of the stairs might be carpeting, but it rises in an unbroken abstract area. The window frame, the stair rail, its spindles, belong both to realism and to abstraction: they are revealed by line yet they are set within three dimensions."[1] Sheeler used pigment sparingly. Each line is thinly drawn, recalling the effect of charcoal or conté crayon. By sketching rather than fully modeling the balusters of the railing, Sheeler transformed the bottom of the stairway to a new shape, a fluted column on a wide base. This columnar form, a visual pun, shares a contour with the banister; as a result, the stairs appear to spill forward rather than to flow back into space. A brittle tension exists between line and form, surface and depth. The window at left becomes an abstraction as well, for Sheeler left its exact form uncertain. Light streams in, but the dark shadows it creates relate primarily to the abstract design rather than to natural effects.

In his February 1920 solo exhibition at Marius de Zayas's Modern Gallery, Sheeler exhibited this picture as *The Stairway*. It was a motif he would use throughout his career to suggest transition or passage. It appears in the 1920s in *Stairway to the Studio* and *Staircase, Doylestown* (cat. nos. 28 and 29); in the 1930s in *Newhaven* (cat. no. 44) and *The Upstairs* (fig. 23); and in his late work, *General Motors Research* (fig. 31); as well as in many photographs throughout his career. The open window would also become a recurring image. *Hallway* thus foreshadows the color, structure, and themes of some of Sheeler's important later paintings.

1. Rourke, *Sheeler*, p. 67.

13

Flower Forms

Former title: *Forms – Flowers*

Signed and dated lower left:

Charles Sheeler 1919

Oil on canvas, 23¼ x 19¼ in.

(59.0 x 48.9 cm.)

Daniel J. Terra Collection, Terra Museum of
American Art, Chicago

Fig. a. Charles Sheeler, *Nude*, 1918-19, gelatin-silver print, The Lane Collection

Flower Forms has consistently mystified Sheeler's admirers. Forbes Watson, in the first critical article devoted to Sheeler, described it as an "attempt to create forms suggested by nature without attempting any visible resemblance to the natural forms." Constance Rourke's observation, though general, seems most apt: she called *Flower Forms* "fanciful in character and even in a sense fantasy." Echoing these ideas some years later, Martin Friedman described the picture as a dramatic close-up of a lily and noted that it was one of a series of "large-scale botanical studies" in which Sheeler applied cubist principles to abstract shapes.[1] Sheeler's own suggestion that the natural origin of his forms was secondary to his experiments with arbitrary color and, above all, design,[2] is not, finally, any more illuminating.

Despite the painting's title (which was undoubtedly Sheeler's own),[3] what one sees in *Flower Forms* cannot readily be identified as a lily or any other blossom. The picture consists of odd, bulbous brown and ochre forms emerging from a shadowy green space. These forms possess a degree of abstraction and sensuality unprecedented in Sheeler's work. Pulsating, intertwining, voluptuous, even erotic, they evoke some undefined organic rhythm.[4]

Some of the impetus for this unusual picture may have come from Sheeler's associates in 1918 and 1919, and from the art that he found most intriguing in those years. Through the collectors Walter and Louise Arensberg, whom he met in about 1916, Sheeler became well acquainted with Francis Picabia and Marcel Duchamp; by 1919, the Arensbergs owned several of their paintings, and their work also had been exhibited in New York and Philadelphia.[5] It may well have been the example of

paintings like Duchamp's *The Bride* (owned first by Picabia and later the Arensbergs) that stimulated Sheeler to set aside the Cézannesque lavender, cream, and blue palette he had been using for the ochres and browns then preferred by Duchamp, and to temporarily abandon his customary rectilinear shapes for the kinds of throbbing organic forms found in Duchamp's and Picabia's pictures. Like his French colleagues, Sheeler avoided any indication of an external, directional light source; rather, his forms are luminous and seemingly lit from within, like a shadow box. Nor was he oblivious to the mechano-erotic themes of Duchamp's and Picabia's works, in which sexuality is depersonalized, abstracted, even mocked.

In Sheeler's own work, the stimulus for *Flower Forms* was a series of photographs of a nude model he made in about 1919. Two of these photographs (fig. a and the Lane Collection), show the model posed with her legs raised and bent at the knee so the camera focuses on her fleshy thighs. (Her face, torso, hands, and feet have been excluded from the picture, preserving her anonymity. Presumably the model was Sheeler's future wife, Katharine.) These photographs seem to have suggested the pliant shapes and voluptuous contours of *Flower Forms*. The large ochre shapes at upper left and right of the painting suggest thighs and buttocks seen from below; calf and knee (upside-down) are alluded to by the form at lower right, and so on. But unlike

the sexual machines designed by Duchamp and Picabia, Sheeler's image is not so much slyly intellectual and mocking as diffident. In the hands of an aggressive Dada practitioner the image might have become rudely erotic; Sheeler's generalized forms and diverting title transform it into an object of gentle fantasy.

1. Watson, "Charles Sheeler," p. 338; Rourke, *Sheeler*, p. 66; Friedman, *Sheeler*, p. 31.

2. "Following the Armory show, and largely influenced by it, my work dealt with abstract forms. Sometimes with a clue to natural forms being evident, but quite as often without that evidence. Always, however, derived directly from something seen in nature. Color was entirely arbitrary with the intention of contributing to the organization of forms comprising the design" (Sheeler Papers, NShl:74).

3. The painting appeared with the title *Forms – Flowers* in Sheeler's solo show at de Zayas's gallery in New York in February 1920.

4. That *Flower Forms* might represent a nude was first suggested in a discussion of this picture with Norman Keyes, Jr.

5. Marius de Zayas showed Picabia's works at the Modern Gallery in 1915 and in a solo show in 1916; that same year, Philadelphia's McClees Gallery included Picabia and Duchamp in a group show. Both artists were represented by several works at the Armory Show.

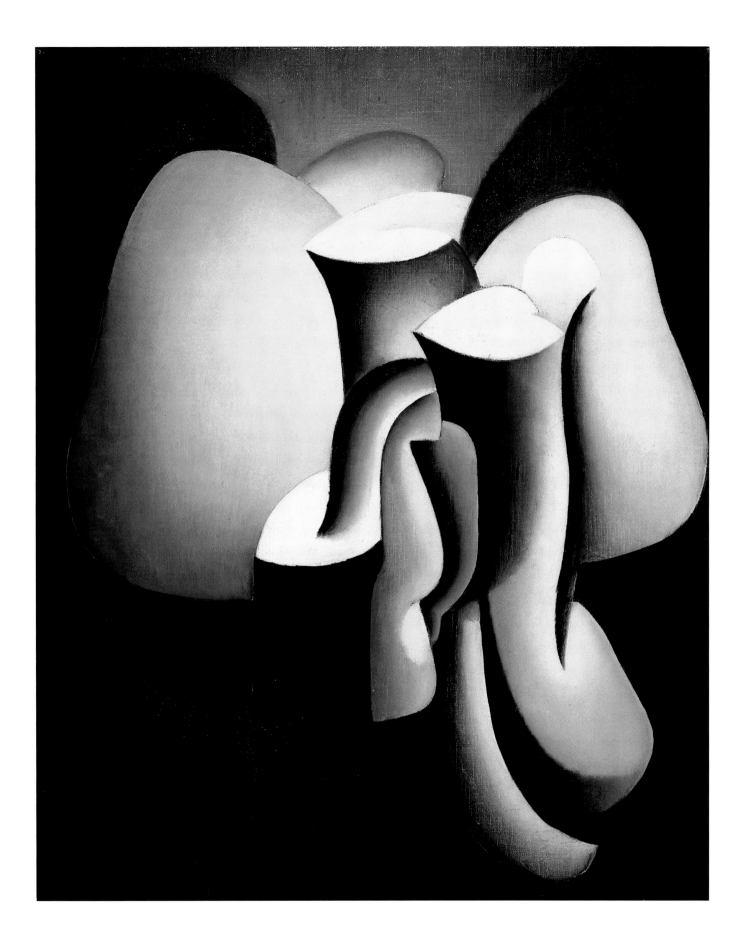

14
Nude
Signed and dated upper right: *Sheeler/1920*
Graphite on paper, 4⁹/₁₆ x 6 in.
(11.5 x 15.2 cm.) (sheet size)
Museum of Fine Arts, Boston. The M. and M.
Karolik Fund

15
Nude Torso, c. 1920
Pencil on ivory wove paper, 4⁵/₁₆ x 6⁵/₁₆ in.
(11.5 x 16 cm.)
The Art Institute of Chicago. Gift of
Friends of American Art

In about 1919, probably after his move to New York City, Sheeler began experimenting with a motion picture camera. The best-known product of these experiments is the film *Manhatta*, completed in 1920 and shown for the first time in a movie theater on Broadway in 1921. Sheeler may have used the same camera to make studies of a nude (presumably the model was Sheeler's future wife, Katharine) which survive as a series of ten photographs. These in turn inspired one work in oil (see cat. no. 13) and at least two exquisite drawings.[1]

The dated *Nude*, which shows the figure lying on her side, repeats almost exactly the tightly curled pose Sheeler's model assumed for one photograph in the series. The parallel between photograph and drawing in the case of *Nude Torso* is less exact: the knees are drawn up more tightly in the drawing, and more of the upper body is shown. The monumentality and sculptural presence of these figures are surprisingly neoclassical; Sheeler's carefully controlled outlines and subtle shading, and indeed his very choice of subject, attest to his respect for the academic tradition. His conception in these drawings, however, is more photographic than painterly. Closely framed, the images fill our field of vision. Sheeler's concentration on his subject is so intense and immediate that all sense of scale, and of individuality, disappears. By compressing the poses and smoothing over details so that body parts are indecipherable, and by excluding the most expressive parts of the body – the face and hands – Sheeler eradicated the model's personality and any erotic overtones. The drawings function successfully as pure, abstract design, and are satisfying from whatever direction they are viewed.

Of the two drawings, *Nude Torso* is the more sculptural. There is a stronger sense of directed light, the torso is more fully modeled, and the one physical detail that Sheeler elaborates – the dimple at the elbow – evokes a finely chiseled marble figure. The rough hatching at lower left (which represents the dark velvety cloth against which the figure was posed) creates a shadowed area from which the strongly modeled thigh projects. But the emphatic plasticity of the figure's left side is countered by greater abstraction at right, where the elegant contour of the back dissolves into the creamy whiteness of the paper. The other drawing is even more abstract. Highlights and shadows are evened out, minimizing the sense of directional lighting. No remnant of the black background remains; instead, a finely penciled contour, and pale, regular shading are all that separates the figure from the background. The contour itself disappears entirely at the thigh at right. Here especially the image appears to be less a human figure than a generalized natural form, which, as one scholar has described it, assumes "the monumental impersonality of a sloping hillside."[2]

Both the drawings and the photographs are very small. Their size imparts a kind of preciousness that eliminates any voyeuristic appeal while encouraging private contemplation. The soft medium-gray tones underscore their luxuriousness: the photographs have a warm, velvety, old-masterish aura; the drawings are executed with a control and delicacy reminiscent of silverpoint. And although they are sensuous, the drawings especially have none of the obvious eroticism of the most famous nude images of the era: Stieglitz's studies of O'Keeffe, Weston's photographs of the mid-twenties, Picasso's *Demoiselles*, or Matisse's languid nudes. Rather, they maintain a brilliant tension between ephemeral abstraction and sculptural sensuality. Pale and unaccented, yet with rich, voluptuous contours, Sheeler's evocative marmoreal forms are as much still lifes or landscapes as they are nudes.

1. In 1924 Sheeler drew two other nudes that also may have derived from these photographs. These were loaned to Sheeler's 1939 exhibition at the Museum of Modern Art by Rita Benson. However, their current whereabouts is not known and no photograph or other reproduction has come to light, and so their connection with the present works remains hypothetical.

2. D'Harnoncourt, in *Philadelphia: Three Centuries of Art*, p. 522.

14

15

16

Church Street El
Signed and dated lower right: *Sheeler. 1920*
Oil on canvas, 16⅛ x 19⅛ in. (41 x 48.6 cm.)
The Cleveland Museum of Art. Mr. and Mrs.
William H. Martlatt Fund

Church Street El shows the view from the Empire Building at 71 Broadway in lower Manhattan, with the elevated train at right and the Trinity Church Sexton's Office (at the corner of Thames Street and Trinity Place) at upper center. The painting was based on a sequence in Sheeler's film *Manhatta*, which he made with Paul Strand in 1920. That sequence, like much of the film, describes the tension between the city's history and its present, between architectonic solidity and imminent movement. From the Empire Building's lofty height, the viewer gazes down at the city block behind Trinity Church, which is surrounded by solemn, massive structures. The fixed view is interrupted by the elevated train streaking through the scene at right. Sheeler published stills from *Manhatta* in the April 1922 issue of *Vanity Fair*, including one closely related to *Church Street El*. The image, titled "The Moving Street," bore the caption: "A study in the relation between movement in the street and the stability of the buildings."[1]

Sheeler was not the first American artist to take as his subject New York's new skyscrapers and the stimulating vistas they afforded. Alfred Stieglitz, for example, photographed Burnham and Root's Flatiron Building (1901-3) shortly after it was erected; John Marin painted the Woolworth Building (1913) repeatedly in the teens and twenties. But unlike many of his colleagues, who composed honorific portraits of these new landmarks, Sheeler here and in his other architectural subjects portrayed unadorned, mute façades. Showing buildings from the back, he removed from his scene all architectural elaboration, all picturesque detail, and depicted not Trinity Church, an architectural masterpiece, but the more mundane Sexton's Office. The already blocky buildings become even more regular, abstract shapes; most windows are eliminated; the empty city lot is a flat ochre plane. The Sexton's Office is rendered in a generalized manner; its steeple is drawn in a caricaturish style anticipating Grant Wood's images of the 1930s.

If Sheeler's view of lower Manhattan is deliberately unexceptional, it is also mysterious and insidiously futuristic. On the one hand, Sheeler's buildings are anonymous, even mundane; on the other hand, as he reduces them to simple shapes with elegant, subtly modu-

lated surfaces, they become luminous forms with translucent skins, glowing from within. The plunging perspective (deliberately chosen, Sheeler claimed, to "include the spectator, . . . give him importance")[2] provides a wondrous, streamlined view of the city's grand design. Majestic façades, lightning-fast vehicles, and spires soar out of the field of vision, while dense shadows and bleak masonry walls create a sense of confinement. The scene at once convincingly evokes the actual view and presents an intriguing visual pattern.

The view is also vaguely disorienting. The space is tilted up, pushing the buildings forward, and the vertical lines emphatically articulated by the staccato band of windows at left pull the eye to a point far below the bottom edge of the picture plane. The sensation of vertigo that results is compounded by the discordance of the buildings' ponderous downward motion and the train's rushing up and out of the picture at right, as though independent of the forces of gravity.[3] Finally, Sheeler's treatment of shadows contributes both to the handsome composition and to the sense of unease. Perhaps inspired by the photograph's tendency to record shadows as sharp edged and opaque, Sheeler here gives them a presence as dramatic as the architecture. Although there is no light to suggest time of day, no foliage or passers-by or weather effects to indicate the season, the shadows seem, in accordance with the strong diagonal movement in the picture as a whole, to be creeping forward, signaling the passage of time.

1. *Vanity Fair*, April 1922, p. 51.

2. In Rourke, *Sheeler*, p. 90.

3. This disjunction is aggravated by the fact that, while all the vertical edges of the buildings at left conform to Sheeler's perspective system (that is, all drop to a single vanishing point), the orthogonals defined by the train tracks do not, but remain parallel.

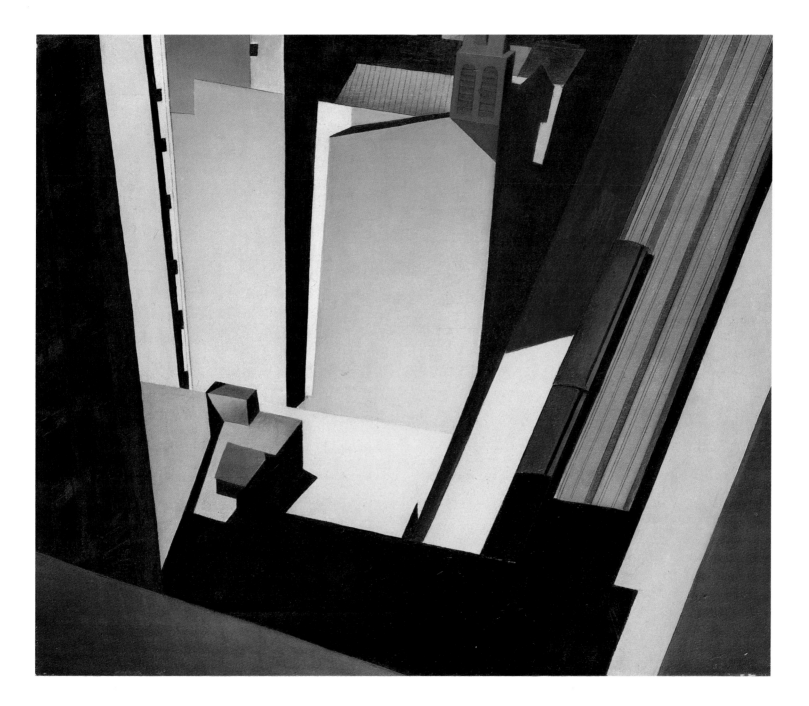

17
New York
Signed and dated lower center: *Sheeler 1920*
Sheeler 1920
Pencil on paper, 21⅝ x 15½ in.
(54.8 x 39.4 cm.)
The Art Institute of Chicago. Gift of Friends
of American Art

18
Skyscrapers
Former title: *Offices*
Signed and dated lower right: *Sheeler 1922*
Oil on canvas, 20 x 13 in. (50.8 x 33.0 cm.)
The Phillips Collection, Washington, D.C.

Beginning around 1920, Sheeler made numerous photographs of New York skyscrapers, some on commission, some resulting from *Manhatta*, the 1920 film on which he collaborated with Paul Strand, and others evidently on his own initiative.[1] Of this last group, he seems especially to have favored the photograph generally known as *New York*, which shows the back of the building at 15 Park Row, seen from the forty-one-story Equitable Building at 120 Broadway. He printed the same photograph in several sizes, cropping it at different points and also altering the size and position of the mat window to arrive at slightly varying conceptions of the image.[2] Shortly after he made the photograph Sheeler used it as the basis for two other pictures: *New York*, a large, highly finished pencil drawing (1920); and the painting *Skyscrapers*, completed two years later, of identical size. These two works testify to Sheeler's continued fascination with this elegantly attenuated composition. While throughout his career Sheeler would explore the same themes and even depict identical subjects in painting and in photography, the close relationship between these three related works in different media is unique in his oeuvre.

The subtle changes Sheeler made from photograph to drawing and oil indicate that in the photograph he sought specificity while in the drawing and painting he attempted a more reductive, idealized view. He eliminated several buildings at the sides of the photograph to narrow the proportions and so describe an even more compact wedge of the cityscape. The serpentine patterns of the building, with deep alleys cutting between them, become an opaque wall. And neither drawing nor painting employs Sheeler's customary symbols of energy and growth. No smoke pours from the chimneys to darken the façades, and the artist has eliminated the cranes at lower center as well as all idiosyncratic or historically distinctive architectural features: gone are the rusticated façade and balustraded balconies of the central wing and the single window on the otherwise blank face of the main building at right. Neither oil nor drawing distinguishes the various building materials so clear in the photograph or shows any dirt or deterioration. In short, in both the drawing and the oil, Sheeler erased all

details that might suggest motion or human activity and tie the buildings to a particular moment.

In the drawing, Sheeler eschewed strong contrasts and instead built his picture from a subtle range of warm, silvery middle tones. He also suppressed the shading along the lower portion of the drawing, defining the rooftops there primarily with penciled outlines: this device minimizes the foreground space so that (even more dramatically than in the photograph), the columnar buildings, energized by the staccato rhythms of their windows, fill our field of vision. In the painting, he employed a luminous palette of reddish browns and ochres — an unusual choice for a representation of modern city buildings. Sheeler used a similar color scheme and technique, with smooth, almost invisible brush strokes, in the contemporary *Church Street El* (cat. no. 16). But where the vertiginous perspective and ominous blacks of that picture convey a thrilling sense of the city, the flat, shallow space and medium tones here give a stolid impression.

In January 1921, Sheeler's photograph was reproduced in *Vanity Fair*. It bore the heading "Cubist Architecture in New York"; the accompanying caption asserted that Sheeler admired these buildings for their efficient design ("The artist felt . . . the beauty of the architectural forms that have been created in New York to meet the fundamental necessity of providing buildings with the greatest cubic area upon the smallest possible base.").[3] The drawing was acquired in 1922, probably from Marius de Zayas, by the Friends of American Art for the Art Institute of Chicago. It represented the artist at Chicago's "Century of Progress" show in 1933, but elicited no comment. In 1926 the painting was acquired from the Charles Daniel Gallery for $400 by Duncan Phillips (who seems to have substituted for Sheeler's original *Skyscrapers* the more prosaic title *Offices*).[4] Phillips, oddly, saw in this picture a commentary on the alienation of city office workers. The windows were "apertures of escape out of the steel-bound canyon"; the view itself, though handsomely rendered, was "unexceptional," a "typical cross-section of the rear of tall buildings, many windowed, in the glare of any sunny afternoon, as one would stare at such a scene from across a city canyon,

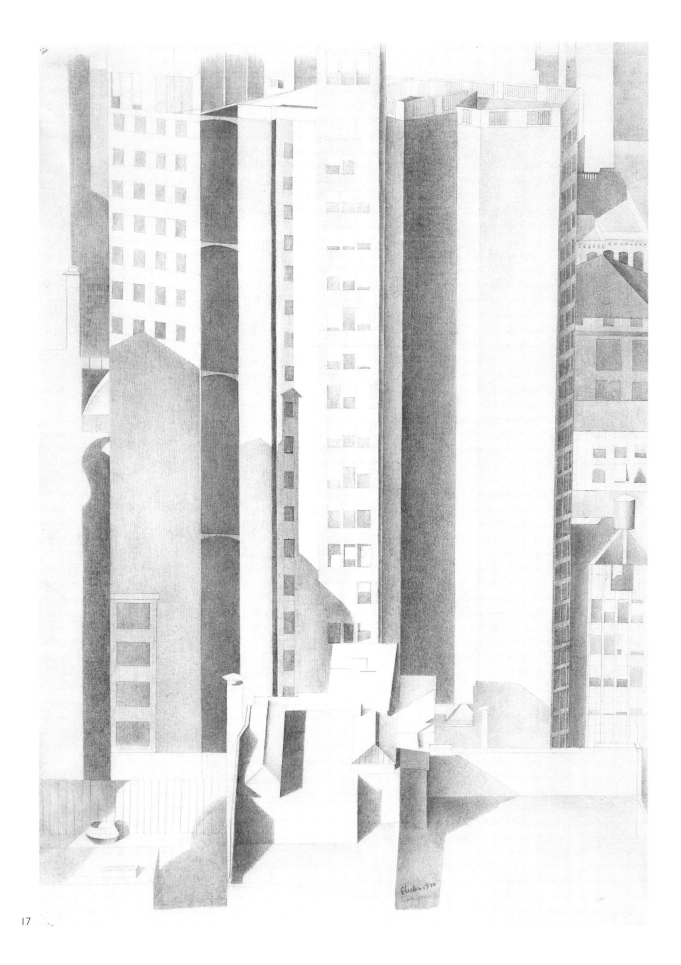

17

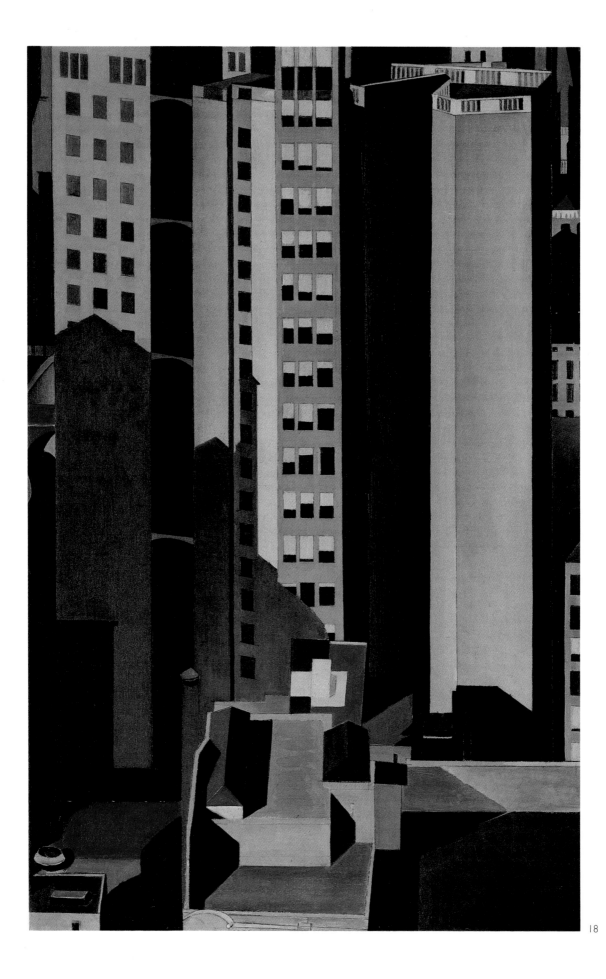

18

while wedged in some other wall of brick and steel."[5]

Probably for Sheeler the skyscraper image was neither a paean to the efficiency of modern architecture nor a protest against urban fatigue. Rather, by choosing undistinguished buildings, and by eliminating all incidental and peripheral detail and all signs of decay, Sheeler apparently wanted to portray a timeless, eternal city. His repeated use of the skyscraper subject in several media demonstrates that he found it a compelling image. In his renditions, cheerless monolithic buildings are transformed into flattened abstract shapes with great formal vitality. The geometric rhythms and vibrant balance of lights and darks in Sheeler's skyscrapers rival the elegance of a Mondrian.

1. Sheeler began his photographic career in about 1912, documenting newly built houses for Philadelphia architects. When he moved to New York in 1919, he again used his camera to record urban architecture, and while he seems personally to have preferred unremarkable, nonhistoric structures, he made many photographs of the city's landmarks, especially the fabulous skyscrapers then being built, each taller than the next. These photographs appeared in various periodicals during the 1920s, most notably as illustrations for Charles Downing Lay's article "New Architecture in New York," *Arts* 4 (August 1923): 67-86.

2. The office buildings that dominate this picture appear as well in several other photographs Sheeler made of this area. See ibid., p. 72.

3. *Vanity Fair*, January 1921, p. 72.

4. An inscription in Sheeler's hand across a photograph of *Skyscrapers* he made for the Daniel Gallery (and so presumably dating before the 1926 sale of the picture to Phillips) gives the painting its present title. "Offices" first appears in Duncan Phillips's *A Collection in the Making*, p. 65.

5. Phillips, "Original American Painting of Today," pp. 199-200.

19

Tulips and Etruscan Vase
Former title: *Demarcation of Forms*
Signed and dated lower right: *Sheeler 1922.*
Pencil on paper, 21¼ x 16 in. (54 x 40.6 cm.)
The Museum of Modern Art, New York.
Given anonymously

20

Suspended Forms (Still Life), 1922
Charcoal, chalk, and watercolor on paper,
19 x 15¼ in. (48.3 x 38.7 cm.)
The St. Louis Art Museum. Bequest of Marie Setz Hertslet

21

Tulips — Suspended Forms
Former titles: *Tulips; Suspended Forms*
Signed and dated lower right: *Sheeler 1922*
Inscribed on reverse: *#3. Tulips - suspended forms./ Charles Sheeler.*
Tempera and conté crayon on paper,
20 x 16 in. (50.8 x 40.6 cm.)
Mr. and Mrs. Carl D. Lobell

This group of still lifes premiered at Sheeler's solo exhibition of paintings, drawings, and photographs at the Charles Daniel Gallery in April 1922 and were singled out by the *New York Times*'s reviewer for special praise. They "wear a brightly deceptive appearance of simplicity and commonplace," it was noted, and represent "hard-won victory and passionate effort to create an original mold of form and an original architecture of design."[1]

The drawings here form half of the original series of six works, variously executed in pencil, conté crayon, colored crayon, and tempera, and showing an assortment of ordinary objects, including a small bouquet of tulips, a cylindrical glass vase, a flat, straight-sided glass dish, and a black Etruscan pitcher.[2] The works range in complexity from the busy *Still Life, Pitcher*, which shows three pieces of fruit, two glass vessels, and the Etruscan vase, to the austere *Tulips and Etruscan Vase*, but in all cases, Sheeler's selection and arrangement of objects was thoughtful and deliberate. These are among the most contrived yet the most pure and elegant still lifes Sheeler created.

The artistic program behind these pictures is hinted at in their titles, which connote measure, separation, and balance. As Sheeler told the critic Thomas Craven early in 1923, his goal was to give his work "the absolute beauty we are accustomed to associate with objects suspended in a vacuum."[3] In his autobiographical notes, he spoke of creating a "group of drawings and watercolors – objects isolated against paper" with the "intention of suspending forms in space without an environment."[4] The sense of reduction and isolation, of the object removed from its context in order to reveal its pure, abstract structure, is a constant in these works. A simple horizontal crayon stroke defines the tabletop: Sheeler's restrained shading, which gives the backgrounds of many of his works a subtle texture and substance, is conspicuously absent here. In some of the pictures, objects cast no shadows. The measured intervals between objects are as vital as the objects themselves. These negative spaces often play a critical role in the picture's design, as in *Tulips — Suspended Forms*, where the oval described by the handle of the Etruscan pot is balanced by its counterpart, formed by the long green tulip leaf.

As a group, these still lifes are also marked by great sophistication and diversity of handling. The most unusual of these is the sketchlike *Tulips and Etruscan Vase*, which is uncharacteristically informal. The drawing is nonetheless carefully controlled and finished, subtle rather than dramatic. Here Sheeler avoided flamboyant linear gestures or stark juxtapositions of dark and light. In certain areas, such as the blossoms, his line is astringent, like an etching stroke, while in contrast, soft hatching defines the stems suspended in the water and the swelling curves of the body of the pot. The opposite effect is achieved in *Tulips – Suspended Forms*. It is a lush picture, emphasizing the voluptuous contours of the Etruscan vase and the provocative red petals of the overripe tulips. *Suspended Forms* combines the techniques and mood of the other two works. The glass vase, the round candies or marbles, and the dish that contains them are sketched simply in conté crayon. The Etruscan vase is subtly modeled in matte brownish-black tempera; its round shape is balanced by the ovoid mass of the apple in the lower corner, which is painted dark red and is very flat, like a cutout.

The importance of these still lifes to Sheeler is reflected in their provenances. *Tulips and Etruscan Vase* was acquired by Abby Aldrich Rockefeller from the Downtown Gallery in 1928. It was the first Sheeler she bought and one of his first works to be offered by the gallery. Sheeler kept *Suspended Forms (Still Life)* and *Leaves, Flowers, and Glass* for his personal collection; they were in his studio at his death. *Still Life, Pitcher* was acquired by Alfred Stieglitz, probably in the early twenties, when he and Sheeler were in close contact (Sheeler had already given him a photograph of an Aztec head).[5] And Sheeler gave the rich, sensuous *Tulips – Suspended Forms* to the poet William Carlos Williams, whom he met about the time he was working on these still lifes, and who would remain a lifelong friend.

1. "Charles Sheeler," *New York Times*, April 9, 1922.

2. The other three drawings are *Still Life*, in graphite, charcoal, and colored pencil (1922; Norton Gallery of Art, West Palm Beach, Fla.), *Still Life, Pitcher*, in conté crayon (1922; Van Vechten Art Gallery, Fisk University, Nashville) and *Leaves, Flowers and Glass*, in conté and colored crayon (1922; location unknown).

3. In Craven, "Charles Sheeler," p. 71.

4. Sheeler Papers, 1811:750.

5. See Sheeler to Stieglitz, December 5 (no year), Stieglitz Archive.

19

22

Pertaining to Yachts and Yachting
Inscribed on reverse: *Pertaining to Yachts and Yachting/Charles Sheeler/1922*
Oil on canvas, 20 x 24 in. (50.8 x 61 cm.)
Philadelphia Museum of Art. Bequest of Margaretta S. Hinchman

23

Pertaining to Yachts and Yachting – Study
Inscribed on reverse: *Pertaining to Yachts and Yachting/Charles Sheeler/1922*
Colored crayon and pencil on paper,
19 x 24½ in. (48.3 x 61.6 cm.)
Lent by the Whitney Museum of American Art, New York. Purchase

In the early twenties, the photographer Paul Strand wrote to Alfred Stieglitz about several motion pictures he hoped to make, some of them with Sheeler, his collaborator on the 1920 film *Manhatta*. These included a film of athletes in motion, and another about the New York Yacht Club.[1] Although these ventures never materialized, Strand's second proposal likely caused Sheeler to familiarize himself with the Yacht Club's graceful sailboats. He may have even photographed them, although no such photographs survive.[2] Just as Sheeler's work on *Manhatta* inspired him to paint New York's skyscrapers, so this project prompted him to undertake a number of pictures of sailboats. Rendering these handsomely designed vessels was a challenge Sheeler clearly enjoyed meeting, for he produced at least six variations on the theme in the early 1920s (including a lithograph, the second of his six prints [fig. a]) and returned to it at least three times in the late 1940s.[3]

Of these, the large drawing and the oil, both known as *Pertaining to Yachts and Yachting*, are the most ambitious, and the most successful. The drawing is a full-scale preparatory study for the oil, and in it the two hulls, the myriad sails, the riggings, and their shadows are rendered precisely as they appear in the painting. But in the oil, the hulls of the boats lose their portholes and evolve from playful, toylike forms into sleek abstract shapes, and the rolling waves and the clear sky take on more substance. Likewise, the delicate blue and rust color scheme of the drawing becomes more forceful in the oil. There pencil is used to reinforce the edges of the sails, and the drawing's animated surface pattern is adapted to suggest the scene's glittering light: the sails seem luminous, glowing from within; at the same time, they sparkle in the sun and reflect light glancing off the waves.

Sheeler not only captured the graceful silhouettes of these yachts but also expressively evoked their movement. Their masts and rigging are summarily rendered, and the sails – multiplied and enlarged beyond the requirements of the vessels they propel – float free from the decks. The great triangular wedges of canvas strain forward, in keen anticipation of the finish line. Arranged in parallel formation across the picture's space, they form a diagram of sequential motion, for what at first appears to be a fleet of sailing ships is in fact only a few vessels.

Both drawing and painting have distinguished provenances. The oil was acquired in 1927 by Sheeler's friend and fellow artist Earl Horter, whose collection of Sheelers also included *Flower Forms*, *Nude*, and *Stairway to the Studio* (cat. nos. 13, 14, and 28). The drawing, which according to legend only the intervention of Marius de Zayas prevented Sheeler from destroying,[4] was later sold by the dealer to Juliana Force, the Whitney Museum's first director.

1. See Strand to Stieglitz, undated letter and letter of July 9, 1923, Stieglitz Archive.
2. Patterson Sims (*Sheeler*, p. 15) has described the Whitney's drawing in photographic terms: "Stills of the boats' movement are compressed within a single frame."
3. In addition to these two pictures, there are three drawings depicting yachts, at least two of which (untitled [*Yachting*], c. 1922; Coll. Robert Rosenberg, Weston, Mass.; and possibly *Yachts*, 1923; formerly Coll. Mrs. Thomas Metcalf, current location unknown) relate to the Philadelphia oil; another drawing (untitled [*Yachting*], 1924; private collection), relates to the 1924 lithograph *Yachts*. Sheeler returned to the theme in the late forties and executed at least three works depicting sailboats: *Wind, Sea, and Sail* (cat. no. 71, fig. a), *Wings* (cat. no. 71); and *Wings #2* (1949; National Gallery of Canada, Ottawa).
4. Conversation with William H. Lane, July 1986.

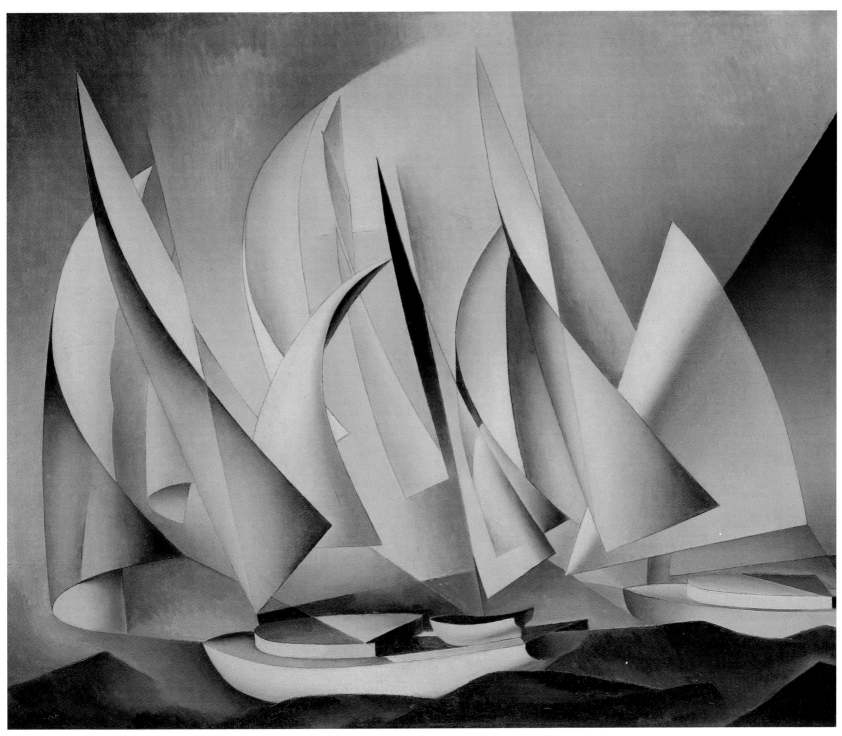

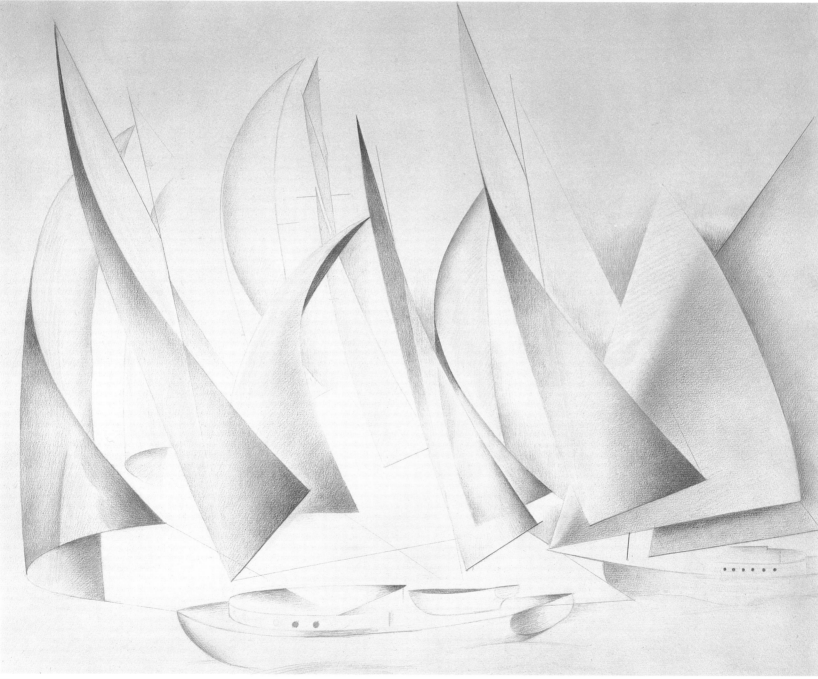

23

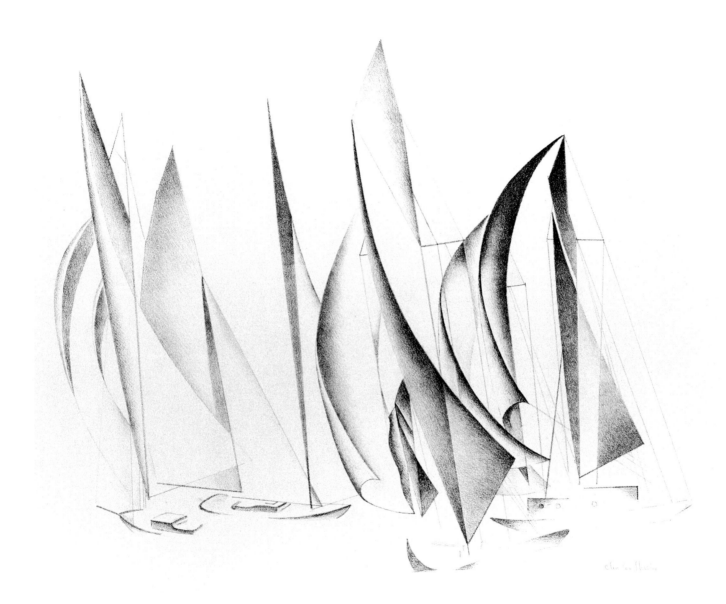

Fig. a. Charles Sheeler, *Yachts*, 1924, lithograph, Amon
Carter Museum, Fort Worth, Tex.

24

Chrysanthemums
Former titles: *Dahlias and White Pitcher; Still Life with Dahlias*
Signed and dated lower right: *Sheeler 1923.*
Gouache and conté crayon on paper,
25½ x 19 in. (64.8 x 48.3 cm.)
Columbus Museum of Art. Gift of Ferdinand Howald, 1931

In about 1925, Sheeler wrote an essay on still life painting that served as a credo for his own works of the period. Writing of Cézanne and other painters he especially admired, he noted that they, "by an intensive and selective realism, have caused our eyes in conjunction with our minds, to convert the realistic presentation into a design of various contrasts of visual qualities based upon a geometric structure."[1]

The geometry and the visual contrasts of *Chrysanthemums* are readily apparent. Cones, squares, and a somewhat bulbous cylinder are the dominant shapes; the contours of the glass and the graceful ironstone pitcher, familiar from several other of Sheeler's still lifes of the period, are clean and regular; the arrangement of forms is centralized and iconic. The two stems of autumn flowers are so vividly depicted that one nearly smells their musty perfume. To evoke the velvety, pollen-dusted texture of the rust-colored chrysanthemums, Sheeler emphasized the matte quality of gouache, while many of the petals of the white flowers, less full and sturdy, are rendered in conté crayon outline, making those blossoms seem all the more feathery by contrast. The flowers are fanned out in a carefully ordered arrangement (the dark ones arching out toward the viewer, the white ones turned away), echoing the balance between the rather aggressively placed, heavy-footed goblet and the slender, inward-turning handle of the pitcher below.

Chrysanthemums has been described as a still life typical of the artist in its contrast of natural and geometric forms.[2] But in fact Sheeler's chief concern here, as elsewhere, was the contrast between the world of observed reality and the world of art, between the physical, three-dimensional solidity and logic of the forms he sought to describe and the demands of the two-dimensional picture space. It was a concern he shared with Cézanne, and like Cézanne, too, he revealed not only the tension in that contrast but also the wit. Thus the pitcher and glass are firmly placed but nonetheless threaten to slide forward on the slick, tilted-up aqua square beneath them. The viewer is given something of a worm's-eye view of the still life, so the pitcher and glass seem attenuated and the leggy stems and untidy blossoms seem to stretch beyond the upper limits of the picture space. The ambiguous colored squares on which the pitcher rests are textured and solid, while the tabletop has no substance at all. In another paradox, pitcher and glass cast soft shadows – inconsequential ghostly shapes – on those squares, but not on the pale wall behind.

Chrysanthemums was one of a half-dozen large, ambitious still lifes Sheeler painted in 1923 and showed at his first solo exhibition at the Whitney Studio Galleries the following year. It was subsequently purchased for $500 from Ferdinand Howald, Sheeler's principal patron in those years. It was the fifth still life by the artist to enter Howald's collection.

1. Sheeler, Forbes Watson Papers, D56:1094. The essay was never published.
2. See Parker, "The Classical Vision of Charles Sheeler," p. 68.

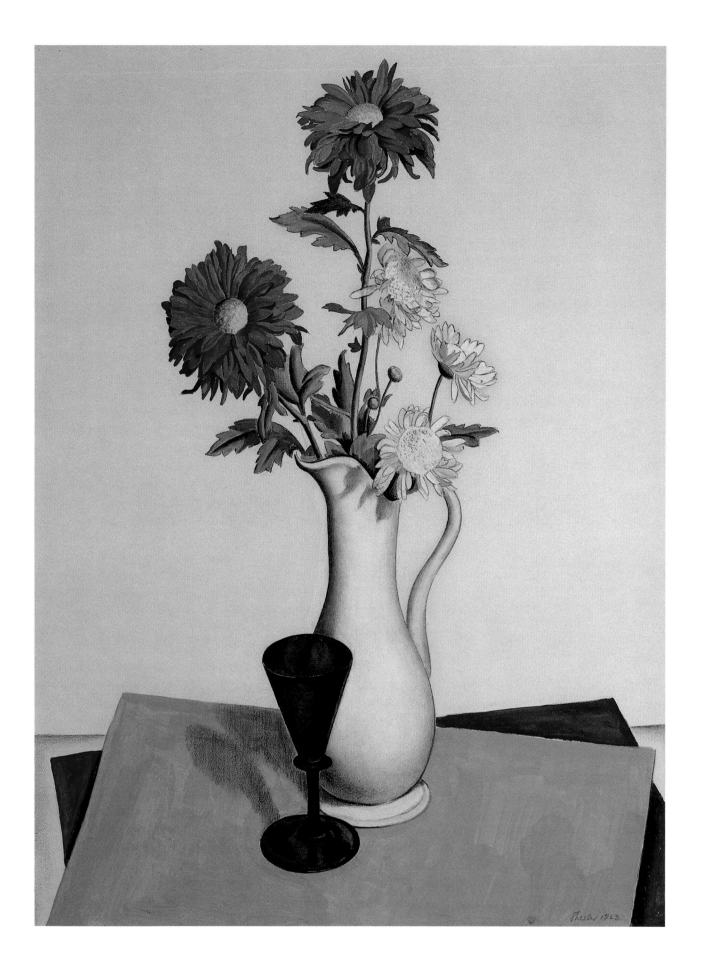

25

Self-Portrait
Former titles: *Still Life; Audubon 451-*
Signed and dated lower left:
Charles Sheeler 1923.
Conté crayon, gouache, and pencil on paper,
19¾ x 25¾ in. (50.1 x 65.4 cm.)
The Museum of Modern Art, New York. Gift
of Abby Aldrich Rockefeller

Beginning with *Flower Forms* (cat. no. 13), Sheeler adopted the practice of using bland, neutral titles to distance himself from his most personal works. This famous image, now known as *Self-Portrait*, was originally exhibited with the simple title *Still Life* and subsequently was called *Audubon 451-*, which has since been identified as the beginning of Sheeler's telephone number. It probably was not until 1931, when Abby Aldrich Rockefeller bought the drawing from the Downtown Gallery, that it was given the title by which it is now known.[1] The title has led to much speculation about the meaning of the drawing, and the picture has been treated more like a cryptogram than a work of art.

Self-Portrait reveals Sheeler as a master of compositional design. The window cleverly conforms to the framing edges of the drawing, creating a neat pun on the notion of a picture as a window onto reality. The table becomes a ledge extending into the viewer's space, thrusting the telephone forward. Sheeler conceived the drawing in black and white but made subtle use of reddish-brown tempera in the figure's face and jacket (the color in this drawing is overlooked even more often than the figure in the window), adding richness and warmth to the composition. The dark-light contrasts (and in certain areas the dextrous rendering of darks against darks and white against white) that establish the drawing's structural rhythm also cause the figure to retire, while emphasizing the iconic prominence of the telephone. Mediating between the ephemeral figure and the solid telephone are the cords of the telephone and the window shade, which snake animatedly through the left half of the picture. The serpentine patterns they trace are complicated by their shadows,

which (as often occurs in Sheeler's renderings), do not exactly reflect the twists and loops made by the cords themselves.

Although the subject of this drawing quite possibly was suggested by the most mundane of circumstances — Sheeler sitting down at his table to make a call and noticing his reflection in the window opposite — Constance Rourke, who provides the best commentary on this picture, calls it fantasy, a fable, an allegory of the relationship between the artist and his subject.[2] Here Sheeler consciously chose a role of self-effacement, for which the reflected image of a figure, presumably the artist, his face obscured by a half-lowered shade, was an ideal metaphor. That notion is amplified by the image of the telephone: like Sheeler's art, a telephone communicates — replicates life — in the absence of an actual human presence. The instrument, bearing Sheeler's number, has been identified simply as Sheeler's alter-ego, a technological form with special appeal to the machine age sensibility, an image associated with Charles Demuth's poster portraits and with Francis Picabia's mechanomorphs. The drawing thus has been explained as "evidence of the artist's thorough understanding of New York Dada"; and indeed, the drawing was admired by the master of New York Dada, Marcel Duchamp, to Sheeler's great satisfaction.[3]

It has also been noted that the window here functions as a mirror, a traditional device in artists' self-portraits, and that the vertical strip shown in the window represents Sheeler's drawing board, which he customarily held on a strict perpendicular when he worked. Other explanations suggest themselves. The window, an emblem Sheeler would often use to evoke either a barrier or a transition to an uncertain future, here shows nothing but a figure's reflection: the artist thrown back on his own resources, as it were. The figure whose features are not visible, the vertical element, and the empty chair on the other side of it evoke the solemnity and anonymity of the confessional. *Self-Portrait*, for all its cleverness, is at base an expression of loneliness, as indicated by the isolation of the figure of the artist and the encasement of his reflection in the glass. At the same time, the portrait suggests an ambivalence about being exposed.

Sheeler probably made this drawing in Janu-

ary 1923,[4] when he was almost forty years old. Although he had won some recognition since arriving in New York a little over three years earlier, it was as much for his photography as his painting.[5] By the beginning of 1923, many of his friends and supporters were withdrawing from the New York art scene: Duchamp left for an extended stay in Paris shortly after this drawing was completed; Marius de Zayas's gallery had been closed for over a year, and his art collection (which Sheeler had photographed) would be sold that March; the Arensbergs, Sheeler's first great patrons, had resettled in California; and Sheeler's association with Juliana Force and the Whitney Studio Club was just beginning. *Self-Portrait* expresses the vulnerability Sheeler no doubt felt at this time, and beyond its other meanings the drawing could be read as an appeal from an artist for recognition and understanding. The telephone, its cord twisting energetically from the receiver, is pushed out toward the viewer. The window shade's cord also suggests an invitation, either to bring the shade down, obscuring the artist's image entirely and so, in Rourke's words, completing his self-effacement, or to raise the shade, bringing the artist, and by extension his art, into fuller view.

1. The drawing was first publicly exhibited in Paris, at the Durand-Ruel galleries ("Exposition de [sic] Tableaux par Charles Demuth, Walt Kuhn, H. E. Schnackenberg, Charles Sheeler, Eugene Speicher, Allan Tucker, Nan Watson") in November 1923 under the title *Nature Morte — Telephone*, and in January 1924 at the Whitney Studio Galleries as *Audubon 451-*. A letter of April 16, 1931, from Edith Gregor Halpert in the Museum of Modern Art's files is the first known mention of the drawing as a self-portrait ("The Sheeler drawing recently acquired by Mrs. Rockefeller, called Self-Portrait, was exhibited in a special American show."). I am grateful to Olive Bragazzi for the information about Halpert's letter.

2. See Rourke, *Sheeler*, p. 96.

3. Yeh, *Sheeler and the Machine Age*, p. 100. See also her earlier article, "Charles Sheeler's 1923 'Self Portrait,'" pp. 106-9, and Rourke, *Sheeler*, pp. 94-95.

4. Or prior to the February 1923 departure of Duchamp, who admired the drawing in Sheeler's studio before leaving New York for Paris.

5. Sheeler had had exhibitions at de Zayas's galleries in 1917 (photographs) and 1920 (paintings, drawings, and photographs) and at Charles Daniel's gallery in 1922. Several photographs, but only one painting (*Church Street El*), had been reproduced in *Vanity Fair* between 1920 and 1922.

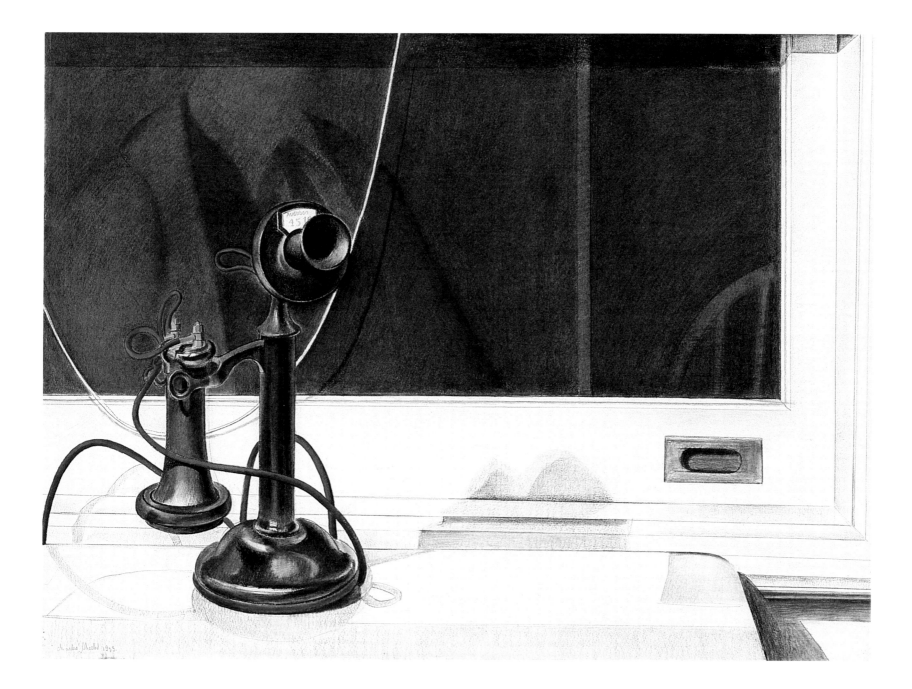

26
Bucks County Barn
Signed and dated lower right:
Charles Sheeler/1923
Tempera and crayon on paper, 19½ x 25½ in.
(49.5 x 64.3 cm.)
Lent by the Whitney Museum of American
Art, New York. Gift of Gertrude Vanderbilt
Whitney

Sheeler became intensely interested in the in-digenous architecture of Pennsylvania in the late teens. At that time, he was living in Phila-delphia and spending weekends in the area around Doylestown, photographing and drawing Bucks County's eighteenth-and early-nineteenth-century houses and barns. He pro-duced nearly two dozen pictures of barns in 1917-18 alone. He then set the subject aside and concentrated on tabletop still lifes, an in-vestigation that culminated in 1922 with the "Suspended Forms" series (see cat. nos. 19, 20, and 21), in which he attempted to find "the ab-solute beauty we are accustomed to associate with objects suspended in a vacuum."[1] Sheeler also applied this aesthetic principle here, con-structing a composition of delicately colored, carefully sculpted ordinary objects floating in a sea of space.

Sheeler clearly identified with the nameless builders who erected these barns. He spoke at length of the structures' impressive beauty, which he found directly related to their utility: "The shapes of the early barns of Bucks County . . . were determined by function; one sees that, feels it. The strong relationship be-tween the parts produces one's final satisfac-tion." He further explained that, like those builders, his goal for his pictures was a con-struction so clear and harmonious that the viewer would be unaware of the contrivance of the maker: "I would arrive at the picture which I eventually hope to paint through form that is architectural, whether the subject is buildings or flowers, set forth with the utmost clarity by means of a craftsmanship so ade-quate as to be unobtrusive."[2]

It is no coincidence that *Bucks County Barn* was painted at the height of Sheeler's involve-ment with classical art,[3] for this humble com-plex is presented as an ideal form, an arrange-ment so perfect it seems preordained. But if Sheeler imbued an unexceptional building with the stature of a classical monument, he also created an image that is extraordinarily mod-ern and innovative. *Bucks County Barn* is a trea-tise on the interplay between pictorial fact and pictorial illusion. By floating his structure on an empty field, Sheeler prevents the viewer from succumbing entirely to its illusionism. The barn appears collagelike, a cutout pasted on a blank sheet; its elegant silhouette flattens the building

just as its textures, shadows, and ponderous geometric shapes suggest volume. Once again shadows are as substantial as the structure's cubic masses, and the richly worked, sun-drenched surfaces — the walls of warm Penn-sylvania fieldstone, the bleached wood siding, and the rosy gray rectangular shingles — not only provide textural variety but play an active role in the drawing's design.

Finally, as in so many of Sheeler's images, beneath the classical stringency and formal restraint of *Bucks County Barn* is an emotional element. Compared to his barns of 1917-18, the structure shown here is unusually closed: the façades are blank and sheer like castle walls, permitting no entry. The doors are tiny, the two equally minuscule windows are shut-tered. And the neutral wintery tones, unre-lieved by the accents of red, ochre, or aqua that Sheeler used frequently during this pe-riod, impart to the drawing a quietly elegiac quality.

1. In Craven, "Charles Sheeler," p. 71.
2. In Rourke, *Sheeler*, pp. 97-98.
3. Sheeler photographed Marius de Zayas's collection of classical art in 1923 in anticipation of the latter's collection sale at Anderson Galleries that year. He subsequently in-stalled and photographed an exhibition of Greek art at the Whitney Studio Club and wrote a compelling essay on the subject, which appeared in *The Arts* in March 1925.

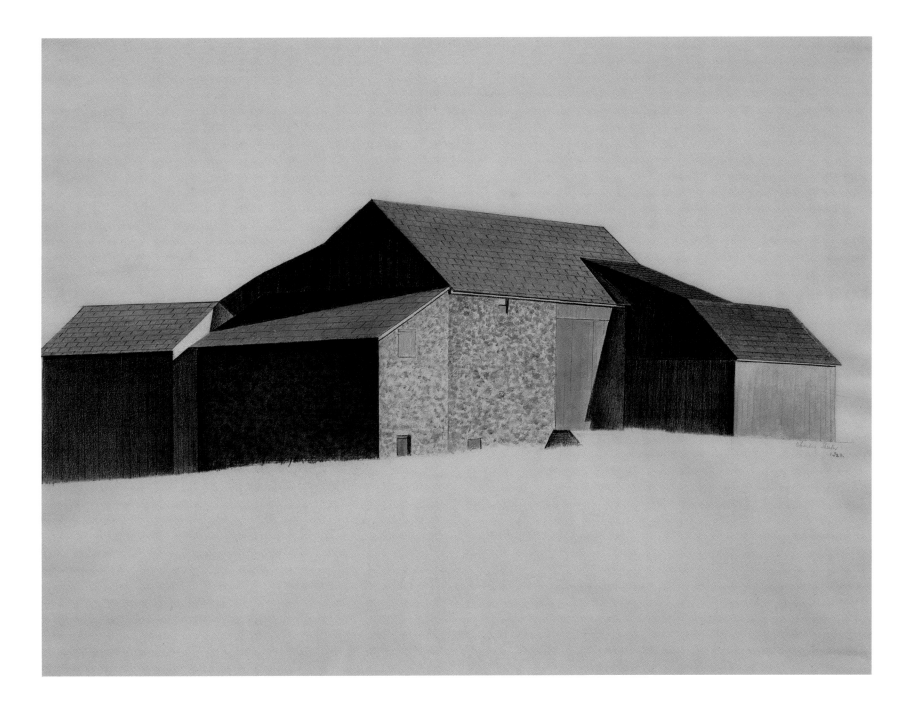

27

Still Life and Shadows
Former titles: *Still Life No. 1; Still Life with White Teapot; Objects on a Table*
Signed and dated lower right: *Sheeler 1924.*
Conté crayon, watercolor, and tempera on paper, 31 x 21 in. (78.7 x 53.3 cm.)
Columbus Museum of Art. Gift of Ferdinand Howald, 1931

In 1925 Charles Daniel wrote to Ferdinand Howald, the Ohio industrialist, to offer him "a remarkable large colored crayon" drawing by Charles Sheeler. Howald had already purchased four Sheelers from Daniel and continued to express interest in the artist. To stimulate that interest, the dealer cautioned him, "Sheeler has not done much work in Painting, his Photography taking so much time, and we might not have an opportunity later [to secure a work of such quality]."[1] Shortly thereafter, Howard bought *Still Life and Shadows* from Daniel for $500; it was to be his most expensive Sheeler, and it was the artist's most lucrative sale to date.

Daniel's warning to Howald was somewhat exaggerated, for despite extensive commitments as photographer-in-residence for the Whitney Studio Club and frequent assignments for *The Arts*, Sheeler in those years was quite prolific as a painter. In 1924 alone, he produced at least twenty-five works, including four oils and several large-scale, highly finished compositions in pastel or tempera and conté crayon on paper, of which *Still Life and Shadows* is the best known. Still, his photographic career did affect his work as a painter: Sheeler himself occasionally spoke of the frustrations of having time to paint only in the evenings, for example, which deprived him of the opportunity to work in natural light. Not infrequently, the techniques of the photographic studio found their way into his drawings and paintings: one scholar explains the apparently disparate sources of illumination in the present picture as a carryover from the photographic practice of lighting the subject from several different angles.[2] With the strong light in this picture – Sheeler possibly used a photographer's lamp – the pitcher, the goblet, and especially the table cast the deep shadows in which he consistently delighted. Here the still life is as much on the wall behind as it is on the table. The crisscrossed lines and intersecting planes evoke forms reminiscent of Sheeler's Bucks County barns or his New York skyscrapers and are prophetic of the shrouded camera in *View of New York* (cat. no. 42).

The photographic scrutiny in *Still Life and Shadows*, the apparent precision and objectivity with which forms are rendered, are furthermore a mask for Sheeler's wit, and for the liberties he enjoyed taking with reality as the viewer thinks he perceives it. These liberties are admirably discussed in a 1976 essay by Anne d'Harnoncourt:

> The light operates at the artist's will: while the wine glass and the graceful teapot cast emphatic shadows, the octagonal plate is not obliged to do so, and the three visible table legs and their perversely invisible companion create an illogical but pictorially satisfying web of shadows shooting in all directions. The band of Oriental carpeting along the bottom edge is as neat a device as ever a Cubist devised for forcing a determinedly three-dimensional perspective back into the flat picture plane.[3]

1. Daniel to Howald, August 15, 1925, Object Files, Columbus Museum of Art.
2. See Yeh, *Sheeler and the Machine Age*, p. 125.
3. D'Harnoncourt, in *Philadelphia: Three Centuries of Art*, pp. 526-27.

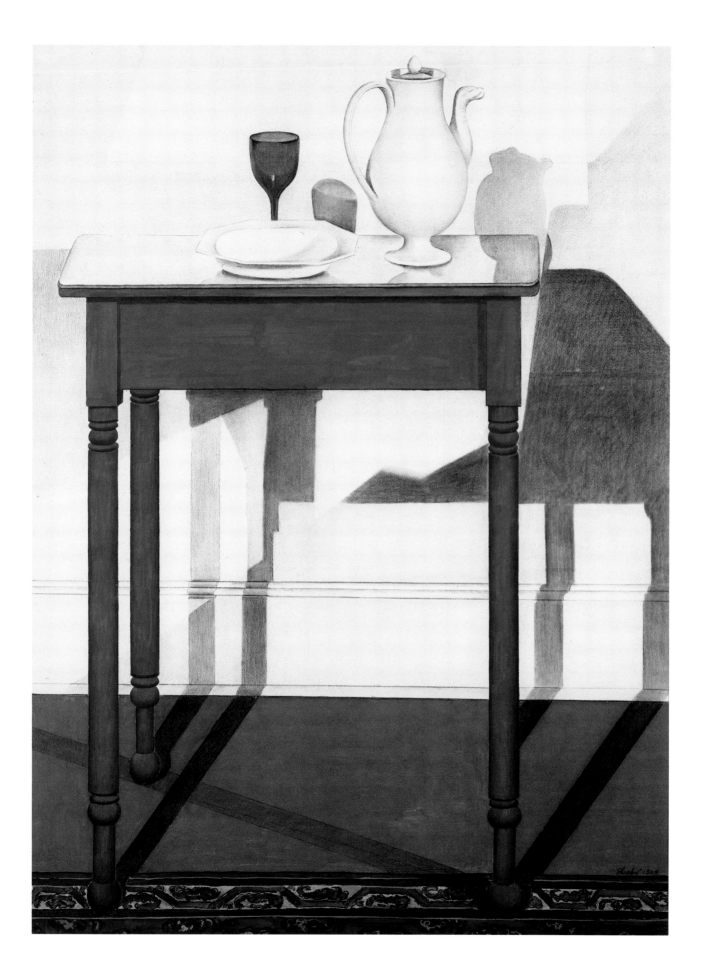

101

28

Stairway to the Studio
Signed and dated lower right:
Charles Sheeler 1924.
Conté crayon and tempera on paper, laid on
board, 25⅜ x 19¾ in. (64.4 x 50.2 cm.)
Philadelphia Museum of Art. Bequest of
Mrs. Earl Horter in memory of her husband

During the summer of 1923, Juliana Force invited Sheeler to occupy a studio at 10 West 8th Street, above the galleries of the Whitney Studio Club, of which she was then director. Sheeler's involvement with the club's activities increased dramatically from that point: in the first three months of 1924 alone, he organized an exhibition of modern European and American art, photographed the club's inaugural exhibition of folk art, and had his first solo show there, featuring twenty-two paintings and drawings. In the same year, he made this large-scale drawing of the stairway leading to his new home.[1]

Prior to *Stairway to the Studio*, his most recent work had been a group of tabletop still life drawings in the same large format (larger, in fact, than most of his oils to date). These ambitious pictures were mostly executed in crayon, tempera, or pastel, and whether intense or pale were fully colored. But for *Stairway to the Studio*, Sheeler returned to the subtle, near-monochrome palette of the most personal of these large drawings, his *Self-Portrait* of 1923 (cat. no. 25), conceived, as is this picture, largely in black and white, augmented by areas of chocolate-brown tempera.

With its unremarkable subject matter and subdued palette, *Stairway to the Studio* seems somewhat static, even bland. Sheeler's method of construction enhances that impression: apparently he used a ruler rather than drawing freehand. The space he describes seems thoroughly logical, organized according to classical doctrines of single-point perspective. Yet the drawing's apparent orderliness is belied by deliberate inaccuracies in the perspective: the handrail, the baseboard moldings, and the balcony railings define several different vanishing points. These subtly shifting vantage points generate a sense of insecurity, unease. Stability gives way to motion: the viewer perceives the stairs as though he were climbing them; the emphatic, zooming orthogonals simultaneously seem to suck him in and thrust him forward. The strong, straight lines of Sheeler's drawings create an image that is at once dizzyingly three-dimensional and emphatically abstract, patterned, and on the surface. The space throbs with contradictory motion.

Sheeler's handling in *Stairway to the Studio*, which underscores the mysterious, confining nature of the space, suggests that he may have had an emotional agenda for the drawing as well as an artistic one. As one ascends, the lines become fainter and the shading softer, and so the space seems more ephemeral. The composition emphasizes constriction: the stairwell is narrow, with walls rising sharply on either side, and the heavy railings of the balcony converge at an extreme diagonal at the base of the stairs. The gate stretched across the head of the stairs bars access to the subject announced by Sheeler's title: the artist's studio. Thus the stairway, with its disconcerting, ambiguous space and its barrier to entry, becomes a metaphor for Sheeler's diffidence about the creative process, for his own insecurities about art-making, and for his insistence that the product of that process speak for itself.[2] In this case, the product is a subtle essay on Sheeler's principal artistic concern of the 1920s: the tensions between first appearances and deeper perceptions, and between palpable reality and complex, evocative abstract design.

Although Sheeler sold *Stairway to the Studio* to fellow Philadelphian Earl Horter sometime around 1930, he long maintained that it was one of his favorite works.[3] He returned to the subject, and to the trapezoidal shape, which so effectively expressed the tension between spatial recession and surface pattern, in a photograph of a stairwell made ten years later at Colonial Williamsburg.

1. In a letter from Constance Rourke to Sheeler dated January 31, 1938, the drawing is referred to as "the Whitney staircase" (Sheeler Papers, 1811:172).

2. In an often-quoted maxim, Sheeler asserted: "I have come to favor the picture which arrives at its destination without the evidence of a trying journey, rather than one which shows the marks of a battle. An efficient army buries its dead" (Sheeler Papers, NShl:89).

3. See Rourke, *Sheeler*, p. 166.

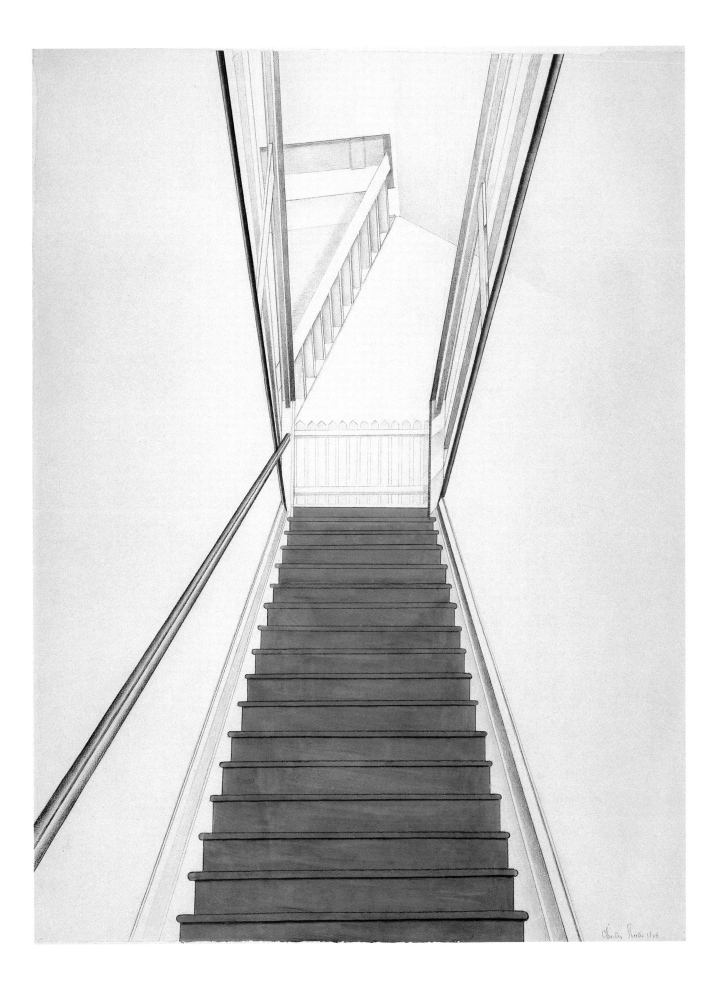

29

Staircase, Doylestown
Signed and dated lower right: *Sheeler-1925.*
Oil on canvas, 25⅛ x 21⅛ in.
(63.8 x 55.6 cm.)
Hirshhorn Museum and Sculpture Garden,
Smithsonian Institution, Washington, D.C.
Gift of Joseph H. Hirshhorn Foundation, 1972

Staircase, Doylestown was the major work in oil Sheeler produced in 1925. It was first exhibited, along with works by Louis Lozowick, at J. B. Neumann's New Art Circle early in 1926 and subsequently was chosen by Alfred Barr for a show of "Progressive Modern Painting" at the Wellesley College Art Museum. The young Lloyd Goodrich, then a critic for *The Arts*, praised the sense of space in Sheeler's pictures and his "intense concentration on the visual reality of objects, which leads him to see and paint aspects of the outside world that no other painter seems to attempt."[1] Most of the other subjects Sheeler addressed while working on *Staircase, Doylestown* were more conventional. He continued his series of tabletop still lifes (see cat. no. 30), which had become a specialty, and embarked on a group of rural landscapes based on summer visits to Vermont and Cape Cod.

A more meaningful stimulus proved to be Sheeler's Doylestown cottage, a tiny two-story stone farmhouse built in 1768, which he began renting as a weekend retreat about 1910 and only relinquished in 1926.[2] Sheeler had made many photographs of the house in the 1910s. Two of those, which show the stairwell, record some of the abstract structures that so fascinated the artist in *Staircase, Doylestown,* the first work in oil in which he detailed any features of the house. One photograph in particular (fig. a), which shows the underside of the stair leading to the attic, closely parallels the upper part of the painting. In both the photograph and the oil, Sheeler celebrated the swirling motion of the stair and used the apparent lucidity of the architectural elements to disguise his imaginative distortion and complication of the space. But while the photograph evokes a secret, narrow, intimate space,

Fig. a. Charles Sheeler, *Doylestown House: Stairs from Below,* 1917, gelatin-silver print, The Lane Collection

the staircase in the oil, with its double twists and turns, greater breadth, and energetic elaboration of perspective, is monumental and expansive, recalling Sheeler's great architectural subjects of 1920-22.

Staircase, Doylestown marks an exuberant return to that earlier aesthetic, following three years in which the artist concentrated on still life. As in *Church Street El* (cat. no. 16), Sheeler used a warm, glowing palette and built his composition on a shifting, moving space rather than a static one. Here, too, he manipulated the scale of different features of his picture for expressive effect. The treads of the steps fan out in a complex serpentine pattern, so the staircase reveals its underside; the viewer simultaneously looks up at the broad, winding steps and down at the impossibly small table, whose bright red legs and jaunty black top are deliberately tilted at an illogical angle inconsistent with the rest of the space. Without sacrificing the stability of the composition, Sheeler's

inventive perspective, based on a carefully worked-out structure of multiple vanishing points, creates a remarkable sense of energy: the house seems to be rolling like the deck of a ship.[3]

The first owner of *Staircase, Doylestown* was historian and critic Matthew Josephson, whom Sheeler had known since 1923. Josephson had owned another Sheeler, a still life, which he had unsuccessfully tried to save in a fire that destroyed his house in 1930. Moved by the story of Josephson's rescue attempt, Sheeler selected *Staircase, Doylestown* for him as a replacement.[4] It remained in Josephson's collection until 1967, when it was acquired by Joseph Hirshhorn.

1. Goodrich, "New York Exhibitions: Sheeler and Lozowick," pp. 102-3.
2. See Davies, "Sheeler in Doylestown," pp. 135-36.
3. Sheeler's analysis of the picture alludes to this combination of energy and order: "Two things are going on at the same time in the picture, irrelevant to each other but relevant to the whole, one in the room downstairs, one leading to the room upstairs. I meant it to be a study in movement and balances" (in Rourke, *Sheeler,* p. 108).
4. Josephson to Abraham Lerner, August 24, 1969, Archives of the Hirshhorn Museum and Sculpture Garden.

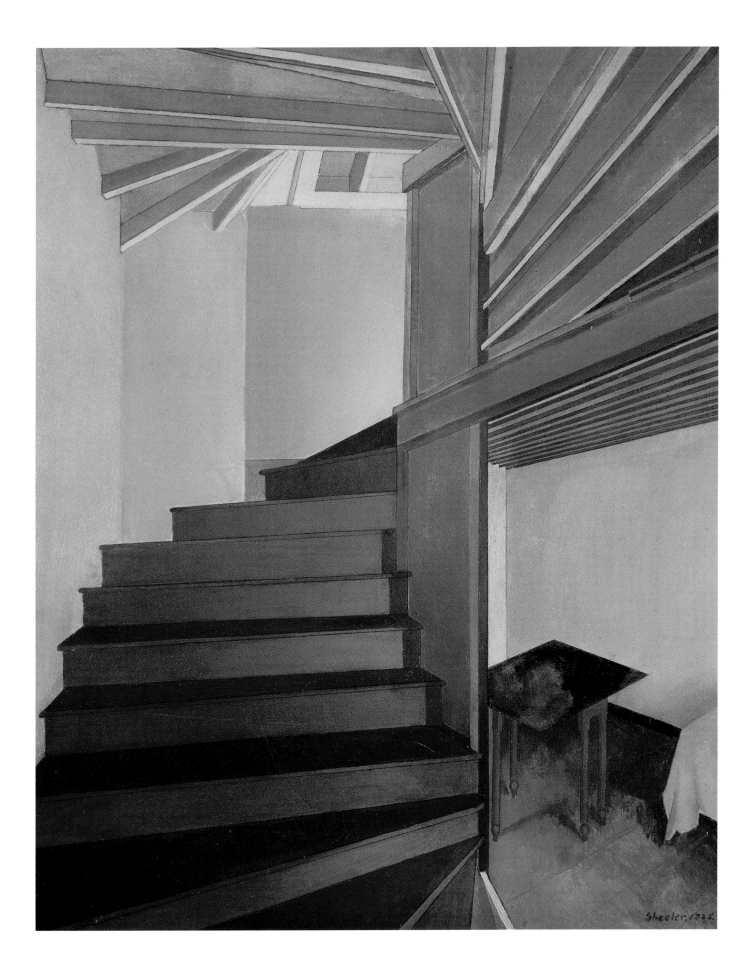

30

Red Tulips, 1925-26
Signed lower right: *Sheeler.*
Oil on canvas, 30 x 20 in. (76.2 x 50.8 cm.)
James Maroney, New York

The remarkable series of still lifes Sheeler produced in the mid-1920s were constructed from deceptively simple means. He generally used a traditional formula: fruits or flowers arranged on a tabletop, supplemented by simple articles of furniture, glassware, and pottery. He painted the same forms repeatedly: the glass vase holding the tulips occurs in at least one other still life he made during this period; the dark green goblet (or a close variant) appears in as many as four contemporary paintings; and the octagonal table apparently made its debut in a 1925 composition featuring tulips and yellow irises (fig. a) and subsequently was used in three other paintings executed in 1925 and 1926.[1]

These ordinary domestic items were in fact part of Sheeler's growing collection of early American furnishings. The octagonal table is a candlestand, a late-eighteenth-century object that (according to the prevailing taste for high-style forms) would not have seemed particularly distinguished to Sheeler's contemporaries. It was, in fact, a production-line item devoid of all fancy carving: the only decorative feature is the curved molding defining the table's edge. The objects Sheeler painted again and again in the 1920s were consistently plain — the flowers were never exotic species, the glassware and furnishings were distinguished by their proportions rather than by surface embellishments — and he rendered them in an understated, self-effacing way.

Red Tulips is one of Sheeler's most elegant still lifes, with pleasing contrasts between crisp, sensuous outlines and softly painted, opalescent passages. Thinly brushed in delicate color (even the usually assertive reds and greens are darkened and muted), and with a slightly dry surface, the painting reveals both Sheeler's sensuality and his restraint. But in contrast to the satisfying elegance of Sheeler's technique, his simple arrangement of flowers on a table is vaguely disquieting. Although the blossoms are

Fig. a. Charles Sheeler, *Still Life,* 1925, oil on canvas, Private collection, on loan to the Worcester Art Museum

arrayed in harmonious symmetry across the picture's surface, they nonetheless wind and sway on their elongated stems, bobbing out toward the viewer and twisting back into the shallow space in a kind of contrapuntal rhythm. The apparently perfect, restful compositional balance Sheeler achieved between the vase, the tabletop, and the goblet is undermined by the fact that the tabletop is pushed noticeably off-center and is tilted up, pressing the glassware forward.

The pleasing stability of *Red Tulips* is further undercut by Sheeler's interpretation of the objects themselves: not only the tulips, which are by their very nature ephemeral, but the furnishings too seem insubstantial. The base of the candlestand is cut off, and the blank background reveals only the slightest suggestion of a shadow to guarantee the table's physicality. The tulips cast no shadow, the vase captures no reflection. The glassware is fragile and transparent, qualities Sheeler celebrated in a magical passage that is at once abstract and true to nature: the soft light filters through one, then two, then three thicknesses of glass as the viewer peers through the bowl of the improb-

ably small green goblet that anchors the composition.

Still lifes traditionally are reassuring; most of Sheeler's contemporaries who favored the genre in the 1920s used its inherent tranquility to win acceptance for their radical painting styles. Sheeler's program of evoking the unease beneath that stability may account for the fact that few of his still lifes sold in the 1920s, except to the most discerning collectors. After exhibiting *Red Tulips* in a few group shows, in 1930 Sheeler gave the painting to his nephew Richard Kyle as a wedding present.

1. For the vase, see *Still Life* (1925; Fine Arts Museums of San Francisco); for the goblet, the same *Still life* and *Still Life and Shadows* (cat. no. 27), among others; and for the candlestand, *Still Life - Yellow Iris; Geranium* (c. 1926; Whitney Museum of American Art, New York), and *Gladioli in White Pitcher* (1926; Santa Barbara Museum of Art).

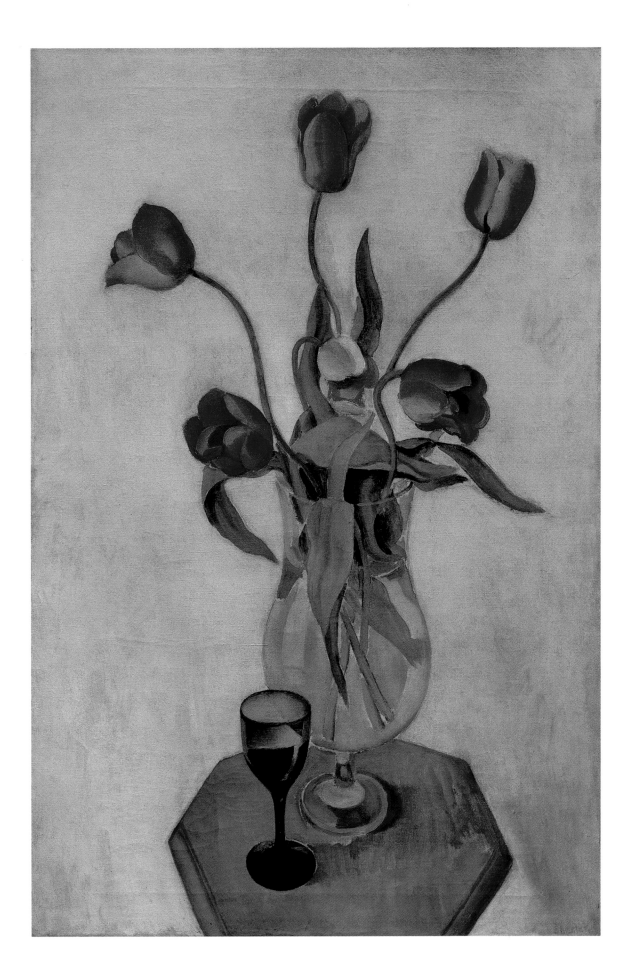

31

Apples on Pewter Plate
Signed and dated lower left:
Charles Sheeler-1926
Tempera on paper, 12 x 13 in. (30.5 x 33 cm.)
The Lane Collection

Sometime in the early 1920s, Sheeler borrowed from his friends and patrons the Arensbergs a small painting by Cézanne, *Still Life with Apples* (fig. a), which Sheeler later described as having been "painted by one of the Angels."[1] The picture was most likely a fragment, cut by Cézanne from a larger composition,[2] and may have suggested to Sheeler the idea of making a still life vignette, a close-up of a single motif extracted from its context. Sheeler's simple, pyramidal (though slightly, and deliberately, off-axis) grouping of apples has parallels in other paintings by Cézanne that he knew well. For example, the grouping recalls the detail at lower left in Cézanne's *Still Life with Plaster Cupid* (1892-93; Courtauld Institute Galleries, London), a painting Sheeler saw in the 1916 Cézanne exhibition at the N. E. Montross Galleries in New York,[3] as well as the plate of apples at the right in *Still Life* (1892-94), owned by the Barnes Foundation, whose collection Sheeler had admired since the teens and had photographed for a 1923 article in *The Arts*.

Sheeler's tribute to Cézanne in *Apples on Pewter Plate* is further visible in his juxtaposition of chromatic opposites — red and green, with yellow used for the most brightly highlighted areas — which makes the apples solid and palpable. Equally Cézannesque are the broad, parallel brush strokes (an emphatic handling unlike Sheeler's usual reticent technique), the off-center placement of the plate of apples, and, above all, the dynamic tension between realism and abstraction in his picture. Sheeler attributed this tension in Cézanne's still lifes to objects "detach[ed] from human association," whose "selection is based upon preference in the matter of shapes, surfaces, and quantities related to a geometric structure,"[4] and he strove for a similar emphasis on design in his own work.

Yet for all its acknowledgment of Cézanne's

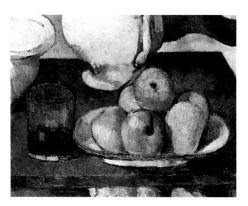

Fig. a. Paul Cézanne, *Still Life with Apples*, 1877-79, oil on canvas, Philadelphia Museum of Art, The Louise and Walter Arensberg Collection

mastery, *Apples on Pewter Plate* is a work of homage, not imitation. The objects were not only chosen for their formal properties; many are familiar from his other works. The patterned background is in fact the rug that also appears in *Interior* (cat. no. 32), here removed from its context and barely recognizable; the pewter plate, a mid- to late-eighteenth-century form of the kind produced in quantity for middle-class households both in the Philadelphia area and the Connecticut River valley, is also similar to the pewter platter in *Interior*.[5] Sheeler had been collecting this kind of homely, unadorned object belonging to an American tradition of common household items, and they are imbued with a patina of affection and familiarity. Yet Sheeler's design here is as radical as his objects are familiar and gives the work a subtle energy that, along with its elegant handling, elevates it above the commonplace.

Sheeler used a variety of devices to remove his still life from its normal context, the kitchen or dining room table. He tilted up the surface on which the plate of apples rests, he eliminated the foreground and all peripheral detail, and he chose a tightly framed, close-up view. He had used these techniques in several earlier works, most notably his photograph *Side of White Barn* (fig. 8). Their effect is to make his subject dramatically immediate, unavoidably present. The subject's isolation reveals the abstraction underlying Sheeler's realistic rendering: the apples are both apples and spheres in counterpoint to the crisscrossed diagonal pat-

tern of the textile (a pattern that would become a signature: see his 1927 photograph *Criss-crossed Conveyors*). Those diagonals form an unfinished diamond shape which the eye then completes, an effect that amplifies the picture's surface energy. And finally — and also uniquely characteristic of Sheeler — the shadows, particularly the crescent surrounding the plate at right, have almost as much substance as the forms that cast them. That shadow stretches the plate, returns it to the center of the composition, and so perpetuates the tension between imbalance and serenity that marks Sheeler's most original work.

1. In Hayes, "Reminiscence," in Friedman et al., *Sheeler*, p. 68.

2. See Joseph J. Rishel, *Cézanne in Philadelphia Collections* (Philadelphia Museum of Art, 1983), cat. no. 3.

3. That exhibition, held in January 1916, included thirty watercolors and seven oils, of which the Courtauld picture was no. 2. For Sheeler's mention of this exhibition, see Sheeler Papers, 1811:779.

4. These comments come from Sheeler's unpublished article on still life painting, written about 1925 (Forbes Watson Papers, D56:1094).

5. I am grateful to Edward S. Cooke, Jr., Department of American Decorative Arts, Museum of Fine Arts, Boston, for this information.

32

Interior

Signed and dated lower left: *Sheeler. 1926.*
Oil on canvas, 33 x 22 in. (84.0 x 56.0 cm.)
Lent by the Whitney Museum of American Art, New York. Gift of Gertrude Vanderbilt Whitney

Between 1926 and 1934 Sheeler produced a series of seven paintings, beginning with *Interior*, that depict his collection of early American furnishings as they were arranged in his South Salem, New York (and in one case, Ridgefield, Connecticut), home.[1] In his autobiographical notes, Sheeler referred to this picture as *Interior, South Salem*,[2] but when it was first exhibited in December 1927 as part of the Whitney Studio Club's traveling exhibition, it bore the less personal name *Interior*, and would thereafter be known by that title.[3] The change may indicate Sheeler's characteristic reluctance to reveal himself; or perhaps he was eager to stress the painting's broader meanings.

Many of the objects depicted in *Interior* are familiar from Sheeler's earlier, more conventional tabletop still lifes; others – the four-door cupboard (of which only the bottom third is visible, at upper left), the early-nineteenth-century turned-post bed, the rugs – recur in other works in this series. Only the Shaker dining table and the small wooden stand do not appear in any other painting or in the inventories of Sheeler's furnishings. The stand seems to have vanished completely; however, its rural vernacular origins and its extraordinary proportions (surely exaggerated here) are typical of Sheeler's taste. The table may be the one barely visible in a photograph of another room in the South Salem house – the room depicted in *Americana* (fig. 18) – and again in a photograph of his Ridgefield studio that appeared as the frontispiece of the catalogue for his 1939 Museum of Modern Art exhibition; presumably he later sold it.

But even after most of these objects are identified as ones Sheeler owned, many conundrums remain. The missing table leg, the strange distortions of scale and uneasy relationships between objects, and the vertiginous

space all seem incongruous in a composition ostensibly so realistic. Even the handling reveals unexpected deviations from Sheeler's typical style. Most of the painting exhibits his characteristically smooth, thin application of pigment, with precise contours made even crisper by reinforcement of the pencil under-drawing. Local color, albeit in a high key, is strictly adhered to. Yet in certain areas, especially the smooth back wall and the polished tabletop, Sheeler used rough, square, obvious strokes, uncharacteristically thick impasto, and interjections of forest green against brown to create a boldly textured surface. Relieved from literal description, these peripheral areas gain an independent vitality and an artistic, rather than naturalistic, logic.

Unlike Sheeler's subsequent interiors, which retain the kinds of incongruities apparent here while embodying perfect construction and design, *Interior* seems slightly awkward, the interrelationship of objects artificial. At the same time, in both content and style, it was Sheeler's most ambitious work to date, showing him striving to reconcile his interest in European avant-garde compositional design with his commitment to an American vocabulary of forms.

In the work of Cézanne and that of such painters as Braque and Picasso, Sheeler would have found reinforcement for the self-advertising brushwork, for the deviations from local color, and particularly for the daring spatial structure used here. He employed a high horizon and radically tilted-up ground plane so that the furniture in the picture seems to slide forward toward the viewer, an effect heightened by his cutting off the feet of the little stand in the foreground. What is actually deep space appears almost like a relief. The table edge, the bed, the rag rug, and the sectioned floor form a patchwork of interlocking squares; the animated pattern seems all the flatter for the absence of a single, consistent light source. The objects remain distinct, yet are bound together in shifting relationships that aim to approximate our vision as we look about the room.

What Sheeler is wrestling with, in short, is cubism, but in a manner neither derivative nor slavishly adulatory. This is the imagery not of the café or the French countryside but of the

collective American past; nor is it the kind of abstraction and objectivity to which modern art increasingly was dedicated. *Interior* was a bold attempt to bring the avant-garde styles that had so intrigued Sheeler to the attention of the American public, to domesticate cubism in a country where, as the perceptive critic Henry McBride later would say, "cubism is against the law."[5]

1. In addition to *Interior*, the following paintings depict Sheeler's home in South Salem: *Spring Interior; Home, Sweet Home; American Interior* (cat. nos. 33, 34, 43, 52) and *Americana* (1931; fig. 18). The entrance hall of Sheeler's house in Ridgefield is depicted in *Newhaven* (cat. no. 44).

2. See Sheeler Papers, NSh1: 93-94 and 1811: 750. I am grateful to Olive Bragazzi for pointing this out to me.

3. A photograph taken of the same room a few years after the painting was completed shows many of the same pieces (the bed with its plaid coverlet, the Shaker four-door chest) arranged in roughly the same positions as they appear here. That the painting is clearly dated 1926 would indicate that Sheeler moved to South Salem in 1926, not 1927 as is usually supposed. Again, this hypothesis is Olive Bragazzi's, who also has informed me that Sheeler's name first appears in the Westchester telephone directory in the summer of 1927.

4. See, e.g., the list of his folk paintings (Downtown Gallery Papers), the list of works sold to Hancock Shaker Village (Archives, Hancock Shaker Village), and Andrew Dintenfass, "Inventory of Furniture Owned by Charles Sheeler" (c. 1970), the last as noted in Fillin-Yeh, *Sheeler: American Interiors*, p. 22, n. 59.

5. McBride, "Paintings by Charles Sheeler."

33

Spring Interior
Signed and dated lower right: *Sheeler 1927.*
Oil on canvas, 30 x 25 in. (76.2 x 63.5 cm.)
The Lane Collection

34

Gladioli
Signed and dated lower right: *Sheeler 1927*
Oil on canvas, 28 x 22 in. (71.1 x 55.9 cm.)
Mr. and Mrs. Richard C. Hedreen, Seattle

After a peripatetic seven years and moves to at least five different addresses, Sheeler finally settled with his wife, Katharine, in the rural community of South Salem, New York, by 1926. Shortly thereafter, he began work on three large-scale still life compositions, one in tempera (*Gladioli [Summer Flowers]*, Coll. Glenn C. Janss, Sun Valley, Idaho) and these two in oil, all of which develop the innovative formula of a still life within a domestic setting he had introduced in *Interior* (cat. no. 32) the year before. The natural season of the flowers depicted, as well as the paintings' titles, suggest that *Spring Interior* was begun first; whether Sheeler painted it "rapidly, without preliminary study," as Constance Rourke asserts,[1] or whether he continued to work on it through the summer, is not known, although Sheeler's habitual meticulousness and the complexity of the picture argue against its spontaneous construction. Although *Gladioli* was included in Sheeler's solo exhibition at the Museum of Modern Art in 1939, it was not shown again in public until after the artist's death, when it was included in a Downtown Gallery presentation of the artist's personal collection. *Spring Interior* was first shown at an exhibition at the Whitney Studio Club's "summer residence" in Charlestown, New Hampshire, in late August 1927.[2] There it attracted the attention of Juliana Force, who subsequently acquired it for the newly established Whitney Museum of American Art. In 1954 the museum exchanged it, and several other works, with the Downtown Gallery for *Architectural Cadences* (1954). *Spring Interior* was acquired by the current owner the same year.

The mood of these paintings is cheerful; one can imagine they reflect Sheeler's feelings of optimism and well-being. The arrangement of forms seems conventional and the objects depicted are familiar and ordinary: common flowers in both pictures; in *Spring Interior*, Sheeler's often-used candlestand and a glass mug; in *Gladioli*, his little Chinese vase, with a somewhat clumsy glass container holding the pinky-white blossoms. The architectural features are undoubtedly those of Sheeler's house in South Salem.

In spite of the familiar subjects, however, the paintings seem experimental, for they are painted with a variety of techniques. In *Gladioli*,

the mantel seems iridescent, with scumbled pinks, pale greens, and aqua over white. Sheeler achieved a comparable painterly effect in the tabletop by laying down choppy green strokes over brown. In *Spring Interior*, the shimmering, opalescent backdrop is thinly painted, with virtually no sign of brush stroke, while the mantelpiece, rendered in the same tones, is thick and creamy. The stems of the forsythia, refracted through water and glass, are rendered with coloristic and technical complexity. The petals are richly painted, each described by a single deft, lean stroke, while the bricks above the mantel are rendered with pigment so thinned down as to resemble watercolor; the mortar between the bricks is defined by pencil underdrawing and bare canvas. It is as though Sheeler were pushing the medium of oil paint in several directions in order to achieve as many different effects and surface textures as he could.

Sheeler's obvious pleasure in painting beloved objects in new surroundings and his interest in his medium were matched by his enjoyment in the manipulation of space. The arrangement of forms in *Gladioli* seems straightforward and natural, yet, as in several of his still lifes of the period, this sense of cozy harmony is coupled with a disconcerting instability. The flowers are slightly off-center, and the tabletop is pushed against the fireplace opening and tilted up so that the vases seem in danger of sliding out of the picture space – a manufactured imbalance that the artist slyly acknowledged by having the base of the Chinese vase rest on the bottom edge of the painting. There is an equally charged interplay between the fireplace wall, which moves away from the viewer at a sharp diagonal, the bunches of flowers, which fan out parallel to the picture plane, and the red blossoms bobbing provocatively into the viewer's space.

Spring Interior is even more complex. Here the branches of forsythia form a screen before a delightfully confounding series of optical illusions. At right, the series of moldings that ornament the mantelpiece seem at once to undulate and to project progressively into space as the eye moves away from the hearth. And at left, the wall recedes into space at the bottom, suggesting stairs or bookshelves, while at the top the same horizontal slats form part of

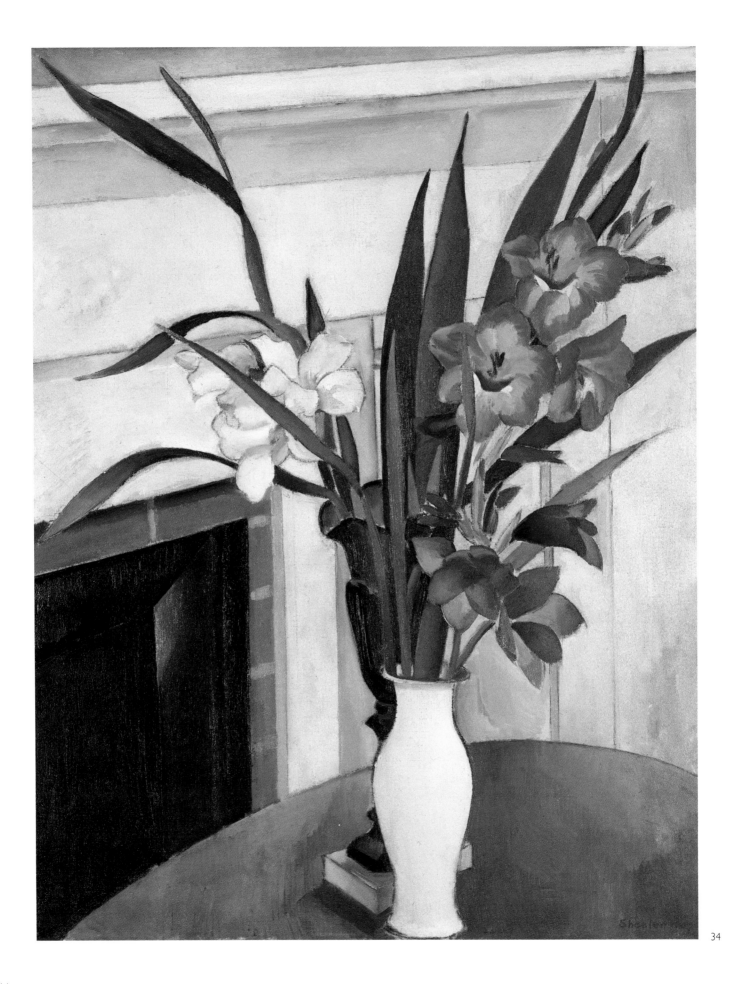

a pattern of flat bands decorating a wall that is flush with the mantel. The illusion of recession is contradicted by the shaft of the candlestand, which shares an outline with the mantel, so they appear to be simultaneously side by side and before and behind. These ambiguities, these disjunctions between what the eye sees and what the mind records, take on a more unsettling, somber quality in such late works as *Begonias* (cat. no. 79). Here, in keeping with the sunny palette and the pleasant, everyday objects, the effect is coy and playful.

1. Rourke, *Sheeler*, p. 142.

2. Juliana Force rented Maxstoke, a huge house in Charlestown, as a summer residence for the members of the Whitney Studio Club. Sheeler spent several weeks there, as did Edward Hopper, Henry Schnackenberg, and others. The culmination of the summer's activities was a group exhibition, held between August 20 and September 1 in the drawing rooms of Maxstoke (Archives, Whitney Museum of American Art, New York). The inclusion of *Spring Interior* in this exhibition makes it impossible that it was "done immediately after his return from Detroit" late in 1927, as Rourke (ibid.) suggests.

35

Upper Deck
Signed and dated lower right: *Sheeler - 29*.
Oil on canvas, 29⅛ x 22⅛ in. (74 x 56.3 cm.)
Harvard University Art Museums (Fogg Art Museum). Purchase, Louise E. Bettens Fund

About 1928, Sheeler was hired to take photographs of the S.S. *Majestic* to illustrate a brochure for a German steamship company. Apparently the photographs were never published, and only three prints resulting from the assignment have come to light.[1] Two of these photographs show a relatively expansive view of the *Majestic*'s upper deck with an enormous funnel as the main motif; the third (fig. a.), the one Sheeler called his "blue print" for *Upper Deck*,[2] shows a much smaller view, encompassing two of the ship's electric motors, "squirrel cage" fans, and ventilator stacks. These machines are visible as small details in the other photographs. It was not unusual for Sheeler to find a pictorially promising subject in a fragment of a broader view. Five years before, his photographs of New York had suggested a similar approach for his painting *Sky-scrapers* (cat. no. 18). That view, like *Upper Deck*, focuses on details in such a way that scale, context, and even the identity of the subject are not immediately obvious.

The S.S. *Majestic*, remodeled in 1921, was one of the largest and most luxurious ocean liners afloat. Likened to a "floating town, with homes for 5200 persons,"[3] it was the flagship of the prosperous White Star Line and, in the heyday of the glamorous Atlantic crossings, the epitome of *le style paquebot* – a streamlined, stripped-down, sophisticated style, derived from both the vessel's sleek, made-for-speed contours and the modern elegance of its interior decor. The contemporary beauty of *le style paquebot* was touted by Le Corbusier (whose Villa Savoie had been admiringly compared to the sports deck of a great ship) and elegantly illustrated by such painters as Charles Demuth and Gerald Murphy.[4]

Upper Deck frequently has been associated with *le style paquebot* and with the "functionalist sensibility" of the machine aesthetic,[5] which celebrated in art the crisp lines and potential power of modern industrial design. In fact, Sheeler did not entirely subscribe to either aesthetic. Although in developing *Upper Deck* he "streamlined" the photograph that preceded it by eliminating the rivets, seams, and signs of rust, and although he would later talk about the "sense of truth" of the utilitarian objects he depicted,[6] his manner of representing

the *Majestic*'s upper deck is more baroque than *moderne*, more symphonic than telegraphic. His pristine color scheme – rather improbable for this gritty machinery – of vivid whites, pearly tones, and softer, grayed hues tinged with lavender and ochre suggests this was a traditional artistic exercise, a test of painterly powers of the sort beloved by such artists as Whistler, Sargent, and others working in a lush, late-nineteenth-century style. Sheeler here adapted it to his newly developed enamel-like technique, and the result is a tour de force. Like his predecessors, he punctuated his white-on-white scheme with the shock of contrast: the funnel openings are black, "like pistol shots."[7] A rich web of geometric patterns is interwoven on the picture's surface and in space. Diagonal lines – the black cables, their gray shadows, and the white bar at the center – fan forward across the face of the picture, while the gridlike geometry of the ventilators and manifolds is set on another diagonal retreating from the viewer. And compared to the photograph, the space of the deck here is compressed to tighten the rhythm of the four circular forms: two generators, two funnels, and their steel halos behind.

Nor is Sheeler's approach to his subject truly jazz age, or machine age. He emphasizes neither the glamour of the great ocean liner nor its enormous power. Rather than the elegant promenade deck, he shows the ship's breathing apparatus; the mammoth 375-ton engines, capable of generating 64,000 horsepower and propelling the ship at an astonishing 23 knots,[8] appear rather domestic in scale. Sheeler gives no clue to the vast size of the machines on the upper deck, nor explicitly to their function: the image is cropped to isolate the machines so that their context is almost unrecognizable. The ship's rail is barely seen at far left, and the sea beyond, not at all.

Sheeler viewed this painting as a watershed in his career. Thereafter he consistently used his photographs as preliminary studies for his paintings to suggest subject matter, compositional arrangements, and value contrasts. By using the camera to extract and isolate intriguing forms from their contexts, he found a means of reconciling his predisposition toward realism with his urge toward abstraction. As he said of *Upper Deck*, "This is what I have

Fig. a. Charles Sheeler, *Upper Deck*, c. 1928, gelatin-silver print, Gilman Paper Company Collection

been getting ready for. I had come to feel that a picture could have incorporated in it the structural design implied in abstraction and be presented in a wholly realistic manner."[9]

1. See Yeh, *Sheeler and the Machine Age*, p. 109.

2. Interview by Friedman, p. 2.

3. "Largest Ship Nears Completion Abroad," *New York Times*, August 22, 1921, p. 6, col. 1.

4. See Yeh, *Sheeler and the Machine Age*, p. 176, and 186, quoting Le Corbusier (*Towards a New Architecture* [New York, 1960], reprint of 1927 English edition, pp. 102-3): "If we forget for a moment that a steamship is a machine for transport and look at it with a fresh eye, we shall feel we are facing an important manifestation of . . . beauty."

5. Yeh, *Sheeler and the Machine Age*, p. 179.

6. In Rourke, *Sheeler*, p. 145.

7. Rourke, ibid., p. 143.

8. See "Largest Ship Nears Completion," p. 6.

9. In Rourke, *Sheeler*, p. 143.

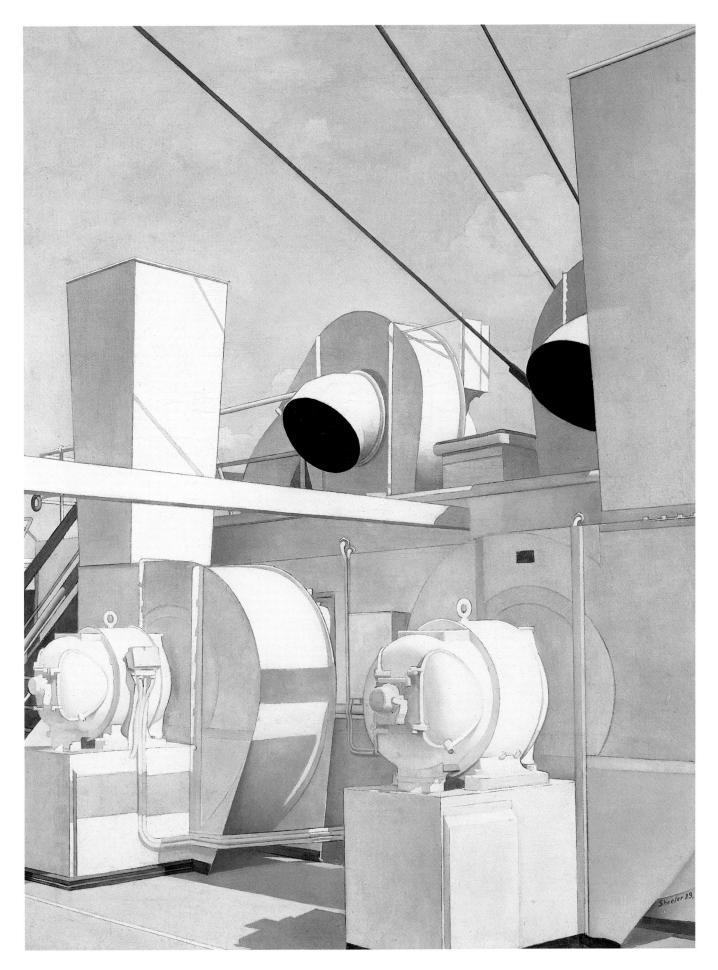

36

American Landscape
Signed and dated lower right: *Sheeler-1930*
Oil on canvas, 24 x 31 in. (61 x 78.7 cm.)
The Museum of Modern Art, New York. Gift
of Abby Aldrich Rockefeller, 1934

American Landscape was the first in a series of
works by Sheeler depicting the Ford Motor
Company's River Rouge plant outside De-
troit.[1] Sheeler spent six weeks at the plant
starting in October 1927, photographing it for
the Philadelphia advertising firm N. W. Ayer
and Son, and its client, Ford. Sheeler said of his
trip: "I was out there on a mission of photogra-
phy. Period. And when I got there, I took a
chance on opening the other eye and so then I
thought maybe some pictures could be pulled
out. But I had to come home, and it was sev-
eral years later that they had really digested,
and they started coming out."[2] As he had done
with *Upper Deck* (cat. no. 35), which also grew
out of a photographic assignment, Sheeler as-
similated the rhythm and beauty of form that
he perceived in industrial structures and trans-
lated them into other media. In making this
transition, the artist explored the visual vocab-
ulary of photography and incorporated its
special effects into each of the oils and draw-
ings in the series.

American Landscape is panoramic, a view
perceived as though through a wide-angle
lens. The scene is the Rouge's boat slip and the
cement plant on its eastern shore, which Shee-
ler first recorded in the background of the
1927 photograph *Salvage Ship* (fig. a). The pho-
tograph shows the hull of a ship being disman-
tled for scrap metal. Sheeler selected a van-
tage point that dramatized the receding
diagonals of the hold and the linear interplay
between the ship's stays and flooring and the
almost tangible shadow of an unseen derrick.
The next year he painted the boat slip in a
small watercolor that features a more serene,
generic part of the composition, based on the
upper right corner of the photograph. (fig. b)
American Landscape followed two years later.[3]

Almost all the details of the scene are tran-
scribed from the photograph, even the ladder
at lower right, which no longer appears to lead

Fig. a. Charles Sheeler, *Salvage Ship – Ford Plant*, 1927,
gelatin-silver print, The Lane Collection

from anywhere and acquires a subtle, teasing
quality as it straddles Sheeler's signature.
There are few signs of animation: only the
small figure running along the tracks, which
Sheeler added, along with the billowing
plumes from the smokestack and the sheet
waving in front of the crane, which appear in
the photograph. The rest of the picture is very
still. Here Sheeler differentiated between the
manmade and the organic through his tech-
nique, carefully delineating the architecture
first with a pencil and then with thinly applied
pigment, reserving a fuller brush and looser
treatment for the sky, the piles of ore in the
central storage bins, and the water of the boat
slip. These three areas become discrete design
elements, bands separated by a series of finely
drawn, uninterrupted horizontal lines, which
enhance the picture's serenity.

Although Sheeler did admire Henry Ford's
accomplishments, *American Landscape* is not a
polemic in defense of Fordism; in fact, several
contemporary critics did not even recognize
the factory.[4] Instead, the painting represents
the discovery of a peculiarly American vista.
Just as the Rocky Mountains and Niagara had

inspired Sheeler's predecessors, the Ford
plant impressed modern visitors as a symbol
of American grandeur. "Where then does the
'real America' begin? You will see it, is the an-
swer, when you get to Detroit," wrote J. A.
Spender, an English visitor to the Rouge in
1927.[5] His amazement at the scale, arrange-
ment, and cleanliness of the plant was typical,
for it seemed to be a new world.

1. The series consists of six paintings (*American Landscape*,
Classic Landscape, *River Rouge Plant* [cat. nos. 36, 37, and
46], *Slag Buggies* [current location unknown], *City Interior*
and *City Interior #2* [both Worcester Art Museum]); two
watercolors (*Classic Landscape* [Coll. of Mr. and Mrs. Bar-
ney A. Ebsworth, St. Louis] and *River Rouge Industrial Plant*
[fig. b.]); the lithograph *Industrial Series #1*; three conté
crayon drawings (*Smokestacks* [The Lane Collection], *Bal-
let Mechanique* and *Industrial Architecture* [cat. nos. 38 and
39]); and a design for a photomural, *Industry* (Art Institute
of Chicago); all made within ten years after Sheeler's re-
turn from Detroit.

2. Interview by Cowdrey, p. 46.

3. The identification of the sites and processes Sheeler de-
picted at the Rouge have been carefully researched by
Mary Jane Jacob and Linda Downs in *The Rouge*.

4. Henry McBride, after mentioning the Rouge photo-
graphs, describes the scene of *American Landscape* as
"precisely like the sort of thing you see when motoring
between here and Newark" ("Paintings by Charles Shee-
ler," p. 184). W. B. McCormick describes "two industrial
plants, possibly in the Middle West" ("Machine Age
Debunked").

5. Spender, *Through English Eyes*, p. 19.

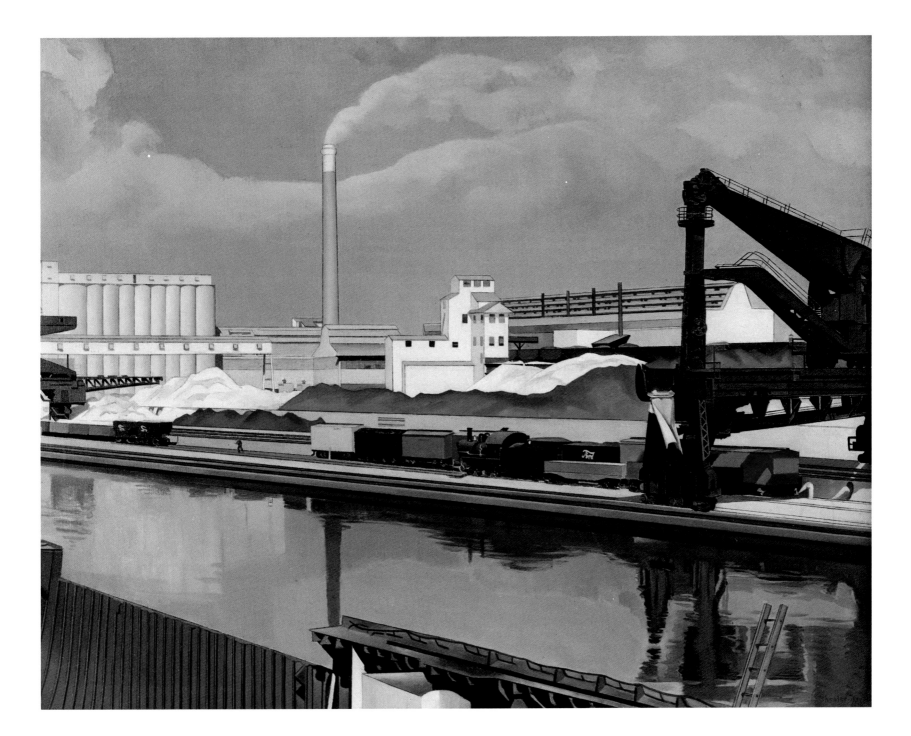

Fig. b. Charles Sheeler, *River Rouge Industrial Plant*, 1928, graphite and watercolor on paper, The Carnegie Museum of Art, Pittsburgh, Gift of G. David Thompson, 1957

37
Classic Landscape
Signed and dated lower right: *Sheeler-1931*
Oil on canvas, 25 x 32¼ in. (63.5 x 81.9 cm.)
Collection of Mr. and Mrs. Barney A.
Ebsworth Foundation

The best known of Sheeler's paintings of the Ford Motor Company's River Rouge plant, *Classic Landscape* was the only one to be owned by a member of the Ford family. Henry Ford's son Edsel, always interested in design and aesthetics, by the late 1920s had become an astute collector of Renaissance and modern painting. Edsel was Sheeler's liaison to the company for the 1927 photographic commission, and in 1932 he financed Diego Rivera's monumental mural cycle of the Rouge for the Detroit Institute of Arts. That same year he purchased *Classic Landscape* from the Downtown Gallery. Edith Halpert, the gallery's director, reported that this gave Sheeler special pleasure.[1]

Classic Landscape shows the Rouge plant on the east side of the boat slip, looking toward the silos of the cement plant and the irregular form of the slag screen house (fig. a).[2] Dominating the scene are the railroad tracks known as the "High Line." This elevated system carried slag from the blast furnaces to the screen house, where it was sifted before being used to produce cement. Sheeler's composition is based upon a watercolor he made shortly after his Detroit visit (fig. b). The view encompassed by the oil is somewhat larger in scope than that of the watercolor; they may both have been inspired by a photograph, but no such image survives.[3]

A photographic source might explain the dramatic perspective of *Classic Landscape*, in which the scale of the railroad ties is enormous in comparison to the distant silos. Artists had been exploiting the expressive distortions made possible by a wide-angle lens since the 1850s, and beginning in the 1930s film-makers capitalized on its emotional potential.[4] Here it might have suggested the violent recession that rushes the viewer into the distance toward a waiting railroad car.

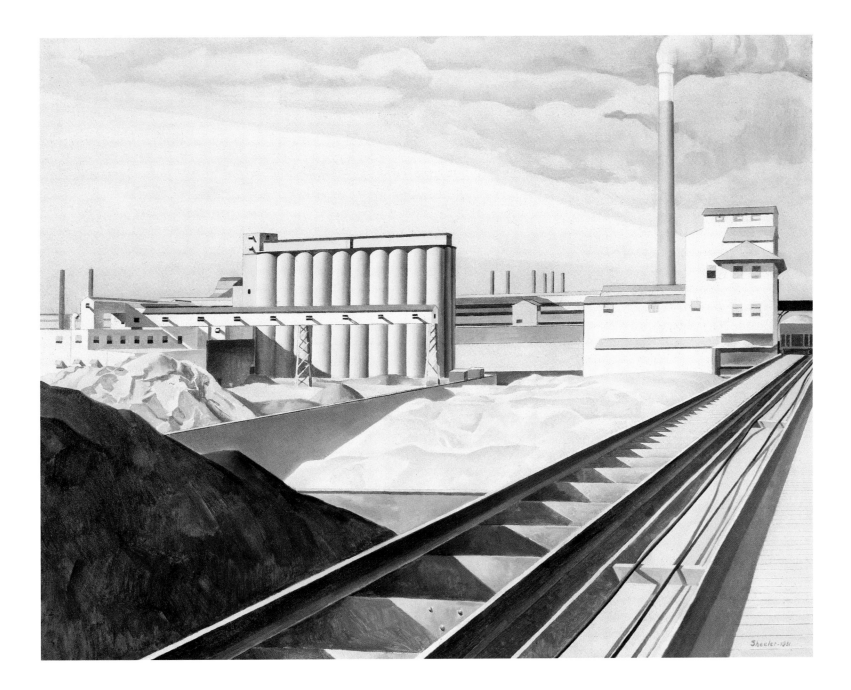

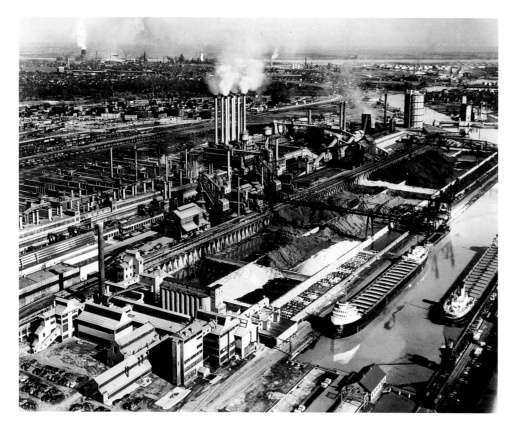

Fig. a. Aerial view of the Ford Motor Company's River Rouge Plant, 1947, from the collections of the Henry Ford Museum and Greenfield Village

Sheeler had used steam and smoke as symbols of energy since his 1920 film *Manhatta*. In *Classic Landscape*, the plume of smoke billowing from the cement plant smokestack into the wintry sky indicates that the plant is in operation. Yet the scene appears oddly static. The harsh, bleaching light with its unyielding shadows creates a barren effect, enhanced by the enormous irregular heaps of raw material and the absence of human figures. The emptiness was not entirely the artist's invention: when Sheeler visited the Rouge in 1927, before regular production of the Model A had begun, the plant was operating at a severely reduced capacity.[5] Even when the plant was fully engaged, most of the activity took place inside, leaving the exterior in "motionless quiet."[6] Sheeler here conveys both this sense of stillness and, through the dramatic perspective, the plant's immense energy.

Sheeler's title for this work is both intriguing and appropriate. The repetitive columnar forms of silos and smokestacks and the strictly formal composition combine with the scene's quietness to produce a classical effect. As with *American Landscape*, the title reminds the viewer that the picture is not merely an illustration of a specific factory but expresses a more universal theme: like the ancient temple, the factory symbolizes the hopes and values of its society. This is a landscape for the industrial age: earth has been replaced with the mountainous piles of mud-brown and gray ore, coal, and limestone, and the sky is filled with the clouds of industry, tinged a delicate rose-pink. Such allusions were not lost on the general public, for classicism was an important part of contemporary vocabulary in architecture and design, lending an aura of stability and tradition to the rapid changes of the modern world.[7]

1. Sheeler's reaction to Edsel Ford's purchase was noted by Halpert in a letter to Edmund Gurry, June 18, 1932, Downtown Gallery Papers. Sheeler later recalled that Edsel Ford had offered him the chance to design the radiator cap for the Model A (See interview by Cowdrey, p. 50).

2. These same buildings are visible in *American Landscape* (cat. no. 36).

3. Sheeler presented thirty-two photographs to the Ford Company in 1928. These are now lost, although twelve

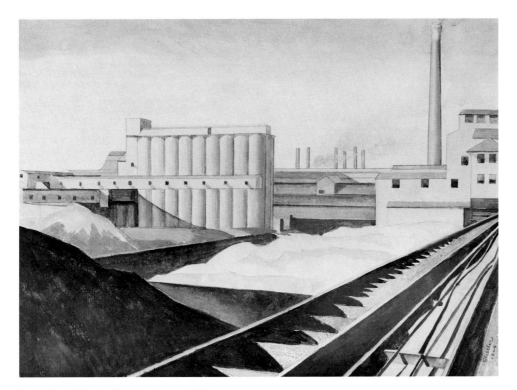

Fig. b. Charles Sheeler, *Classic Landscape*, 1928, water-color, gouache, and graphite on paper, Collection of Mr. and Mrs. Barney A. Ebsworth

copy photographs, taken in 1929, survive at the Henry Ford Museum (Deerfield, Mich.). Sheeler undoubtedly made many other photographs at the Rouge. Some of these (some similar to the original set) survive in the Lane Collection and others may have been destroyed by the artist.

4. See Aaron Scharf, *Art and Photography* (New York, 1974), pp. 190-95.

5. Ford laid off sixty thousand men in Detroit when the Model T production line at Highland Park was closed in May 1927. The production line was transferred to the Rouge for the Model A, but very few vehicles were produced between the time of the car's introduction in December 1927 and the spring of the following year. See Robert Lacey, *Ford: The Men and the Machine* (Boston, 1986), pp. 298-99.

6. John H. Van Deventer (author of thirteen articles on the Rouge for the periodical *Industrial Management*), in Nevins and Hill, *Ford*, pp. 282-83.

7. Dianne H. Pilgrim, "Design for the Machine," in Wilson, Pilgrim, and Tashjian, *The Machine Age in America*, pp. 322-23. See also the discussion of the term "classic" as it was used in contemporary literature, in Stewart, "Sheeler, Williams, and the Precisionist Aesthetic," pp. 140-45.

38

Ballet Mechanique
Signed and dated lower right: *Sheeler-1931*
Conté crayon on paper, 10¼ x 10 in.
(26 x 25.4 cm.)
Memorial Art Gallery of the University of
Rochester. Gift of Peter Iselin and his sister,
Emilie I. Wiggin

Of the three conté crayon drawings that Sheeler made of Ford's River Rouge plant, *Ballet Mechanique* is the most complex in conception and execution. With its deep, rich tones and compact composition, it is a masterful example of Sheeler's control over both his medium and his subject matter. The drawing portrays a network of pipes and supports that carried compressed air and excess gases between the power house and the blast furnaces; the same structure can be seen in the lower portion of the drawing *Smokestacks* (fig. a). Both compositions may have been inspired by a single photograph (now lost) from which Sheeler selectively produced these two dynamic images.

Ballet Mechanique demonstrates Sheeler's fascination with intricate surface pattern and texture. Using a sharply pointed conté crayon with faultless control, he contrasted the round pipes with their flat supports and created a lacelike web of railings and struts across the picture surface. The white of the paper combines with the tonal range of rich grays and velvety blacks to produce textures reminiscent of Sheeler's finest photographic prints. The result is an elegant, complex image formulated from machinery that had been designed for function alone.

The drawing is a tightly cropped, close-up view; none of the equipment is shown in its entirety. The pipes lead in and out of the picture with no hint of their origin or destination. The ladderlike supports on which they rest are cut off at top and bottom, so that the entire system seems suspended in midair; their distance from the ground and the artist's vantage point are equally ambiguous. The shape of the drawing itself, an almost perfect square, enhances the impression of limitless expansion. The scale of these pipes is equally ambiguous: they seem enormous in comparison to the small windows of the building behind them, but the relative distance between these structures is impossible to gauge. Despite the strict realism, the viewer cannot imaginatively enter this space.

Sheeler here had isolated the machinery from its place and purpose in the plant. With no perceptible context, the pipes and supports become abstract shapes in a strictly formal composition. This same device had been explored by Fernand Léger in his 1923 film

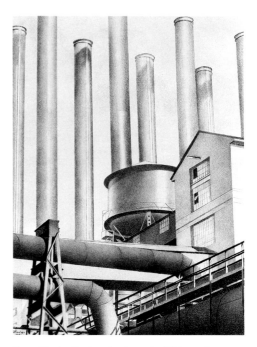

Fig. a. Charles Sheeler, *Smokestacks*, 1931, conté crayon on paper, The Lane Collection

Ballet Mécanique. Sheeler certainly knew Léger's work; it premiered in New York in 1924, only four years after Sheeler and Paul Strand had produced their own film, *Manhatta*. Léger's *Ballet Mécanique* represents a constant vibration of images, in which everyday items such as saucepan lids and wire whisks are juxtaposed with spinning machine parts in a turbulent, nonnarrative rhythm. For his drawing, Sheeler appropriated not only Léger's title but the film's visual cacophony. In the drawing, the idea of a mechanical ballet calls the viewer's attention to the grace of the delicately modeled, curving pipes.[1]

1. The novelty and romantic fascination that Americans had for the machine in the 1920s shifted to one of suspicion with the Depression, and these interpretations were imposed upon Sheeler's image when it was reproduced, along with *Smokestacks* and *Industrial Architecture*, in Paul Kellogg's magazine *Survey Graphic* (March 1932), in a small feature entitled "Order in the Machine Age." While Sheeler himself professed no interest in social concerns, these drawings were used to illustrate a discussion of "those same tools of man's making, which seem to have got out of hand" (F.L.K. [Florence Loeb Kellogg], "Order in the Machine Age," *Survey Graphic* 20 no. 6 [March 1932]: 589-91).

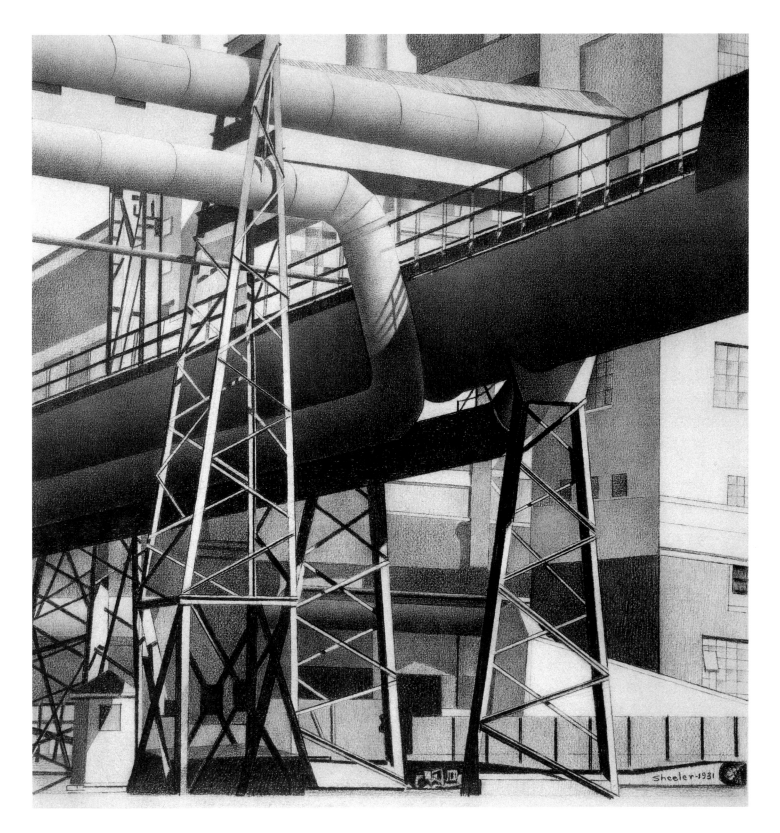

39

Industrial Architecture
Signed and dated lower right: *Sheeler 1931*
Conté crayon on paper, 9½ x 7½ in.
(24.2 x 19 cm.)
Private collection

Industrial Architecture shows the life line of the Ford Motor Company's River Rouge plant: the conveyor system, which brought every ingredient to its proper place in the assembly process, from raw ore to finished automobile parts. Here, Sheeler depicts the covered conveyors that brought coal from the railroad cars on the High Line to the Pulverizer Building (at the rear of the picture), where it was crushed and placed on other conveyors to be taken to the coke ovens or the power house boilers.

Just as conveyors established the rhythm of work at the factory, here they create the visual rhythm in Sheeler's composition. The upper conveyor rushes in from an unseen location, creating a dynamic, slightly skewed diagonal with its shadow and its twin below. Superimposed upon this scheme is a complementary pattern of diagonals, formed by the support struts, the end of the crane at left, and the roof of the Pulverizer Building.

Sheeler created an architectural space from this exterior view by using the conveyors and their supports to shape the area. He related it to human scale by retaining from his photographic source the cropped head and shoulders of a workman, a fragment that lends spontaneity and transience – qualities of a snapshot – to the image. The title causes the viewer to consider these structures artistically, as architecture rather than simply industry. The scene is delicately beautiful, with areas of high contrast made possible by conté crayon, and large sections of the blank paper set off against rich, deep blacks. The rope pulley suspended from the building, which shifts from black to white as it passes before the dark open doorway, is especially elegant.

Like other works in this series, *Industrial Architecture* was inspired by a photograph (*Pulverizer Building*) Sheeler made at the Rouge. His vision in the drawing was further shaped by his visit to Chartres Cathedral in 1929, and the brilliant group of photographs which were made on the journey (fig. a). In both series of images – of Chartres and of the Rouge – Sheeler used the same vocabulary, dramatically cropping his views to please his sense of harmonic design and emphasizing the dynamic rhythms he found in both buttresses and conveyors. The connection between the Rouge and the Chartres images extends to their ico-

Fig. a. Charles Sheeler, *Chartres – Flying Buttresses, East End, with Chapel Roof*, 1929, gelatin-silver print, The Lane Collection

nography. Both concentrate on architectural rhythm and proportion, and neither includes a conventional view of its subject, the towers and stained glass of Chartres or the assembly line and cars at Ford. Sheeler's experience at Chartres caused him to refine his understanding of the Rouge. Like the communities at Ephrata and Hancock Shaker Village (see cat. no. 51) Chartres was a product of communal effort. The Rouge represented a similar alliance: despite its domination by Henry Ford, it depended upon the teamwork of seventy-five thousand employees for its success. Sheeler called it an "unbelievable establishment. . . . It defies description."[1] In *Industrial Architecture* he gave to this modern scene the power and beauty of Gothic architecture.

1. Sheeler to Walter Arensberg, October 25, 1927, Arensberg Archives.

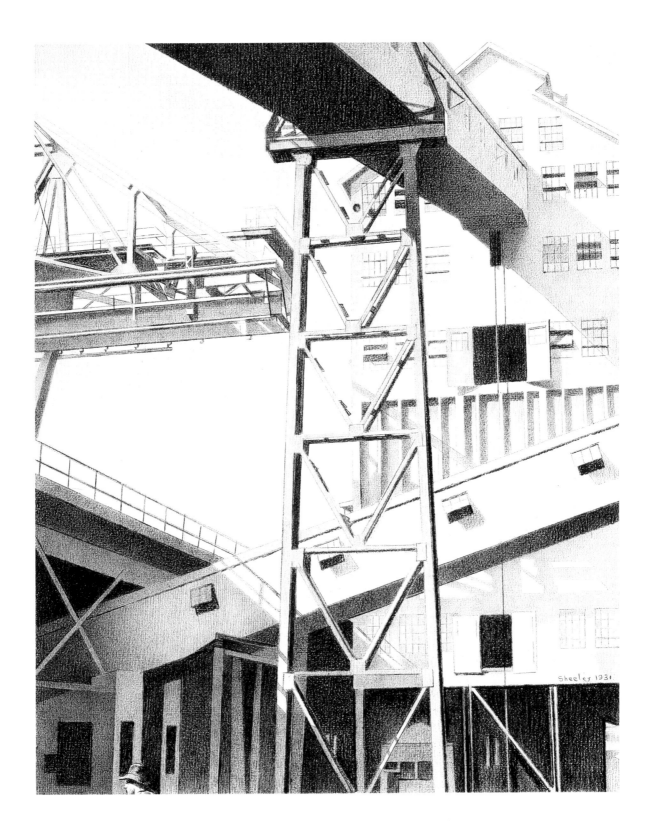

40

Tulips
Signed and dated lower right:
Charles Sheeler/1931./Charles Sheeler 19
Conté crayon on paper, 29½ x 22¾ in.
(74.9 x 57.8 cm.) (sight)
Mr. and Mrs. James A. Fisher, Pittsburgh

Although Sheeler had used conté crayon for a few drawings in the 1920s, it was not until after his return from Europe in the summer of 1929 that he became particularly devoted to the medium. *Tulips* is one of at least six exquisite drawings in conté crayon Sheeler made in 1931, and it is by far the largest, rivaling his contemporary works in oil in scale and presence. Sheeler found conté crayon ideal for his meticulous working method and his self-effacing style. The textured paper he used here would have created drag on his pencil, demanding that he work slowly to retain control. In order to create the precise contours that define the pedestal, lamp, and especially the tulips and their leaves, Sheeler must have sharpened his pencil to a very fine point; for the shaded areas he most likely used a stump to blend his medium, suppressing individual strokes and creating a smooth, even tone and seamless texture. The warm, sensuous gray shades Sheeler achieved though skillful use of conté crayon give *Tulips* a velvety surface that softens the geometric regularity of its forms.

In about 1930 Sheeler moved into a studio in the newly completed Beaux-Arts Apartment Hotel at 310 East 44th Street.[1] The art deco building was a few blocks away from Sheeler's principal employer in those years, Condé Nast Publications, and he used the studio primarily for commercial photographic work. However, in 1931 he made at least five images of that studio – two photographs, two oils (cat. nos. 41 and 42), and *Tulips*[2] – that document the studio's contents, revealing his predilection for modern interior design. Despite their apparent austerity, these are highly personal, expressive works.

In *Tulips* Sheeler returned to one of his favorite still life motifs and a compositional formula he had employed repeatedly since 1912 (see cat. no. 3): three tulips, casually

Fig. a. Anton Bruehl, *Untitled*, n.d., gelatin-silver print, Collection of The Museum of Modern Art, New York, Gift of Samuel M. Kootz

arranged in a broad chevron, placed in a container on a stand. Here the stand is a cylindrical art deco pedestal with a highly reflective top; a more significant addition is the photographer's lamp, at right. Sheeler was not alone in incorporating photographic equipment into his still lifes and other compositions: his mentor Steichen included lamps and cameras in his 1920 gelatin-silver print *Steichen with Photographic Paraphernalia – Self-Portrait* (cat. no. 42, fig. b) as did Anton Bruehl, his colleague at Condé Nast, in his untitled photograph of an apple on a china plate (see fig. a). However, it was unusual for an artist to include such equipment in a drawn or painted image, especially of a subject so traditional as *Tulips*. Equally noteworthy is the fact that Sheeler's lamp is conspicuously disconnected, and the intense light, producing brilliant highlights and deep shadows, comes from other lamps Sheeler arranged outside the picture.

By manipulating his light source, Sheeler was able to create slightly disconcerting shadow patterns that add intrigue and animation to his controlled, symmetrical composition. The shadows are active presences: the looming silhouette of the tulip on the back wall almost looks like a fourth blossom, while the tactile presence of the snaking lamp cord is undermined because it casts no shadows at all. The rectilinear panels of black, white, and gray on the pedestal and back wall set up a complex pattern of advancing and receding spaces; at the same time, those passages work as pure

geometric abstraction, paralleling the contemporary efforts of such painters as Xceron, Diller, and Bolotowsky.

Sometime after 1939, when *Tulips* was exhibited in Sheeler's retrospective at the Museum of Modern Art, the sheet was trimmed about 1½ inches at the bottom, eliminating the original signature. The drawing was then signed again,[3] suggesting that the cropping may have been done by the artist himself, who during this period was actively engaged in matting and rematting his own photographs to adjust the proportions of the image.

1. The Beaux-Arts Apartment Hotel was actually twin buildings facing each other at 307 and 310 East 44th Street (between First and Second Avenues). The buildings, completed in 1929, were designed by the New York firm of Murchison and Hood, Godley and Fouilhoux, which was known for art deco designs. They are still standing. See Cervin Robinson and Rosemary Haag Bletter, *Skyscraper Style: Art Deco New York* (New York, 1975), pl. 48.

2. It is quite likely that Sheeler also made a photograph of the corner of his studio and the still life arrangement recorded in *Tulips*, although none has yet come to light.

3. In fact, Sheeler signed the work twice, indicating – as does the fact that the lower signature is incomplete – that he may have contemplated a further cropping of the drawing.

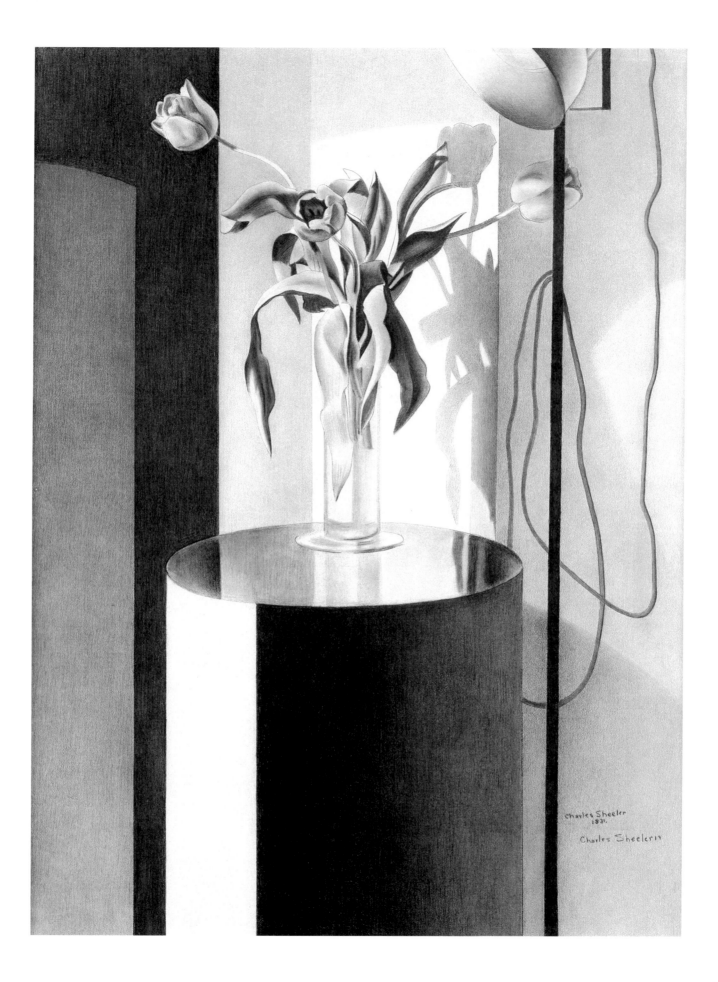

41

Cactus
Signed and dated lower right: *Sheeler-1931.*
Oil on canvas, 45⅛ x 30¹⁄₁₆ in.
(114.6 x 76.4 cm.)
Philadelphia Museum of Art. The Louise and
Walter Arensberg Collection

Walter and Louise Arensberg bought *Cactus* out of Sheeler's first solo exhibition at the Downtown Gallery, held in November 1931. By the summer of 1939, Sheeler was asking to borrow it back for his show at the Museum of Modern Art, explaining that "I continue to think of it as one of my best."[1] The painting already had attracted considerable notice, having been praised as one of the works in the Downtown show that best revealed "a striking development in strength and sureness and an increasing fluency and richness of color. . . . Mr. Sheeler has brought to his canvases the photographer's eye for light and for masses, together with an extraordinarily sensitive photographic conception of light and shadow."[2] In the case of *Cactus*, the comparison with photography was particularly apt, for it was one of at least five images Sheeler made in 1931 depicting his new commercial photography studio in the Beaux-Arts Apartment Hotel on East 44th Street in New York, and is most closely related to his gelatin-silver print known as *Cactus and Photographer's Lamp* (fig. a).

New York Sun critic Henry McBride said of *Cactus* that the picture "could not have been painted in any period but our own." His comments draw particular attention to the machine age modernity of this image: "The cactus is taking a hygienic bath in some kind of electric rays and the artist does full justice to the apparatus employed and to the startlingly clear lights and shadows that result."[3] The modern taste is epitomized by the decor – the functional lamps, art deco pedestal (light on one side and dark on the other for maximum usefulness to the photographer), white walls, and venetian blinds. Sheeler renders these forms with the same respectful precision as he does the American artifacts in his domestic interiors.

Fig. a. Charles Sheeler, *Cactus and Photographer's Lamp*, 1931, gelatin-silver print, Collection of The Museum of Modern Art, New York, Gift of Samuel M. Kootz

Although the painting's realism carries with it a guarantee of truthfulness that is as modern as the studio's decor, *Cactus* is both a feat of abstract design and a subtly suggestive image. The composition is complex, dominated by three large, unrelated objects and their shadows seen at very close range. There is no foreground, space is shallow, and the alternately light and dark vertical planes defined by the faceted back wall advance and recede ambiguously. Sheeler cropped his image so that some of the objects seem not just to be incomplete but to float in space: the lamp dangles overhead; the zigzag pattern in the upper left corner – in fact, a venetian blind – is virtually indecipherable. *Cactus* exhibits a clever interplay of rectilinear and cylindrical shapes and an innovative exercise in spatial manipulation.

Behind its careful description and rigorous design, *Cactus* is mysterious and quietly surreal. The strange juxtaposition of objects, which contemporaries like Magritte might have made violent or shocking, is here only

gently disconcerting. The ghostly shadows, the nocturnal light, the extinguished lamps, and the lowered blinds create the eerie impression of a studio unused, abandoned. The objects cast peculiar shadows on the walls, and the overhead lamp's silhouette is stretched and bent as it follows the angles of the wall. Most telling is Sheeler's treatment of the cactus itself, which has been called "almost machine-like in its suggestions of toughness and durability . . . a streamlined form" but which suggests a poignant message as well.[4] The picture was painted just as Sheeler was about to set aside a lucrative career as a commercial photographer for a less certain future as a painter, and his treatment of the cactus hints at his anxieties about the transition. Isolated on a slick tabletop, the only living form in a room filled with machinery, bombarded with a harsh, scrutinizing light and – in the most significant change from the photograph – with its spines removed, the cactus appears vulnerable and defenseless.

1. Sheeler to Louise Arensberg, July 19, [1939], Arensberg Archives.
2. H.V.D., "Art: Charles Sheeler's Exhibition."
3. McBride, "Paintings by Charles Sheeler."
4. Yeh, *Sheeler and the Machine Age*, p. 235.

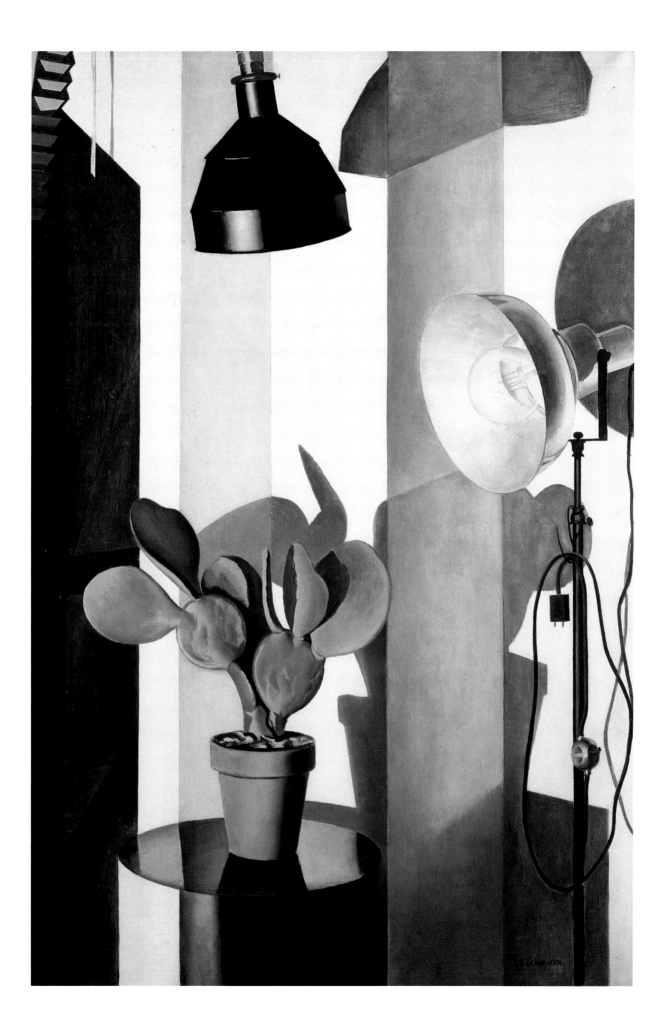

42

View of New York
Signed and dated lower left: *Sheeler-1931.*
Oil on canvas, 47¾ x 36¼ in.
(121.3 x 92.1 cm.)
Museum of Fine Arts, Boston.
The Hayden Collection

Nineteen thirty-one was an exceptional year for Sheeler's development as a painter. In it he produced many of the images – *Classic Landscape, Cactus, Home, Sweet Home* (cat. nos. 37, 41 and 43) now recognized as among his greatest achievements. Many of these works premiered at his first solo exhibition (November 1931) at the Downtown Gallery, an event that marked the beginning of his exclusive relationship with that gallery, then the most exciting showcase for contemporary American art in New York. That year also marked a watershed for Sheeler's photographic career, for when the Downtown Gallery's director Edith Halpert added Sheeler to her roster, she advised him to set aside photography, which she felt interfered with both his productivity and his reputation as a painter. Acting on her recommendation, Sheeler gave up his extremely lucrative commercial career with Condé Nast Publications and virtually ceased to make photographs to show as works of art. The difficulty of the decision, and his ambivalent feelings, are poignantly expressed in *View of New York.*[1]

The title of the painting is both literal and ironic. Shown is Sheeler's photography studio, which faced east, and when he occupied it the view of the East River and beyond was not blocked by a building, as it is today. The fleecy, pinkish clouds are what Sheeler may well have seen outside his window on pleasant afternoons. Yet such a placid, general view is not the image of New York, with its tall buildings, bustling traffic, and crowded streets, that one would expect to be shown in a painting with this title, especially one by Sheeler, who in the 1920s had enhanced his reputation with a series of images celebrating New York's architecture.

View of New York is closely related to a photograph Sheeler made at the same time (fig. a). That composition, however, is more frontal and formally balanced, and there the venetian blind has been lowered, blocking the "view" of the painting. For the photograph, moreover, Sheeler used a strong light behind him, causing the shrouded camera to throw a large, hulking shadow on the wall. Both oil and photograph demonstrate Sheeler's admiration for up-to-the moment furnishings and functional, unembroidered design: the lamps are utilitarian and

Fig. a. Charles Sheeler, *Studio Interior*, c. 1931, gelatin-silver print, The Lane Collection

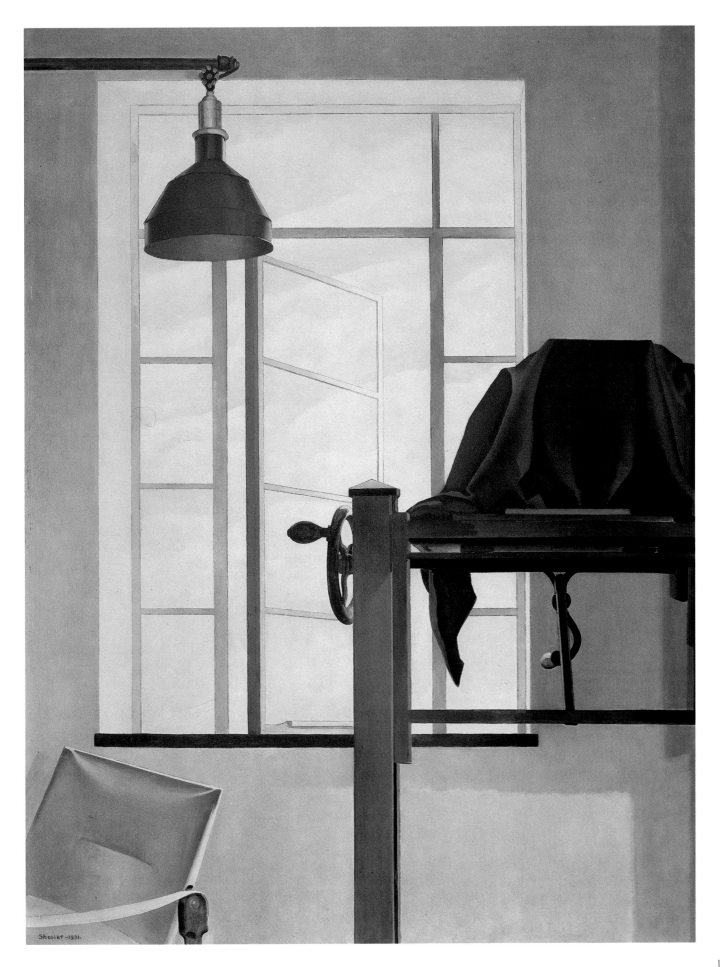

Fig. b. Edward Steichen, *Steichen with Photographic Para-phernalia — Self Portrait*, 1929, gelatin-silver print, Collection of The Museum of Modern Art, New York, Gift of the Photographer

unornamented; the lines of the camera stand and the window are spare and rectilinear (an austerity matched in the oil by the cool, subdued palette and smooth, nongestural paint handling); and the chair (replacing a small square table in the photograph) is a prototype of the famous "safari" chair by Danish craftsman Kaare Klint, and was one of the most advanced furniture designs of its day.[2]

If *View of New York* embodies modernity, it also has important roots in art of the past. It is a variant on the studio self-portrait, which for centuries artists had used to demonstrate their talents to potential patrons and to dramatize their own artistic concerns. The subject had been the continual preoccupation of Sheeler's teacher William Merritt Chase, whose lushly painted images of his magnificent studio served as a form of personal advertisement. The work of Sheeler's mentor Edward Steichen was probably more influential: in Steichen's witty *Self-Portrait with Photographic Paraphernalia* (published in *Vanity Fair* in 1929; fig. b), a camera, a lamp, and the photographer himself are paired with their shadow silhouettes. Sheeler may have found precedent here for his expressive use of shadows and for the association of a photographer with his equipment. Unlike Steichen's image, however, Sheeler's has the lamp off, the camera draped, the studio curiously inoperative. Similarly, *View of New York*'s major motif, the open window, was one that artists of the Romantic era developed into an emblem of poetic longing.[3] The window, opening onto a generalized landscape, came to be viewed both as a shield from the risks of the outside world and as a threshold that beckoned from a confining, if comfortably familiar, existence to a more challenging if uncertain future. The device of the open window is central to *View of New York*, a painting Sheeler called "cold . . . uncompromising . . . inhuman,"[4] but which was in fact autobiographical, his vehicle for expressing, in his characteristically reticent way, his deepest emotions and personal concerns.

With his camera covered, the lamp switched off, the chair empty, Sheeler bids farewell to a nearly twenty-year career as a commercial photographer. He was exchanging an art form that had provided him with economic stability and creative inspiration for one

(though he claimed it was his preferred medium) in which his success, both financial and critical, had thus far been modest. By adapting traditional motifs — the somber, closed-down studio, with an open window admitting an undefined yet pleasing view — to his modern imagery and style, Sheeler found a universal language to express both his reluctance to set aside photography and his anxieties and aspirations for his future as a painter.

1. For a fuller discussion of *View of New York* and related works, see Troyen, "The Open Window and the Empty Chair."

2. I am grateful to John T. Kirk and Trevor J. Fairbrother for information about the chair by Klint, who called his furniture "tools for living," and whose philosophy of design emphasized utility and timelessness — values parallel to Sheeler's own. See Esbjorn Hiort, *Modern Danish Furniture* (New York, 1956), p. 8.

3. See Lorenz Eitner, "The Open Window and Storm-Tossed Boat: An Essay in the Iconography of Romanticism," *Art Bulletin* 37 (December 1955): 281-87.

4. In Rourke, *Sheeler*, p. 156.

43

Home, Sweet Home
Signed and dated lower right: Sheeler-1931.
Oil on canvas, 36 x 29 in. (91.4 x 73.7 cm.)
The Detroit Institute of Arts. Gift of
Robert H. Tannahill

In the midst of his involvement with subjects inspired by his 1927 visit to the Ford Motor plant at River Rouge, Sheeler returned in 1931 to a domestic theme he had begun to investigate five years before in a painting simply titled *Interior* (cat. no. 32). Like that work, *Home, Sweet Home* is half still life, half genre painting. It is a natural arrangement of ordinary, old-fashioned objects in a comfortably familiar domestic setting; at the same time, it demonstrates the artist's penchant for clever and challenging compositional design. Though not without its sardonic undertone – for this cozy scene is oddly devoid of human presence – the title Sheeler gave this picture acknowledges the nostalgic quality of its imagery and identifies it with basic American values. The picture also reflects an important, if seldom recognized, side of Sheeler's nature – he was sentimental, and tended to idealize things and people he admired – and may indicate as well his contentment at finally being settled after a decade of changing residences and long trips related to photographic assignments.

Home, Sweet Home shows a cozy room in Sheeler's house in South Salem, New York.[1] His collection of early American furnishings is attractively showcased in this picture: the assortment of colorful rugs, both hooked and braided; the long Shaker table and bench; and the main motif, the roomy, rush-seated ladderback armchair, cozily placed beside the hearth.[2] The hearth, however, is composed of both a traditional fireplace and a boxy modern heater, merged into one visual unit by the playful overlapping of their shadows, making this a witty variation on a traditional scene: the comfortable chair is drawn up not to the fireside but to the oil burner.[3] This image is an example of both Sheeler's dry humor and his belief in the continuity between historic and modern vernacular design.

Sheeler's simple furnishings create an ex-traordinarily rich and busy composition. Rectilinear shapes and clean contours predominate, yet the effect is far from the streamlined, functional machine age aesthetic to which he is often said to subscribe. Here we see lively diagonals, not stable grids; deep, warm colors, not cool monochromes. A gay multiplication of shapes and designs is produced by the vibrant rugs, each with a different pattern, placed at odd angles overlapping the wide-board floors. The edges of the floorboards are carefully articulated in pencil to emphasize another pattern, this one of regular stripes, which, like the whole composition, are set at a diagonal that cuts across the grid of the picture space.

Adding to the complexity created by the patterns, the space is not perfectly logical. The floor is tilted up so that the room is foreshortened and the viewer's sense of scale confounded: the table in the foreground seems somewhat shrunken, while the chair, with its long arms and broad seat, dwarfs the fireplace just beyond it. And as in so many of Sheeler's paintings of this period, the shadows play an active role: the silhouette of the ladderback chair creates a lattice design on the rug at center left; that rug's zigzags are echoed by the fall of light on the stairs. Most telling are the shadows on the fireplace and the heater, which create a clever play of positives and negatives. The overlapping silhouettes – dark against light on the mantel, light against dark on the heater – join to form a keystone shape, an appropriate symbol for Sheeler's feelings about home and hearth.

Home, Sweet Home was preceded by a study in colored crayon (private collection), which records all significant details later rendered in oil. The drawing shows a slightly broader view of the room and includes in the lower left corner a portion of a small gate-legged table. That work was acquired in 1938 by Dorothy Miller, the organizer of Sheeler's 1939 retrospective exhibition at the Museum of Modern Art (in which both drawing and oil were featured); the oil, after being exhibited at Sheeler's first Downtown Gallery show in 1931 and subsequently at the Chicago Arts Club, was purchased by Henry Ford's cousin Robert Tannahill, the Arts Commissioner for the city of Detroit and a major benefactor of the Detroit Institute of Arts.

1. The heater set before the fireplace has suggested to at least one scholar that the room is a finished basement; however, it is equally likely that it is the same room Sheeler depicted in *Spring Interior* (cat. no. 33), with the stove replacing the firescreen, the mantel less impressionistically rendered, and the mysterious pattern of horizontal slats and white spaces in the earlier picture now clearly delineated as stairs. See Yeh, *Sheeler and the Machine Age*, p. 241.
2. The chair is of Pennsylvania – probably Delaware Valley – origin, and dates to about 1800. When it was made, the chair was valued because of its strong, simple lines and because it was inexpensive: it would have been found in a minor room of a major house, or in any room of a less elaborate house. See Benno Forman, "Delaware Valley 'Crookt Foot' and Slat-Back Chairs: The Fussell-Savery Connection," *Winterthur Portfolio* 15 (Spring 1980): 41-64. I am grateful to John T. Kirk for this information.
3. See Yeh, *Sheeler and the Machine Age*, p. 242.

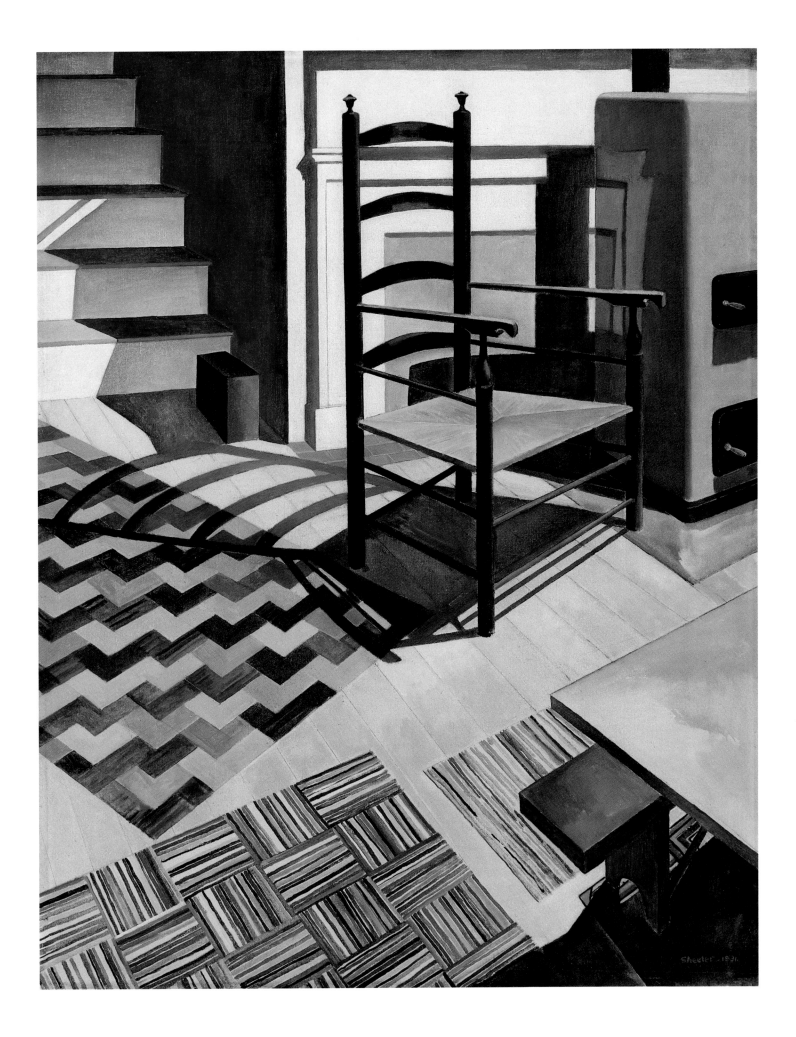

44

Newhaven
Signed and dated lower left: Sheeler-1932
Oil on canvas, 36 x 29 in. (91.4 x 73.7 cm.)
The Lane Collection

In the early spring of 1932, Sheeler and his wife Katharine moved from South Salem, New York, where they had been living for six years, to more comfortable quarters in nearby Ridgefield, Connecticut. Their new house, located about a mile from the center of town, was a two-story stucco cottage erected in 1929 by "Major" J. W. Turnbridge, a local builder.[1] Shortly after settling in Ridgefield, Sheeler began this picture, which focuses on the stairway to the second floor of the house, from which are seen the back of the mammoth living room fireplace, the compact front hall, and the large living room, which he also used as his studio (see fig. a).[2] The picture was completed over the summer and was first shown at the Downtown Gallery's fall exhibition, which opened in October of that year.

The style of the house had great appeal for Sheeler. It was modern, with contemporary conveniences such as brass piping, and also featured huge casement windows admitting ample light into the living room/studio. Yet it was deliberately simple, even rustic in its materials, and incorporated elements from the past. The huge rough-hewn beams surrounding the doorway to the living room were salvaged from an earlier structure, possibly the school that was razed to build this house. The living room mantelpiece was constructed from parts of an old stone "boat" (a toboggan-like cart designed to carry huge stones). The brickwork patterns in the chimney and the stained glass vignettes inserted at random into the window panes no doubt reminded Sheeler of the decorative schemes of his friend and Doylestown landlord, Henry Mercer.

The ordinary materials and rusticated style of the interior also provided a comfortable setting for Sheeler's growing collection of American decorative arts. He favored simple pieces rather than high-style or elaborately ornamented ones, furnishings that originally decorated middle-class homes or the lesser

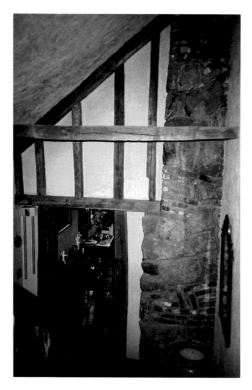

Fig. a. Interior of Sheeler's house at Ridgefield, 1986 (photo by Carol Troyen)

rooms of the wealthy. The three-legged table at the base of the stairs probably was designed as a dressing table or a server. The Windsor side chair, with its gracefully tapered spindles and simple, slender foot, dates from the late eighteenth or early nineteenth century, probably from New England, its only unusual feature being the down-turned scroll on the ends of the crest rail. The rush-seat ladderback chair, which also appears in *Americana* (fig. 18) and *American Interior* (cat. no. 52) is far more unusual: it is most likely English (although most connoisseurs and collectors of Sheeler's day believed it to be American), from the early nineteenth century, and with its bulbous legs, stretcher bar with swelling turnings, and wavy, scalloped slats was the fanciest and most sophisticated version of the form.[3]

Sheeler's Ridgefield house undoubtedly delighted him. Its large, light-filled living room allowed him to work in comfort and enticed him to curtail his trips to his New York City studio

for energy-sapping (though lucrative) hours of commercial photographic work, and dedicate himself to his painting. The sense of renewed opportunity is clearly reflected in the title he gave to this picture, which refers to his sense of sanctuary and fresh beginnings.

The painting's warm rusts and browns, echoing the welcoming color scheme of the actual interior, also suggest Sheeler's affection for the new house. The builder's delight in textures – brick, wood, stone, and stucco, all harmoniously integrated – allowed Sheeler to indulge in his love of pattern. Grid overlaps grid as he carefully detailed the eccentric diaper pattern of the chimney brickwork inserted into the more irregularly shaped stone; the neat rectilinear flagstones are sliced into diamonds and parallelograms by the banister. The shadows cast by that banister create an energetic series of zigzags on the stair, a pattern that Sheeler employed frequently to create a sense of motion in his pictures (see cat. no. 37).

The complicated rhythms created by the architect also allowed Sheeler to incorporate into this seemingly ordinary portrait of a house the subtle optical puns he relished. These compensate for the relative sparseness of the furnishings and the absence of figures or other living things, which reveal a disturbing loneliness in this otherwise lively image. Thus the front door of the house is decorated with the Windsor chair's spidery, twisted shadow, which bends at a right angle as it strikes the floor. The logical diminution of scale of objects in receding space is defeated by the heavy flagstone slabs abutting the shrunken, frilly lines of the rush-seated chair in the living room. And most disconcerting are the stair rails at lower right: one seems to descend and the other rises as the viewer surveys Sheeler's new haven from the head of the stairs.

1. I am most grateful to the current owners of Sheeler's Ridgefield house for the information about its history and construction.

2. This same view is preserved in a photographic negative Sheeler made of his new house at about the same time this picture was painted.

3. John T. Kirk generously helped me with the identification of the furnishings in this painting. For the ladderback chair in particular, see his *American Furniture and the British Tradition to 1830* (New York, 1982), esp. fig. 764.

45

Bucks County Barn
Former title: *White Barn*
Signed lower right: *Sheeler-1932*
Oil on gesso on composition board,
23⅞ x 29⅞ in. (60.7 x 75.9 cm.)
The Museum of Modern Art, New York. Gift
of Abby Aldrich Rockefeller, 1935

In 1932, when Sheeler was approaching fifty, he moved to a new house in Ridgefield, Connecticut. But the comfort and security he sought there were diminished by his knowledge of his wife's terminal illness. At his dealer's request, he ended a lucrative six-year arrangement as a fashion and celebrity photographer for Condé Nast and reduced his energetic participation in photography exhibitions in order to concentrate on his painting. Despite his curtailed involvement with photography, however, he remained committed to exploring the creative interrelationship between the two media. *Bucks County Barn* was one of four works, and the only oil, made in 1932 in which Sheeler embarked on a new approach to that interchange.

Rather than developing new images in the two media simultaneously, as he had with *Upper Deck* (cat. no. 35) or with his New York views of the previous decade, Sheeler turned to his photographs from the teens, the barns and rustic interiors of Bucks County, as the inspiration for paintings and drawings executed in his newly evolved, realistic style. These familiar images from his past may have provided solace for the insecurities of the present. From his photograph of a simple barn in rural Pennsylvania, Sheeler forged an image of stability. As the artist explained, "In the 'White Barn' ... I gave some thought [to] building up a sense of permanence by using contrast between elements which were mobile and static. The chickens might change their places, the barn wouldn't – that was the idea. Well, these things might fool us. The barn might change and the chickens wouldn't. One might do something with ideas like that in painting."[1]

Details of the painting quietly echo the themes of immutability and change Sheeler claimed for his picture. Unlike the barn in the photograph, the one in the oil has clean and regular siding so that the structure appears newly built or at least freshly whitewashed, although the roof shingles testify to periodic replacement and repair. The sky, clear and cloudless in the photograph, here is filled with streaking clouds that signal an impending weather change. By contrast, the weathered barn itself, subject to the forces of nature, is the dominant symbol of permanence: solid and foursquare, tightly closed up and secured,

a fortress against the passage of time. So viewed, *Bucks County Barn* becomes the rural equivalent of *Classic Landscape* (cat. no. 37) a picture of the previous year that is almost exactly the same size. There, ordinary cement silos are also silhouetted against a rapidly changing sky and become, in Sheeler's interpretation, heroic emblems of immutability.

With *Classic Landscape* and *Bucks County Barn* Sheeler embarked on a series of architectural subjects executed in a manner more exacting than he had previously attempted. Works like *Ephrata* (cat. no. 51), *Clapboards* (1938; Pennsylvania Academy of the Fine Arts, Philadelphia), and the group of pictures he painted at Colonial Williamsburg are similarly precise. In these paintings, but especially in *Bucks County Barn*, Sheeler's palette assumed an unnatural clarity and brightness comparable to the hues preferred by Grant Wood and other painters who were dealing in an apparently straightforward way with rural themes, but whose keyed-up color, like Sheeler's, gives a clue to more subtle ambitions.

The image recorded in *Bucks County Barn* was clearly important to Sheeler, for he rendered it four times over a period of twenty years. In addition to the photograph, this oil was preceded by a very loosely washed watercolor (San Diego Museum of Art); he returned to the subject in 1938 with a wash drawing, which was reproduced on the cover of Constance Rourke's biography.[2]

1. In Rourke, *Sheeler*, p. 198.
2. The San Diego drawing traditionally has been dated 1926 (the date assigned to it in the 1939 exhibition catalogue *Charles Sheeler* [Museum of Modern Art, New York]). However, there is no other evidence to explain the six-year gap between the watercolor and the oil; the two might equally well have been produced at the same time. The second watercolor, now in the collection of the Delaware Art Museum, Wilmington, is signed and dated 1938.

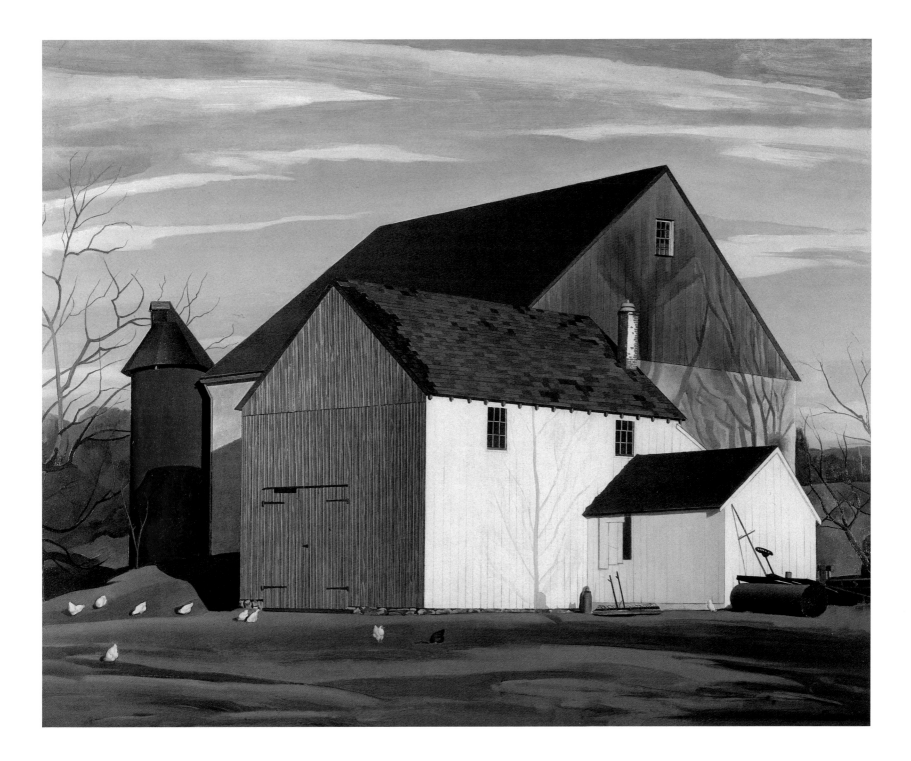

46

River Rouge Plant

Signed and dated lower right: *Sheeler 1932.*

Inscribed on reverse: *River Rouge Plant/ Charles Sheeler*

Oil on canvas, 20 x 24 in. (50.8 x 61 cm.)

Whitney Museum of American Art, New York. Purchase

River Rouge Plant shows the terminus of the boat slip that Sheeler had depicted two years earlier in *American Landscape* (cat. no. 36). The storage silos of the cement plant are seen from the side, rising behind the conveyor that brought in coal to be crushed for fuel. To the left is a boat house, and to the right, cropped almost beyond recognition, two large ships, anchored on opposite sides of the slip. The boat house and ships serve as repoussoir elements, thrusting the viewer into the picture space. The composition is based on a repeating pattern of overlapping planes and strict vertical and horizontal lines. Boxlike and contained, the space is rendered with simple one-point perspective, which makes its vast size comprehensible. The numbers that run down the right edge of the canvas — actually the load gauge on the foreground ship — enhance the composition's deliberate, stage-set quality.[1]

River Rouge Plant exhibits the differing techniques by which Sheeler distinguished between manmade and natural forms. The buildings are tightly rendered with a complex network of straight lines made with pencil and ruler, and colored in with thin layers of paint. The water, by contrast, is freely painted, enlivened with an extravagant (for Sheeler) use of pigment. The sky too is quite loosely brushed, and with the water provides the only sense of movement in this confined space.

River Rouge Plant is the only oil in the Rouge series without a poetic title and the only one to identify the site specifically. Yet like the other paintings in this series, this work does not reveal the purpose and function of the plant. No automobiles are visible, nor is Henry Ford's famous assembly line, and the buildings depicted are ones in which processes only tangential to the final product were carried out. Sheeler was interested primarily in the abstract beauty of the architecture he found at the Rouge. He did not intend his work to promote either management or the worker, or to convey any social or political message:

We are all confronted with social comment, but for myself I am keeping clear of all that. I am interested in intrinsic qualities in art not related to transitory things. I don't believe I could ever indulge in social comment. I could be disturbed by it. But it is so transitory. I think

of art as being fundamentally on a different plane. I maintain an idea of Venus as a symbol of beauty unsupported by social considerations. A foot of Venus is just as much of our time as it was of its time. Nothing to do with government.[2]

Sheeler's realism is not that of the illustrator; it is general rather than specific, as abstract and universal as any nonobjective work. The Rouge plant embodied for Sheeler the visual harmony and order he made the basis of his art.

1. Sheeler had experimented with this compositional device in several of the Rouge photographs, for example *Ladle Hooks* (1927; The Lane Collection), which displays the same boxlike space. The device is also used in *City Interior* (fig. 17).

2. In Wight, *Sheeler*, p. 28.

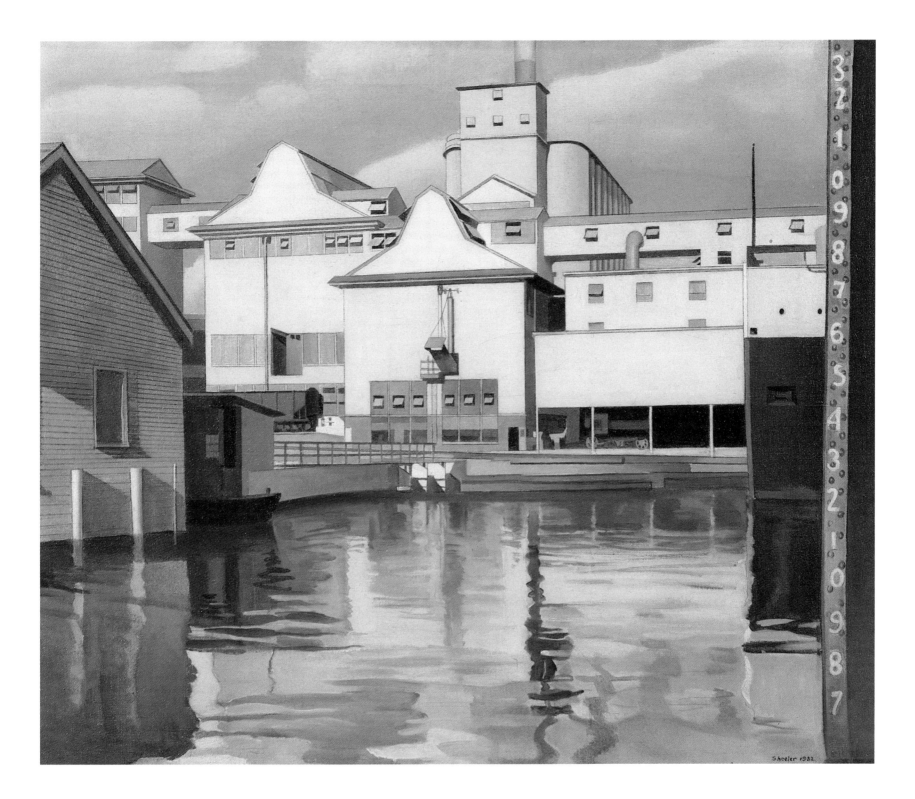

47

View of Central Park
Inscribed and dated lower left:
For Mrs. Rockefeller/by Charles Sheeler-1932.
Conté crayon on paper, 17⅞ x 19⅛ in.
(45.4 x 48.5 cm.)
Private collection, New York

Abby Aldrich Rockefeller, perhaps Sheeler's most important patron, bought her first works by the artist from the Downtown Gallery in 1928. Her support was unfailing over the next decade, when Sheeler was making the difficult transition from professional photographer to full-time painter. She would eventually own at least eleven drawings and paintings by Sheeler, many of which she gave to the Museum of Modern Art; she also sponsored his 1935-36 visit to Colonial Williamsburg, which the Rockefellers were restoring, and purchased two of his oil paintings of the village. According to Sheeler, in about 1932 Mrs. Rockefeller asked him to render this view of Central Park looking east from the American Museum of Natural History, a vista of which she was particularly fond, and which construction in the park was about to alter.[1]

To produce this view Sheeler most likely surveyed Central Park from a room (now used for storage) in the sixth-floor rotunda at the southeast corner of the museum. In the immediate foreground he shows the entrance road from 77th Street and the north-south drive along the lake; in the far distance, the view opens out to include the Ramble at upper left and the profiles of buildings visible beyond the lake's eastern shore. The body of water in the lower right corner of the drawing – most likely the section of the park beloved by Mrs. Rockefeller and soon to change – is the northern half of an hourglass-shaped pond that was part of Frederick Law Olmsted and Calvert Vaux's original plans for Central Park. During the malaria epidemic of 1880 the pond had been partially filled in, and during a series of alterations to the park in the mid-1930s it was completely eliminated and subsequently replaced by a playground.[2]

Both the broad vista and the wealth of detail depicted by Sheeler suggest he originally may have used his camera to record the scene, as was his practice in those days. Although he did make a photograph of the park from approximately the same direction, none survives that corresponds precisely to the view described here. A small, more loosely rendered conté crayon drawing of Central Park (current location unknown) from the same vantage point also preceded this picture.[3]

View of Central Park is unique among Shee-

ler's conté drawings of the period in its emphasis on linear detail, from the lampposts and street signs to the brittle tree branches of early spring. Also unusual is the prevalence, especially in the foreground, of rich, velvety blacks. Sheeler seldom made use of such dramatic contrasts, generally restricting his palette to softer middle tones. More typical is his masterful use of conté crayon to evoke various textures: the alternately dense and open hatching that defines the jagged boulder at left (foreshadowing his even more schematic treatment in *Rocks at Steichen's* [cat. no. 54]); the even tone, with the pigment perhaps blended with a stump, that renders the smooth roadway; and the mottled area that describes the shallow lake with a few icy patches remaining on its surface. The silvery profile of the tall buildings in the far distance is reminiscent of *New York* (cat. no. 17), Sheeler's elegant drawing of 1920 in which he likewise abstracted skyscrapers into carefully outlined rectilinear shapes. But his approach to the cityscape is now surprisingly anecdotal and evocative of the era, the early 1930s. *View of Central Park* is filled with picturesque details, such as the first rowboat of spring, a tiny craft just visible among the almost-budding branches; the matron waiting for a streetcar at lower left; the mother and child just entering the park; and the long sedan edging into the picture at center right – charming incidentals that create a sentimental portrait of the park designed to please Sheeler's much-admired patron.

1. See Dochterman, *The Stylistic Development*, p. 70.
2. Olive Bragazzi generously shared with me the results of her research into the view represented by this picture. She further pointed out that New York City Parks Department photographs made in July 1934 show the pond in the process of being filled in; later photographs (December 1935) show the work almost completed.
3. See Dochterman, *The Stylistic Development*, no. 32.172, and Downtown Gallery Papers.

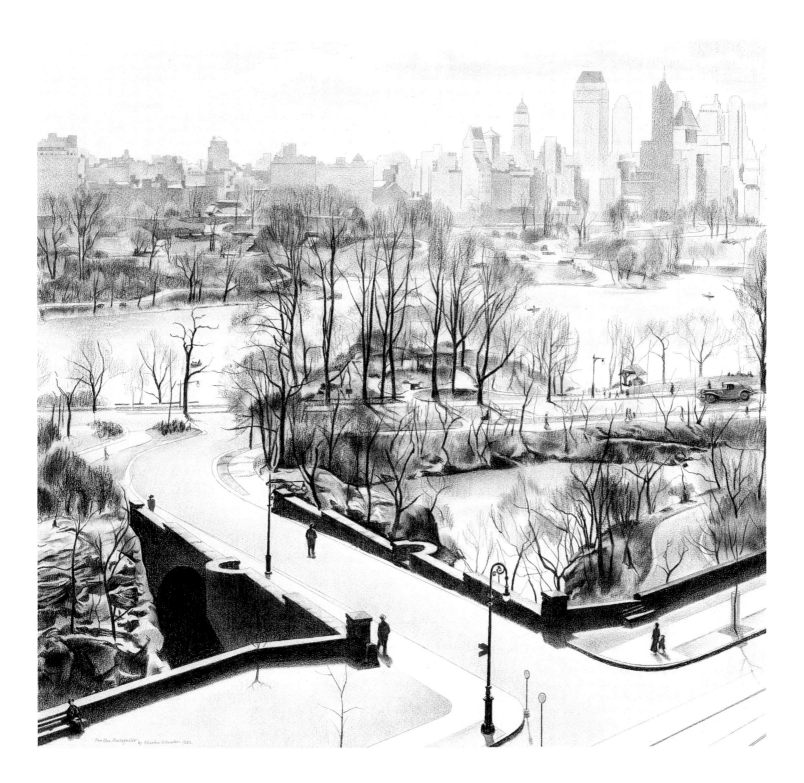

For Mrs. Rockefeller by Charles Sheeler. 1932.

145

48

Portrait (Katharine)
Signed lower center: *Sheeler*; and lower right
below drawing: *Charles Sheeler 1932*
Conté crayon on paper, 12¹⁄₁₆ x 9¹⁵⁄₁₆ in.
(30.6 x 25.3 cm.)
Collection Constance B. and Carroll L.
Cartwright

Virtually nothing is known about Katharine Baird Shaffer Sheeler, the artist's first wife. She is not mentioned in his autobiographical notes or in Constance Rourke's 1938 monograph, where this drawing of her is simply titled *Portrait* and the identity of the sitter never mentioned. Nor does her name appear in Sheeler's surviving correspondence until 1922, a year after they were married.[1] If Katharine served as the model for Sheeler's series of nude photographs and related pencil drawings (see cat. nos. 14 and 15), as seems likely, she and the artist must have been acquainted by 1919. Sheeler made two photographic portraits of her (The Lane Collection) when he made the nudes, and preserved them together as a package of unique prints (possibly movie stills); they were in his studio at his death. Those portraits show a rather matronly woman, somewhat conventional in appearance and yet lively. As the Sheelers' close friend William Carlos Williams remembered her, "[She was] the earthy type. Small hands and feet but generous at heart . . . a gifted raconteur."[2]

This portrait, made two years before her death from what Williams described only as "a malignant disease," shows a much more pensive and subdued woman than Sheeler's earlier photographs reveal. She was about fifty, two years Sheeler's senior, at the time of the portrait. He posed her somewhat casually, in one of the few pieces of contemporary furniture he is known to have owned, Marcel Breuer's tubular steel club armchair (later known as the "Wassily" chair), whose design dates to 1925.[3] Sheeler positioned the chair on a diagonal and then had Katharine turn back to face the viewer, producing an arrangement that is balanced but not static, formal but not devoid of spontaneity.

Although Sheeler had worked only briefly with conté crayon in this carefully controlled manner when he undertook his wife's portrait, his mastery of the medium was complete. His exquisite, seemingly effortless technique governs a wide range of tones, from the deep black of Katharine's dress to the bright white of the paper on the leather strap of the chair, her forearms, and the side of her face, where the light strikes most strongly. There are few sharp outlines; rather, contour and volume are suggested by delicately blended middle tones, which take their texture from the grainy tooth of the paper. These grays are especially evocative in the mottled shadows that fall across Katharine's face and throat. Like most of the conté drawings Sheeler made in the early 1930s, this portrait probably was made not from life but from a photograph; however, no photo of Katharine in this pose has come to light.

Sheeler attempted very few figurative subjects after his student years. A few drawings of nudes; three self-portraits (1923-24); *Lady of the Sixties* (1924; Coll. Carl Rieser, New York), a painted copy of a Victorian photograph made, probably as a spoof, for his friend Juliana Force; *Lady at the Piano* (c. 1926; current location unknown), for which the model, wearing her dark hair tight to her head, might have been Katharine; and a late, sketchy page of ink drawings (*Improvisations*, 1945; The Lane Collection) – these are all that are known. Of these pictures, this one had the deepest meaning for Sheeler, yet he attempted to disguise the personal connection with a neutral title and by rendering the drawing in the same somber, classically balanced, unaccented style he used for his still lifes of the period. Despite his reticence and the absence of biographical information, however, Katharine Sheeler is truly immortalized here.

1. See Sheeler to Stieglitz, November 13, 1922, Stieglitz Archive. The Sheelers were married April 7, 1921. I am grateful to Olive Bragazzi for this information.

2. Williams, *Autobiography*, p. 322.

3. Sheeler probably owned the definitive model of the chair, which Breuer produced in his studio at the Bauhaus in 1927-28.

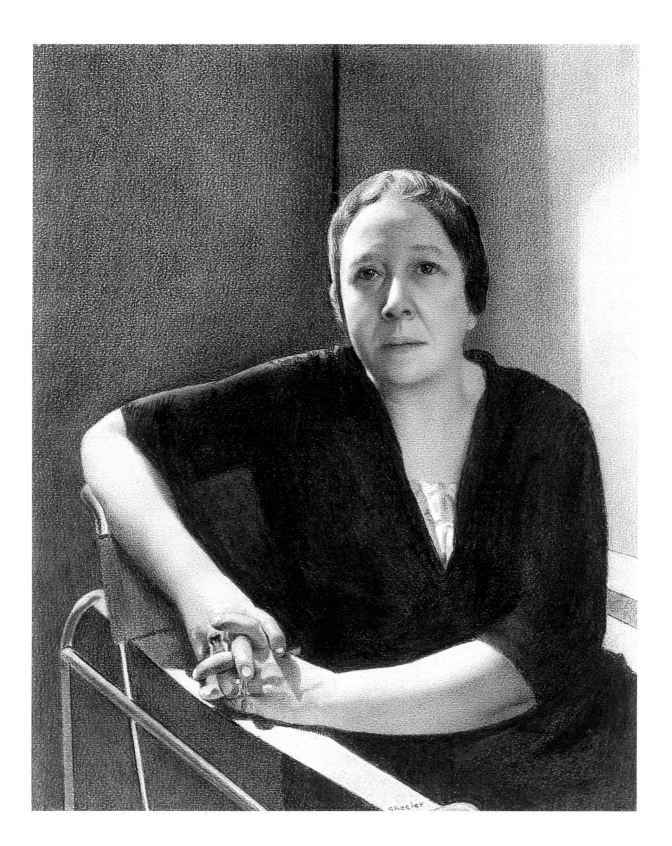

49

Of Domestic Utility
Signed and dated lower left: *Sheeler/1933*
Conté crayon on paper, 25 x 19⅜ in.
(63.5 x 49.2 cm.)
The Museum of Modern Art, New York.
Gift of Abby Aldrich Rockefeller

This complex and beautiful conté work belongs to a series of drawings with Bucks County themes that stem from photographs Sheeler made in about 1917. The group includes *The Stove* (1931; Wadsworth Atheneum, Hartford), *Interior with Stove* (1932; Coll. Joanna T. Steichen, New York), *Interior, Bucks County Barn* (1932; Whitney Museum of American Art, New York), and *The Open Door* (fig. 21). Of these, *Of Domestic Utility* is the most intimate in subject. It is a close-up view of a late-nineteenth-century enamelled tin washstand and pieces of firewood standing next to the hearth in the Doylestown house Sheeler had rented from 1911 to about 1926 (fig. a).[1]

Sheeler's facility with conté crayon is particularly impressive here. He began the drawing by carefully inscribing a rectangle upon his blank sheet. In developing the image, he never strayed past this arbitrary boundary. Gray tones predominate, lightly blended into the rough fiber of the paper to create a velvety surface texture. Sheeler reserved the point of the conté pencil to draw the smooth surface of the stripped logs, each stroke defining the grain of the wood. The white of the paper provides the brightest highlights, at the edges of the fireplace, the rim of the washbowl, and the neck of the pitcher. Sheeler's biographer, Constance Rourke, judged this to be one of the artist's best works: "None of the group of drawings, one might almost say none of Sheeler's paintings, is more original in form than this, though the objects seem almost rudely placed. To follow its design is to enter upon a surprising experience as its dimensions widen, as its simple forms show fresh and unaccustomed relationships."[2]

Sheeler's chief concern in this drawing is surface pattern and texture. He contrasts the finished wood molding of the fireplace with

Fig. a. Charles Sheeler, *Doylestown House: Closet Door with Scythe*, 1917, gelatin-silver print, The Lane Collection

the bare stick propped against it, and the smooth logs with the rough kindling scattered at right. Circles and squares play off each other: a series of rectangles draws the viewer into the picture space while the circles of log ends, bowl, and pitcher, each tipped at a different angle, create a lively design across the surface.

The objects depicted here are unpretentious, notable more for their usefulness than for their beauty or value.[3] Yet their function is only intimated, not demonstrated. The pitcher sits precariously on the edge of the slanted log, while the washbowl is tilted up, out of use. The logs make no cozy fire; the hearth is cold and empty.

Of Domestic Utility was completed shortly after the death of Sheeler's wife, Katharine. It was the only work of art Sheeler made in 1933 and the first he created after seven months of inactivity.[4] The drawing quickly was sold for $600 by Edith Halpert to Abby Aldrich Rockefeller.

1. While the other drawings in the series have specific sources in the Doylestown photographs, no print survives that exactly matches *Of Domestic Utility*. The same hearth can be seen in many of these other Doylestown works.

2. Rourke, *Sheeler*, p. 160.

3. Sheeler later used the phrase "of domestic utility" to describe the type of objects that were collected by Henry Mercer, the pioneer collector of Americana whom he had befriended in Doylestown (interview by Friedman, pt. 2, p. 4).

4. "I must think of getting down to work again after seven months of nonproduction. Not because I stress the importance of production but work has always been the balance wheel with me. Edith Halpert, probably with an idea of giving me something tangible to work for, has proposed an exhibition of my black and white drawings for the Fall. With this in view I must try to add to those which I already have" (Sheeler to Walter and Louise Arensberg, June 27, 1933, Arensberg Archives).

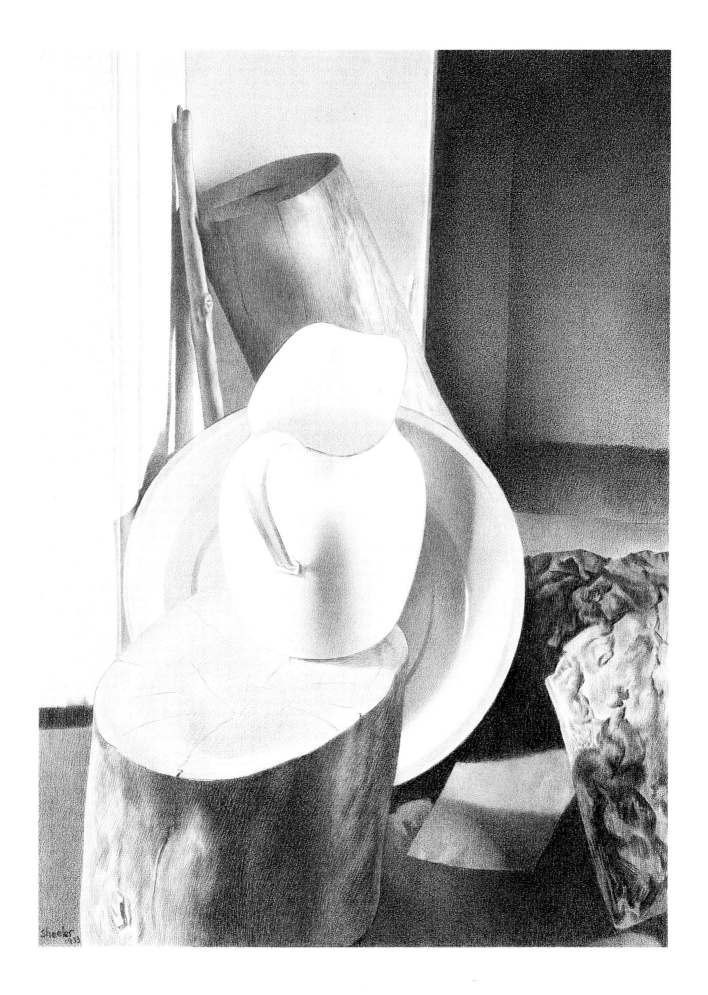

50

Feline Felicity

Signed and dated lower right: *Sheeler-1934*
Conté crayon on paper, 22 x 18 in.
(55.9 x 45.7 cm.)
Harvard University Art Museums (Fogg Art Museum). Purchase, Louise E. Bettens Fund

Feline Felicity is perhaps Sheeler's best-known and most appealing drawing. It was purchased for Harvard within two weeks of its arrival at the Downtown Gallery in October 1934.[1] Since then, it has been exhibited in virtually every Sheeler retrospective, and has been discussed and reproduced in numerous histories of drawings and in over a dozen drawing manuals, testimony to both the attraction of the image and its extraordinary technical accomplishment.[2] At the same time, it is an unusual image for Sheeler, and it may be that he undertook this gentle rendering in response to the criticism that his cold, precise style was suitable only for representations of technology.[3] The drawing is charmingly domestic, its sentimentality engaging rather than cloying. Yet like most of Sheeler's work, it was conceived as a still life, with the organic form serving as·counterpoint to a strong structural underpinning.

The drawing was done at Sheeler's home in Ridgefield. The flagstone floor and early-nineteenth-century slatback chair are familiar motifs from earlier paintings, while the hearthside setting is reminiscent of the similarly cozy fireside of his Doylestown house, represented in the previous year's *Of Domestic Utility* (cat. no. 49). With that drawing, *Feline Felicity* marks Sheeler's resumption of artistic activity after the death of his wife in June 1933, and with the oil *American Interior* (cat. no. 52) this would be his last exploration of the domestic themes that preoccupied him in the early thirties. Hereafter he would seek less directly personal subject matter.

In keeping with his practice during this period, Sheeler modeled *Feline Felicity* after a photograph, a casual snapshot of his cat Duke (the photograph is now in the Lane Collection). The drawing's composition is intentionally photographic, based on a close-up view

recorded from above and cropped to focus attention on the light-dappled tabby asleep on the chair. Perhaps in deference to his subject, Sheeler seems not to have employed his photographer's lamp and the stronger, more dramatic light it yielded, but rather posed the cat in natural light coming in from an unseen window behind him and, as suggested by the shadows on the back wall, diffused by a tree outside. As a result, although the tonality of the drawing extends from palest ivory in the highlighted areas through innumerable middle grays to ebony in the deepest shadows, flickering patterns, rather than harsh silhouettes, dominate. The brindled fur of the cat is set off against the more regularized rhythm of the chair's webbed seat and then is echoed by the dancing shadows in the fireplace.

To render his dozing pet, Sheeler employed a meticulous technique of tiny, barely discernible strokes. The same technique describes the chair rungs, flagstones, and logs in the fireplace, which comprise the cozy scene's grid-like underpinnings. He softened this matrix by deciding against a frontal view; instead, he set the chair at an angle, so that pleasing triangles define the basic structure of the composition. The understated strength of the drawing's design, as well as its tonal sophistication, caused Sheeler's biographer, Constance Rourke, to assert that its power derived from something other than the artist's commitment to naturalism:

> *Its title almost goes out of its way to announce that this is a genre piece, a bit of naturalism, a silver tabby in a ladderback chair; and those who wish may take it so: it seems all immediacy, all close detail, nothing is generalized. But shadows in nature do not fall in so beautifully soft and complex a pattern. . . . Though they do not seem so, these harmonies are outside nature. The subject has been floated quietly within a formal order.*[4]

There can be no doubt that Sheeler manipulated the details of this picture, yet homage must be paid to the eye that detected both the comforting serenity and the formal elegance of such a scene. Sheeler asserted that his role as an artist was "to present the subject as far as possible without imposing anything — to give it on its own terms."[5] In *Feline Felicity* he shares with the viewer a common domestic moment,

realistically portrayed with uncommon craftsmanship and an exquisite eye for design.[6]

1. See object files for *Feline Felicity*, Harvard University Art Museums, Cambridge, Mass.

2. *Feline Felicity* is discussed in anthologies of drawings by Charles Slatkin and Regina Shoolman (1947) and Theodore E. Stebbins, Jr. (1976), and in drawings manuals by Daniel Mendelowitz (1967, 1976, 1982), Seymour Simmons III (1977) and Claire Leslie (1980), among many others.

3. See H.Z.R. [Harry Z. Rand], "Feline Felicity," *American Art at Harvard* (Fogg Art Museum, Harvard University, 1972), cat. no. 144.

4. Rourke, *Sheeler*, pp. 158-59.

5. In ibid., p. 123.

6. I am grateful to my former student Jo-Anna J. Moore for sharing with me her insightful ideas about *Feline Felicity*, many of which are reflected here.

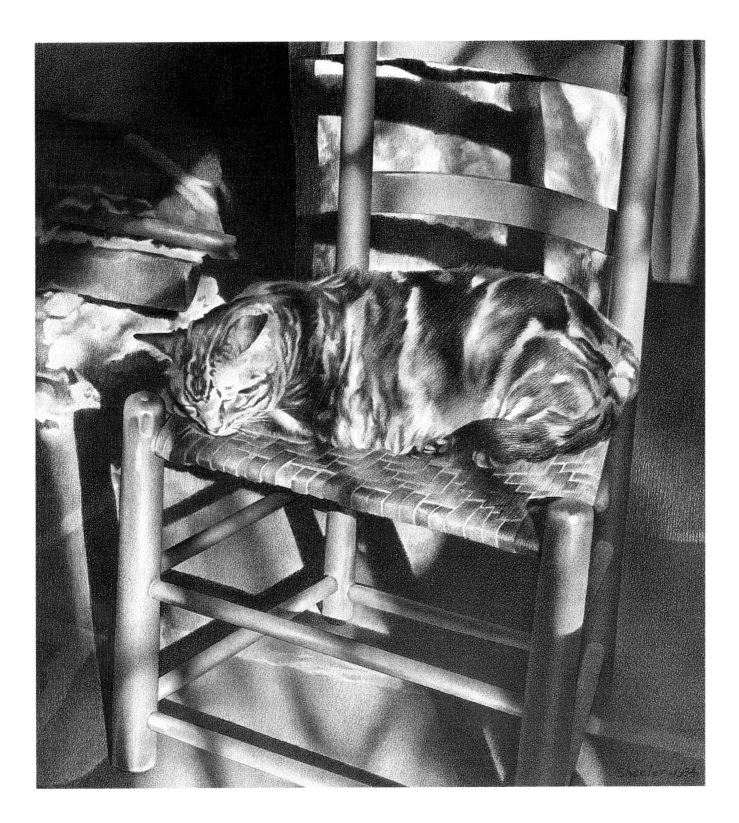

51

Ephrata

Signed and dated lower right: *Sheeler-1934.*
Oil on panel, 19½ x 23½ in. (49.5 x 59.7 cm.)
Museum of Fine Arts, Springfield, Mass.
The James Philip Gray Collection

Ephrata, a small village some sixty miles west of Philadelphia, was the site of the Ephrata Cloister, an eighteenth-century monastic community founded in 1732 by the German Pietist Conrad Beissel. The mystical religious order grew to nearly three hundred members by mid-century. Its beliefs centered on the imminence of the millennium and on spiritual purification through physical denial, and its practices included celibacy, foot washing, and adult baptism. The community operated a school and a highly successful printing press, and excelled at calligraphy, carpentry, farming, and milling. Despite the initial prosperity of the cloister, by 1800 the order was practically extinct, and subsequently the buildings were taken over by the Seventh Day German Baptist Church.

When Sheeler visited the cloister in about 1917 it was little used and in disrepair. The artist photographed the buildings, concentrating on the best preserved, chiefly those which had been at the center of life in the community in its most active days: the bakery (the center of food production for the largely vegetarian society), the Saal, or meetinghouse, and the Saron, or sisters' dormitory, all built in the 1740s in the architectural style of the members' Rhenish homeland. One of these photographs, taken from the community's graveyard (fig. a), became the basis for this painting, executed almost twenty years later.

Sheeler's trip to Ephrata, and his exploration of the architectural remains of this religious community, was part of his developing interest in eighteenth- and nineteenth-century American rural cultures, first those of eastern Pennsylvania and then of the similarly mystical Shakers. He painted this picture at the height of his enthusiasm for Shaker architecture and while working on a series of domestic interiors, many of them featuring Shaker and other early American artifacts.

Fig. a. Charles Sheeler, *Ephrata Cloister from the Cemetery,* c. 1917, gelatin-silver print, The Lane Collection

During this period Sheeler's style was realistic and highly finished; on occasion it lapsed into a somewhat mundane literalism. Here, however, although he followed his photograph in almost every detail, he eliminated the graveyard in the foreground and cropped the composition at the sides and thus was able to demonstrate his talent for creating lively textural patterns – on the stone fence, the bake house walls, and the crinkly foliage – and to emphasize the balanced massing of forms – dark against light, rectilinear architectural forms against the softer, curved masses of the trees. Compared to the photograph, the painting exhibits a dense composition and insistent surface design. Sheeler's naturalistic color scheme is dominated by soft secondary hues, in particular the creamy lavender (which would become a staple of his palette) used for the warm Pennsylvania fieldstone of the build-

ings. The painting is skillfully and sensitively designed, yet there is little that is invented: Sheeler's realism and the smooth, careful finish were calculated to demonstrate the simple elegance and proportion of the buildings without drawing attention to his own hand. His attitude toward his subject, it would seem, parallels that of the original residents of the community toward their own creations: humility and reverence.

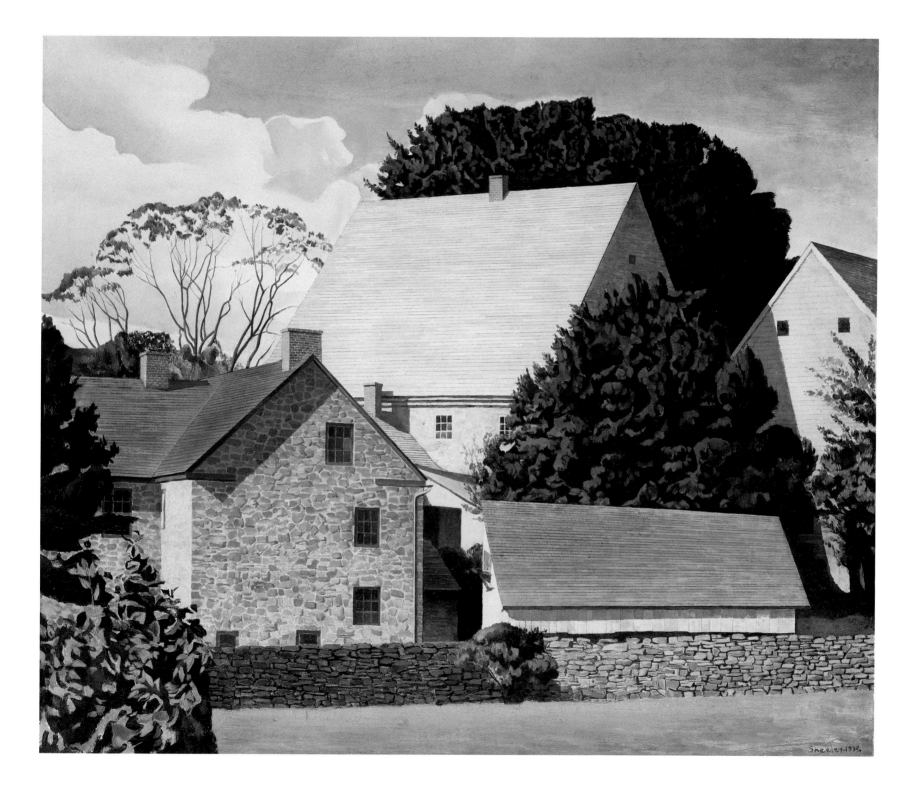

52

American Interior
Signed and dated lower right: *Sheeler 1934*
Oil on canvas, 32½ x 30 in. (82.6 x 76.2 cm.)
Lent by the Yale University Art Gallery.
Gift of Mrs. Paul Moore

American Interior is the last of the series of domestic portraits Sheeler began in 1926. Of these, five, painted between 1926 and 1931, represent his South Salem, New York, house, while the sixth, *Newhaven* (cat. no. 44), is a celebration of his new surroundings in Ridgefield, Connecticut. In this work Sheeler once again depicted South Salem, even though he had moved away over a year before.

Like the other paintings in this series, *American Interior* demonstrates Sheeler's sensual enjoyment of the objects he had collected and lovingly arranged: the Shaker table with cleated end, the early-nineteenth-century turned-post bed, the array of textiles, the Whieldon ware mug. This is the warmest painting of the series, with the greatest tactile appeal.[1] The soft color harmonies of red and blue, the vibrant juxtaposition of textiles with contrasting geometric designs, and the sunlight streaming into the room and producing strong shadows all add to the painting's patterned richness, creating both visual delight and a sense of cozy familiarity. The arrangement of furnishings, which appears to be casual, is in fact carefully structured; yet the formal rigor that made some of the early works in the series overcomplicated (e.g., *Interior*, cat. no. 32) is here fully mastered. Although the painting's grid underpinnings can be detected, Sheeler's gentle skewing of some of the verticals and his introduction of prominent diagonals (the table at lower left and the seat of the chair) make the scene seem utterly natural.

Sheeler prepared carefully for *American Interior*. As he had done for *Home, Sweet Home* (cat. no. 43), he first made a small study in watercolor (fig. a), in which he worked out spatial and color relationships between the objects, established his atypical square format, and recorded, in an unusually loose hand, all the details that appear in the finished oil (with the exception of the slender, tapered table leg at upper right). Both the oil and the watercolor

Fig. a. Charles Sheeler, *Study for American Interior*, c. 1934, watercolor and pencil on paper, National Museum of American Art, Smithsonian Institution, Washington, D.C., Transfer from the Archives of American Art, Smithsonian Institution.

Fig. b. Charles Sheeler, *South Salem Interior*, 1929, gelatin-silver print, The Lane Collection

were based on a photograph (fig. b), one of a group Sheeler had made in about 1929 showing the living room of his South Salem house.

The photograph, a horizontal composition that Sheeler cropped to yield a square, records almost exactly the placement of forms as they appear in the oil. It was made from an elevated vantage point, possibly from a stair, which accounts for the steep pitch of the floor in the painting – a perspective that projects the viewer into the heart of the picture, underscoring the intimacy suggested by the homey objects.

Sheeler's decision to return to the South Sa-

lem house as the setting for his last domestic interior, rather than continuing to paint his new Ridgefield house, may have been influenced by personal events. He and his wife Katharine moved to Ridgefield in the spring of 1932. Her illness, nowhere identified but presumably some form of cancer, slowly worsened after their move; she died in June 1933. In the preceding two years, Sheeler had been remarkably prolific, creating many of his best-known works.[2] In 1933, however, he completed only one picture, *Of Domestic Utility* (cat. no. 49), and presumably began this one.[3] His productivity resumed the following year as he emerged from the depths of bereavement. In choosing his subject, he understandably avoided the Ridgefield house, initially viewed with such optimism but subsequently associated with tragedy, and returned to South Salem. That setting reflected happier times, his beloved artifacts in their familiar surroundings recalling security and contentment.

In contrast to the personal subject matter, Sheeler's broad title (like that of *American Landscape*; cat. no. 36) allowed him to get some emotional distance and suggests a larger theme. The title pays homage to the unpretentious but handsome assemblage of traditional and native manufactures depicted, and also intimates that this sort of simple interior represents the best of national values. The artist's dealer anticipated the public's response to the patriotic message and selected it to represent Sheeler in annuals held in museums all over the country, and in February 1941 the editors of *House and Garden* chose to reproduce it as their cover illustration.

1. See Rourke, *Sheeler*, p. 167. Rourke notes its "richly textured intimacy" and Sheeler's "striking technical accomplishment in the rendering of thin, tangible glass, of plates whose glaze can be felt, whose complex patterns can be closely seen, in other patterns and textures."

2. In 1931, Sheeler produced fourteen works, including *View of New York, Cactus, Classic Landscape, Home, Sweet Home*, and *Americana*, as well as several conté crayon drawings. In 1932, his output included four conté crayon drawings (among them, the large scale *Interior with Stove*) *River Rouge Plant, Newhaven*, and six other works.

3. A work of this scale and complexity undoubtedly took more than a month to complete. By January 1934 it had been received by the Downtown Gallery and was then transmitted, as a potential purchase, to the Fogg Art Museum, where it arrived on January 30, 1934 (Archives, Harvard University Art Museums).

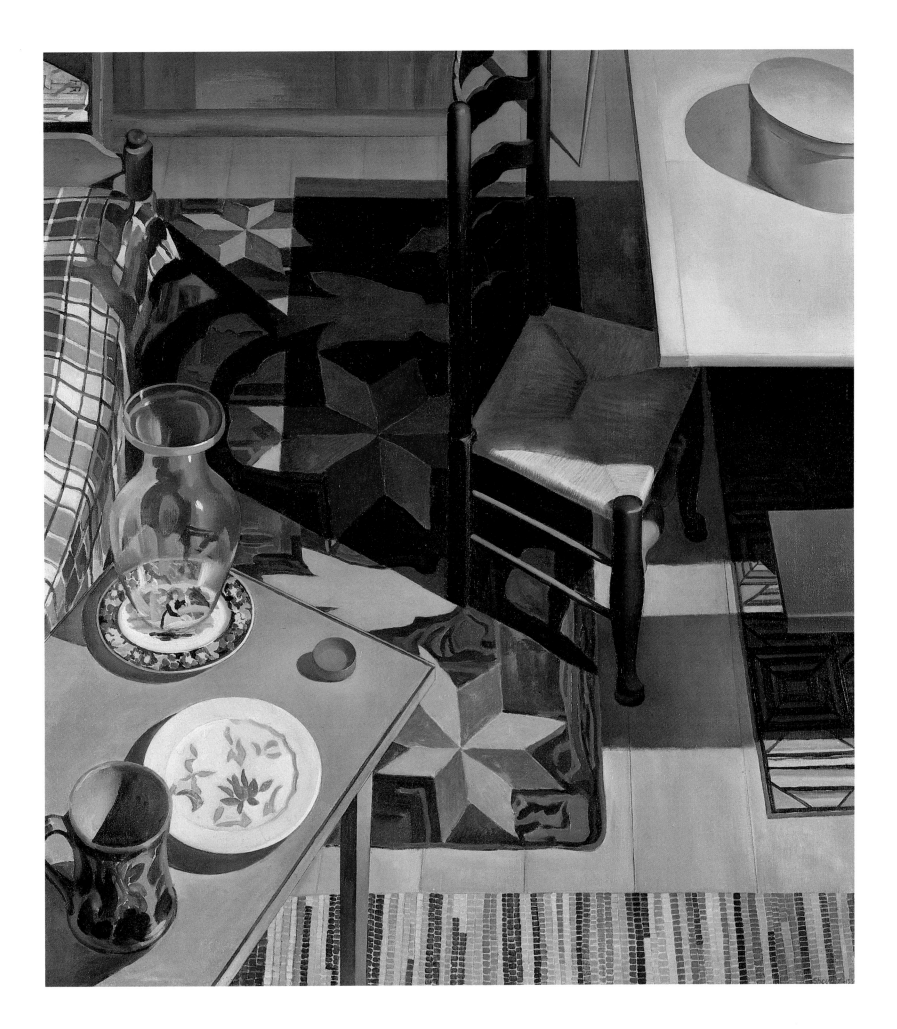

53

Totems in Steel
Signed and dated lower right: *Sheeler-1935*
Conté crayon and graphite on paper,
19⅛ x 22¾ in. (48.5 x 57.7 cm.)
Harvard University Art Museums (Fogg Art
Museum). Bequest of Meta and Paul J. Sachs

Totems in Steel originated with a frame from
the film *Manhatta*, which Sheeler made with
Paul Strand in 1920. That film documented the
dynamism of the modern city; the construc-
tion site depicted here served as an emblem of
Manhattan's unprecedented growth. In the
years between the making of the film and the
drawing, New York acquired a new and spec-
tacular skyline. In the same interval, Sheeler at-
tained artistic maturity, mastering several new
media (among them conté crayon) and ex-
ploring new themes, including urban and in-
dustrial subjects, which are the basis of his
reputation today.[1]

With *Totems in Steel* Sheeler attained the ar-
tistic goal he set for himself in *Upper Deck* (cat.
no. 35): to present a subject in such a way that
it simultaneously appears realistic and reveals
its inherently abstract design.[2] The vividness of
this scene derives less from the precise tran-
scription of details than from Sheeler's com-
pelling use of perspective. By placing the un-
completed floor at the bottom of the drawing,
Sheeler invites the viewer to step directly onto
the construction platform. At the same time,
he creates a lively formal tension between
space and surface, description and design. His
composition is additive: the eye is not drawn
to a single point, formal or dramatic, in the pic-
ture, but rather follows the rhythmic march of
steel columns across the drawing's width. The
delicate modulation of gray tones simultane-
ously leads the eye into the distance. This bal-
ance between abstract surface pattern and illu-
sion of depth is epitomized by the tall diagonal
crane, which guides the viewer across the
drawing from left to right while gradually dis-
solving at the top, as though it were reaching
back into space.

The machine age muscularity of Sheeler's
subject is belied by his love of decoration: the

Fig. a. Charles Sheeler, *Totems in Steel*, 1935, tempera,
Memorial Art Gallery of the University of Rochester, Gift
of Peter Iselin and his sister, Emilie I. Wiggin

steel crossbars reinforcing the cranes become
delicate latticework; the geometric patterns
they define are art deco in feeling and are also
reminiscent of the stained glass windows de-
signed by Frank Lloyd Wright. The large trian-
gles created by the huge columns, cranes, and
cables are echoed by the tiny shapes within
the cranes, a repetition of forms that suggests
one of many parallels between the construc-
tion of the building and the construction of the
drawing. And the occasional round forms –
the pulleys, the worker's hard hat – that ap-
pear against the rectilinear scaffolding com-
plete the ornamental web across the picture's
surface: they are like points on a grid, con-
nected by the cables.

The decorative patterns of the drawing and
its tension between realism and abstraction
are not nearly so apparent in the frame from
the film (reproduced in *Vanity Fair* in April
1922). Nor are they evident in the small tem-
pera (fig. a) made between the film still and the
drawing. In the drawing Sheeler also elimi-
nated the two tiny workers perched on the
uppermost girder at right, thus removing the
only anecdotal detail and enhancing the still-
ness and monumentality of the structure. The
figure at lower left, on the other hand, reiter-
ates the heroic scale of the construction pro-
ject and serves as a surrogate for the viewer,
marveling at the scene.

For Sheeler, *Totems in Steel* was not simply a
paean to the city's growth and progress but a
metaphor for artistic creation. He alludes to
this poetic function in his title. Taken literally,

the steel columns are like streamlined totem
poles, each crowned with a different geomet-
ric configuration in much the way northwest
Indians individualized their totem poles. As
revered symbols that allude to both the wor-
shipper's aspirations and his ancestry, the col-
umns become personal totems of Sheeler's
lifelong interest in architecture and design. It
was no accident that Sheeler chose to express
this interest by depicting a steel skeleton
rather than a finished building, its framework
rather than its external outline, for he believed
that the principal responsibility of the artist
was not to record impressions but to reveal
the underlying structure of things.[3]

1. I am indebted to Diane Dillon, a student in my seminar
on Sheeler offered at the Museum of Fine Arts in the fall of
1985. Her excellent paper on *Totems in Steel* formed the
basis of this catalogue entry.

2. "I had come to feel that a picture could have incorpo-
rated in it the structural design implied in abstraction and
be presented in a wholly realistic manner" (Sheeler, in
Rourke, *Sheeler*, p. 143).

3. See his "Notes on an Exhibition of Greek Art," p. 153.

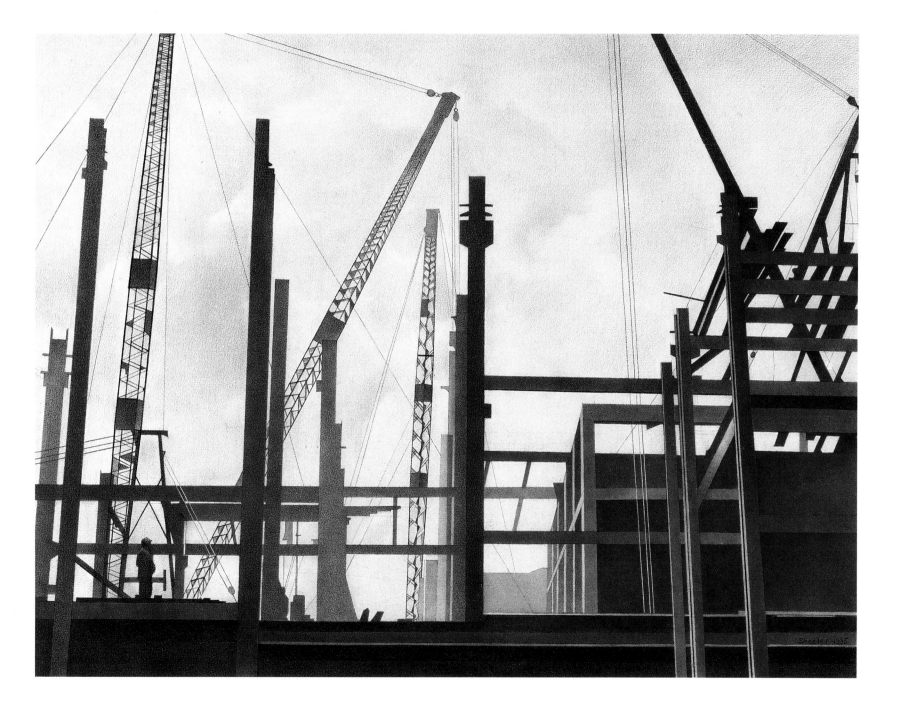

157

54

Rocks at Steichen's
Signed and dated lower right: *Sheeler.1937*.
Conté crayon on paper, 15⅞ x 13⁹⁄₁₆ in.
(40.5 x 34.5 cm.)
The Baltimore Museum of Art. Gift of Lilian
Greif, Nelson and Juanita Greif Gutman.
Collection, and Gift of Dr. Eleanor P.
Spencer, by exchange

Sheeler's friendship with the photographer
Edward Steichen had begun in about 1923,
when Steichen invited Sheeler to join him on
the photographic staff of Condé Nast Publica-
tions. Despite their very different photo-
graphic styles and subjects, the two artists
respected each other's work and they re-
mained close even after Sheeler's retirement
from Condé Nast in 1932. Sheeler gave
Steichen his large conté crayon drawing *Inte-
rior with Stove* (Coll. Joanna T. Steichen, New
York), which he made the year he retired. The
present drawing was made several years later
on the grounds of Steichen's West Redding,
Connecticut, home, only a few miles from
Sheeler's residence in Ridgefield. Sheeler
clearly treasured *Rocks at Steichen's*, for it re-
mained in his own collection for many years,
and was sold only after his death.

Rocks at Steichen's is the last of a series of
extraordinary, highly finished conté crayon
drawings Sheeler made in the 1930s and, by
virtue of its subject, the most abstract. Pure
landscape was rare in Sheeler's art; most likely
what appealed to him in this view was the
animated patterns of light and shadow and the
variety of textured surfaces (delicately ren-
dered in the matte blacks and silvery grays his
medium afforded), rather than the opportu-
nity for geological description. The plant forms
are not drawn with botanical specificity, as one
might expect in a drawing obstensibly so real-
istic, and while the rocks have great sculptural
presence, the shadows are as concrete as the
outcroppings that cast them.

In *Rocks at Steichen's*, Sheeler used a com-
positional formula he invented in the 1917
photograph *Side of White Barn* (fig. 8) and
would use again for subjects as diverse as *Roll-
ing Power* and *Shaker Detail* (1941; Newark
Museum): the image is so closely cropped that
it fills the visual field completely. There is little
foreground, no far distance and no peripheral
space, and virtually no interval at all between
viewer and subject. As a result, scale becomes
difficult to judge, and the drawing quickly tran-
scends its subject and becomes an abstract vi-
sion of light and dark shapes, lively and, for all
its realism, mysterious.

55

Still Life

Signed and dated lower center:
Sheeler-1938
Inscribed on back of original stretcher:
Charles Sheeler, Still Life 1938, Charles Sheeler
Oil on canvas, 8 x 9 in. (20.3 x 22.8 cm.)
Collection of Mr. and Mrs. Barney A.
Ebsworth

With *Still Life*, Sheeler returned to the tabletop arrangements he had painted and photographed repeatedly in the 1920s, addressing this traditional genre for the first time in many years. He returned as well to two of his favorite objects, which had appeared frequently in those pictures but seldom since – the Etruscan vase and ironstone pitcher, here coupled with cuttings from a coleus plant rooting in a glass of water. The mood and style of this work are very different from those much-admired pictures of the 1920s and reflect his adoption of a more descriptive and "modern" manner.

The inspiration for *Still Life* was a series of photographs of these objects made during the 1920s (fig. a). But following his custom in translating a photographic image into a painted one, here Sheeler erased the objects' imperfections: the slightly battered base of the Etruscan vase (the incised bands of decoration around the body also are eliminated) and the pitted surface and badly chipped rim of the ceramic pitcher are shown as though in perfect condition. Nor did he revive the symphony of shadows that he used repeatedly in the paintings and photographs of the 1920s (see cat. no. 27) to knit his disparate objects together across a shallow space and to impart a mysterious elegance and romance to the composition. Rather, volume dominates here, and, as in his architectural subjects of the same period (see cat. no. 56), the objects become weighty, iconic, pure in outline, and above all monumental – they seem far larger than the tiny size of the canvas would allow.

In the 1920s Sheeler's still lifes revealed the grace and age of the objects he depicted. He preferred warm tones – often velvety brown-blacks in the photographs, and reds and reddish-browns in the paintings – which suggested a kind of homey familiarity and frequent use. But in *Still Life*, the idealized, unblemished forms are bathed in cool light, and the near-monochrome palette and the clever superimposition of white pitcher on black vase on pale background make their contours even more crisp and precise, converting these antique forms into modern artifacts.

However brilliant and controlled the rendering, this work is not simply an exercise in still life painting that parallels the stylistically

Fig. a. Charles Sheeler, *Arrangement*, c. 1920s, gelatin-silver print, Collection of The Museum of Modern Art, New York, Gift of Samuel M. Kootz

similar architectural and industrial subjects Sheeler produced during this period. The objects in the picture had important personal associations for him. Not only were they beloved forms chosen from the eclectic collection of objects he had assembled since the teens, but they also served as emblems of cultures and aesthetic attitudes that had been continual sources of stimulation for him and his art: the classical world, the America vernacular tradition, and a token of the natural world, tamed and cultivated, and painted with a miniaturist's care and adulation.

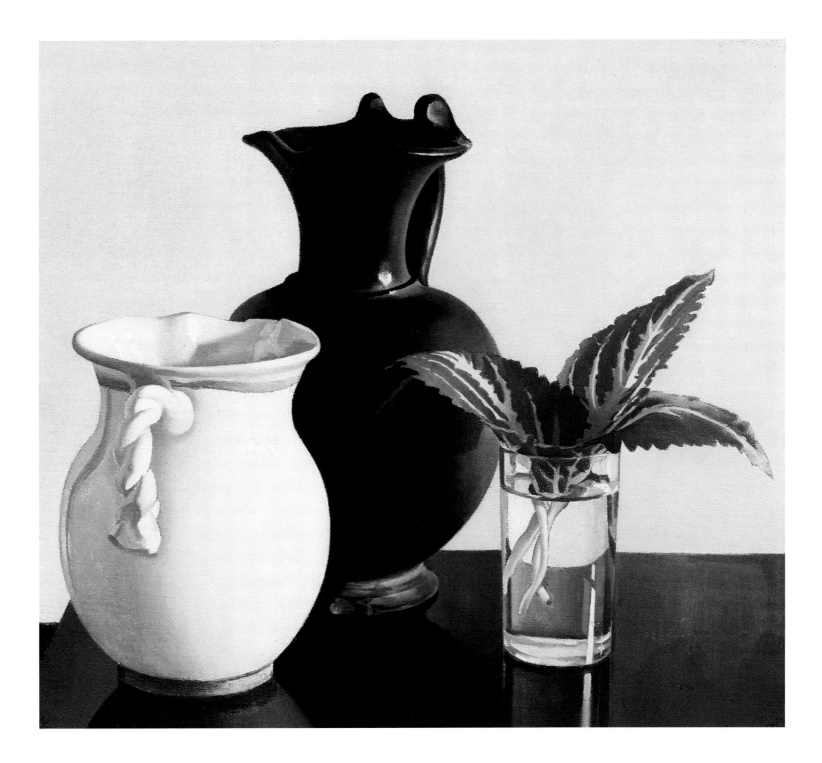

56

Silo

Signed and dated lower right: *Sheeler-1938*

Oil on canvas, 20 x 19 in. (50.8 x 48.3 cm.)

Steve Martin

"Sheeler Finds Beauty in the Commonplace," the feature article on Sheeler that appeared in the August 8, 1938, issue of *Life* magazine, included a photograph of the artist at his easel, working on *Silo* (then half finished) (fig. a). This was Sheeler's first effort for *Fortune*, *Life*'s sister publication in the Time empire directed by Henry Luce, which in the 1930s and 1940s routinely hired prominent artists (among them Herbert Bayer, Charles Burchfield, and Fernand Léger) to illustrate its cover and feature stories. *Silo* was reproduced on *Fortune*'s April 1939 cover. The periodical was then nine years old; its circulation by that time was sufficient to guarantee that Sheeler's design would reach well over 100,000 readers.[1]

Sheeler's preparation for *Silo* followed the working practice to which he had adhered for at least a decade. The painting's subject — a tall clapboard silo supported by cables and a wood-sided barn topped by a square cupola and amusing weathervane in the shape of a cow — had appealed first to his photographer's eye as he roamed western Connecticut in the late 1930s. Although the surviving photograph of this site is horizontal, showing the buildings cut off at the bottom, it may have been cropped, or there may well have been another photograph — vertical in orientation and so emphasizing to an even greater degree the silo's monumental qualities — which Sheeler discarded after the painting was finished.

The handling of *Silo* shows the artist's characteristic restraint. It is painted extremely thinly, with no visible impasto. The pencil underdrawing is exploited to add definition to such details as the boards facing the silo and barn. This smooth, nongestural technique, the crisp realism, and the dramatic, worm's-eye angle of vision might all seem photographic; however, the palette decidedly is not. The subtle gradation of the facets on the sunny side of the silo from creamy white through lavender and maroon gives the siding an almost opalescent sheen; the cottony clouds against the brilliant blue sky (the photograph records no such bucolic backdrop) contrasted with the rosy-colored barn is improbably cheerful. But if the colors in the painting create a pastoral mood, the composition — astonishingly simple after the descriptive complexity of Sheeler's works of the mid-1930s (see, e.g., *City Interior*,

Fig. a. Alfred Eisenstaedt, "Sheeler Paints a Cover for *Fortune* magazine," *Life*, August 8, 1938, p. 42 (© Time Inc.)

fig. 17), and centering on the monolithic presence of the silo — anticipates the iconic austerity of the "Power" subjects (see cat. nos. 57-62, especially *Yankee Clipper*) begun for *Fortune* the next year. The painting is so similar to those muscular pictures in mood and handling that *Silo* could as well have been titled "Agricultural Power" — except that Sheeler, with sly humor, presents as counterpoint to the sleek, imposing buildings an old-fashioned weathervane, gently satirizing the self-important grandeur of the thrusting silo with the silhouette of a golden calf.

Sheeler's admiration and enjoyment of these buildings did not wane after he finished the painting, for when Edward Weston visited Sheeler in 1941, the two photographers returned to the site. Weston was also inspired, and produced an image of the whole complex, entitled *Connecticut Barn* (1941; Museum of Modern Art, New York).

1. See Elson, *The World of Time Inc.*, vol. 2, p. 220.

57

Primitive Power

Signed and dated lower right: *Sheeler-1939*

Tempera on paper, 5 x 7 in.

(12.7 x 17.3 cm.) (sight)

The Regis Collection, Minneapolis

Late in 1938 Sheeler received a commission from *Fortune* to paint a series of pictures on the theme of "Power" for reproduction in the magazine. The resulting picture essay was composed of six portraits of energy-generating machines that symbolized, in *Fortune*'s words, "exquisite manifestations of human reason."[1] To produce it, Sheeler traveled intermittently during 1939, to New York and Alabama (the site of the present picture) in the first half of the year, and to Boulder Dam in the fall, finally finishing the series in March 1940. It was published in *Fortune*'s December issue, and the paintings were exhibited at the Downtown Gallery that same month.[2]

Primitive Power, the first picture of the series, shows "an overshot waterwheel, still turning millstones at Hamilton, Alabama."[3] It is the only historical image in the series and is perhaps the most straightforward and descriptive, depicting not just the implements of power itself – the sluice and waterwheel – but also the stream, the ramshackle wooden mill building, and, at the outer edges of the picture, its placid landscape setting. The picturesque quality of the image was perceived by at least one reviewer, who nostalgically described the waterwheel as "still grinding corn for neighboring farmers."[4]

In style, *Primitive Power* relates more closely to certain works of the mid-1930s than to the rest of the "Power" series, for which it serves as a kind of preface. With *City Interior #2* (fig. a), for example, it shares medium (tempera over deliberately visible pencil drawing, rather than oil, like the rest of the series), a delicate palette of soft lavender, pale blue, and ivory, a miniaturist's crisp touch, and above all a sense of microcosm. Although both pictures are tiny, the space seems enveloping, and in both motion is only implied: the machines appear at rest or even abandoned. But whereas in *City Interior #2* the plunging perspective and lively patterns described by the architecture suggest that the plant's frenzied production might resume at any moment, in *Primitive Power* activity seems more permanently suspended, and one readily mistakes the frothy foam cascading over the waterwheel for water that has frozen as it fell. Through the soft color, the lovingly detailed hand-crafted construction of the building, and the lack of either human pres-

Fig. a. Charles Sheeler, *City Interior No. 2*, 1935, pencil and gouache on paper, Worcester Art Museum, Gift of William H. and Saundra B. Lane

ence or mechanical energy, Sheeler has taken care to imply that we are witnessing a bell-jar world, one of archaic charm, and one that he has distinguished in medium, size, and mood from the brawnier images of power that follow.

1. "Power," p. 73.

2. In a letter of July 19, 1939, to Louise Arensberg, Sheeler notes that *Yankee Clipper* and *Suspended Power* (cat. nos. 58 and 60) are finished, and that he intends to visit Boulder Dam in September or October of that year. In a subsequent letter to Walter Arensberg (June 4, 1940), he notes that the *Fortune* series was completed that March and was awaiting December publication (Arensberg Archives).

3. "Power," p. 73.

4. Lowe, "Sheeler's Symbols of the Machine Age," p. 11.

58

Yankee Clipper
Signed and dated lower right: *Sheeler-1939*.
Oil on canvas, 24 x 28 in. (61 x 71.2 cm.)
Museum of Art, Rhode Island School of Design. Jesse H. Metcalf Fund and
Mary B. Jackson Fund

In the 1920s and 1930s, airplanes were not only of enormous interest to adventurous travelers and aerodynamic engineers, but they also inspired artistic fantasies by the era's leading designers, such as Norman Bel Geddes, and by painters like Elsie Driggs, whose *Aeroplane* (1928; private collection) was one of the first images to celebrate this new mode of transport.

Airplane technology developed rapidly during this period. The Clipper series, which pioneered long-distance passenger service, was designed by the engineer Igor Sikorsky for Pan American Airlines in 1931. Increasingly powerful Clippers were introduced over the next few years; the Atlantic Clipper was twice as large as the China Clipper, Pan Am's previous model, and was capable of flying from New York to London in twenty-four hours.[1] The Atlantic Clipper was previewed in *Life*'s August 23, 1937, issue with a thrilling photograph of one of the plane's whirling propellers on the cover, and it was put into service the next year.[2] The even faster Yankee Clipper was ceremoniously christened by Eleanor Roosevelt on March 3, 1939, and provided Pan Am's first regular nonstop transatlantic passenger service.[3]

Powered by four 1600-horsepower Wright cyclone engines and capable of a cruising speed of 220 miles per hour, the Yankee Clipper was enthusiastically described as a "flying boat," for in its design it resembled an airborne ocean liner. But in photographing this extraordinary aircraft, Sheeler focused neither on its mammoth scale nor on its dramatic power. Rather, he sought out its most elegant details, the propeller and wing, and photographed them from several angles (see fig. a), ultimately choosing for his painting this closely cropped view, emphasizing the diagonal thrust of the massive engine and the gracefully elongated propeller blades.

When *Fortune* reproduced *Yankee Clipper*, it lauded the "poised and infinitely precise propeller, aimed at the sky" as a portent of man's "adventure in space,"[4] and Sheeler's sunlit plane, with its handsome geometric forms sheathed in glistening metal, silhouetted against the sky, does in part convey an optimistic vision of the conquest of nature. But unlike the *Life* cover photograph, which vigorously cele-

Fig. a. Charles Sheeler, *Propeller*, 1939, gelatin-silver print, The Lane Collection

brated the power and thrust of these huge machines by placing the viewer directly beneath the roaring engines, Sheeler's view is more distant and sober, calling attention more to the abstract formal relationships of the plane's mechanical parts than to its astonishing mass and impressive capacity for motion. The resting propeller blades, which seem impossibly thin for their function, are elegant, crisply outlined shapes, and they appear almost organic against the geometric regularity of the wing and engine casing. The salmon dots on the blades are cheerfully ornamental and echo the circles on the plane's body and wing. Sheeler took special care in rendering the aircraft's metal skin: the subtle tonal progressions dematerialize the aircraft, suggesting sleekness rather than weight and muscle. The carefully graduated blue-gray tones create a faceted surface that glistens luxuriously in the sun. As Sheeler did in the still lifes of the 1920s, in which he repeatedly demonstrated the deeply satisfying beauty to be found in everyday things, in *Yankee Clipper* he celebrated his subject's elegance rather than its might.

1. See Wilson, "Transportation Machine Design," in *The Machine Age in America*, pp. 126-28.
2. "Transoceanic Air Service," *Life*, August 23, 1937, pp. 36-42.
3. See Carla M. Woodward and Franklin W. Robinson, eds., *A Handbook of the Museum of Art, Rhode Island School of Design* (Providence, 1985), p. 220.
4. "Power," p. 82.

59

Rolling Power

Signed and dated lower right: *Sheeler-1939.*
Oil on canvas, 15 x 30 in. (38.1 x 72.6 cm.)
Smith College Museum of Art,
Northampton, Mass.

Since its completion in 1939, *Rolling Power* consistently has been singled out as the most compelling of the works Charles Sheeler produced for *Fortune*. It was chosen as the frontispiece of *Art News*'s December 14, 1940, issue (shortly after the opening of the "Power" exhibition at the Downtown Gallery); it was the first to be sold and, since its acquisition by the Smith College Museum of Art, has been the most frequently exhibited and reproduced of the group.[1] And Sheeler's well-known photograph *Wheels* (fig. a), which the artist made as part of his preparation for this painting, was selected by Edward Weston to illustrate his article on photography for the *Encyclopaedia Britannica*.[2]

Sheeler's subject, explained the editors of *Fortune*, was "an anatomical study" of the "driving mechanism of a Hudson-type locomotive, designed to haul heavy New York Central passenger trains up to possible speeds beyond 100 miles per hour."[3] It was typical of Sheeler to focus on humble details rather than on the romantic, newly streamlined locomotive itself, which had come to symbolize the exciting technological developments of the era, and which, with its simplified, aerodynamically improved profile, made the extraordinary speeds possible.[4] The design of the locomotive's crank shafts and drive wheels had not changed significantly during the machine age, and the scale of these parts, in Sheeler's rendering, does not seem particularly impressive: his meticulous treatment suggests the internal mechanism of a fine watch rather than the mammoth wheels of a steam engine.

Critics have claimed that the Hudson locomotive represented to Sheeler "the very essence of kinetic energy"; in fact, *Rolling Power* is probably as close as the artist ever came to an Eakins-like infatuation with mechanical details.[5] Sheeler acknowledged that his choice of viewpoint reflected his interest in the painstaking transcription of the minutiae of machinery; he also later acknowledged the role of his pho-

tography in enabling him to render such details: "Since I could not camp beside [the locomotive] for the three months I required to paint it, I made a photograph."[6]

Sheeler's accurate recording of detail in *Rolling Power*, attributable in part to his use of a camera, has been seen as grounds for criticism. One reviewer argued that the painting "has nothing to offer beyond the colored photograph and the question may legitimately be raised as to whether these paintings are art."[7] In fact, the photograph served Sheeler as an aid, not a template, allowing him to build an original, creative composition. Typically, Sheeler showed the working parts of the drive wheels as static and pristine in the painting; signs of wear, spots of grease, and the sense of motion momentarily arrested that give *Wheels* its vitality are not part of *Rolling Power*. Furthermore, despite the clarity with which details are described, there is no painterly illusionism, that is, no suggestion of deep space, and no sense of the train moving across the viewer's field of vision and out of sight, to complete the impression of "photographic" realism. Rather, the vividness of *Rolling Power* stems from the lively visual pattern established by Sheeler's opposition of repeated forms: the circular wheels (as well as the disks within them) are in counterpoint to the horizontals of the piston rods, the crank shafts, and the track itself. Finally, the extreme horizontality of the composition, accentuated by close cropping and the unusual, stretched-out format (the width of the canvas is exactly twice its height), as well as the shallow space from which brilliant highlights seem to project into the viewer's space and the near-monochrome palette, suggest an abstract, highly tactile, richly sculpted relief.

Fig. a. Charles Sheeler, *Wheels*, 1939, gelatin-silver print, Museum of Fine Arts, Boston, Gift of William H. and Saundra B. Lane

6. Typewritten note, February, 11, 1963, in the files of the Museum of Modern Art, quoted by Millard, "Charles Sheeler, American Photographer." See also interview by Friedman, in which Sheeler noted that he used photographs "for specific details" because they have a greater sense of "actuality" than drawings and supplied him with "greater definition than I could [obtain] by making a quick sketch from the subject."

7. Brown, "Sheeler and Power," p. 46.

1. See Jere Abbott, "Burchfield and Sheeler for the U.S. Collection at Smith College," *Art News* 39 (December 14, 1940): 6, 12, 17. See also Kootz, *New Frontiers in American Painting*, no. 77, for an early discussion and reproduction of the painting.

2. Although planned for the encyclopedia's 1940 edition, Sheeler's photograph did not actually appear until 1942.

3. "Power," p. 78.

4. See Wilson, "Transportation in Machine Design," in *The Machine Age in America*, pp. 136-42.

5. Ibid., p. 142

60

Suspended Power
Signed and dated lower right: *Sheeler/1939*.
Oil on canvas, 33 x 26 in. (83.3 x 66 cm.)
Dallas Museum of Art. Gift of Edmund J. Kahn

Sheeler's attitude toward the colossal machines he depicted in the "Power" series he created for *Fortune* magazine was somewhat equivocal. In *Conversation — Sky and Earth* (cat. no. 62), he encouraged the viewer to look up with wonder and admiration at the huge cables carrying energy away from Boulder Dam. In *Yankee Clipper* (cat. no. 58), he celebrated the airplane's design, revealing the formal harmonies in the shapes of its parts. But in *Suspended Power*, the machine, while no less magnificent, inspires both awe and fear, for as the mammoth turbine hangs in midair, about to be lowered into place, it threatens to obliterate the workers below.

Suspended Power depicts the installation of the recently built Unit #2 of the Tennessee Valley Authority's hydroelectric plant at Guntersville, Alabama. Sheeler painted his subject with all the attention to pleasing balance of shapes and concern for surfaces that he lavished on his most delicate still lifes. His palette is surprising for the great steel and concrete apparatus: it is not, as one might expect, a metallic grisaille, but rather a range of rosy tones — the pinks, flesh colors, and maroons he had recently used with great success (and in an equally unexpected context) in *City Interior* (fig. 17). *Suspended Power* is the only work in the "Power" series to use this color scheme, which tempers the more ominous qualities of the composition. It is furthermore the largest of the "Power" pictures and, with *Steam Turbine* (cat. no. 61), the most complex, the setting contributing as much to the painting's impact as the machine itself.

The surviving photograph from Sheeler's trip to Guntersville (fig. a) and a contemporary photograph taken by the TVA of one of the hydraulic turbine generation units at the plant[1] indicate the degree to which Sheeler altered the setting to achieve the painting's disturbing effect. Both photographs show the plant as a busy place, bustling with workers and

Fig. a. Charles Sheeler, *Installation*, 1939, gelatin-silver print, The Lane Collection

crammed with machinery, lumber, wire, and debris. In the painting, all of this detail has been eliminated. Attention is focused almost exclusively on the mammoth turbine, and the power station appears austere and pristine. *Fortune*'s accompanying commentary compared the hushed atmosphere of the painting to the halls of the Vatican. To the magazine, the image was one that hallowed modern technology: the article proudly pointed out that the generator would produce power for decades with "few stops, no fuel, and very little supervision."[2]

But in fact Sheeler's interpretation was neither so optimistic nor so boosterish. The scene is viewed not from the workers' perspective but from an elevated, omniscient vantage point that puts the spectator at eye level with the great structure. One is thus asked to identify with a machine portrayed as an aggressor: the turbine is about to thrust inexorably down past the crenellated walls of the pit — it is an image of driving, domineering sexuality. Comparison with the photographs reveals that Sheeler exaggerated the machine's scale in relation to the figures. He lavished far more care on the rivets, sheets of steel, and pulleys

that compose the turbine than on the workers' inconsequential physiognomies. Their proximity to the giant blades has been increased, making all too literal *Fortune*'s triumphant claim that the machine would eliminate labor. Even the painting's very title, suggesting a ponderous mass hanging from an unspecified support, connotes unease.

The imminence of power in Sheeler's picture is both thrilling and threatening, an ambiguity absent in his photograph showing the turbine already lowered into place and generating energy. In *Suspended Power*, perhaps more than any other image in the series, the artist presents with great subtlety a metaphor for the moral dilemma of the machine age: the potential violence of a technology promoted as the nation's social and economic salvation.

1. This photograph is reproduced in "Eddie Kahn: 'His Painting,' " *Dallas Museum of Art Bulletin* (Winter 1985/86): 10.
2. "Power," p. 74.

61

Steam Turbine
Signed and dated lower right: *Sheeler-39*
Oil on canvas, 22 x 18 in. (55.9 x 45.7 cm.)
The Butler Institute of American Art,
Youngstown, Ohio

The paintings Sheeler produced to illustrate the theme of "Power" for *Fortune* are oddly unmatched. They are not consistent in medium, in size and shape of the canvas, nor in palette; they are similar only in subject. Whether on his own initiative or at *Fortune*'s urging, Sheeler sought superlatives: he depicted the fastest airplane, the largest dam, and here "the world's largest steam power plant," the Hudson Avenue Station of Brooklyn Edison. To describe this technological marvel, the editors of *Fortune* used religious metaphors: electric power, they explained, was a God-given asset, as natural as the elements; this station, with its 160,000-kilowatt turbine units, was a wonder of the modern world.[1]

Sheeler's attitude toward the colossus seems more ambivalent. Despite the descriptive solidity of the scene, this picture more than any of the others makes the viewer feel as though he were in the realm of fantasy or science fiction. The grim palette – predominantly gray and a steely bluish-purple, with touches of lavender – sets a somber mood. There is no sense of the outside world: the space of the power plant seems stuffy and cavernous, as though it were underground. The light is entirely unnatural and comes largely from undisclosed sources; there is a ghostly sheen on the loop of the turbine, which throws a huge shadow on the wall behind. The plant seems totally dehumanized, automated. Only the steel turbine seems organic, sheathed in a smooth gray skin, much larger and simpler in form than anything else in the picture. It is hemmed in on all sides by other mechanical and structural devices, whose function it is to contain and harness the turbine's power. The intricate, automatonlike contraption in the foreground, which *Fortune* describes as "an array of heat exchanges, pumps, automatic valves, and other auxiliaries,"[2] is presented as the master of the giant turbine behind it. Unlike the airplane of *Yankee Clipper* or the transmission tower of *Conversation – Sky and Earth* (cat. nos. 58 and 62), the turbine is not shown as an icon, heroically filling the viewer's field of vision, but is presented at a sobering remove. Set behind the white wooden fence that separates it from visitors to the plant, it is like a freakish caged beast in the zoo.

That fence, with its traditional molding, is the most incongruous feature of Sheeler's vision (it encases Sheeler's signature as well). Recorded in the photographs Sheeler used in planning the picture, the fence may have been the key to his interest in the subject. It documents the coincidence of the colonial revival and the machine age, and is a souvenir of America's rural, agrarian past. It seems altogether too graceful and fragile to be charged with containing the hulking turbine looming up behind. Sheeler's understated contrast between the old-fashioned fence and the streamlined steam turbine suggests that he found this emblem of power more infernal than idyllic. In the face of the nation's headlong rush to mechanize, to control the world through industry, he reminds us of the need to ponder values, both aesthetic and humanistic, of the nation's past.

1. See "Power," p. 80.
2. Ibid.

62

Conversation – Sky and Earth
Signed and dated lower right: *Sheeler-1940.*
Oil on canvas, 28 x 23 in. (71.2 x 58.4 cm.)
The Regis Collection, Minneapolis

Hoover Dam (which was rechristened Boulder Dam in 1933, and continued to be known by that name through Franklin D. Roosevelt's presidency) was begun in 1930 as the largest government-sponsored construction project ever undertaken. Located in the southeast corner of Nevada on the Arizona border and less than thirty-five miles from Las Vegas, the dam was built to harness the treacherous Colorado River. When completed in 1936 it was the largest dam in the world, rising 726 feet, forming the largest reservoir, Lake Mead, and capable of generating electric power equivalent to one-eighth the total power available in the rest of the United States. Near the dam in the heart of the desert, a model community was erected to provide housing and all other facilities for the work force, which numbered more than five thousand at the peak of construction. During the 1930s, the dam was a mecca for scientists, engineers, reporters, artists, and tourists.[1] Sheeler visited the site in the fall of 1939 as part of his assignment for *Fortune.*

Sheeler produced an extraordinary photographic series contrasting the manmade and natural wonders at Boulder Dam. There are several breathtaking views of the colossal structure, including panoramas taken from great height and distance, and a dramatic view of the massive concrete wall holding back the river. The photograph he chose as the basis for the composition of the present painting shows a much more immediate view (fig. a). It records a transmission tower poised on the rocky mounds of the Nevada-Arizona border, which seems "to dwarf in perspective the immensity of the greatest dam on earth."[2]

Some critics found the close relationship between Sheeler's painting and his photograph troubling. One even reproduced *Conversation – Sky and Earth* with the caption, "Is this a photograph or a painting?"[3] Such a view belittles the extraordinary sense of composition and

Fig. a. Charles Sheeler, *Boulder Dam – Transmission Towers,* 1939, gelatin-silver print, The Lane Collection

design that shaped both works. The choice of a worm's-eye view causes the spectator to gaze up in awe at, in *Fortune*'s poetic terms, "a fragile transmission tower hung with insulators like pendants of glass beads."[4] At the same time, this dramatic perspective, and the silhouetting of the tower's delicate latticework construction against the solidity of the rock and concrete walls behind, also suggests the precariousness of man's construction. Sheeler's dam is a mysterious, extra-ordinary structure. By suppressing all unnecessary detail evident in the photograph, Sheeler imbued the scene with a magical quality. The picture effectively captures the blistering sun and azure sky of the southwest, but by restricting his palette to that astonishing turquoise, vibrant white, and sepia, Sheeler enhanced the structure's removal from everyday experience.

Fortune saw *Conversation – Sky and Earth* as a spiritual work of art, an altarpiece devoutly recording the engineer's handiwork as though it were a miracle of divine creation,[5] and indeed Sheeler's title, at once sentimental and mystical, encourages that interpretation. It was Jeanette Lowe, a critic for *Art News*, who best explained the romance in Sheeler's vision: "To some people his paintings may seem like cold

photographs, devoid of all emotional motivation. But take the Boulder Dam transmission tower seen against a turquoise sky in this strange, unearthly country, where until the Dam came no spear of grass grew. . . . [It] makes the imagination leap."[6]

About ten years after the *Fortune* series was published, Sheeler turned again to this composition to produce a cover illustration on the theme of electric power for *Reader's Digest* (February 1941). The design survives in the form of a small pencil drawing (James Maroney, New York) recording the central core of the composition. To further emphasize the awe-inspiring scale of the dam, Sheeler, with characteristic economy of means, extracted a figure from *Suspended Power* (cat. no. 60) and placed him, head bowed, between the insulators.[7]

1. See Wilson, "The Machine in the Landscape," in *The Machine Age in America,* pp. 111-15.
2. "Power," p. 76.
3. Brown, "Sheeler and Power," p. 46.
4. "Power," p. 76.
5. See ibid.
6. Lowe, "Sheeler's Symbols of the Machine Age," p. 11.
7. See Maroney, *"The Elite and Popular Appeal,"* p. 16.

63

Fugue

Signed and dated lower right: *Sheeler-1940*

Tempera on gessoed panel, 11½ x 13¼ in. (29.2 x 33.7 cm.)

Museum of Fine Arts, Boston. Arthur Mason Knapp Fund

Fugue was one of the first pictures Sheeler made after he had completed his six paintings on the theme of "Power" commissioned by *Fortune* magazine (cat. nos. 57-62). He had traveled extensively in 1939-40 seeking subject matter for that series, and it was during this time that he visited a small power plant in New Bedford, Massachusetts, the scene of *Fugue*. "I was on a motor trip through New England and in passing through New Bedford in the late afternoon I came upon this subject unexpectedly," he wrote. "It was a breath-taking sight. I walked around it for several hours."[1] The plant, no longer standing, was most likely that which supplied power for the city's electric trolleys.[2]

Sheeler made several different photographs of the site from a neighboring park and later selected one of these images as his model for *Fugue*. Following his usual practice, in the painting he faithfully rendered the facts of the scene but eliminated many incidental details recorded in the photograph, such as the chain-link fence behind the barrels, the guy wires supporting the chimneys and smokestacks, and the thick black smoke. He chose instead to emphasize the formal aspects: the continuity of lines marking string courses and window ledges from one building to another across the picture plane; the stately rhythm of the smokestacks and the play of their cylindrical forms with those of the tank, barrels, and utility poles below; the elegant checkered patterning of the small windowpanes and the yellow-gray corrugated siding of the central shed.

The conscientious repetition of like forms in the painting presumably inspired Sheeler's title, for a fugue is a musical composition in which a theme is introduced by one voice and then repeated and developed by other voices into a well-defined whole.[3] The constant overlapping of forms in a fugue is here realized in visual terms. Each structure is flattened and superimposed upon the next, creating a band of design across the picture's surface and emphasizing two-dimensional pattern rather than spatial recession. This purposeful control is reiterated by Sheeler's choice of a small brush and the tempera medium, whose quick-drying properties require the careful use of deliberate strokes.

Fig. a. Charles Sheeler, *Stacks in Celebration*, 1954, oil on canvas, Dayton Art Institute, Gift of Mrs. Otto L. Spaeth

Fugue was first exhibited, along with recent works by other artists, at the Downtown Gallery's inaugural show in its new 51st Street location. Reviewers admired its exactness and its crisp, cool palette.[4] It was immediately purchased by the Museum of Fine Arts, Boston (the only modernist painting the museum bought that year), where it joined *View of New York* (cat. no. 42), acquired in 1935. Sheeler continued to be inspired by this functional, unornamented building with its rhythmic grouping of smokestacks, and painted two other canvases based upon it: *Fugue* (1945; Regis Collection, Minneapolis) and *Stacks in Celebration* (fig. a).

1. Sheeler to W. G. Constable, Curator of Paintings, December 20, 1940, Department of Paintings Files, Museum of Fine Arts, Boston. Sheeler had visited New Bedford by October 1939, as the photographs he made there were included in his retrospective exhibition at the Museum of Modern Art.

2. I am grateful to John Kroll for this information. The plant was located near the Fairhaven Bridge on Route 18.

3. *Fugue* is the first of several compositions of the 1940s with musical titles, including *Music in the Air* (1941; current location unknown), *Fugue* (1945; Regis Collection, Minneapolis), *Improvisations* (1945; The Lane Collection), *Incantation* (cat. no. 67), *Polyphony* (1947; current location unknown), and *Counterpoint* (cat. no. 70).

4. "Sheeler's color is more pastel and his eye no less exact than usual in *Fugue, 1940*" (Jeanette Lowe, "51st Street Becomes Downtown," p. 12).

64

Winter Window
Signed and dated lower right:
Charles Sheeler-1941
Oil on board, 30 x 24 in. (76.2 x 61 cm.)
James Maroney, New York

For many years, Sheeler used the large living room of his house in Ridgefield, Connecticut, as a painting studio. The enormous paned windows on two sides of the room admitted wonderful light, only partially filtered by the graceful pines then surrounding the house. After nearly ten years of living there, he made the largest window the subject of a painting, although with characteristic reticence he gave the picture an impersonal title, *Winter Window*.

Today, a visit to the house, virtually unchanged since Sheeler's time, reveals that in one sense Sheeler painted the room as he saw it. He accurately recorded the lower half of one of the huge double windows, which contain casements secured by wrought-iron latches. The compote at lower right was part of his nineteenth-century American glass collection; the patterned textile on the tilted-up table is similar to fabrics appearing in other works; the table is probably his Shaker dining table, which appears (as does the compote) in a 1938 *Life* magazine photograph of the artist at work in his Ridgefield studio (see fig. 24).[1] That table, which seems to rise up from the floor parallel to the picture plane,[2] creates a teasingly ambiguous space reminiscent of that in several other of Sheeler's interiors, most notably *Spring Interior* (cat. no. 33), and is equally serene and witty in its challenge to our perceptions.

Even more playful is the disjunction between the interior scene, closely based on reality, and the view through the window of skiers descending a rugged mountain that is pure fantasy — a fantasy in the form of a private joke (or perhaps another expression of Sheeler's diffidence), for only those who knew the artist and his Ridgefield house would recognize the fictional nature of the outdoor scene. Unlike other pictures Sheeler produced at this time, such as *The Artist Looks at Nature* (cat. no. 66) and *Nativity* (fig. 26), which likewise mix the observed and the imagined, the disjunction is not unsettling or surreal. The scene Sheeler invented is pleasing, for the warm winter sun pouring in through the windows unifies the soft greens and browns of the snug interior with the cooler blues and lavenders of the snow-covered mountains, and tempers the bleak winter landscape.

The window fills the viewer's visual field, admitting no periphery and barely any foreground. This compositional scheme, immediate and quietly insistent, was a favorite of Sheeler's, just as the window image was one he used often in pictures that are both iconic and shyly autobiographical (see *Self-Portrait* and *View of New York*, cat. nos. 25 and 42). In all three of these works he drew upon the traditional romantic associations of the motif as both threshold and barrier between familiar domestic surroundings and wilder nature or another form of the unknown, and by extension between the secure present and the uncertain future. Like *View of New York*, *Winter Window* shows an appealing vision of nature; as in *Self-Portrait*, the prominent window shade can be pulled to sever the connection with the imaginary external world or raised to welcome more of the view. *Winter Window* is thus a modern disquisition on the romantic dilemma about the lure of nature and the unknown. For Sheeler, this disquisition had important private implications as well. The interior, filled with his favorite belongings, was personally reassuring. The fictional exterior was a dream world: unfamiliar, exotic, potentially dangerous, but certainly thrilling. *Winter Window* probably was completed over the summer of 1941 and, as Sheeler's major work of the year, it was first shown in the Downtown Gallery's inaugural exhibition of the fall season. It was preceded by a somewhat loosely executed conté crayon drawing (current location unknown; photocopy of photograph, Downtown Gallery Papers), which was inscribed "To Musya April 2, 1941." Sheeler had married the exotic and flamboyant Musya Sokolova on April 2, 1939.

1. The *Life* photograph shows Sheeler before the smaller of the two windows in the studio; *Winter Window* depicts part of the larger one, which stretches from the chair rail nearly to the cathedral ceiling of the room.

2. James Maroney, in his catalogue *The Odd Picture*, offers an illuminating discussion of the ambiguous space of *Winter Window*, and a thoughtful and stimulating analysis of the "inner and outer realities" of the painting (p. 29).

65

White Sentinels
Signed and dated lower right:
Charles Sheeler-1942.
Tempera on illustration board,
14¾ x 22 in. (37.5 x 55.9 cm.)
Private collection, New York

Prompted by Alfred Stieglitz, the California photographer Edward Weston first sought out Sheeler in New York in 1922. Although the two artists were not to see each other again for almost twenty years, their correspondence and Weston's entries in his daybooks testify to their mutual admiration.[1] When Weston returned east in 1941 he again visited Sheeler, who was by then living in Ridgefield, and the two toured the surrounding area with their cameras. It was apparently a pleasant reunion, resulting in some playful projects as well as in serious photography.[2] They were especially attracted to the indigenous rural architecture Sheeler had admired since his early years in Pennsylvania, and presumably it was Sheeler who led Weston to a barn and site he himself had photographed, and then painted, in 1938 (see cat. no. 56). The result was Weston's very different *Connecticut Barn* (1941; gelatin-silver print; Museum of Modern Art, New York).

On at least one other occasion, Sheeler and Weston tackled the same subject: a rambling barn with two wooden silos, corn crib, and shed located on Old Town Farm Road in New Milford, Connecticut, about twenty-five miles from Ridgefield.[3] The resulting photographs were quite similar, but with revealing differences. Weston's *Connecticut* (fig. a) was taken at an oblique angle, and at a closer vantage point than Sheeler's. As a consequence, his image is the more dramatic: the heroic cylinders of the two silos are clearly the subject of his picture. They loom large, and their siding, cables, and pediments are picked out in sparkling detail. At the same time, the harmonious relationships of the triangular pediments, roof lines, and shadows reveal the composition's underlying abstract structure. Sheeler's approach (fig. b) was more direct and more deadpan, yet the simple majesty of these buildings is no less apparent. He photographed

Fig. a. Edward Weston, *Connecticut*, 1941, gelatin-silver print, Museum of Fine Arts, Boston, In admiration of William H. Lane and his appreciation for the vision of Charles Sheeler, 1983.292

Fig. b. Charles Sheeler, *Barn in Connecticut*, 1941, gelatin-silver print, The Lane Collection

the barns straight on, and from a greater distance, exchanging Weston's architectural drama for a gentler sentimentality, the bold shapes and strong outlines of the Californian's image for subtler patterns created by the elegant shadows of the roof lines and the rhythmic punctuation of the windows.

Sheeler's photograph and the pictorial values it contains inspired his *White Sentinels*, painted the next year. This work exhibits one of the artist's richest color schemes, pairing aqua and ochre, black and ivory, and the clay brown and acid green he would use to such startling effect in *The Artist Looks at Nature* (cat. no. 66). The brilliant hues echo the relatively high contrast of the photograph, itself a result of the intense summer sun, from which all living creatures seem to have taken refuge. In this tempera, the buildings have been cleaned up and given an almost utopian purity: the barns' geometry has been regularized, the long horizontal of the roof lines exaggerated and underscored by the seemingly endless succession of windows. Sheeler intensified the contrast between sunlit and shaded surfaces, and the shadows' swooping, graceful contours seem to be the only animate elements in this carefully composed work. Finally, the incidental details, so critical to Weston's photograph and downplayed in Sheeler's, are eliminated almost entirely in the tempera: mullioned windows become opaque squares and the tumble-down fence in the foreground is reduced to three mysterious posts placed at irregular angles across the now barren farmyard. The shingles on the silos and the cables surrounding them also disappear, and the silos themselves, tilted in the photograph, stand erect here, guardians of the silent, empty yard. In contrast to the iconic quality of Weston's photograph and the poignancy of Sheeler's, the tempera stresses the stern and hollow beauty of the barns.

Sheeler was clearly deeply moved by these buildings. He never exhibited his photograph, but always preserved it as a reference and perhaps as a memento of his friendship with Weston. The tempera was exhibited twice at the Downtown Gallery before it was sold in 1946; that same year, as though to retain the image, Sheeler painted two other temperas that are abstract variants on the same architectural configuration: *Gray Barns* (Regis Collec-

tion, Minneapolis) and *Blue Barns* (current location unknown). In 1950 he produced an oil, *Family Group* (Loch Haven Art Center, Orlando, Fla.), which again shows these barns, even more schematized and in reverse. He returned to the subject a final time in 1958, for *On a Connecticut Theme* (to which Sheeler originally gave the sentimental title "Bucolic Landscape"), now owned by the Whitney Museum of American Art, New York.

1. In his daybooks, Weston in November 1922 records Stieglitz's recommendation that "you should see Sheeler's work" and his own subsequent enthusiasm for Sheeler's New York photographs. He later noted his admiration for Sheeler's drawing *New York* (cat. no. 17), which he saw at the Art Institute of Chicago. (See Weston, *Daybooks*, vol. 1, pp. 6, 7, 190). Some of their correspondence is preserved in the Archives of the Center for Creative Photography, Tucson. In 1932, Sheeler wrote the introduction to Merle Armitrage's *The Art of Edward Weston*, and in 1940, Weston illustrated his *Encyclopaedia Britannica* article on photography with an illustration of Sheeler's *Wheels*.

2. An amusing souvenir of their travels is Weston's photograph of Sheeler, in profile and with an engineer's cap on his head, seated in the cab of a locomotive (The Lane Collection).

3. I am grateful to James Maroney for bringing the Weston photograph to my attention, and for sharing with me the location of the barns, which he reports are in a sadly deteriorated state.

66

The Artist Looks at Nature
Signed and dated lower right: *Sheeler-1943*
Oil on canvas, 21 x 18 in. (53.5 x 45.8 cm.)
The Art Institute of Chicago, Gift of the
Society for Contemporary Art

Along with *Self-Portrait* (cat. no. 25), Sheeler's other admittedly autobiographical picture, *The Artist Looks at Nature*, has been seen as his most intriguing, and baffling, work. Numerous critics have remarked on its enigmas and inconsistencies, especially the one presented by the title: the artist, sitting before a colorful landscape, is inspired to render not what he sees but an image from memory, a monochrome portrait of the interior of a house he had lived in some thirty years before. The landscape itself is peculiar: although individual elements are depicted in a straightforward manner, they bear no logical relationship to one another. The image has been called introverted, "a stage for the display of geometrical bodies," and "a statement about dislocation and ambiguous time."[1]

Although *The Artist Looks at Nature* is something of an anomaly in Sheeler's work, its coupling of a fantastic and disconcerting subject with a precise, descriptive style was not out of step with the times. In 1942 the prize winners in the Metropolitan Museum of Art's mammoth and highly publicized contemporary art exhibition "Artists for Victory" were the surrealists Ivan Albright and Peter Blume; in 1943, the year this picture was painted, the Museum of Modern Art mounted its "American Realists and Magic Realists" exhibition.[2] Sheeler's painting also reflects two traditional genres: the artist in his studio, or more precisely, the artist painting out-of-doors, a subject especially beloved of impressionists from Monet to Sargent; and the picture within a picture, a device by which artists from the fifteenth century forward inserted symbolic commentary into ecclesiastical and domestic interiors.

In Sheeler's own work, there are three antecedents for his picture's critical detail, the artist at his easel: a photograph, *Interior with Stove*, which he made in about 1917 in his weekend house in Doylestown; a large conté crayon drawing (Coll. Joanna T. Steichen) based on that photograph and shown in progress here; and a photographic self-portrait (fig. a) made in about 1931, of his 44th Street studio. In that photograph, the artist shows himself dressed as he is here, in his shirt sleeves (as one critic noted, an indication of his earnestness);[3] the drawing is at the same stage of completion. He changed his pose slightly for

Fig. a. Charles Sheeler, *Self-Portrait at Easel*, 1932, gelatin-silver print, The Lane Collection

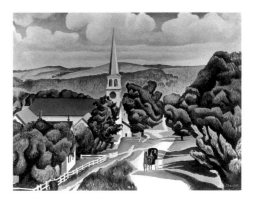

Fig. b. Charles Sheeler, *Vermont Landscape*, 1924, oil on canvas, Private collection

the painting, crossing his legs and discarding his cigarette. He also eliminated the front and side stretcher bars from the late-eighteenth-century side chair on which he sits.[4]

Sheeler's landscape is imaginary, though it too conjures up elements from his earlier work. The sheer concrete walls carving up the countryside evoke Boulder Dam, which Sheeler photographed and painted in 1940 (see cat. no. 62). The green fields traversed by dirt paths in the hot summer sun recall his cheerful New England landscapes of 1924 and 1925 (fig. b). But whereas those landscapes are expansive, bucolic, even sentimental, the view here is brutally cut up, hemmed in by high retaining walls and battlements. The warm greens of the New England countryside have turned acid. The only vaguely old-fashioned element in the picture, the rail fence (curiously incomplete on the right side), has no other function than to block the dirt path leading into the distance. The peculiar harshness of this landscape offers one clue as to why Sheeler is drawing not what he sees but a fondly remembered image.

The Artist Looks at Nature was painted at the height of wartime, and although Sheeler's reactions to the war were not recorded, he produced relatively few works during this period.[5] He was, of course, too old to serve in the army by this time but nonetheless was involved in a number of patriotic projects: the "Power" series (cat. nos. 57-62), meant to stimulate pride and confidence in America's industrial might at the outbreak of the war; photographic documentation of the collections at the Metropolitan Museum, which were relatively inaccessible during the war; and a chauvinistic painting of the nation's Capitol (fig. 22). The subjects he himself chose to paint during the same period were, for the most part, from the past: old barns, Shaker buildings, and so forth. *The Artist Looks at Nature* is also about seeking solace in that past. What the artist sees when he looks at nature is a landscape that has become both denatured and forbidding. In Sheeler's imagination it is full of barriers that dissect the countryside and entrap the artist, who is confined to a small corner of the picture. He is cut off from the landscape, the artist's traditional source of inspiration; and although his isolation may be self-imposed (the

stairs that offer the only possible access to the landscape are impossibly steep), it is nonetheless daunting, and he depicts himself finding consolation in a graceful, modest, domestic past. In *The Artist Looks at Nature*, Sheeler asserts, however obliquely, that the rich arsenal of remembered images that stimulate his creative output are more satisfying than what he sees around him; they will fortify him against a troubling present and future.

1. See, among many other assessments of the picture, Dochterman, *The Stylistic Development*, p. 83; Born, *American Landscape Painting*, p. 211; and Friedman et al., *Sheeler*, p. 131. Two of the most provocative recent commentaries are Davies, "Sheeler in Doylestown," p. 137, and Maroney, *The Elite and Popular Appeal*, pp. 14-15.

2. In the foreword to the "American Realists and Magic Realists" catalogue (p. 5), Alfred H. Barr, Jr., explains magic realists as "painters who by means of an exact and realist technique try to make plausible and convincing their improbable, dreamlike, or fantastic visions."

3. Maroney, *The Elite and Popular Appeal*, p. 14.

4. The chair, a square-backed neoclassical side chair with square, tapered legs, was more commonly produced in England than America. See John T. Kirk, *American Furniture and the British Tradition to 1830* (New York, 1982), fig. 1014.

5. A series of letters Sheeler wrote to Alfred Stieglitz in the late summer of 1918 (Stieglitz Archive), describe his horror of war and apprehension about being drafted. Presumably his distress resurfaced at the outbreak of World War II.

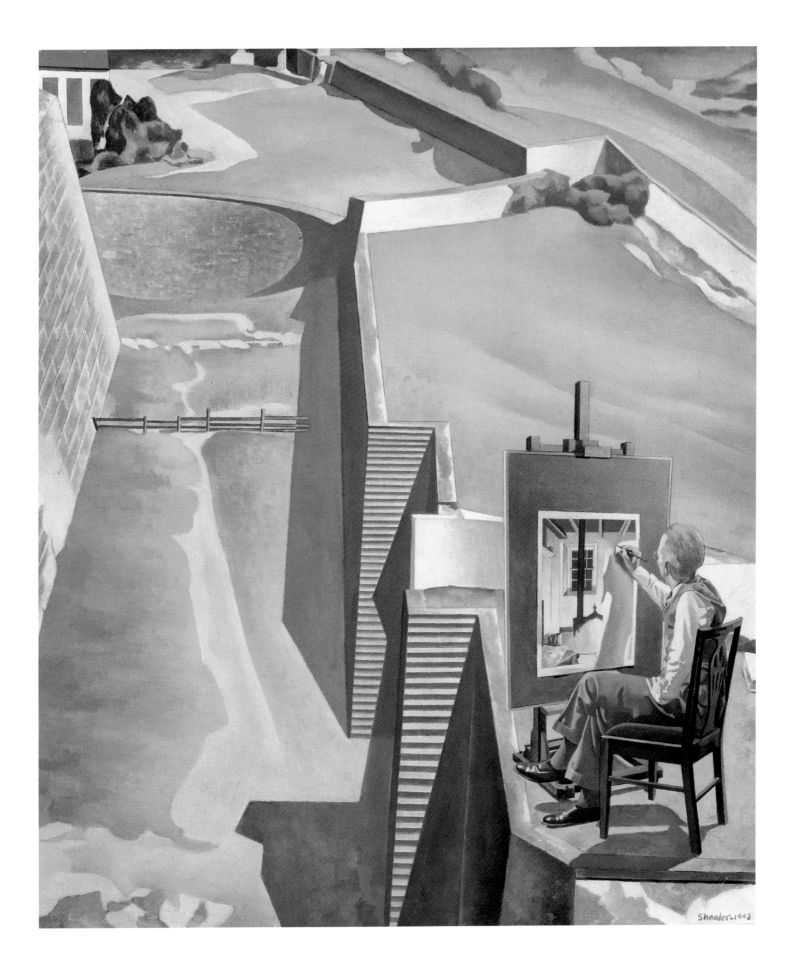

67

Incantation

Signed and dated lower right: *Sheeler-1946*
Oil on canvas: 24 x 20 in. (53.3 x 45.8 cm.)
The Brooklyn Museum, N.Y. John B. and
Ella C. Woodward Memorial Fund

In the late 1940s, Sheeler demonstrated a re-
newed interest in abstraction. His concern
with the underlying structure, design, and pat-
tern found in realistic scenes had been a con-
stant in his work, but now he literally nar-
rowed the focus of his industrial subject
matter, changing his approach to express his
new graphic style. He no longer presented
panoramic views, as he had in most of the
Rouge pictures (cat. nos. 36-39, 46) or even
entire objects in isolation as he did in the
"Power" series (cat. nos. 57-62). Instead, he
began to paint fragments of machines and in-
dustrial apparatus, segments selected purely
for their formal arrangement of line and shape.
The viewer is not able to recognize individual
machines or to identify specific locations.
Enhanced with arbitrary colors, these scenes
seem purely imaginative.

Probably in the mid-1940s, Sheeler made a
number of photographs of a synthetic rubber
plant in West Virginia.[1] One of these (fig. a),
which contrasts the heavy bulk of cylindrical
storage tanks with a lacelike net of smaller
tubes and pipes leading into them, formed the
basis for *Incantation*.

Sheeler's title for this picture conjures the
mystical overtones of ritualized chanting or a
magic spell. It lends an impression of motion
and rhythm that is heightened by the vibrant
colors. The magic of *Incantation* is its surface-
oriented abstraction, accomplished through
precise realism. Sheeler filled the center of the
composition with the space between two of
the storage tanks, carefully delineating, first
with pencil and then with bright opaque pig-
ment, the network of pipes and rods between
them. The resulting grid remains on the sur-
face of the picture, isolated against the cobalt
blue background, creating a tension between
the viewer's perception of the scene as ma-
chinery silhouetted against the sky and as a
two-dimensional pattern of line and color. The
design is constructed not only with bright hues

Fig. a. Charles Sheeler, *Synthetic Rubber Plant*, c. 1940-
45, gelatin-silver print, The Lane Collection

and irregular shapes but also with light itself.
The sweeping arcs of the shadows at left and
right take on palpable substance; they no
longer define the curved shape of the storage
tank on which they fall, but instead appear to
be as solid as any of the three-dimensional ob-
jects portrayed.

Soon after its completion, *Incantation* was
reproduced in *Fortune* magazine in an issue de-
voted to labor in industry. The caption for the
picture read: "Labor has always feared tech-
nology. In this richly austere industrial scene,
inspired by the great continuous-flow plants of
the oil industry, the U.S. worker is missing. La-
bor is disturbed by such glittering geometry; its
fear that the machine will put man out of work
is a short-range truth, a long-range error."[2]
When the painting was shown in Sheeler's solo
exhibition at the Downtown Gallery in 1949, a
critic for the *New York Daily Worker* found it
"an industrialist's heaven where factories work
themselves," and other art critics too found it
spare and sober.[3] But Sheeler's interest, as in
the Rouge paintings, was not social comment
but formal design. He likened *Incantation* to a
skeleton: "Every picture should have a steel
structure, and by frankly revealing it instead of

covering it with embellishments, I believe that
my new work shows a pronounced change."[4]

1. Many of Sheeler's late industrial works were commis-
sioned, however there is no documentation specifically
identifying this plant, nor is there a record of Sheeler's rea-
son for going there. Four oil paintings resulted from the
experience: *Incantation*, *Mechanization* (1946; Whitney
Museum of American Art, New York), *It's a Small World*
(1946; Newark Museum), and *Catwalk* (1947; Coll. of Mr.
and Mrs. Barney A. Ebsworth).

2. *Fortune* 34 (November 1946): 127.

3. Corwin, *New York Daily Worker*, February 4, 1949, cited
in Friedman et al., *Sheeler*, p. 57. The reaction of art critic
Henry McBride was typical: "What makes the work pecu-
liarly American is its mechanistic cleanness, neatness, and
sobriety. It is also somewhat hard. That, too, is American.
We do not as a people like to swoon in public. We can be
enthusiastic about facts but we like to hand them to you
cleanly proven and without any mistiness. There is cer-
tainly no mistiness in Sheeler's 'Incantation,' which is the
title he gives to his handsome arrangement of ship pipes
and valves seen against a blue sky" (McBride, "Attractions
in the Galleries").

4. In Preston, "5 Stars for February," p. 15.

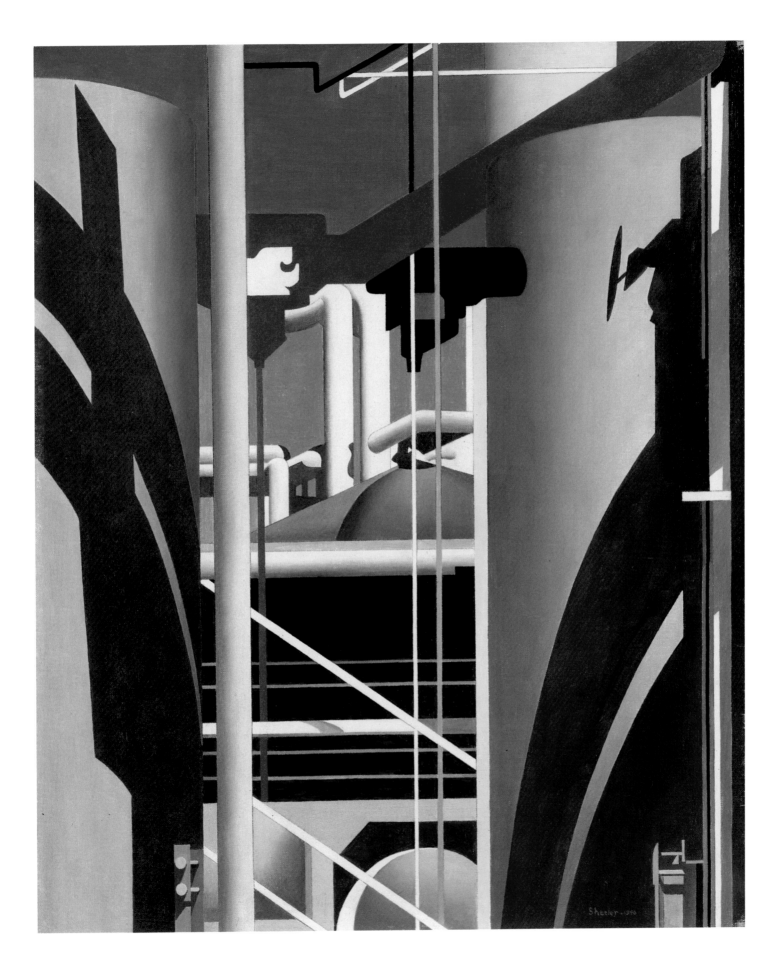

68

Amoskeag Canal
Signed and dated lower right: *Sheeler-48*
Inscribed on reverse: *Charles Sheeler/1948*
Oil on canvas, 22⅛ x 24⅛ in.
(56.5 x 61.3 cm.)
Lent by the Currier Gallery of Art,
Manchester, N.H.

In May of 1948, Sheeler spent two weeks as artist-in-residence at the Currier Gallery of Art in Manchester, New Hampshire. His only responsibility was to produce two sketches, from which the Currier staff and trustees would choose one to be executed in oil; the oil would then be acquired by the museum.¹ Although Sheeler later claimed to have found Manchester dispiriting (he called it the worst of the factory ghost towns), his experiences there inspired at least three temperas and three major works in oil.²

Sheeler's gloomy perception of Manchester was not inaccurate. In 1948 the city's economy still had not recovered from the closing of the textile mills twelve years earlier. At the turn of the century, there had been thirty mill buildings and 17,000 workers in a city of 55,000, and the Amoskeag Manufacturing Company, which ran the mills, had become the largest textile plant in the world. But in the 1920s labor difficulties and overexpansion precipitated the company's decline, and by 1936 the Amoskeag Mills were bankrupt, which devastated Manchester's economy.³ Nonetheless, in 1948 the physical presence of the mills still dominated the city. The red brick factory buildings lined the Merrimack River for almost a mile on one side and over a half mile on the other, and extended for an imposing distance along the upper canal. It was this latter view that Sheeler chose for his representation of Manchester.

Amoskeag Canal was based quite closely on a photograph Sheeler made of the site (fig. a). It represents the canal looking north from Stark Street, with the Limerick Mills at right, and beyond them a small white powerhouse and other mill buildings. The painting is rendered in a realistic style reminiscent of several works Sheeler had produced in the early 1930s (see, e.g., cat. nos. 45 and 51) and is a

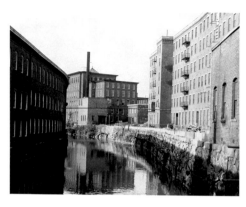

Fig. a. Charles Sheeler, *Amoskeag Mill Buildings*, 1948, gelatin-silver print, The Lane Collection

Fig. b. Charles Sheeler, *Amoskeag Mills #1*, 1948, tempera on board, Currier Gallery of Art, Manchester, N.H., Currier Funds

clear departure from the highly abstracted architectural subjects he recently had painted. Although at first glance *Amoskeag Canal* seems a direct transcription of his photograph, Sheeler's imaginative investment in the subject keeps it from being mere illustration.

For this painting, Sheeler altered the view in his photograph to arrive at an almost utopian vision of the mills, one that paralleled the founders' conception of this self-sufficient community.⁴ Whereas the sharply contrasted tonalities of the photograph (unusual in Sheeler's work) suggest the decline of the mills and of

the city around them, the painting's palette — soft pastel tones, predominantly pinks, creams, and lavenders — are unexpected for a grim industrial scene. Sheeler eliminated much of the incidental detail and exploited other decorative devices, contrasting the smooth façade of the brick building with the rougher, variegated surface of the stone wall and again with their painterly reflections in the water, and emphasizing patterns, such as the telegraphic rhythms of the factory windows. The strong diagonal pull into the picture, created by the banks of the canal, provides the only drama, the only energy, in this otherwise serene composition — a placid interpretation of a subject others found so highly charged.⁵

Sheeler's view of the Amoskeag Mills is oddly ahistorical, neither re-creating their past glory nor documenting their decay. The buildings are pristine, seemingly unaffected by either hard use or abandonment, and are completely unpopulated. As in *Classic Landscape* (cat. no. 37), Sheeler's famous image of the Ford plant at River Rouge, there is no sign of activity, no human interference. The squat, repetitive buildings do not blight the landscape; rather, they are enobled, gracing the banks of the canal in an idyllic, timeless vision.

1. As negotiated by the Currier's director, Gordon Smith, Sheeler's contract specified a $1,000 fee for the sketches and another $1,500 upon delivery of the completed oil. See Paintings Files, Currier Gallery of Art.

2. See interview by Cowdrey, p. 23. Of the two studies submitted, the Currier's trustees preferred the more literal one (*Amoskeag Mills*, current location unknown). The director seems to have preferred the more abstract and schematic picture, *Amoskeag Mills No. 1* (fig. b), and subsequently acquired it for the Currier. In addition, Sheeler painted a third tempera, *Amoskeag Mills No. 2* (Regis Collection, Minneapolis), and two important oils, *Manchester* and *New England Irrelevancies* (cat. nos. 69 and 75), based on his observations of the mills.

3. See Tamara K. Hareven and Randolph Langenbach, *Amoskeag: Life and Work in an American Factory City* (New York, 1978), pp. 9-26.

4. The Amoskeag Manufacturing Company was founded in 1838 when members of Boston's Coolidge family acquired the water power rights for the entire Merrimack River and bought fifteen thousand acres of land in Manchester. The founders of the mills originally tried to run a model community, providing for the workers' living and recreational needs, as well as regulating Amoskeag's moral code and social activities. See ibid., p. 14.

5. See, e.g., Lewis Hine's photographs made at Amoskeag in 1908 as part of his project to document child labor.

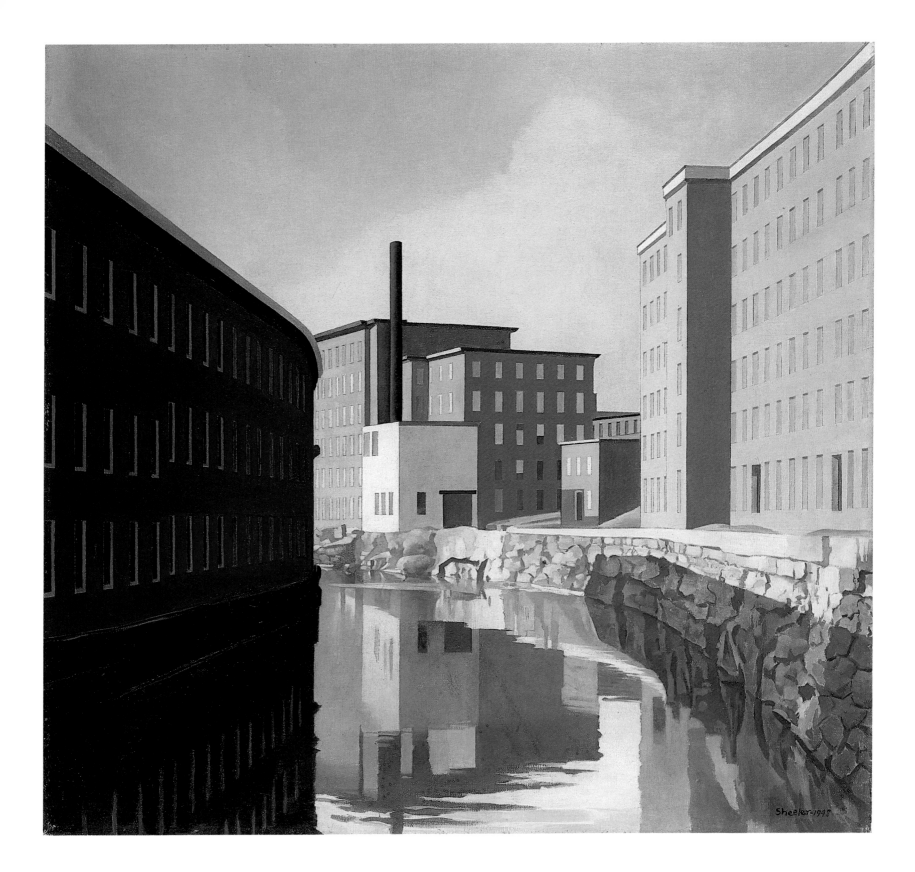

69

Manchester
Signed and dated lower right: *Sheeler-1949*
Oil on canvas, 25 x 20 in. (63.5 x 50.8 cm.)
The Baltimore Museum of Art. Edmund
Joseph Gallagher III Memorial Collection

The neutral title of this picture – the first major oil Sheeler completed after fulfilling the Currier Gallery of Art's commission (see cat. no. 68) – belies the importance of Sheeler's experiences in Manchester. Although he found the city depressing (his wife Musya later described it as a city of "windows, windows, windows, windows, rain, rain, rain, rain") its deserted textile mills proved to be extremely stimulating.[1] After a half decade of relative stagnation, Sheeler's visit to Manchester provided him with new imagery and suggested an innovative and productive means of integrating painting and photography.

Manchester combines a view of the factory yard looking north from the Waumbec Mills (a subject he had already recorded in a tempera study, *Amoskeag Mills No. 1* [cat. no. 68, fig. b]) with that of a narrow passageway between two unidentified mill buildings. In the second view, it clearly was the skeletal fire escapes silhouetted against the sky and the blocky brick buildings that attracted the artist. Sheeler first conflated these views in a photographic "sandwich," a print made from two superimposed photographic negatives (fig. a). This print yielded the compositional design and the dark-light relationships of the oil (the top photograph of the "sandwich" yielding the more shadowy forms). The mysterious image that resulted expresses in vivid terms Sheeler's contradictory memories of the city.

The rhythms of Musya's comment echo the rhythms in the picture. Patterns – of attenuated brick columns alternating with narrow bays at right, and of windows, reduced to reversed L-shapes, at left – dominate, forming an almost musical cadence as they pull the eye into the picture's space. These areas alternate with blocky squares of opaque color, which do not recede but stubbornly cling to the picture surface, establishing a lively tension between illusionistic space and flat, geometric design.

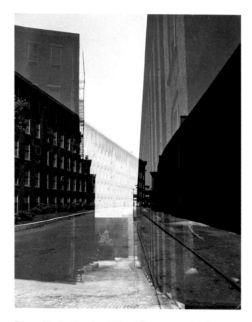

Fig. a. Charles Sheeler, *Millyard Passageway*, 1948, gelatin-silver print, The Lane Collection

Sheeler's color scheme furthers the tension between description and abstraction. The maroons and pinks derived from the hues of the mills' brick, but here they are completely divorced from reality and become part of the picture's complex patterning: lavender is paired with maroon at left, and with pink at right. Unlike *Amoskeag Canal*, which represents essentially the same subject, there is no modeling and no impasto, just geometric areas of flat color in which the eye is challenged to distinguish among the buildings themselves, their mysteriously transparent silhouettes, and their shadows creeping ominously across the mill yard. And as form and shadow, flatness and space, descriptive and abstract color are deliberately confounded, so are the diverse moods of the picture. In the foreground, dark shadows fall across the empty alleyway and the buildings at right appear to sink below street level, as though we were seeing their submerged foundations or underwater reflections. The dark mood of the foreground echoes the mills' abandonment and decay; the far distance, by contrast, is flooded with sunlight, evoking a more placid, optimistic vision.

The subtle complexities of Sheeler's design were not immediately apparent to his public. Although *Manchester* was shown at the Downtown Gallery in 1949 and again in 1951, it remained unsold for six years, during which time Edith Halpert submitted it on his behalf to a number of museum annuals across the country. In one of these, at the California Palace of the Legion of Honor in San Francisco, Sheeler was identified as one of the "better-known exponents of realism," and *Manchester* was heralded as the premier example of the "non-abstract trend" the show's organizers believed to be increasingly characteristic of American art.[2] And whereas Sheeler's picture is not nearly as distant from observable reality as the works by Willem DeKooning and William Baziotes also included in that show, neither is it simply a descriptive portrait of the city that inspired it. Rather, it offers a summary of Sheeler's rich, and often contradictory, impressions of New England's most important mill town.

1. Musya Sheeler, in interview by Cowdrey, p. 27.
2. "San Francisco Picks to Reflect Non-Abstract Trend," *Art Digest* 26 (February 1, 1952): 7.

70

Counterpoint
Signed and dated lower right: *Sheeler 49.*
Conté crayon on paper, 20 x 28 in.
(50.8 x 71.2 cm.)
Daniel J. Terra Collection, Terra Museum of
American Art, Chicago

Counterpoint was Sheeler's last great conté crayon drawing, produced after a hiatus of twelve years. In it, he returned to the large scale of his earliest works in the medium (see, e.g., cat. no. 40) and created an ambitious composition that evoked both the sensuous intimacy of his photographs, as his first contés did, and the masterly presence and complexity of his contemporary works in oil.

The imagery in *Counterpoint* derives from an abandoned mill at Ballardvale, near Andover, Massachusetts, where Sheeler spent several weeks as artist-in-residence at the Addison Gallery of American Art in the fall of 1946. The decrepit brick mill (which Sheeler described poignantly as one of several "carcasses" he found in the area)[1] inspired him to make first a photograph (fig. a) and then a painting (fig. 29). Over the next few years, he would reprise the subject in oil, tempera, and watercolor.[2] For this picture, he employed a recently evolved compositional method, which would become his principal technique for the following decade.

Counterpoint is at once entirely legible and intriguingly abstract. Sheeler arrived at the complex design of the image by superimposing at least two photographic negatives (one in reverse) of the mill at Ballardvale, and then manipulating them to generate an intricate web of forms and their mirror images. This technique, in which the mill is dissected and spread out on the page so that it can be scrutinized from all sides and then reassembled in the mind, might be explained as a sort of latter-day cubism, analytic and cerebral. Sheeler's innovation lay in his use of photography, which enabled him to arrive at what he called the underlying order of things.[3]

The drawing is built upon a series of overlapping rectangular forms extended laterally across the sheet, alternately evoking two dimensions and three — a structure reminiscent of one of Sheeler's most radical works of the teens, *Barn Abstraction* (cat. no. 9). More fundamental to his new method is the sense of mystery he creates: in *Counterpoint*, distinctions between solids and voids, shadowed areas and areas of substance, organic and inorganic elements, become blurred, and what began as a mundane, tumble-down mill takes

Fig. a. Charles Sheeler, *Ballardvale Mill*, 1946, gelatin-silver print, The Lane Collection

on the romance and elegance of the Pennsylvania barns Sheeler had photographed, drawn, and painted more than thirty years earlier.

1. Interview by Cowdrey, p. 23.

2. The mill at Ballardvale inspired a series of architectural abstractions: *Architectural Planes*, oil on canvas (1947; The Lane Collection); *Variations in Red*, oil on canvas (1949; Toledo Museum of Art); and *Ballardvale Revisited*, tempera on cardboard (1949; Dayton Art Institute). It also inspired a delicate wash drawing, *Reflection*, watercolor on paper (1946; Coll. Charles E. Buckley, Mont Vernon, N.H.), among other images.

3. In the interview by Cowdrey (p. 2), Sheeler describes the intellectual mission of art as to "establish the order which everything has to have."

193

71

Wings
Signed and dated lower right: *Sheeler 1949*
Gouache and pencil on watercolor board,
15⅞ x 20 in. (40.3 x 50 cm.)
Yale University Art Gallery. Gift of George
Hopper Fitch, B.A. 1932, and Mrs. Fitch

Wings is an abstracted vision of boats running before the wind, perhaps in a race, with a full complement of sails. The number of craft and their relative positions are ambiguous; they are reduced to their essence, their sails or "wings." The large parabolic shape in the center of the composition is a spinnaker,[1] a lightweight, balloonlike sail used when the boat is moving with the wind directly behind it. Sheeler implies its fullness with rounded lines and schematic shading. A fortuitous shadow or reflection on the spinnaker acts as a pictograph and seems to reiterate the analogy between sailing and the flight of birds, for the amorphous steel gray form is shaped like a cartoonish wing.

The curvilinear shapes in *Wings* are almost unprecedented in Sheeler's work. They indicate the influence of the contemporary taste for biomorphism, or the use of organic shapes in the fine arts and interior design. Biomorphism, an outgrowth of the machine age style of the 1920s and 1930s, was an attempt to humanize technology by using more natural forms; the style is characterized by irregular, curvilinear shapes.[2]

The seascape in *Wings* is greatly simplified. The sky is shown as faceted shapes of blue and gray; the sparkling water is seen only in a small triangular area at bottom center, where Sheeler used thinner, wetter pigment. While he carefully recorded the position of the sails, no other parts of the boats are defined – there are no masts, rigging, or decks. Sheeler reduced the image, and the activity of sailing, to its fundamentals, capturing the wind itself as it distorts the shape of the sails. This distillation of form is typical of Sheeler's late work. As Frederick Wight noted in his 1954 study of the artist: "The late strong feeling of form works a change. . . . One sees the artist beginning with a portrait and emerging with an archetype. . . ."[3]

Sheeler often returned to subjects he had investigated many years before. *Wings* is such a reprise, based upon a theme the artist had first explored in 1922, with *Pertaining to Yachts and Yachting* (cat. no. 22). It was preceded in 1948 by a moderately-sized oil, *Wind, Sea, and Sail* (fig. a), which develops, in reverse, the pattern of sails in *Pertaining to Yachts and Yachting*, while it explores a much cooler palette. In

Fig. a. Charles Sheeler, *Wind, Sea, and Sail*, 1948, oil on canvas, current location unknown

Wings, Sheeler maintained the new blue-gray color scheme, but created a distinctive, dynamic image.

1. See Dorothea Dietrich Boorsch, "Charles Sheeler, *Wings*," *Yale University Art Gallery Bulletin* 37 no. 3 (Spring 1980), p. 14.
2. See Wilson, "Machine Aesthetics," in *The Machine Age in America*, p. 58. Biomorphism was featured in two important exhibitions in the 1940s: *Organic Design* (1941, The Museum of Modern Art, New York) and Frederick Kiesler's installations for Peggy Guggenheim's Art of this Century Gallery.
3. Frederick S. Wight, "Charles Sheeler," *Art in America* 42 (October 1954), p. 206.

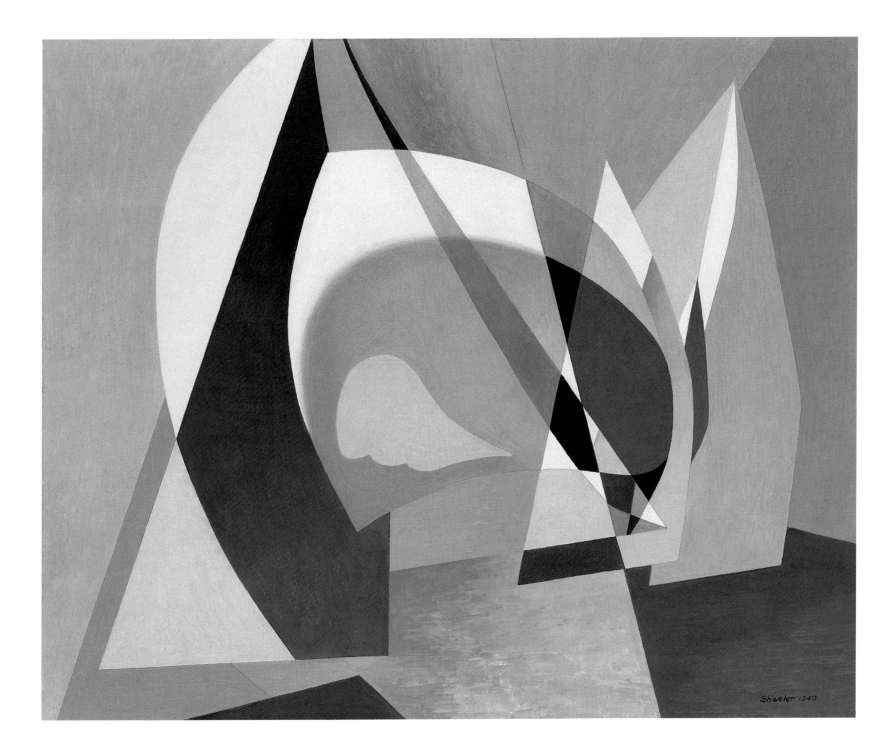

72

Convergence
Signed and dated lower right: *Sheeler-1952*
Oil on canvas, 23 x 15½ in. (58.4 x 39.4 cm.)
Collection of Mr. and Mrs. George
Greenspan

Convergence marks Sheeler's return to a
theme that had engaged him at the beginning
of his career: the architecture of New York.
Revitalized by his creative experiences in the
late 1940s with the mills of New England,
Sheeler embarked on a series of photographs
of the new New York. He recorded mostly
structures that had been built since the 1920s,
when he had last studied the city. From these
he created a group of paintings showing Man-
hattan's skyscrapers.[1]

Sheeler refers directly to his past work in
Convergence: dominating the painting is a rear
view of the Park Row Building[2] the same struc-
ture that had appeared in *New York* and *Sky-
scrapers* (cat. nos. 17 and 18), and in his film
Manhatta. Although *Convergence* was based
on a recent photograph (fig. a), the composi-
tion's strong diagonal emphasis is a reprise of
Sheeler's 1926 lithograph of the Delmonico
Building (fig. b). There too he had selected a
side view of the building, de-emphasizing its
role as a landmark and concentrating on its
sleek, sculptural form. In planning *Convergence*,
Sheeler superimposed his photo of the Park
Row Building on one of a reversed image of
Rockefeller Center. This second view (The
Lane Collection) shows the RCA and the In-
ternational Buildings, and reveals their
stepped-back silhouettes and the ziggurat-
shaped tops of other skyscrapers beyond. The
two scenes seem pinned to each other at the
window at lower right, which acts like a pivot
holding the two translucent images together.
The luminous transparency of his negatives in-
spired Sheeler, and he used it to dematerialize
the buildings' solid forms. The effect is en-
hanced by the color scheme of creamy whites,
lavender, and violet, applied in thin layers inde-
pendent of any descriptive purpose. In *Conver-
gence*, his composition, like his subject matter,
recalls his work of the 1920s, in which he com-
bined recognizable forms with prismatic
abstraction.

Fig. a. Charles Sheeler, *Park Row Building*, 1950, gelatin-
silver print, The Lane Collection

Fig. b. Charles Sheeler, *Delmonico Building*, 1926, litho-
graph, printed in black, Collection of The Museum of
Modern Art, Gift of Abby Aldrich Rockefeller

Convergence represents not only the con-
currence of two different views of New York
buildings but also an evocative unification of
the past and present. By combining an old
building and a new one, and by looking afresh
at a structure that had played such an impor-
tant role in his early work, Sheeler fused mem-
ory with observation.[3] The painting also dem-
onstrates the new unity Sheeler attained
between his painting and his photography. He
translated the photographic qualities of trans-
parency and superimposition into paint, adding
radiant, arbitrary color and simplifying inciden-
tal details to create a new vision, equally in-
debted to the lens and to the brush.

1. The others are: *New York* (1950; Regis Collection, Min-
neapolis), *Skyline* (1950; Wichita Art Museum), and *Can-
yons* (1951; Thyssen Collection, Lugano) – all panoramic
views; and *New York #2* (1951; Munson-Williams-Proctor
Institute, Utica, N.Y.), *Windows* (1951; Hirschl & Adler Gal-
leries, New York), and *Neighbors* (1951; Kemper Collec-
tion, Kansas City, Mo.) – all similar in conception to *Con-
vergence*. Each of these large oils is related to a smaller
study in tempera.

2. I thank Cervin Robinson and James F. O'Gorman for
their help in identifying this structure. The Park Row Build-
ing also appears in *New York #2*.

3. "When we look at any object in Nature we inevitably
carry over a memory of the object we have just previously
seen. Since then I have endeavored to combine the mem-
ory and the present in a given painting," Sheeler, in "Writ-
ings of Charles Sheeler," Friedman et al., *Sheeler*, p. 99.

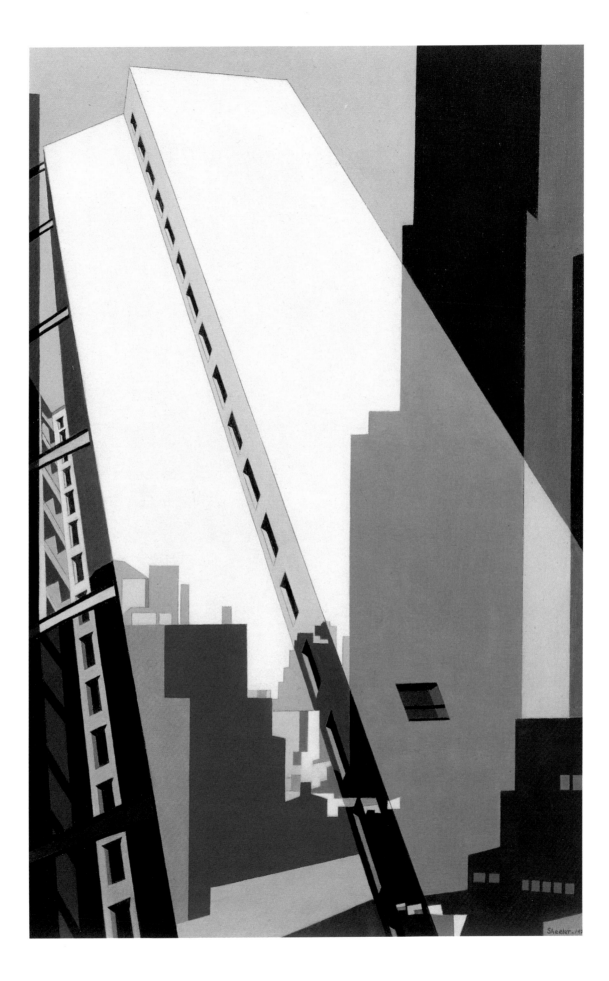

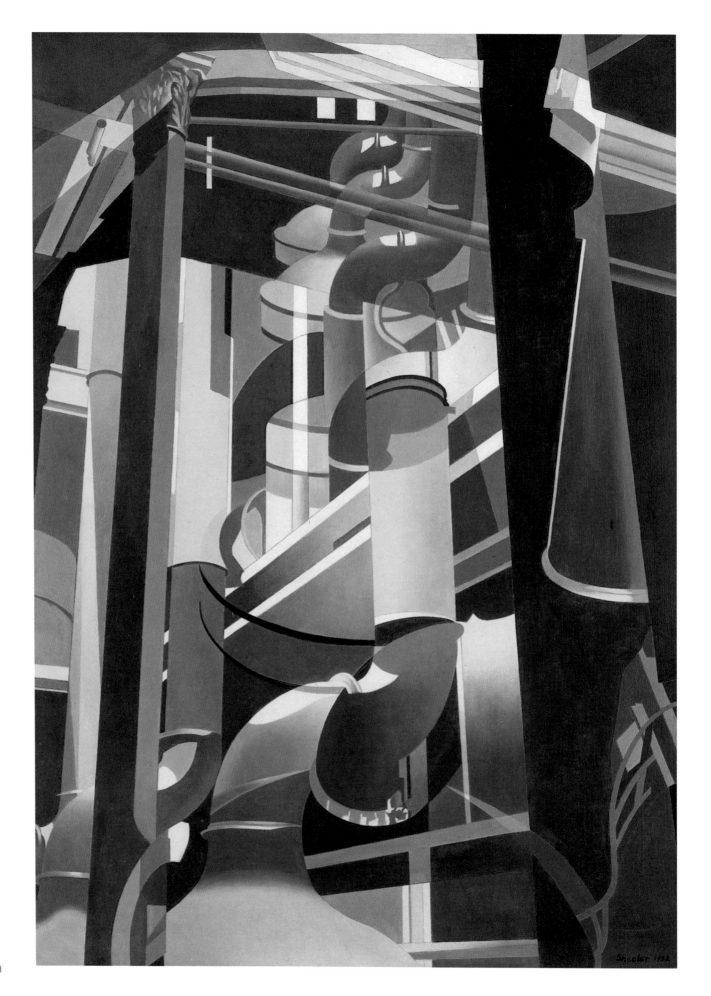

73

Convolutions
Signed and dated lower right: *Sheeler 1952*
Oil on canvas, 36 x 26 in. (91.4 x 66 cm.)
Collection of Mathew Wolf

74

Convolutions
Signed and dated lower right: *Sheeler 52*
Tempera on glass, 9 x 6½ in. (22.9 x 16.5 cm.)
The Lane Collection

In the early 1950s, Sheeler was once again busy with industrial commissions, most of them arranged by the Downtown Gallery. These commissions took him chiefly to the Midwest: he visited U.S. Steel in Pittsburgh, Meta-Mold (now Amcast Industrial) Corporation in Cedarburg, Wisconsin, Inland Steel in the Chicago area, and the General Motors Laboratory in Warren, Michigan.[1] He toured the Pabst Brewery in Milwaukee in May of 1952 and was captivated by the Brew Room, where he took photographs. These led, after his customary studies in tempera on glass, to *Convolutions* (originally titled *Pabst*). The painting, destined for the Chicago office of company president Harris Pearlstein, was reproduced in the brewery's newsletter.[2]

Sheeler's visit to Milwaukee and his subsequent completion of the painting were celebrated in the local paper, which quoted the artist at length on the circumstances of his inspiration:

> *When I saw the Brew Room I quickly sensed that there was the material for my picture. There were the fine big metallic forms of the kettles. There were the fascinating patterns of the pipes. This room seemed to me the heart of the plant, and most tellingly pictured the brewing operation — also offered elements that I would select for my paintings. The material had great possibilities for translation in my personal idiom.[3]*

Sheeler's statement deliberately demystified the creative process, avoiding metaphor and focusing on the mundane. The newspaper arti-

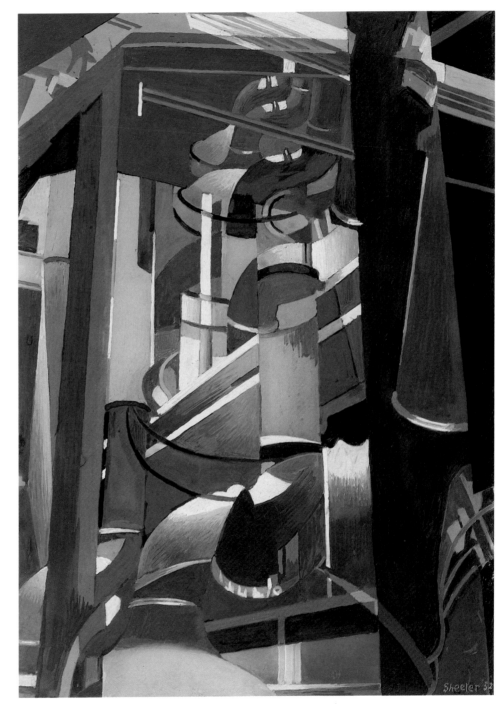

74

cle, however, compared Sheeler's great brew kettles with the lustrous copper pots painted by Chardin (whom Sheeler greatly admired). In fact, Sheeler's radiant mechanical forms, which appear to be illuminated from within, might be seen as the modern equivalent of Chardin's gently glowing vessels, pots, and kitchen utensils. But the mood of *Convolutions* is a far cry from the serenity of Chardin's eighteenth-century masterpieces. The core of the composition is a pattern of swirling forms that spill out toward the viewer, their dynamism expressing the noisy vigor of the plant. The architectural scaffolding, particularly the cast-iron column topped with a Corinthian capital (the one significant detail Sheeler added from his richly and freely painted tempera sketch), is equally energized, so that the entire painting seems to whirr and clatter. The clean, massive industrial machines of the Pabst brewery inspired an image that is oddly organic. The kettles, no longer recognizable as such, become bulbous, supple forms connected by metallic tendons; the splintered walls and columns housing them likewise throb and pulsate.

Sheeler's imagery was inspired by the copper pipes at Pabst, but it resounds with the work of another artist. *Convolutions* recalls *Nude Descending a Staircase* (1912; Philadelphia Museum of Art) and *The Bride* (1912; Philadelphia Museum of Art) by Sheeler's idol, Marcel Duchamp. These paintings were owned by the two artists' long-time friends Walter and Louise Arensberg and, along with the rest of their holdings (including several works by Sheeler), had just entered the collection of the Philadelphia Museum of Art. Here Sheeler echoes not Duchamp's heretical wit but the outlines of his composition, his glowing colors, and the mechano-organic qualities implicit in his lively progression of pliant forms. Sheeler's deadpan rendition of the setting at Pabst does not entirely mask his perception of his subject's sensate allure and surprisingly animate presence. And his title, which points to the twists and turns of gleaming copper tubing that first caught his eye, could also be said to describe the complicated chain of associations that shaped this composition.

1. These visits resulted in such paintings as *Meta-Mold* (1952; Amcast Industrial Corporation, on loan to the Dayton Art Institute), *Western Industrial* (1955; Art Institute of Chicago) and *General Motors Research* (fig. 31).

2. [Pabst] *Blue Ribbon News* (January 1953), cover. See Downtown Gallery Papers, ND40:201.

3. Sheeler, in "Two Wisconsin Sheeler Works Finished." *Milwaukee Journal*, December 28, 1952, sec. 7, clipping, Downtown Gallery Papers, ND41:35.

75

New England Irrelevancies
Signed and dated lower right: *Sheeler 1953*.
Oil on canvas, 29 x 23 in. (73.7 x 58.4 cm.)
The Lane Collection

76

New England Irrelevancies, 1953
Tempera on glass, 9¼ x 7⅝ in.
(23.3 x 19.4 cm.)
Addison Gallery of American Art, Phillips
Academy, Andover, Mass.

Five years after his visit to Manchester, and seven years after working at Ballardvale, near Andover, Sheeler once again turned to the imagery of those mill towns to produce what is arguably the finest and most evocative work of the last decade of his career. The inscrutable title of this painting, *New England Irrelevancies*, is a deliberate departure from the straightforward descriptives Sheeler had applied to his previous mill pictures (see cat. nos. 68 and 69). The title presumably alludes to the impressive buildings and prosperous industries once dominant in the area but now obsolete. The sense of the buildings' irrelevance may have struck Sheeler personally, too: when he completed this painting he was seventy years old, remote from the artistic mainstream and from the intensely personal art then being created.

But if Sheeler found it poignant that an over-the-hill painter had been solicited by out-of-the-way museums to produce images of a defunct industry, he gave no evidence of it in his pictures of the Ballardvale and Amoskeag mills. *New England Irrelevancies* especially is far from grim or moribund. Painted in the opalescent hues (planned in a small tempera-on-glass study) that give so many of Sheeler's industrial subjects an astonishing optimism, the picture represents these decrepit nineteenth-century mill buildings as though they were contemporary skyscrapers.

New England Irrelevancies synthesizes details from the Manchester and the Ballardvale mill pictures, but contains a sense of mystery that neither of them possesses. The left half reintroduces the forms of *Ballardvale* (fig. 29), but here the soaring spire of the mill dematerializes, while at the same time it overlaps the two-tiered brick building from which it rises. The protruding pipes – key features of the original image – are now represented only by their shadows and become an evocative abstraction with no apparent source. The right half reflects in reverse one of Sheeler's photographs of Manchester (see cat. no. 69, fig. a), which features fire escapes climbing the façades of buildings here represented only as wedges of color. The two flat, sliced-off squares in maroon and purple near the center of the painting are in fact two small buildings, one behind the other, dwarfed by the steep walls of the mills on either side. The snaky

form emanating from the ladder at center, which has been described as a canal or river[1] (and which is rendered with the looser, thicker brush strokes Sheeler usually reserved for natural forms) is in fact simply the outline of a change in the pattern of the cobblestones on the mill yard floor. Yet even once identified, this irregular curving stroke weaving among the ordered, geometric buildings remains the most enigmatic and troubling element in the picture. It has an ominous presence, like the fleeting shadows in a painting by DiChirico, which threatens to overtake the viewer or, equally disturbingly, to disappear.

As he had done in *Amoskeag Canal* (cat. no. 68), Sheeler depicted the crumbling façades as though they were new – as new as New York's Lever Building, the subject of a photographic essay he produced the same year. *New England Irrelevancies* and *Street Scene, New York* (fig. a) are in many ways the same picture. In each, sheer walls rise at steep angles and substantial architectural forms dissolve, while shadows with no identifiable source take on an almost intangible presence. And like Sheeler's photographs of the Lever Building and his other New York views of the 1950s, *New England Irrelevancies* is highly energized – quite different from the relative placidity of his other mill pictures. The overlapping shapes and shadows, skewed angle of vision, and ruthless cropping create contradictory sensations: the viewer feels as though he is being sucked into the picture's space and at the same time pressed backward by the buildings' looming walls.

Sheeler worked out the composition of *New England Irrelevancies* by superimposing, manipulating, and printing several photographic negatives he took at Manchester and Ballardvale. More than simply a mechanical means for generating an intriguing composition, the process solved an expressive problem important to Sheeler, who believed that our understanding of the natural order is based not on immediate observation alone but on observation combined with visual memory.[2] Photography was the ideal medium for linking the memory and the present perception: it preserved details, of course, and in Sheeler's innovative use of the medium it could weld together in physical form two ex-

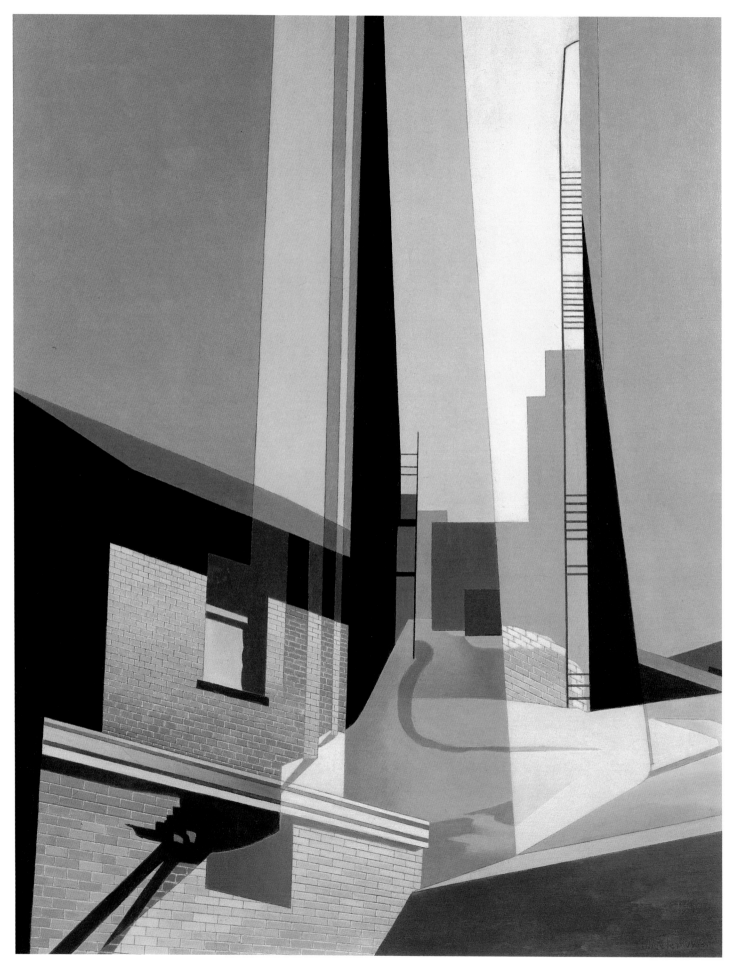

Fig. a. Charles Sheeler, *Street Scene, New York*, 1950, gelatin-silver print, The Lane Collection

periences linked in the mind, as Manchester and Ballardvale were for him. *New England Irrelevancies*, with its combination of images Sheeler had used before and its evocation of the skyscrapers he had recently photographed, not only preserved the memory of the two mill towns but brought them, at least pictorially, into the present.

1. See Stebbins, "The Memory and the Present," in *The Lane Collection*, p. 28.
2. See Friedman et al., *Sheeler*, p. 99.

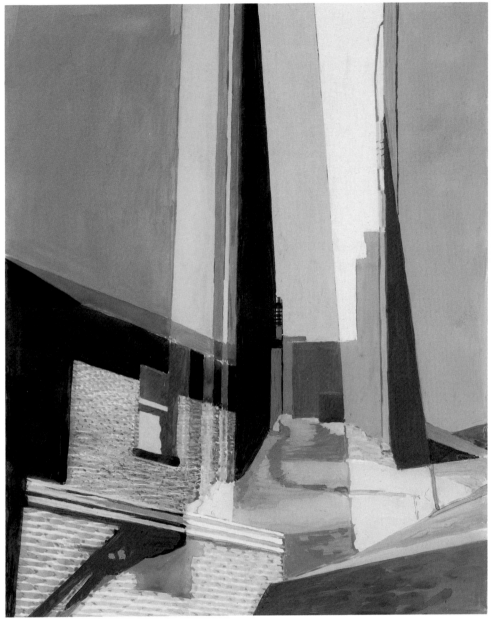

76

77

Ore into Iron
Signed and dated lower right: *Sheeler-1953*
Oil on canvas, 24⅛ x 18⅛ in. (61.3 x 46 cm.)
The Lane Collection

Sheeler first turned to American industry as subject matter on commission, but he came to admire the functional, utilitarian beauty of industrial design and continued to paint and photograph it throughout his career. From the late 1920s, he used its familiar vocabulary to explore each of his new stylistic interests. *Ore into Iron* displays the interest in overlapping, transparent planes that Sheeler developed in the last decade of his career. When first exhibited in New York in 1956, the painting was described as "so complex in its mingling of factual suggestion and abstract distortion that it's practically dazzling."[1]

Ore into Iron depicts the blast furnaces of the U.S. Steel plant in Pittsburgh, which Sheeler visited in 1952.[2] He took several photographs of the plant (fig. a), selecting a low vantage point that made the furnaces appear to soar into the air in the same manner as the New York skyscrapers he had been studying (see cat. no. 72). He later experimented with his photographic negatives in the darkroom, reversing and superimposing them and making composite prints. While some of the Pittsburgh photographs contain human figures, the ones made into composites do not. *Ore into Iron* was modeled after a relatively simple composite print (The Lane Collection) in which the scene appears twice, once frontward and once in reverse.[3] Sheeler undermines the massive bulk of the heavy machinery by rendering it with an extremely delicate touch: the paint is applied thinly and precisely, and is confined to discrete areas by neatly drawn pencil outlines. Color enhances the airy, light effect, as the deep violet-blue used for one image blends into the pinkish brown of the other. Large opaque areas of pigment at the bottom of the composition become translucent at the center and top. The outlines of the furnaces and catwalks meld into one another, so that their function succumbs to intricate pattern. Dense at the bottom of the picture and more delicate at the top, the forms of the blast furnaces become ethereal.

The total effect is almost cinematic, for one image appears to be fading into another, dissolving and reforming on the surface of the canvas, just as ore is melted into iron in the blast furnaces portrayed here. Sheeler's title, explaining the physical process he is showing, is

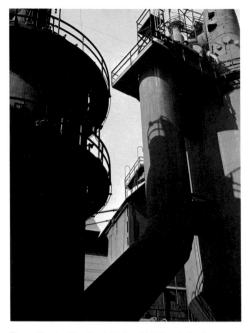

Fig. a. Charles Sheeler, *U.S. Steel*, 1952, gelatin-silver print, The Lane Collection

unusual in its descriptiveness. But he addresses more than this industrial transformation; he explores an aesthetic metamorphosis as well. Here factory forms are translated into artistic ones, photography becomes painting, and reality turns into abstraction.

1. Coates, "The Art Galleries: Gauguin and Sheeler," p. 112.

2. Sheeler apparently negotiated with U.S. Steel for a mural commission, which was never realized. He visited their plant and was also sent many company photographs of the Homestead District Works in Munhall, Pennsylvania. Conversation with William H. Lane, January 1987.

3. *Aerial Gyrations* (1953; San Francisco Museum of Modern Art) is a companion piece to *Ore into Iron*; it was based on the same photographs in a different combination. Four years later Sheeler depicted the same subject matter in *Continuity* (Fort Worth [Tex.] Art Museum). All three pictures have related studies in tempera on paper and in tempera on Plexiglas.

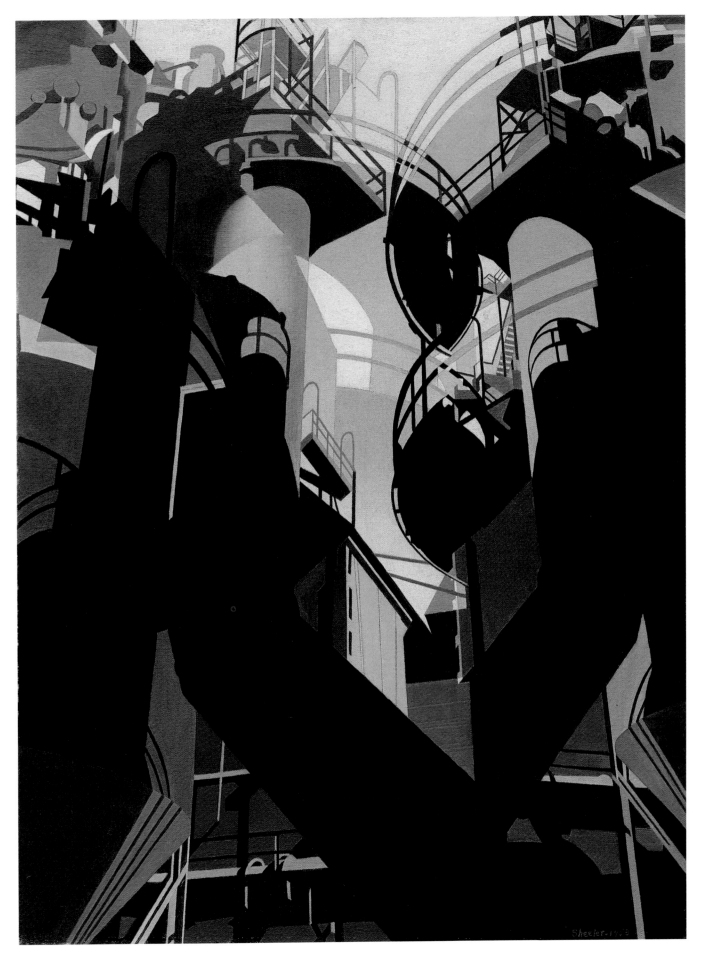

78

Lunenburg
Signed and dated lower right: *Sheeler-1954*
Oil on canvas, 25 x 34 in. (63.5 x 86.4 cm.)
The Lane Collection

In the late fall of 1953, Sheeler and his friend William H. Lane explored the region of north-central Massachusetts where Lane made his home. The area — long settled and rural, its rocky fields offering indifferent hospitality for agriculture — was similar to the region in northwestern Connecticut that had attracted Sheeler in the 1940s. He took numerous photographs of barns and other structures, which later inspired paintings in oil and tempera. Photographs of two of these buildings — a handsome barn complex whose foremost structure featured an unusual, shallow-peaked roofline (fig. a) and a shingled silo (a form peculiar to New England) — were used to produce *Lunenburg*.

Sheeler had been overlapping photographic images in order to generate compositional designs for paintings since about 1946; by the early 1950s, he was completely persuaded of the technique's effectiveness. A group of unmounted photographic "sketches" illustrates his working method. The first, a composite photograph uniting the peaked-roof barn with a larger wooden barn, shows a series of ruled lines framing different segments of the picture, each a potential composition. Sheeler apparently was not satisfied with any of the results created by the union of these two buildings, and so printed another composite photograph (fig. b), which he then cropped to produce the design for *Lunenburg*. The outlines of the resulting shapes, some descriptive but others abstract, were then transferred to the canvas (some of these pencil lines were later reinforced). Sheeler worked out the color relationships in a small tempera-on-glass study (unlocated) and then re-created it on the large painting.

This method had several consequences for Sheeler, who by this time had moved away from precise description to a greater willingness to manipulate his subjects to yield more compelling formal relationships. He diminished

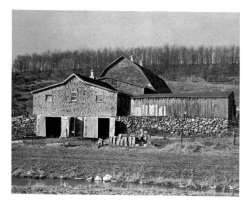

Fig. a. Charles Sheeler, *Barn Complex*, c. 1953, gelatin-silver print, The Lane Collection

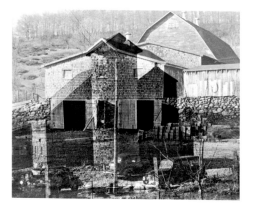

Fig. b. Charles Sheeler, *Barn Complex*, c. 1953, composite gelatin-silver print, The Lane Collection

the corporeality of the barns in *Lunenburg* in favor of a handsome graphic design that emphasizes geometric shapes. Objects that would normally seem to be behind one another in space here become transparent: the shingled façade of one barn (at left) penetrates the smoother-surfaced roof of another; at right, the shadowy form of a smaller silo shades but does not obscure the stone fence. Contrasting patterns and textures, which Sheeler had been using from the outset of his career to produce active surfaces, here alternate with flat, solid areas of color in the service of compositional design rather than description.

Yet *Lunenburg* is neither wholly abstract nor lacking in expressive vitality. The great broad barn spread laterally across the visual field is reminiscent of other rambling structures Sheeler had depicted, beginning with the historic photograph *Side of White Barn* (fig. 8) and *Barn Abstraction* (cat. no. 9). The monumental silos, shown here for the most part as shadowy profiles, evoke other buildings, such as the abandoned mill at Ballardvale (see cat. no. 70), which Sheeler made into icons to express his admiration for those commonplace yet noble structures. That the rosy glow of the silo's shingles and the rendering of its hooded pediment as a transparent silhouette give the form an ephemeral quality turns out to have been prophetic: although some of the buildings in the barn complex are still standing, the silos have been torn down.

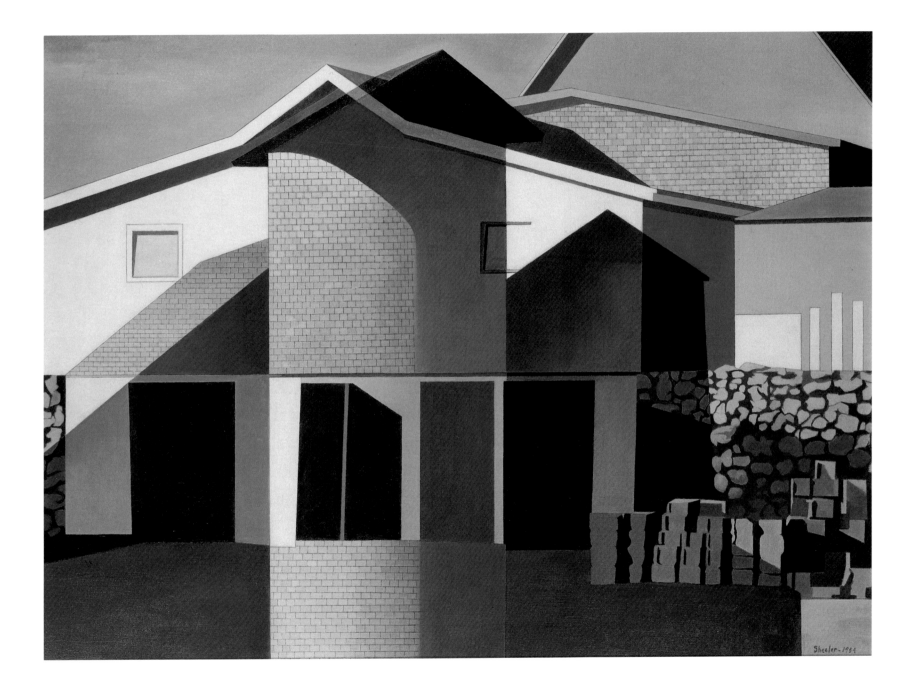

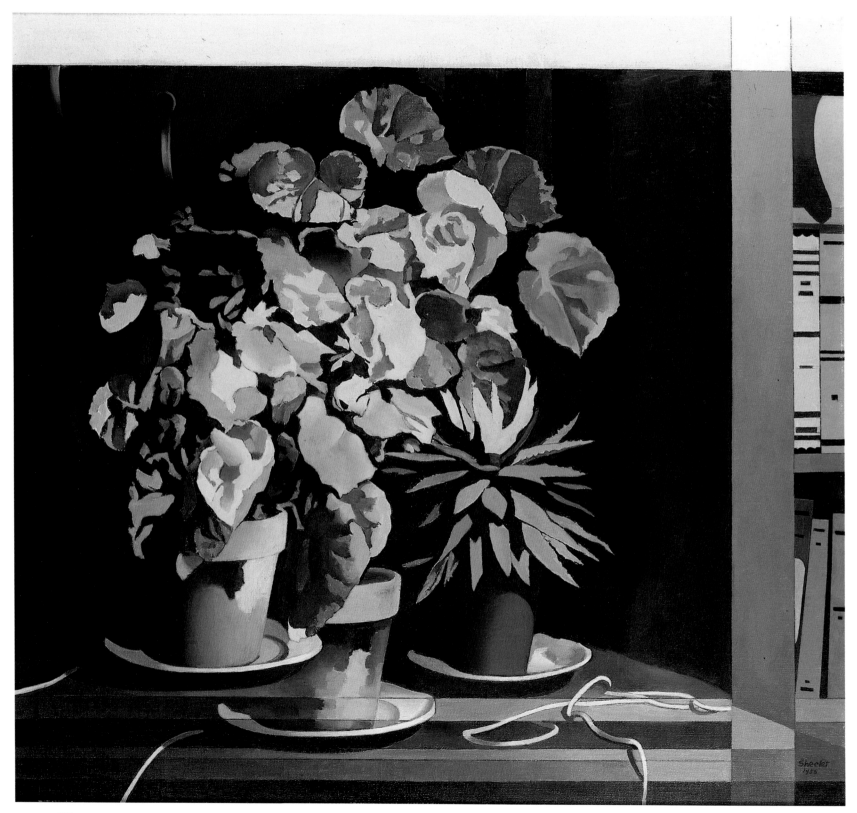

79
Begonias
Signed and dated lower right: *Sheeler/1955*
Inscribed on reverse (on backing): *Begonias/*
Charles Sheeler/1955/Do not remove/this
board/C.S.
Oil on canvas, 25 x 27⅛ in. (63.5 x 68.9 cm.)
The Lane Collection

80
Begonias, 1955
Tempera on Plexiglas, 7⁵⁄₁₆ x 7¾ in.
(19 x 19.7 cm.)
Private collection

The enigmatic *Begonias* was conceived in California and may depict the corner of a study of Ansel Adams's house in Yosemite, where Sheeler was an occasional guest. Sheeler and Adams had been acquainted since the early thirties; thereafter they paid each other numerous visits in New York and on the West Coast.[1] The impetus for *Begonias* came from a mutual friend of the two artists, William H. Lane. Lane was an avid collector of Sheeler's work; by 1955, he owned more than twenty of his paintings and drawings, but none of the still lifes, of which he was a great admirer. Although the artist insisted that he was through with the genre, Lane's enthusiasm, and the urgings of Sheeler's second wife, Musya, persuaded him to attempt the subject once again.[2]

Like other works Sheeler intended for friends (see cat. no. 21), *Begonias* is richly painted and imbued with personal references that are not readily apparent. The colors of the picture are intense and lush, especially the tropical greens of the plant leaves floating mysteriously against the deep mahogany shadows of the niche. The thick paint and resonant color of that part of the painting contrast with the handling of the books at right, where the surfaces are smoother and the tones cool. The spatial conundrum presented here — the indecipherable depths of the niche juxtaposed with the flat, almost cartoonlike bookshelves — is only one of many mysteries Sheeler built into

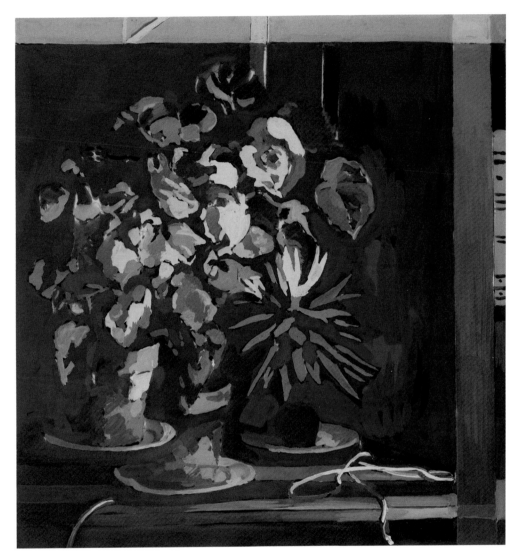

80

Fig. a. Charles Sheeler, *Geraniums, Pots, Spaces*, 1923, chalk with colored chalks and pencil on white laid paper, Courtesy of the Art Institute of Chicago, Olivia Shaler Swan Memorial Collection

Begonias. The plants seem vivid and palpable, but on closer inspection we see they are missing their stems. The flower pot in the immediate foreground, given substance by thick, patchy, Cézannesque strokes, is oddly transparent and hovers over an impossibly shallow ledge that becomes a sheer, striped surface as the eye follows it to the right. The copper-colored handles in the niche at left can't be explained, and the white ribbon, looping lazily around the pots, comes from an unseen source and leads nowhere.

The context if not the explanation for these perceptual riddles is found in a series of still lifes and related compositions Sheeler painted in the 1920s, when he was most actively engaged with the genre. The peculiar space of *Begonias* is a reprise of the similarly witty interplay of depth and surface found in the 1927 oil *Spring Interior* (cat. no. 33), which, fittingly, Lane had acquired the year before. The crinkly foliage silhouetted against a dark ground is reminiscent of similar forms in *Geraniums, Pots, Spaces* (fig. a), where the intervals between the leaves are as vivid and as crucial to the design

of the picture as the leaves themselves, and the pots cast and contain intriguing shadows that undercut their physical presence.

The most telling antecedent for *Begonias* is Sheeler's *Self-Portrait* (cat. no. 25). Both works include a mysterious cord winding in and out of the picture space, tempting the viewer to seize it and somehow connect with the objects depicted. Both are built around an inanimate object, prominently displayed (which in the case of *Self-Portrait* is identified with the artist), and both contain a deliberate pairing of solid and shadowy forms (in *Self-Portrait*, the telephone and the artist's reflection; in *Begonias*, the tangible flower pots and their transparent "double") to underscore the ephemeral nature of perception. Here, Sheeler conjured up not just a new still life but a recollection of his most provocative experiments with the genre. *Begonias* is a précis of his career as a painter, and a personally crafted illustration of his favorite adage: "When we look at any object in Nature we inevitable carry over a memory of the object we have just previously seen."[3]

1. See Adams-Sheeler Correspondence, Ansel Adams Archives. In the 1940s, Adams paid frequent visits to the Sheelers in Irvington-on-Hudson, New York (see Ansel Adams with Mary Street Alinder, *Ansel Adams, An Autobiography* [Boston, 1985], p. 205). During the next decade, he returned their hospitality in California, as their witty correspondence from that period suggests (See Sheeler Papers, NSh3:20-25.)
2. Conversation with William H. Lane, November 1986.
3. Sheeler Papers, cited in Friedman et al., *Sheeler*, p. 99.

81
Golden Gate
Signed lower right: *Sheeler. 1955.*
Oil on canvas, 25⅛ x 34⅛ in.
(63.8 x 88.6 cm.)
The Metropolitan Museum of Art, New York. George A. Hearn Fund, 1955

82
San Francisco — Fisherman's Wharf
Signed lower right: *Sheeler 1956*
Oil on canvas, 31½ x 21½ in. (80 x 54.6 cm.)
Mr. and Mrs. William C. Janss

Sheeler went to California twice in the 1950s. On his first visit, in 1954, his primary purpose was to attend the opening of the exhibition of his works organized by Frederick Wight for the Art Galleries at UCLA. On his second visit, in 1956, he spent more time in the northern part of the state, touring San Francisco and Yosemite. On both trips he took photographs of the San Francisco area. For many of these, he avoided Telegraph Hill and other tourist spots and focused instead on the city streets' steep slide toward the bay. For the scenes destined ultimately for his brush, however, he tackled the better-known sites, and when he returned east, he produced paintings of two of the city's most famous landmarks, the Golden Gate Bridge and Fisherman's Wharf.

Before he left for California in 1954, Sheeler wrote to his long-time friend Edward Weston about the upcoming journey, noting that, although he had been principally occupied with painting, he occasionally treated himself to a holiday by making photographs.[1] Despite this feigned distinction between the media, Sheeler had long used photographs in the service of his painting. Initially a single photograph had suggested the outlines of his composition. By the late 1940s, he used several different negatives, superimposed, to define his subject. In the mid-fifties, he altered his technique once again and made several paintings (see cat. no. 77) by overprinting two negatives of the same or nearly identical photographs, one in reverse.

While there are no surviving prints of Sheeler's Golden Gate photographs, a small collection of 35-mm. color slides documents the bridge from the same vantage point Sheeler selected for his oil. Several of the slides are notched, as though the artist had experimented with combining and superimposing them as he had his negatives. The extraordinary effect produced by this method is recorded in the oil. Although the bridge is isolated against a clear, bright blue sky, the succession of images generated by the composite process suggests motion, and the viewer feels as if he were passing beneath the structure's great towers and cables. While the technique was new to Sheeler's art, the vertiginous effect it produced was not. A contemporary critic called the work "dizzying . . . daring, recalling the unorthodox angle of vision of *Church St. El."*[2]

Completed in 1937, the Golden Gate Bridge was a triumph of modern engineering. Spanning 4200 feet over turbulent waters and a geological fault, the bridge soars above the impressive natural landscape, its "international orange" towers a striking contrast to the brown hills and blue water.[3] Sheeler refined these color juxtapositions in *Golden Gate*, using shades from salmon pink to a brownish maroon to define the bridge and selecting a light olive green to add substance to the shadows formed by the faceted projections on the cross-spans of the tower. These heightened colors give the bridge an unreal quality, making it, in the artist's words, "an opening to wherever the spectator thinks desirable."[4]

San Francisco (Fisherman's Wharf) is based on photographs of the prow of a fisherman's dinghy. In the photographs, the gunwales, oarlocks, and seats cast complex shadows as the boat sparkles in the sunlight. Sheeler's overlapping technique in the oil multiplies the effect, creating sharp, bold shapes and equally bold shadows that form a patchwork across the surface of the canvas.

Sheeler's color attains new brilliance and luminosity in this picture. The vibrant squares and irregular geometric shapes with crisp edges suggest a highly colored mosaic or — in an effect heightened by his thin, textureless application of paint — dazzling prisms of stained glass. The boat itself, shown upended and par-

allel to the picture plane, also evokes an architectural form. Filling the visual field, looming upward with monumental presence, these arched shapes with pointed tops recall the slender lancet windows of a Gothic cathedral.

1. See Sheeler to Weston, August 9, 1954, Weston Archive, Center for Creative Photography, Tucson.

2. Chanin, "Charles Sheeler," pp. 40, 72.

3. See Wilson, "The Machine in the Landscape," in *The Machine Age in America*, p. 110.

4. Sheeler to Robert Hale, June 27, 1955, Object Files, Twentieth-Century Department, Metropolitan Museum of Art, New York.

83
Red Against the White, 1957
Tempera on Plexiglas, 4⅞ x 6 in.
(12.4 x 15.3 cm.)
Museum of Fine Arts, Boston.
A. Shuman Fund

84
Red Against the White
Signed and dated lower right: *Sheeler-1957*
Tempera on paper, 4¹³⁄₁₆ x 5⅞ in.
(12.2 x 15 cm.)
DeCordova and Dana Museum and Park,
Lincoln, Mass. Gift of the Stephen and Sybil
Stone Foundation

A photograph of silos, probably made in the
Midwest, was the inspiration for a group of
paintings on Plexiglas, on paper, and on panel
that Sheeler produced in 1957. The large oil,
Two Against the White, was Sheeler's entry in
the Fourth Annual Hallmark Art Award com-
petition for 1957; he won second prize
($1,000), and Hallmark bought the picture.
The other six works (of which three have
been located) are close variations on that
theme and presumably were Sheeler's work-
ing studies for his prize-winning picture, or his
record of that design made after the fact.
 In the 1950s, Sheeler developed the prac-
tice of planning his large paintings by first mak-
ing elaborate but small-scale pencil drawings of
his design, which he would then attach to a
piece of glass (by 1953, he had substituted the
more durable Plexiglas) to which he applied
tempera to plan color relationships. The pig-
ment could easily be scraped off the glass and
reapplied, a convenient feature for an artist
who gave so much thought to the light-dark
patterns created by his color. When Sheeler
was satisfied with the color relationships, he
would transfer the outlines of the composition
and the color to the large canvas; he then
would detach the drawing from the glass and
color it as a record of the large picture. Until
about 1952, when he was persuaded of their
visual appeal, Sheeler discarded the glass

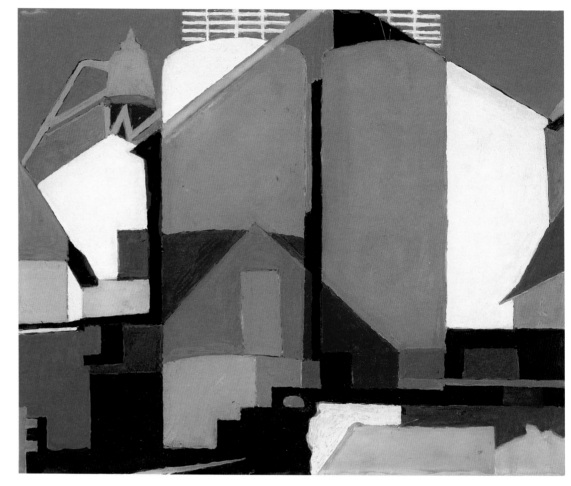

83

paintings. Now these studies are perceived as
the freshest and most spontaneous of his late
work, as a comparison between these two
closely related images shows. In their crispness
and delicacy, the temperas emerge as minia-
ture masterpieces of graphic design.

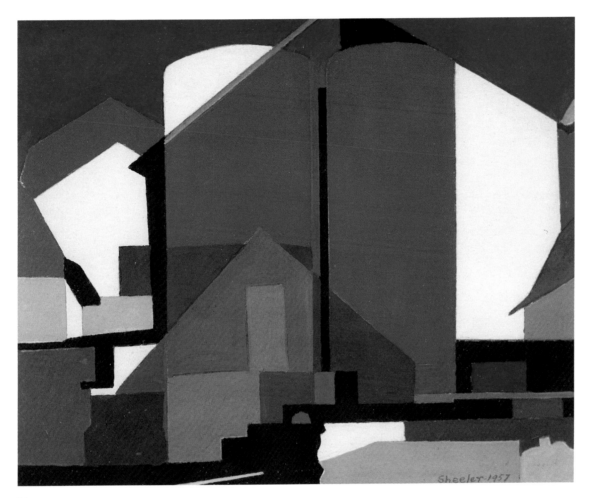

84

85

Yosemite
Signed and dated lower right: *Sheeler/1957*.
Tempera on paper, 6½ x 9⅜ in.
(16.5 x 23.8 cm.)
The Lane Collection

86

Sun, Rocks, and Trees, 1959
Tempera on Plexiglas, 6¾ x 9¾ in.
(17.2 x 24.8 cm.)
Addison Gallery of American Art, Phillips
Academy, Andover, Mass.

On his visit to San Francisco in 1956, Sheeler stayed for several weeks at the home of his long-time friend Ansel Adams, and following the California photographer's example, he explored Yosemite with an eye to making pictures. Both *Sun, Rocks, and Trees* and *Yosemite* grew out of that visit. For Sheeler they were a rare excursion into pure landscape, a genre he seldom attempted and in fact had not experimented with since 1937, when he made a tempera study of the Blue Ridge Mountains (The Lane Collection).

These two paintings take as their subject the national park's low boulders and rocky outcroppings, the site heavily overhung with trees and the far distance barely visible. Sheeler deliberately avoided both the dramatic views of heroic mountains and the close-up examination of nature's floor that were Adams's stock-in-trade. Instead, to express nature's density, he painted an all-over pattern extending beyond the visual field both vertically and horizontally. The details of the landscape and the sense of penetrable space are quickly obscured by Sheeler's resolute abstracting of all forms and by his avoidance of a single dramatic focus. His interest was not in description but in formal problems, most particularly the active role that shadows and negative spaces play, and their emotional consequences. In both *Yosemite* and *Sun, Rocks, and Trees*, the sunny color accents and the animated lacy patterns formed by the foliage and its shadows provide a cheerful counterpoint to the dark, ominous shadows at lower center, creeping silently across the picture's space.

There are three versions of *Yosemite*, all from 1957: a tempera-on-Plexiglas study (Marvin Sinkoff, M.D., New York), in which Sheeler planned his color scheme; a large oil (Hirshhorn Museum and Sculpture Garden, Smithsonian Institution, Washington, D.C.); and this work, which probably followed the oil. *Sun, Rocks, and Trees* also exists in three versions. This picture is the first Sheeler made, and as such represents an unusual survival of a "rough draft." It is one of the few of Sheeler's tempera-on-Plexiglas studies to come to light to which his preliminary pencil drawing is still attached. On that drawing, Sheeler carefully described the details of the composition; the sheet of Plexiglas to which it is attached shows the color relationships Sheeler worked out. Presumably he was not fully satisfied with this version, for several areas are unresolved, and there are changes, particularly in the palette, in the large oil (1959; National Museum of American Art, Washington, D.C.) that followed. A small tempera-on-paper version of this design (1959; Kennedy Galleries, New York) also survives; presumably it is Sheeler's record of the main composition, in which pigment was applied over another pencil drawing – his second draft for the picture – similar to the one behind the Plexiglas in this version of *Sun, Rocks, and Trees*.

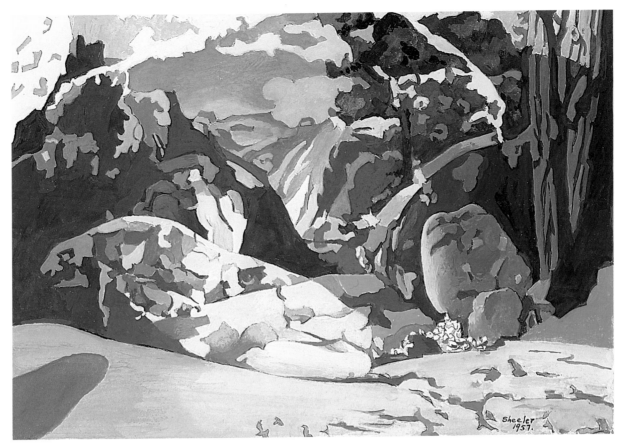

85

86

87

Composition Around White
Signed and dated lower right: *Sheeler 1959*
Oil on canvas, 30 x 33 in. (76.2 x 83.8 cm.)
Private collection

Composition Around White is the last major work Sheeler completed before he suffered a stroke in 1959 that left him unable to paint. That Sheeler should end five decades of creativity with this monumental image of rural architecture is fitting, for the theme had fascinated him throughout his career, beginning with some of his earliest masterworks, the photograph *Side of White Barn* (fig. 8) and the drawing *Barn Abstraction* (cat. no. 9).

Like many of his late paintings, *Composition Around White* is based on a composite photograph. The photograph, of a New England barn complex, had been taken some years before, for the identical image appears in the large oil *Conference* of 1954 (Nelson-Atkins Gallery, Kansas City, Mo.).[1] The composite technique transformed the simple farm buildings into an abstract pattern, whose crisp geometry Sheeler reinforced by outlining each shape with pencil. He further enhanced the abstraction by eliminating the texture of the rough barn siding and stone wall, the architectural details of the gables and window frames, and any signs of wear or deterioration. Thus generalized, the barn loses its historic and geographic context. Sheeler's choice of color adds to the abstractness of the design: a variety of bright and teal blues, pea greens, mauves, and ocher, applied in discrete flat blocks. A wedge-shaped area of pure white in the center of the composition accounts for the title.[2]

Composition Around White demonstrates the concern with superimposed planes that Sheeler had first explored in his landscapes of the teens. Yet just as the image seems to dissolve into an intricate network of linear pattern, Sheeler reminds the viewer of the scene's origin in the visual world. In particular, each silo is delicately and subtly modeled to create an illusion of three-dimensional space, contradicting the viewer's initial conception of the picture as a flat, graphic design.

In his late works, Sheeler returned to several themes that he had favored since the outset of his career: the New York skyline, the simple tabletop still life (see cat. nos. 72 and 79), and the traditional American farm building. In *Composition Around White*, Sheeler reexamined the subject for which he is most celebrated and distilled it into an iconic image, a quintessential barn.

1. The same barn also appears in *Composition Around Yellow* (1958; current location unknown).

2. Sheeler made several paintings of barns in the 1950s with similar titles, including another *Composition Around White* (1951; current location unknown), *Composition Around Red* (1958; The Blount Collection, Montgomery, Ala.), and *Composition Around Yellow*.

Bibliography

Archival Material

Ansel Adams Archive, Center for Creative Photography, University of Arizona, Tucson.

Arensberg Archives, Charles Sheeler Papers, Philadelphia Museum of Art, Twentieth Century Department.

Archives, Colonial Williamsburg, Va.

Downtown Gallery Papers, Archives of American Art, Smithsonian Institution, Washington, D.C.

Archives, Hancock Shaker Village, Hancock, Mass.

Agnes Meyer Papers, Library of Congress, Washington, D.C.

Archives, Pennsylvania Academy of the Fine Arts, Philadelphia.

Charles Sheeler interview by the Brooklyn Museum, April 27, 1965, Brooklyn Museum, N.Y.

Charles Sheeler interview by Bartlett Cowdrey, December 9, 1958, Archives of American Art, Smithsonian Institution, Washington, D.C.

Charles Sheeler interview by Martin Friedman, June 18, 1959, Archives of American Art, Smithsonian Institution, Washington, D.C.

Charles Sheeler Papers, Archives of American Art, Smithsonian Institution, Washington, D.C.

Alfred Stieglitz Archive, Beinecke Library of Rare Books and Manuscripts, Yale University, New Haven, Conn.

Paul Strand Archive, Center for Creative Photography, University of Arizona, Tucson.

Forbes Watson Papers, Archives of American Art, Smithsonian Institution, Washington, D.C.

Edward Weston Archive, Center for Creative Photography, University of Arizona, Tucson.

Archives, Whitney Museum of American Art, New York.

Whitney Museum Papers, Archives of American Art, Smithsonian Institution, Washington, D.C.

Writings by Charles Sheeler

African Negro Sculpture, Photographed by Charles Sheeler. Preface by Marius de Zayas. Privately published, c. 1918.

"Notes." *Metropolitan Museum of Art Bulletin* 1 (January 1943): preceding p. 165.

"Notes." *Metropolitan Museum of Art Bulletin* 1 (April 1943): following p. 260.

"Notes on an Exhibition of Greek Art." *The Arts* 7 (March 1925): 153-58.

"Recent Photographs by Alfred Stieglitz." *The Arts* 3 (May 1923): 345.

"Statement." *The Forum Exhibition of Modern American Painters.* Anderson Galleries, New York, 1916.

Sheeler Exhibition Catalogues

Charles Sheeler: A Retrospective Exhibition. Cedar Rapids [Iowa] Art Center, 1967.

Charles Sheeler: Paintings, Drawings, Photographs. Statements by Sheeler and William Carlos Williams. Museum of Modern Art, New York, 1939.

Charles Sheeler: Retrospective Exhibition. Allentown [Pa.] Art Museum, 1961.

Charles Sheeler: The Works on Paper. Terry Dintenfass, Inc., New York, 1974.

Charles Sheeler (1880-1965) Classic Themes: Painting, Drawing, and Photography. Terry Dintenfass, Inc., New York, 1980.

Dochterman, Lillian. *The Quest of Charles Sheeler: 83 Works Honoring his 80th Year.* University of Iowa, Iowa City, 1963.

Friedman, Martin, et al. *Charles Sheeler.* National Collection of Fine Arts, Smithsonian Institution, Washington, D.C., 1968.

Sims, Patterson. *Charles Sheeler.* Whitney Museum of American Art, New York, 1980.

Wight, Frederick S. *Charles Sheeler: A Retrospective Exhibition.* Art Galleries, University of California at Los Angeles, 1954.

Yeh, Susan Fillin-. *Charles Sheeler: American Interiors.* Yale University Art Gallery, New Haven, Conn., 1987.

Other Sources

Agee, William C. *Morton Livingston Schamberg.* Salander-O'Reilly Galleries, Inc., New York, 1982.

American Realists and Magic Realists. Edited by Alfred H. Barr, Jr., and Dorothy C. Miller. Museum of Modern Art, New York, 1943.

Andrews, Faith, and Edward D. Andrews. "Sheeler and the Shakers." *Art in America* 53 (February 1965): 90-95.

Barkin, Ben. "Art at Meta-Mold." *Art in America* 44 (Spring 1956): 36-38, 63-66.

Baur, John I. H. "A 'Classical' Modern." *Brooklyn Museum Quarterly* 26 (January 1939): 23-24.

Born, Wolfgang. *American Landscape Painting.* New Haven, Conn., 1948.

Brace, Ernest. "Charles Sheeler." *Creative Art* 11 (October 1932): 96-104.

Brown, Milton W. *The Story of the Armory Show.* Greenwich, Conn., 1963.

———. "Sheeler and Power." *Parnassus* 13 (January 1941): 46.

Chanin, A. L. "Charles Sheeler: Purist Brush and Camera Eye." *Art News* 54 (Summer 1955): 40-42, 70-72.

"Charles Sheeler." *Art News* 30 (November 21, 1931): 8.

"Charles Sheeler — 1946." *Art News* 45 (March 1946): 30-31.

"Charles Sheeler at DeZayas." *American Art News* 18 (February 21, 1920): 3.

Coates, Robert M. "The Art Galleries: Gauguin and Sheeler." *The New Yorker,* April 14, 1956, p. 112.

———. "The Art Galleries — A Sheeler Retrospective." *The New Yorker,* October 14, 1939, p. 56.

Coke, Van Deren. *The Painter and the Photograph.* Albuquerque, 1964.

Cortissoz, Royal. "Charles Sheeler." *New York Herald Tribune,* October 8, 1939, sec. 6, p. 8.

Craven, Thomas. "Charles Sheeler." *Shadowland* 8 (March 1923): 11, 71.

Crowninshield, Frank. "Charles Sheeler's *Americana.*" *Vogue,* October 15, 1939, p. 106ff.

Davies, Karen. "Charles Sheeler in Doylestown and the Image of Rural Architecture." *Arts Magazine* 59 (March 1985): 135-39.

Devree, Howard. "Sheeler Complete." *Magazine of Art* 32 (November 1939): 644.

Dochterman, Lillian Natalie. *The Stylistic Development of the Work of Charles Sheeler.* Ph.D. diss., State University of Iowa, 1963.

Driscoll, John. "Charles Sheeler's Early Work: Five Rediscovered Paintings." *Art Bulletin* 62 (March 1980): 124-33.

Elson, Robert T. *The World of Time Inc.: The Intimate History of a Publishing Enterprise.* 2 vols. New York, 1968 and 1973.

Friedman, Martin. *Charles Sheeler.* New York, 1975.

———. *The Precisionist View in American Art.* Walker Art Center, Minneapolis, 1960.

———, et al. "The Precisionists." *Art in America* 48 ([Fall] 1960): 30-61.

Genauer, Emily. "Charles Sheeler in One-Man Show." *New York World,* October 7, 1939, p. 34.

———. "Classical Sheeler." *New York Herald Tribune,* March 30, 1958, book sec., p. 14.

Goodrich, Lloyd. "New York Exhibitions: Sheeler and Lozowick." *The Arts* 9 (February 1926): 97, 102-3.

H.V.D. "Art: Charles Sheeler's Exhibition." *New York Times,* November 19, 1931, p. 32.

Hammen, Scott. "Sheeler and Strand's *Manahatta:* A Neglected Masterpiece." *Afterimage* 6 (January 1979): 6-7.

Hyland, Douglas K. S. "Agnes Ernst Meyer, Patron of American Modernism." *American Art Journal* 12 (Winter 1980): 64-81.

"Immaculate School Seen at Daniel's." *Art News* 27 (November 3, 1928): 9.

Jacob, Mary Jane. "The Impact of Shaker Design on the Work of Charles Sheeler." Master's thesis, University of Michigan, Ann Arbor, 1976.

———, and Linda Downs. *The Rouge: The Image of Industry in the Art of Charles Sheeler and Diego Rivera.* Detroit Institute of Arts, 1978.

Jewell, Edward Alden. "Sheeler in Retrospect." *New York Times,* October 8, 1939, sec. 9, p. 9.

Josephson, Matthew. *Life Among the Surrealists.* New York, 1962.

Juliana Force and American Art. Whitney Museum of American Art, New York, 1949.

Kasson, John F. *Civilizing the Machine: Technology and Republican Values in America, 1776-1900*. New York, 1976.

Kootz, Samuel M. "Ford Plant Photos of Charles Sheeler." *Creative Art* 8 (April 1931): 264-67.

———. *Modern American Painters*. New York, 1930.

———. *New Frontiers in American Painting*. New York, 1943.

Kramer, Hilton. "American Pastoral." *Artforum* 7 (January 1969): 36-39.

———. "The American Precisionists." *Arts Magazine* 35 (March 1961): 32-37.

Lane, James. "Of Sheeler's Immaculatism." *Art News* 38 (October 7, 1939): 10.

Levin, Gail. *Synchromism and American Color Abstraction, 1910-1925*. Whitney Museum of American Art, New York, 1978.

Lowe, Jeannette. "51st Street Becomes Downtown." *Art News* 39 (October 19, 1940): 12.

——— [J.L.]. "Sheeler's Symbols of the Machine Age." *Art News* 39 (December 7, 1940): 11.

Lynes, Russell. "Whose Business Is Art?" *Art in America* 44 (Spring 1956): 11-16, 60-61.

Macgowan, Kenneth. "Philadelphia's Exhibit of 'What Is It?'" *Boston Evening Transcript*, May 27, 1916, pt. 3, p. 6.

"Manhattan — The Proud and Passionate City." *Vanity Fair*, April 1922, p. 51.

Marcel Duchamp. Edited by Anne d'Harnoncourt and Kynaston McShine. Museum of Modern Art, New York, and Philadelphia Museum of Art, 1973.

Marlor, Clark S. *The Society of Independent Artists: The Exhibition Record, 1917-1944*. Park Ridge, N.J., 1984.

Maroney, James. *The Elite and Popular Appeal of the Art of Charles Sheeler*. James Maroney, Inc., New York, 1986.

———. *The Odd Picture*. New York, 1984.

McBride, Henry. "Aestheticism Pays: The Art of Charles Sheeler Now Has a Definite Following." *New York Sun*, March 9, 1946, p. 9.

———. "Charles Sheeler." *New York Times*, April 9, 1922.

———. "Paintings by Charles Sheeler." *New York Sun*, November 21, 1931, Sporting Section, p. 12. Whitney Museum Papers 1: 184.

———. "Work of Charles Sheeler Attracts Attention." *Sun and New York Herald*, February 22, 1920, p. 7.

———. "Attractions in the Galleries — Downtown Gallery." *New York Sun*, January 28, 1949.

McCormick, W. B. "Machine Age Debunked." *New York American*, November 26, 1931.

[McCoy, Garnett] G. McC. "Charles Sheeler: Some Early Documents and a Reminiscence." *Journal of the Archives of American Art* 5 (April 1965): 1-4.

Millard, Charles W. "Charles Sheeler: American Photographer." *Contemporary Photographer* 6 (1967).

Miller, L. W. "The Philadelphia School of Industrial Art." *The Art Amateur* 16 (April 1887): 114-15.

Murals by American Painters and Photographers. Museum of Modern Art, New York, 1932.

Naef, Weston J. *The Collection of Alfred Stieglitz: Fifty Pioneers of Modern Photography*. Metropolitan Museum of Art, New York, 1978.

Naumann, Francis. "Walter Conrad Arensberg: Poet, Patron and Participant in the New York Avant-Garde, 1915-20." *Philadelphia Museum of Art Bulletin* 76 (Spring 1980): 1-32.

———, intro. and notes. "Marius de Zayas, 'How, When, and Why Modern Art Came to New York,'" *Arts* 54 (April 1980): 96-126.

Nevins, Allan, and Frank Ernest Hill. *Ford: Expansion and Challenge, 1915-1933*. New York, 1957.

O'Keeffe, Georgia, Charles Sheeler et al., "Can a Photograph have the Significance of Art?" *MSS.* 4 (December 1922): 1-18.

"Paintings and Drawings by Sheeler." *American Art News* 20 (April 1, 1922): 6.

Parker, Robert Allerton. "The Classical Vision of Charles Sheeler." *International Studio* 84 (May 1926): 68-72.

Philadelphia: Three Centuries of American Art. Edited by Darrel Sewell. Philadelphia Museum of Art, 1976.

Phillips, Duncan. *A Collection in the Making*. New York, 1926.

———. "Original American Painting of Today." *Formes* (English edition) 21 (January 1932): 197-201.

Poore, Dudley. "Current Exhibitions." *The Arts* 7 (February 1925): 115.

"Power: A Portfolio by Charles Sheeler." *Fortune*, December 1940, pp. 73-83.

Preston, Stuart [S.P.]. "5 Stars for February." *Art News* 47 (February 1949): 14-16.

Richardson, Edgar P. "Three American Painters: Sheeler, Hopper, Burchfield." *Perspectives U.S.A.* 16 (Summer 1956): 111-19.

Rosenfeld, Paul. "Carl Sandburg and Photography." *The New Republic*, January 22, 1930, pp. 251-53.

Rourke, Constance. *Charles Sheeler, Artist in the American Tradition*. New York, 1938.

———. *The Roots of American Culture and Other Essays*. Edited by Van Wyck Brooks. New York, 1942.

Sandburg, Carl. *Steichen the Photographer*. New York, 1929.

"Sheeler Finds Beauty in the Commonplace." *Life*, August 8, 1938, p. 42-45.

"Sheeler Paints Power." *Art Digest* 15 (December 1, 1940): 8.

Spender, J. A. *Through English Eyes*. New York, 1928.

Stebbins, Theodore E., Jr., and Carol Troyen. *The Lane Collection: 20th-Century Paintings in the American Tradition*. Museum of Fine Arts, Boston, 1983.

Stewart, Patrick L., Jr. *Charles Sheeler, William Carlos Williams, and the Development of the Precisionist Aesthetic*. Ph.D. diss., University of Delaware, 1981.

———. "Charles Sheeler, William Carlos Williams, and Precisionism: A Redefinition." *Arts Magazine* 58 (November 1983): 100-114.

Strand, Paul. "Photography and the New God." *Broom* 3 (November 1922): 252-58.

———. "Steichen and Commercial Art." *The New Republic*, February 19, 1930, p. 21.

Tashjian, Dickran. *Skyscraper Primitives: Dada and the American Avant-Garde, 1910-1925*. Middletown, Conn., 1975.

———. *William Carlos Williams and the American Scene*. Whitney Museum of American Art, New York, 1978.

Troyen, Carol. "The Open Window and the Empty Chair: Charles Sheeler's *View of New York*." *American Art Journal* 18, no. 2 (1986): 24-41.

Tsujimoto, Karen. *Images of America: Precisionist Painting and Modern Photography*. San Francisco Museum of Modern Art, 1982.

Watson, Forbes. "The Barnes Foundation." *The Arts* 3 (January 1923): pt. 1, pp. 9-23; (February 1923): pt. 2, pp. 140-49.

———. "Charles Sheeler." *The Arts* 3 (May 1923): 334-44.

———. "Opening the New Year." *The Arts* 5 (January 1924): 42-52.

———, and Lloyd Goodrich. "New York Exhibitions." *The Arts* 9, no. 2 (February 1926): 97, 102-3.

Weston, Edward. *The Daybooks of Edward Weston*. Vol. 1: Mexico. Edited by Nancy Newhall. New York, 1961.

Whelan, Anne. "Barn is a Thing of Beauty to Charles Sheeler, Artist." *Bridgeport Sunday Post*, August 21, 1938, sec. B, p. 4.

Williams, William Carlos. *The Autobiography of William Carlos Williams*. New York, 1951.

———. "Painting in the American Grain." *Art News* 53 (Summer 1954): 20-23, 62, 78.

Wilson, Richard Guy, Dianne H. Pilgrim, and Dickran Tashjian. *The Machine Age in America, 1918-1941*. Brooklyn Museum, N.Y., 1986.

Wolf, Ben. *Morton Livingston Schamberg*. Philadelphia, 1963.

Yeh, Susan Fillin. *Charles Sheeler and the Machine Age*. Ph.D. diss., City University of New York, 1981.

———. "Charles Sheeler: Industry, Fashion, and the Vanguard." *Arts Magazine* 54 (February 1980): 154-58.

———. "Charles Sheeler's 1923 'Self Portrait.'" *Arts Magazine* 52 (January 1978): 106-9.

———. "Rouge: Image and Industry in the Art of Sheeler and Rivera." *Arts Magazine* 53 (November 1978): 8.

Zilczer, Judith. "*The Noble Buyer:*" *John Quinn, Patron of the Avant-Garde*. Hirshhorn Museum and Sculpture Garden, Smithsonian Institution, Washington, D.C., 1978.

———. "The World's New Art Center: Modern Art Exhibitions in New York City, 1913-1918." *Archives of American Art Journal* 14, no. 3 (1974): 2-7.

Chronology

1883
Born Charles Rettew Sheeler, Jr., July 16 in Philadelphia, to Charles Rettew Sheeler and Mary Cunningham Sheeler

1900
Enters School of Industrial Art, Philadelphia

1903
Enters Pennsylvania Academy of the Fine Arts, Philadelphia

1904
Travels to London and Holland with William Merritt Chase

1905
Travels to Spain with Chase

1906
Graduates from Pennsylvania Academy; summer at Gloucester, Mass.

1907
Address: 1626 Chestnut Street, Philadelphia

1908
Begins to share Chestnut Street studio with Morton Schamberg
First solo paintings exhibition at McClees Gallery, Philadelphia (November)
Exhibits five paintings at William Macbeth Gallery, New York (November)
Travels in Europe with his parents and Schamberg: Naples, Rome, Venice, Milan, Florence (December); Paris (January and February)

c. 1910
Begins career as a photographer

1910
Rents Worthington House in Doylestown, Pa. (to 1926)

1911
Begins to correspond with Alfred Stieglitz

1913
Exhibits six paintings in the Armory Show, New York

1915
Address: 1822 Chestnut Street, Philadelphia

1916
Exhibits nine paintings and drawings in the Forum Exhibition, New York
Begins to work as an assistant at Marius de Zayas's Modern Gallery, New York

1917
First exhibition of photographs, with Schamberg and Paul Strand, at the Modern Gallery (March 29-April 9)

Solo exhibition at Modern Gallery of Doylestown House photographs (December 3-15)

1918
Wins first and fourth prizes in thirteenth John Wanamaker photography exhibition (March)
Schamberg dies, October 13

1919
Moves to New York (Address: 160 East 25th Street) by September
Sells first paintings to Ferdinand Howald, through Charles Daniel

1920
Films *Manhatta* with Paul Strand
Solo exhibition of paintings, drawings, and photographs at de Zayas Gallery (February 16-28)

1921
Marries Katharine Baird Shaffer, April 7
Address: 344 8th Avenue, New York
Spends summer in Louise and Walter Arensberg's apartment at 33 West 67th Street, moves to 450 West 147th Street by the fall

1922
Solo exhibition of paintings, drawings, and photographs at the Daniel Gallery
Meets Edward Weston

1923
Address: 10 West 8th Street, in apartment above Whitney Studio Club
Breaks with Stieglitz

1924
Solo exhibition of paintings and drawings at Whitney Studio Club

1925
Studio address: 17 West 8th Street
Essay on Greek art published in *Arts* (March)

1926
Begins to work for Condé Nast Publications, Inc. (to 1929)
Moves to South Salem, New York, late in the year; maintains New York City studio on 8th Street
Exhibits photographs at Art Center and paintings at J. B. Neumann's Print Rooms, New York

1927
Spends six weeks in Detroit photographing the Ford Motor Company's River Rouge Plant for N.W. Ayer and Son (October-December)

1928
Short trip to Detroit (January)
Moves studio from 80 West 40th Street to 47 West 49th Street
Abby Aldrich Rockefeller purchases first Sheelers

1929
Last trip to Europe: Paris, Chartres (does photographic series); Stuttgart (work included in "Film und Foto" exhibition); Bavaria (April-August)
Paints *Upper Deck*

1930
Moves studio to 310 East 44th Street

1931
First solo exhibition at Edith Halpert's Downtown Gallery; begins exclusive affiliation with that gallery (November)
Exhibits photographs in inaugural show at Julien Levy Gallery (November)

1932
Moves from South Salem, N.Y., to Ridgefield, Conn.

1933
Katharine Sheeler dies (June)

1935
Travels to Colonial Williamsburg on commission

1938
Constance Rourke's biography, *Charles Sheeler, Artist in the American Tradition*, published, making use of Sheeler's autobiographical notes

1939
Marries Musya Metas Sokolova, April 2, in Rutherford, N.J.
"Power" series of paintings commissioned by *Fortune* – travels to New York, Pennsylvania, Tennessee, and Alabama (Spring), Boulder Dam (October)
Retrospective exhibition of paintings, drawings, and photographs at the Museum of Modern Art, New York (October)

1940
Solo exhibition of photographs in "Pageant of Photography," in Golden Gate International Exhibition, San Francisco

1941
Works with Weston in Connecticut (October)

1942
Moves from Ridgefield, Conn., to "Bird's Nest," Dow's Lane, Irvington-on-Hudson, N.Y.
Begins to work at Metropolitan Museum of Art, New York, as Senior Research Fellow in Photography (July)

1944
Solo exhibition of paintings at Dayton Art Institute

1945
Ends affiliation with Metropolitan Museum of Art (July)

1946
Works as artist-in-residence, Phillips Academy, Andover, Massachusetts (October)

1948
Works as artist-in-residence, Currier Gallery of Art, Manchester, N.H. (May)

Commissioned by Kodak to produce a series of color photographs of Shaker buildings and the U.N. building

1952
Travels on commission to U.S. Steel Co. in Pittsburgh and to Cedarburg, Wisc. (May)

1954
Flies to Los Angeles with William H. Lane for retrospective exhibition of paintings, drawings, and photographs at UCLA

Visits Ansel Adams in San Francisco and Weston in Carmel; photographs Pacific Gas and Electric power plant at Morro Bay

1955
Summers in Cape Split, Maine, at home of John Marin, Jr. (June - August)

Travels on commission to Warren, Michigan to General Motors Research Laboratory (Fall)

1956
Visits Adams in San Francisco and Weston in Carmel; photographs Tidewater Oil Company refinery at Avon with photographer Pirkle Jones; travels to Yosemite, Sequoia national parks, Utah, Colorado Rockies (June – August)

1958
Revisits Williamsburg, travels to Jamestown and Yorktown

1959
Incapacitated by a stroke (October)

1961
Retrospective exhibition at Allentown (Pa.) Art Museum

1962
Receives Award of Merit Medal for Painting, American Academy of Arts and Letters

1963
Elected to membership in National Institute of Arts and Letters

Retrospective exhibition at University of Iowa Art Galleries, Iowa City

1965
Dies, May 7

Index to the Works